C000132380

Picasso's
«Parade»

Public funds from the National Endowment for the Arts have
helped make this exhibition and book possible.

A generous grant from the Howard Gilman Foundation has also
helped to make the exhibition and the book possible.

A grant from the Andrew W. Mellon Foundation supported the
publication of the book.

Picasso's «Parade»

From street to stage

Ballet by Jean Cocteau

Score by Erik Satie

Choreography by Léonide Massine

Deborah Menaker Rothschild

Published in association with The Drawing Center, New York, museum for the study and exhibition of drawings

Sotheby's Publications

Published in conjunction with the exhibition 'Picasso's
''Parade'' from Paper to Stage', presented by The Drawing
Center, 35 Wooster Street, New York, N.Y. 10013,
6 April–13 June 1991

First published 1991 for Sotheby's Publications
by Philip Wilson Publishers Limited
26 Litchfield Street, London WC2H 9NJ

ISBN 0 85667 392 7

LC 90-063717

Designed by Roy Cole
Typeset by Tradespools Ltd, Frome, Somerset
Printed by BAS Printers Ltd, Over Wallop, Hants
Bound by Hazell Books Ltd, Aylesbury, Bucks

Contents

7 Acknowledgement by Martha Beck

9 Author's acknowledgement

11 Foreword by Jeanne Thayer and Michael Iovenko

13 Colour plates

1

29 Music-hall invades art with a capital A

2

42 Cocteau, Picasso, Apollinaire and the origins of «Parade»

3

48 The collaboration begins in Rome then moves to Naples

4

60 'Soyons vulgaires'

5

72 From the street to the élite: the characters and scene of «Parade»

6

86 The music and choreography

7

100 The costumes and décor

8

208 The «Parade» curtain

9

239 Picasso and the dining theme: Neapolitan and Mediterranean influences

10

252 Inspiration for the «Parade» curtain in the poetry of Apollinaire and Verlaine and in the painting of Rousseau

11

259 The «Parade» overture curtain as a reflection of Picasso's life in 1917

267 Appendix: Description of «Parade» by Guillaume Apollinaire

269 Bibliographical abbreviations

270 Bibliography

276 Publisher's acknowledgements

277 Index

Acknowledgement

It was a great pleasure to organize this exhibition and the book that accompanies it. The drawings of the extraordinary genius, Pablo Picasso, wonderfully complement the first historical exhibition I organized in 1977, *The Drawings of Antonio Gaudi*, the great Catalan architect. That was the year The Drawing Center opened and it was a brave, new place. I am proud that in the intervening years it has grown into an institution that is respected around the world.

I want to especially thank the lenders. First, the Musée Picasso, brilliantly directed by Gérard Regnier. I am grateful for the constant help of Brigitte Leal and Paule Mazouet. Secondly, I want to thank Frederick R. Koch for lending his Satie manuscript, now housed at the Pierpont Morgan Library, New York. Rigbie Turner and David Wright of the Morgan Library have aided us at every turn. Thanks also go to Laura Matteoli-Rossi, and to Jacques Helft for his efforts to lend his family's drawing, which appears on the front cover of the book.

Exceptional thanks go to Deborah Menaker Rothschild for the fascinating book she has written.

I want to thank the following: Egbert Haverkamp-Begemann, John Langeloth Loeb Professor of the History of Art at the Institute of Fine Arts, New York University; Per Bjurström, Director of the Nationalmuseum of Stockholm; Dennis Farr, Director of the Courtauld Galleries; John Harris, former Keeper of the Royal Institute of British Architects; C. Michael Kauffmann, Director of the Courtauld Institute; Giandomenico Romanelli, Director of the Civic Museums of Venice; Pierre Rosenberg, Conservateur en Chef, Louvre; and John Rowlands, Keeper of the Department of Prints and Drawings, British Museum. They have generously shared with me their intelligent and splendid knowledge over the years. They have all been blessed with wonderfully discerning visual perceptions which were enlightening to me.

I would like to thank my colleagues at The Drawing Center: Ann Philbin, Director; Meryl Cohen, Registrar; Kristina Friberg, Administrative Assistant; and Peter Gilmore, Director of Operations.

And I would like to thank the Board of Directors for their support: Mrs. Walter N. Thayer and Michael Iovenko, Co-Chairmen; Mrs. Felix G. Rohatyn, Vice-Chairman; Dita Amory, James M. Clark, Jr., Mrs. Colin Draper, Colin Eisler, Werner H. Kramarsky, Abby Leigh, William S. Lieberman, Michael Lynne, Mrs. Gregor W. Medinger, and Edward H. Tuck. Special thanks go to the first chairman, Edward H. Tuck, who responded to the original idea with enthusiasm and in innumerable ways helped to build The Drawing Center. He has continuously lent not only his support, but also his magical charm, for which I am grateful.

I cannot close without also thanking: Pierre Apraxine, David Bancroft, John Barelli, Michael Beirut, Jane Bennett, Huntington T. Block, William G. Bowen, Roy Cole, Margaret Holben Ellis, Robert Falkner, Howard Gilman, Adam Gopnik, Laura Hillyer, Chris Humphrey, Anne Jackson, Anne de Margerie, Richard Oldenburg, Andrew Oliver, Robert Rosenblum, Neil Rudenstine, Kirk Varnedoe, Lella and Massimo Vignelli, Madame Ornella Volta, Alice Martin Whelihan, and Philip Wilson.

Martha Beck

Author's acknowledgement

I began working on Picasso's designs for the theatre at the suggestion of William Rubin, Director Emeritus of the Department of Painting and Sculpture at the Museum of Modern Art in New York. In 1980 when he was organizing the massive *Pablo Picasso: A Retrospective* I was hired as a curatorial assistant. Among my tasks was to find collateral material for the theatre section of the exhibition. Later Mr. Rubin, who was familiar with the holdings of the new Musée Picasso in Paris, told me that there was rich material for a dissertation waiting to be mined on Picasso's theatrical *oeuvre*. Although at times I despaired as I ploughed my way through researching Picasso and his collaboration with the Russian Ballet, I now feel fortunate to have worked on an artist of his magnitude.

There are many other people to whom I owe thanks. First and foremost is Robert Rosenblum, my thesis advisor and mentor at the Institute of Fine Arts, New York University. I am indebted to Professor Rosenblum for recommending my thesis as the basis for this publication to Martha Beck, founder and Director Emeritus of The Drawing Center. Professor Rosenblum's example has been my standard for art historical scholarship for nearly twenty years. Besides the brilliance of his insights and his gifts as a writer, I admire his willingness to re-examine established notions, even his own earlier thinking.

Martha Beck's consistent encouragement and optimistic spirit have been of inestimable value. She, and her successor as Director of The Drawing Center, Ann Philbin, have provided much-appreciated encouragement and support and it has been a delight to work with them. I am extremely grateful to Meryl Cohen for arranging a thousand irritating details with great professionalism and consistent good humour. Caroline Harris of The Drawing Center has also been most helpful. In London at Philip Wilson Publishers it was a great pleasure to work with Jane Bennett.

The staff of the Musée Picasso in Paris has been especially kind. I would like to thank former Director, Dominique Bozo, Honorary Conservateur en chef, Michèle Richet, Curators, Hélène Seckel and Marie-Laure Bernadac, as well as the current Director, Gérard Regnier. Laurence Marceillac and Paule Mazouet have also provided assistance. Also in Paris, Mme. Ornella Volta, of the Erik Satie Foun-

dation, who is a font of little-known information on the period, received me warmly, showed me important documents and shared with me her critical findings on Satie's use of popular music. The staff members of the Bibliothèque de l'Opéra, the Musée d'Arsenal, the Musée de la ville de Paris and the Bibliothèque Nationale were all extremely helpful. Mlle. Caroline de Lambertie of the Service photographique de la Réunion des Musées Nationaux pleasantly met our many requests for photographs.

Parmenia Ekstrom, of the Diaghilev-Stravinsky Foundation was as fascinating to talk to about Diaghilev and his *entourage* as she was informative and helpful. I am deeply grateful to her for arranging a meeting with Diaghilev's librettist and right-hand man, Boris Kochno. Mr. Kochno himself was exceedingly forthcoming with direct answers to my numerous questions and as a witness to the Diaghilev epoch his accounts proved invaluable. Madame Alexandra Danilova, who came on the scene in 1924 as a member of the Ballets Russes troupe was also kind enough to grant me an interview and gave me wonderful insights into the interpersonal relations within Diaghilev's enterprise. Tatiana Massine could not have been more accommodating to my repeated requests for information, interviews and access to archival material. She also put me in touch with a network of ballet scholars including Lynn Garafola and Mary Ann de Vlieg who in turn were most helpful. In London, Pip Dwyer of the Victoria and Albert Theatre Museum and Melissa McQuillan provided useful information.

The late Robert Joffrey spoke to me at length in 1980 about Massine's conception for the choreography of *Parade*. Mark Glimcher of Pace Gallery allowed me to view Picasso notebooks and sketchbooks during the showing of the exhibition *Je suis le cahier* in 1986.

Kenneth Silver, whose research, as my footnotes indicate, I consulted repeatedly, has been a pleasure to talk to and has also been extremely kind and helpful. Patricia Leighten, Jeffrey Weiss, Keith Money and Billy Klüver are other scholars who have been forthcoming with information.

In Williamstown I would like to thank W. Rod Faulds, Acting Director, 1989 and Linda Shearer, current Director of the Williams College Museum of Art for supporting a leave of absence that enabled me to complete my thesis during the summer of 1989. Williams College President, Francis Oakley and provost Gordon Winston, were also supportive of the leave. I cannot adequately express my gratitude to Mrs. Shearer for being so understanding of the time this project needed.

I would like to acknowledge others who have worked on the production of this book. My assistant and dear friend, Lesley Wellman, has been indispensable, bringing thoroughness and intelligence to every task she is given. It was she who undertook the difficult job of securing photographs and permission to publish. Susan Dillman provided skilful editing, Linda Bartlett helped with computer snags, Paulette O'Brien assisted with translations from French, Valerie Krall with translations from Italian and editing. Ramona Lieberoff compiled the bibliography. I am grateful to the staffs of Sawyer Library at Williams College and the Clark Art Institute library; in particular I would like to thank Lee Dalzell, Alison O'Grady, and Paige Carter. I am also indebted to librarians at the Pierpont Morgan Library, the Beinecke Rare Book and Manuscript Library, the Theater Collection and Dance Collection, Lincoln Center, New York Public Library. I am particularly indebted to Dorothy Swerdlove, Curator of the Billy Rose Theater Collection, for her efforts on my behalf.

Darryle Pollack, Eva Grudin, Christine Kondoleon, Adrian Piper, Valerie Cook, Deanna Alpher, Edith and Ernst Rothschild and especially Lois Torf are friends and relatives who have in some measure contributed to this effort. I am also grateful to Sandy Schneiderman and Andy and Maggie Mozsinski for their hospitality in New York and Paris.

Last but not least I cannot thank enough my family for their very tangible support. I am grateful to my mother and father for encouraging me to pursue my own interests, even when they thought them highly impractical. My brother, Dr Steven Menaker, first ignited my interest in art. It was he and my sister-in-law, Joanna, who made possible a trip to Paris and also provided a ready ear for my thoughts on Picasso. My children Adam and Aaron just in their being have been a source of strength and motivation for me. Adam helped hands-on by collating my thesis and even spotting several missing pages. Above all, my husband David Rothschild has borne the brunt of this project over a nine-year period with characteristic grace and good humour.

Foreword

To be surrounded by a pride of Picasso drawings is a rare delight for The Drawing Center. And to have Deborah Menaker Rothschild in her splendid catalogue introduce the year 1917, Picasso, Satie, Cocteau, Massine, Diaghilev and others into our exhibition space is to experience these drawings in a very different way from past exhibitions: we could not be more pleased.

This exhibition could not have occurred without the constant help of Gérard Regnier, Director of the Musée Picasso. But we are also grateful for and touched by the friendship and support which our many French colleagues have so generously extended to the Center, especially Pierre Rosenberg at the Louvre. Martha Beck, Founder and now Director Emeritus of the Center, has been a superb curator for this exhibit, weaving with her customary energy and imagination the complex strands of this enterprise, not unlike those of the *Parade* production itself.

The Drawing Center is now well into its teens. It will continue its extraordinary and varied historical exhibits which have evoked such enthusiastic responses. Also under the guidance of our new Director, Ann Philbin, we will in our exhibits of unknown, contemporary artists reach throughout the United States to cull the best that other cities and regions of the country have to offer. At the same time we look forward to involving ourselves even more intimately with the aesthetic life of New York City. We may also present a restrospective show of an insufficiently recognized talent. We want to continue to support in increasing ways those artists who struggle for understanding and appreciation, whatever form these endeavours may take.

Like every artist, the Center dedicates itself to renewal and to reinforcing the strong reciprocal links we have with our growing number of artists, our audience and supporters, all of whom we value and thank heartily.

Jeanne Thayer, Michael Iovenko
Co-Chairmen, The Drawing Center

Publisher's note

All subjects illustrated in the Colour Plates are from
the monochrome sequence of illustrations. For full
details of subjects illustrated in Colour Plates, see
captions to monochrome illustrations bearing the
corresponding numbers.

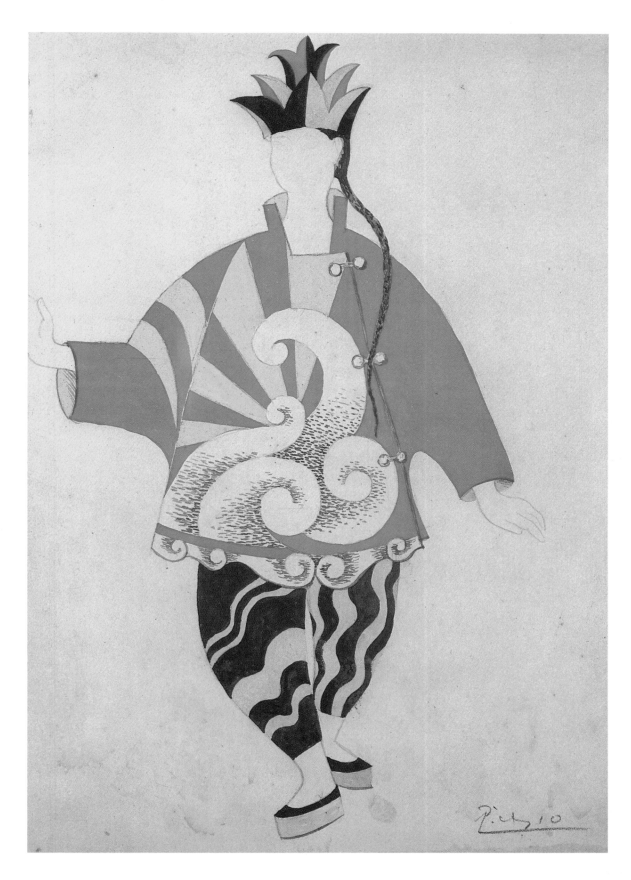

67 Pablo Picasso, study for
the Chinese Conjurer's
costume, watercolour

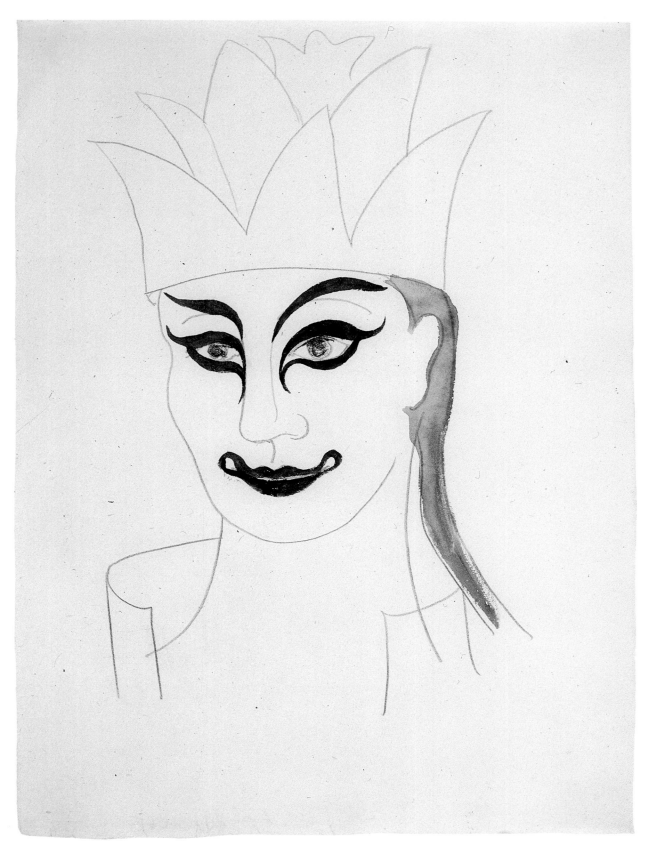

73 Pablo Picasso, study for
the make-up of the Chinese
Conjurer, pencil and ink
wash

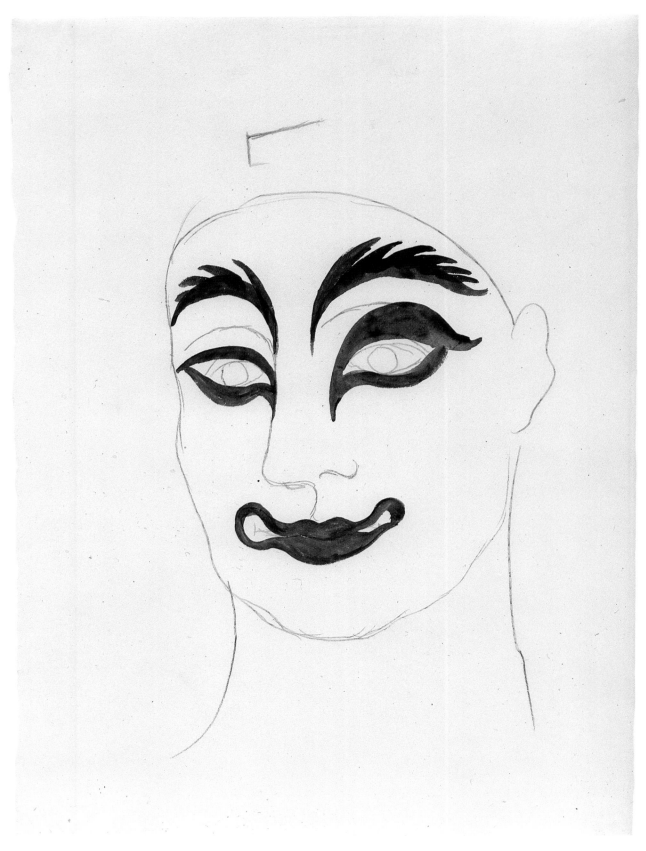

74 Pablo Picasso, study for
the make-up of the Chinese
Conjurer, pencil and
watercolour

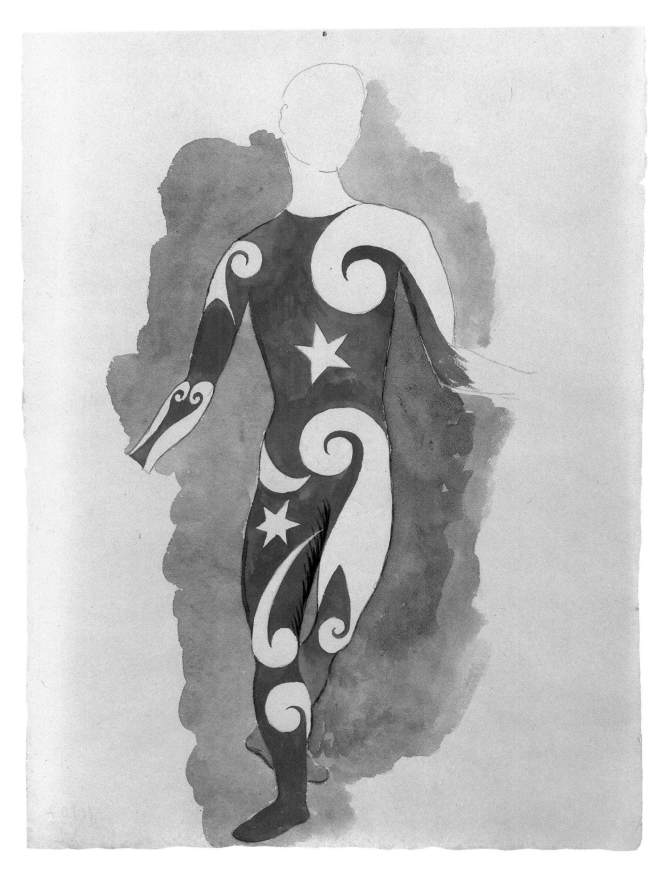

93 Pablo Picasso, project for
the male Acrobat's costume,
watercolour and pencil

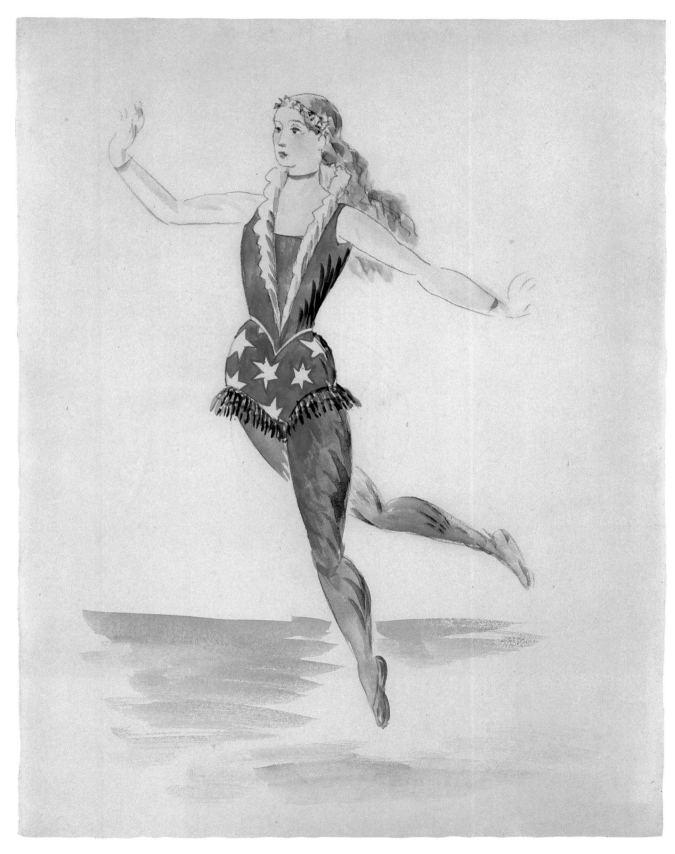

94 Pablo Picasso, project for
the female Acrobat's
costume, watercolour and
pencil

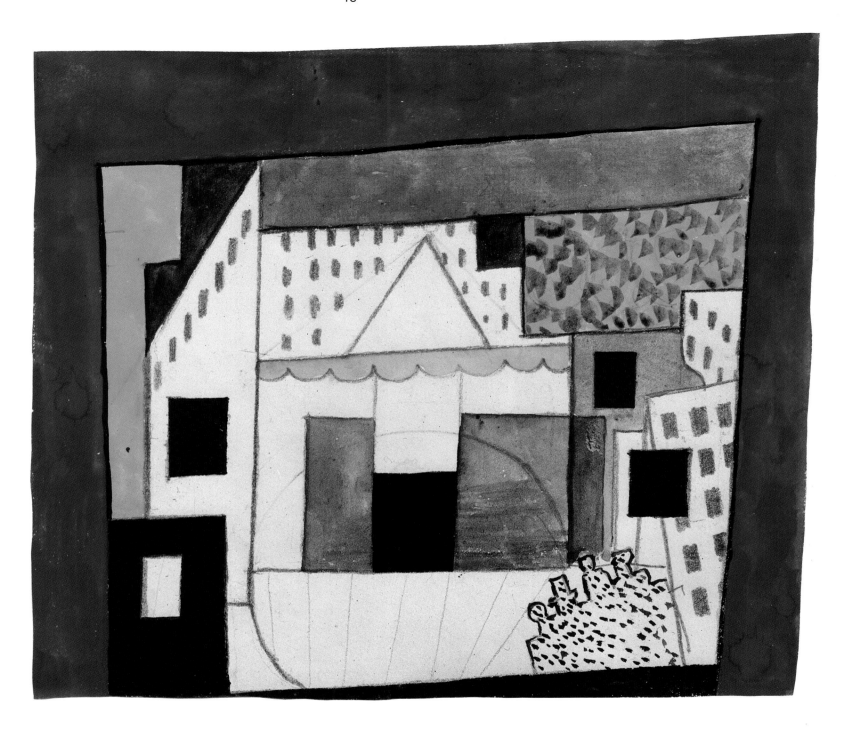

170 Pablo Picasso, study for
the set, gouache and pencil

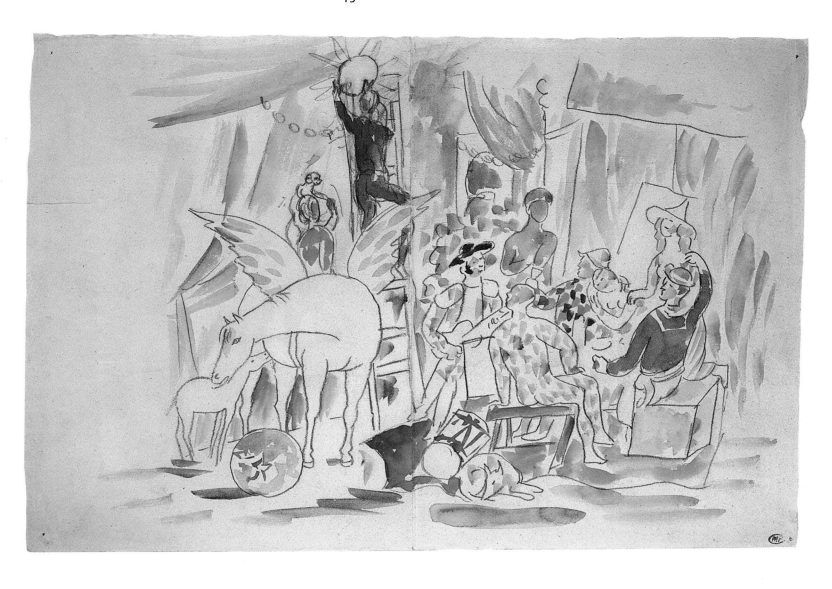

191 Pablo Picasso, project
for the overture curtain,
watercolour and pencil

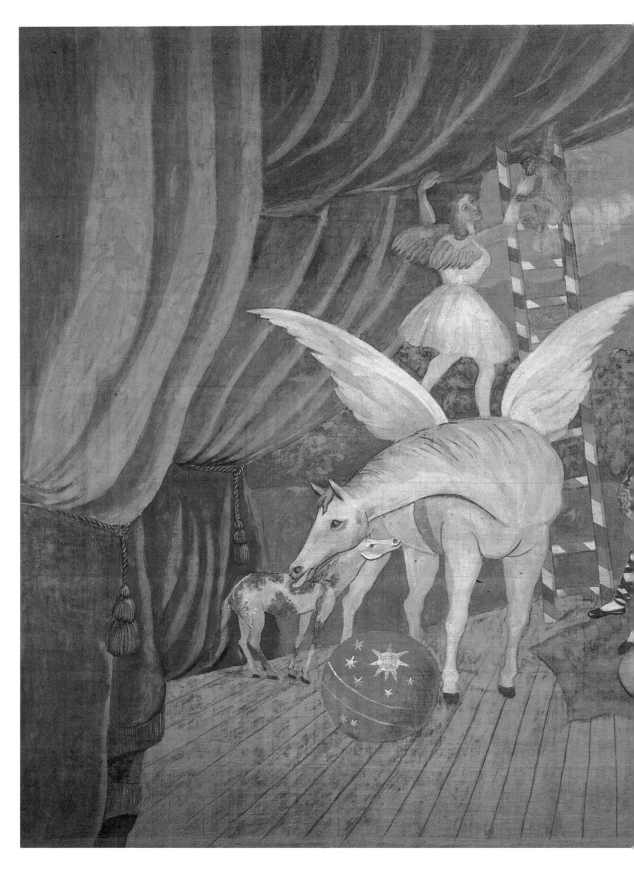

185 Pablo Picasso, overture
curtain for *Parade*, tempera
on canvas

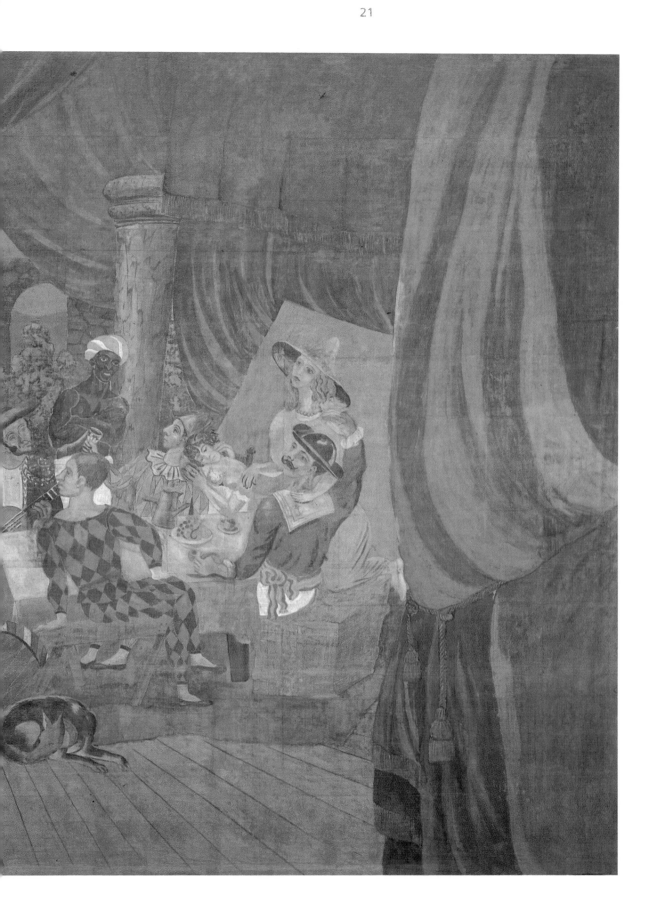

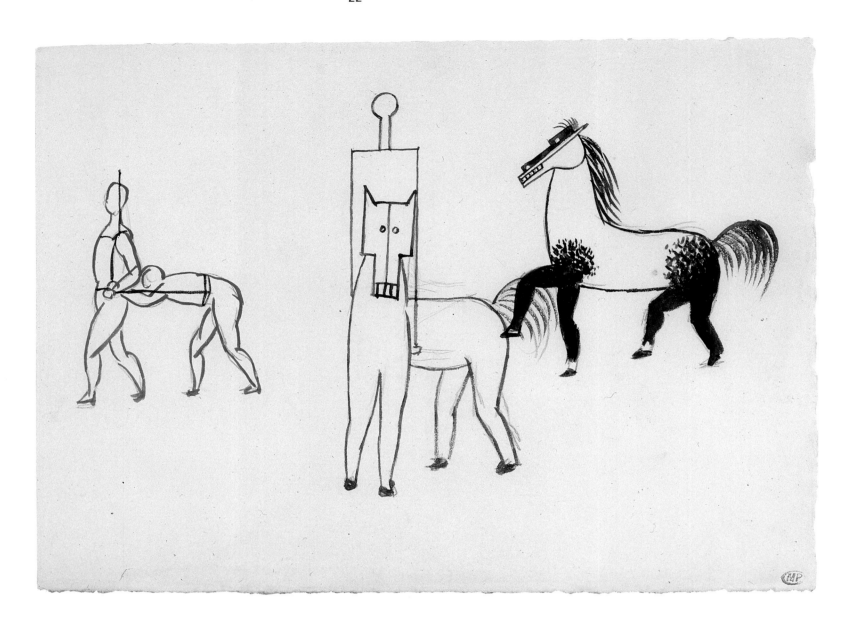

157 Pablo Picasso, studies
for the Manager on
Horseback, brown and blue
ink over traces of pencil

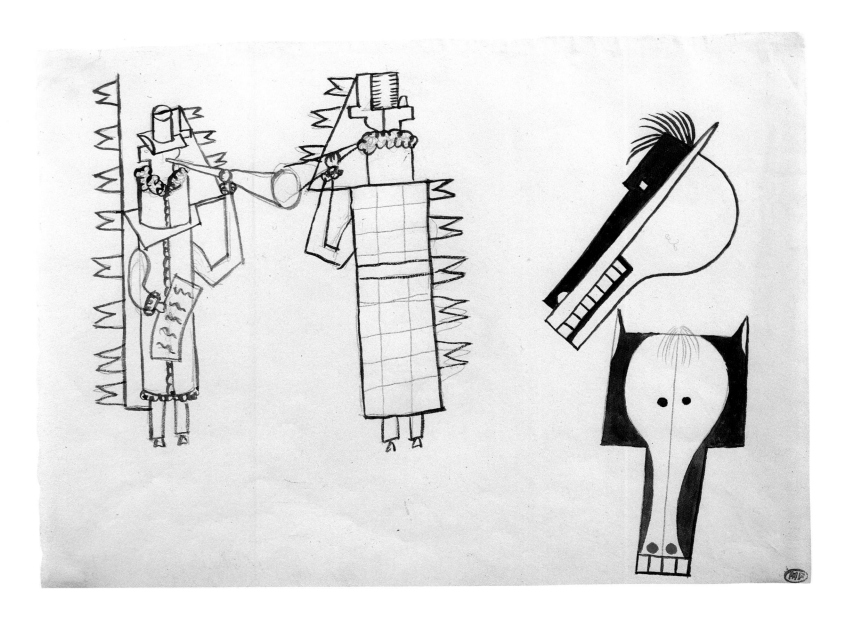

132 Pablo Picasso, study for
the American manager and
the head of a horse, gouache
and pencil

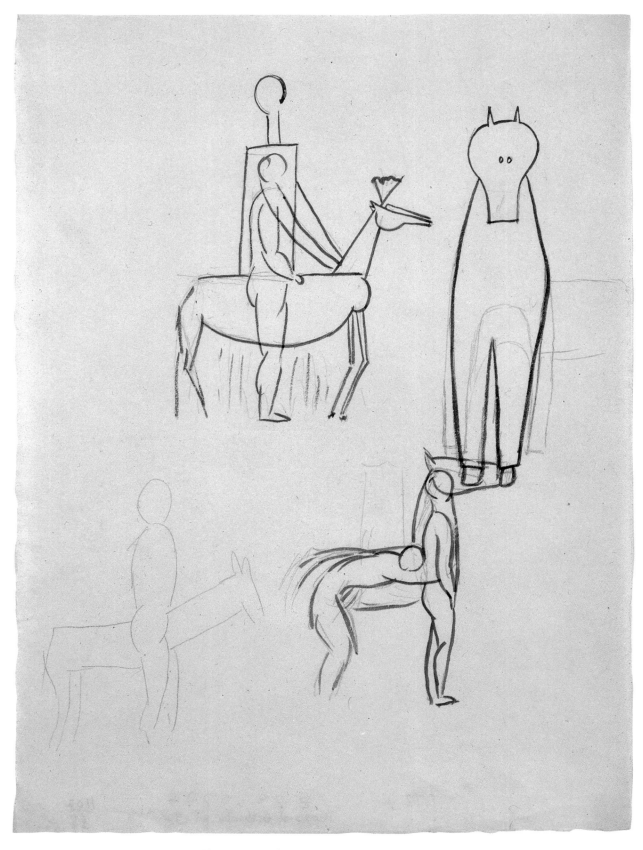

156 Pablo Picasso, studies
for the Manager on
horseback, watercolour and
pencil

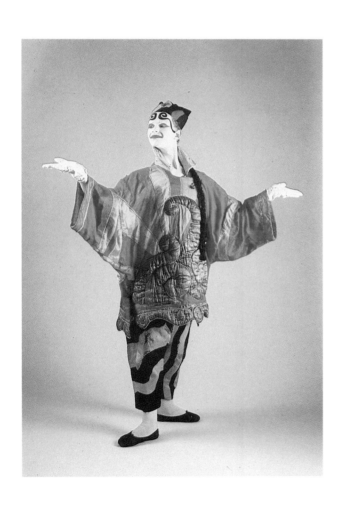

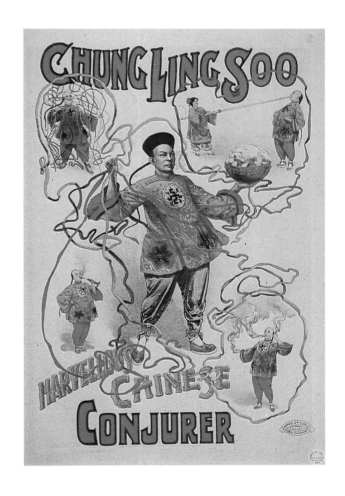

75 Léonide Massine's
original costume for the
Chinese Conjurer in *Parade*

76 Poster for Chung Ling
Soo

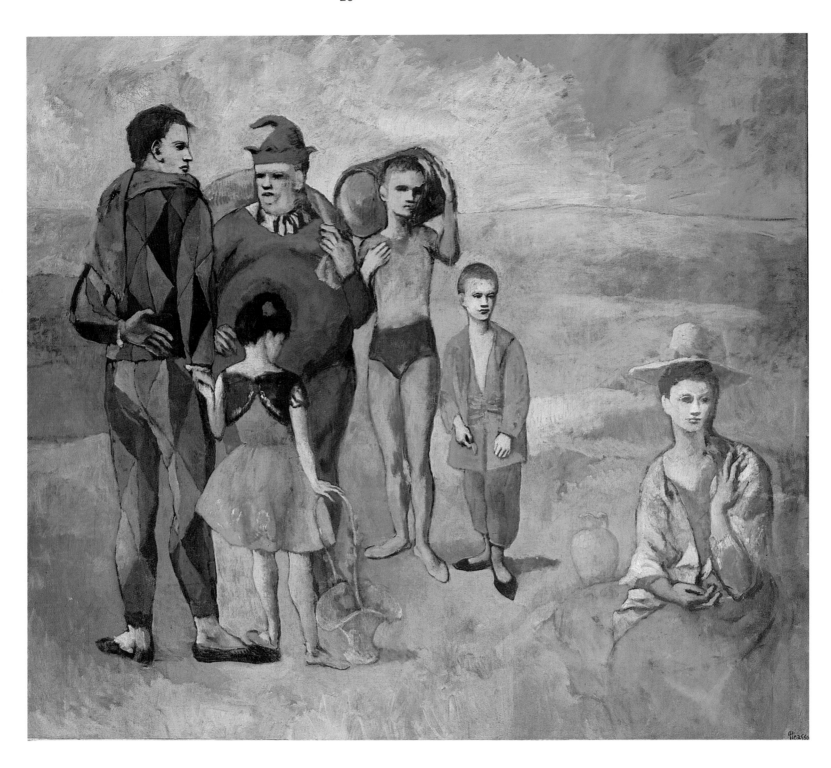

208 Pablo Picasso, *Family of Saltimbanques*, oil on canvas

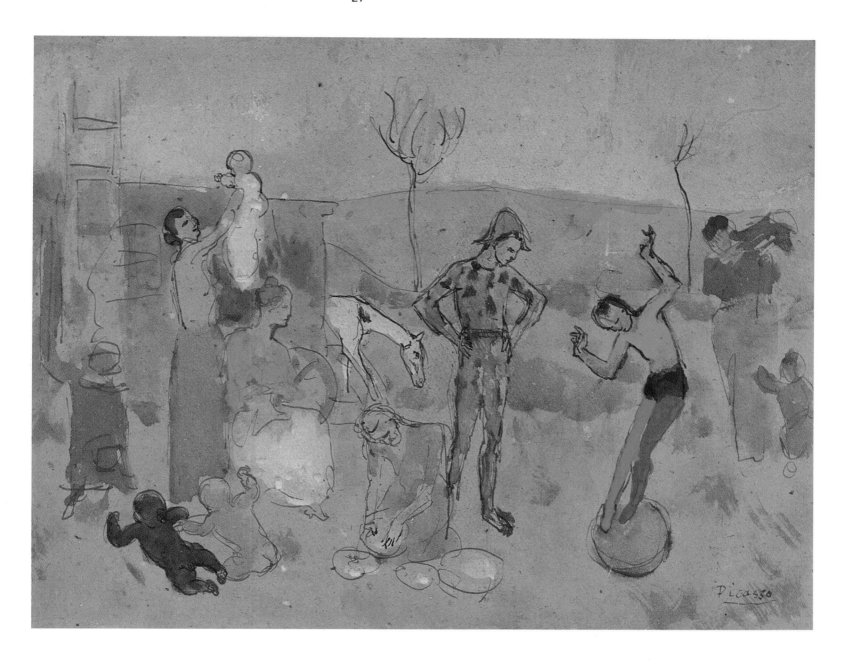

209 Pablo Picasso, *Circus
Family*, pen and black ink,
brush and gouache on
brown composition board

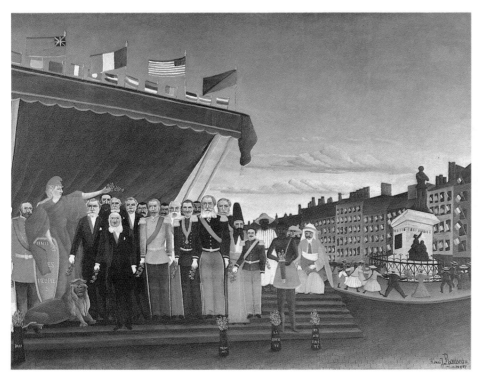

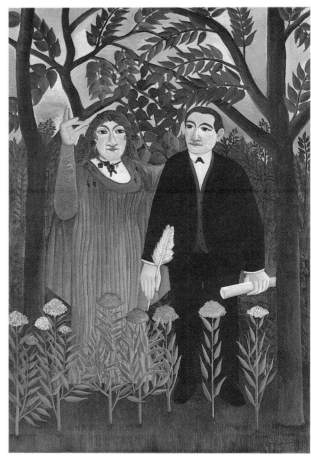

239 Henri Rousseau,
*Representatives of Foreign
Powers arriving to Hail the
Republic as a Sign of Peace*,
oil on canvas

234 Henri Rousseau, *The
Muse inspiring the Poet:
Apollinaire and Marie
Laurencin*, oil on canvas

Chapter 1

Music-hall invades Art with a capital A

Parade, a one-act ballet by Jean Cocteau was presented on 18 May 1917 at the Théâtre du Châtelet, Paris. Music by Erik Satie. Choreography by Léonide Massine. Curtain, décor and costumes by Pablo Picasso.

'Astonish me!' *Ballets Russes* impresario Serge Diaghilev commanded Jean Cocteau as they walked from the theatre one evening in 1912 (fig. 1). His patience was pushed to the limit by the twenty-three year old Cocteau's repeated bids for praise and encouragement. Diaghilev finally exploded; 'I'll wait for you to astonish me.'

According to Cocteau, his life was changed by this utterance. Later he wrote: That break with spiritual frivolity . . . I owe as do so many others, to that ogre, that sacred monster, to the desire to astound that Russian prince to whom life was tolerable only to the extent to which he could summon up marvels.[1]

By Cocteau's own admission, five years elapsed before he was able to meet Diaghilev's challenge. He wrote: 'Finally, in 1917, the opening night of *Parade*, I did astound him.'[2]

Parade constituted the first incursion of truly radical modernism into the ballet. Picasso's décor, in particular the ten-foot constructions of two Managers and a vaudevillian two-man horse, Erik Satie's ambiguous – half fugal, half ragtime – score, Léonide Massine's pantomime-like choreography and the topicality of Cocteau's scenario outraged the Théâtre du Châtelet's audience at the opening performance.[3]

According to Cocteau, even before the curtain fell on the Russian Ballet's matinée première for the War Benefit Fund, *Parade* provoked a riot. The audience booed and attempted to attack the ballet's collaborators with everything from hat-pins to cries of 'salle boche', 'embusqués', and 'métèques' – references to the war and the so-called unpatriotic, Teutonic/Bolshevik nature of the production.[4]

As the fourth and last ballet on the programme, *Parade*'s debut was prefaced by two audience favourites: the romantic and conservative *Les Sylphides* (fig. 2) and the Russian folkloric *Petrouchka*. The third presentation was the more recent, but still conservative, folk-based *Le Soleil de nuit*. Thus, lulled into a sense of satisfaction, pleased at having expectations met, the audience anticipated 'a polite introduction to Cubism'.[5]

From 1909 until 1914, when the First World War put an end to their Paris seasons, Diaghilev's *Ballets Russes* had dazzled audiences with a combination of superb dancers, luxurious sets and costumes and, for the most part, melodic Russian music. Diaghilev's countrymen, Alexandre Benois and Léon Bakst, had concocted opulent, oriental *mise en scènes* that were a feast for the eyes and even inspired a new style of fashionable dress. Often the Russian Ballet provoked scandal as with the debut of Stravinsky's 'savage' score for *Le Sacre du Printemps*, Bakst's costumes for *Scheherezade* or Vaslav Nijinsky's suggestive choreography for Debussy's *L'après-midi d'un faune*. But these were marvellous *succès de scandales* – while shocking they were deemed chic and worthy of approval from the élite audiences who attended their performances. Cast in a lavish and cultivated light, these *Ballets Russes* presentations were exotic and erotic, but never so coarse as to be contemporary, popular, or typically French. *Parade* was all of these. During production Cocteau repeatedly exhorted his collaborators to 'be vulgar!'; he wanted his ballet to reflect the brash commercialism of modern life and the entertainments patronized not by the *beau monde* but by the general public.

Yet is it unlikely that Cocteau and his colleagues – Picasso, Massine, Satie and certainly Diaghilev – intended the *épate* or shock to the bourgeoisie that *Parade* turned out to be.[6] More probably they expected the Russian Ballet's élite patrons to be

[1]Steegmuller, *Cocteau*: p. 82.
[2]Ibid.: p. 83.
[3]Gilbert Guilleminault, *La France de la Madelon* (Paris, 1965) pp. 209–23, for an account of the scandal of *Parade*.
[4]For Cocteau's account see 'La Jeunesse et le Scandale',

Oeuvres Complètes de Jean Cocteau (Lausanne, 1946–51), vol IX, pp. 323–4. See also Silver's *L'Esprit de Corps* for an excellent study of the conservative backlash against *avante-garde* art, especially Cubism, during and after the First World War.

[5]Richard Axsom, p. 1.
[6]Cocteau intended his ballet to be lively and stimulating, but not offensive. His own recipe for 'knowing how far to go too far' reveals his intentions more than his writings on *Parade* after the fact, where he casts

himself as more of a rebel than he actually was.

Frank Ries has argued that Cocteau described *Parade* as more of a scandal than it actually was. Ries believes Cocteau was determined to equal the shock of Stravinsky's *Le Sacre*.

See Frank W. D. Ries, *The Dance Theater of Jean Cocteau*. (Ann Arbor, UMI Research Press, 1986), pp. 50–1.

However, Ries overstates his thesis; according to other contemporary accounts it emerges that *Parade* did provoke a scan-

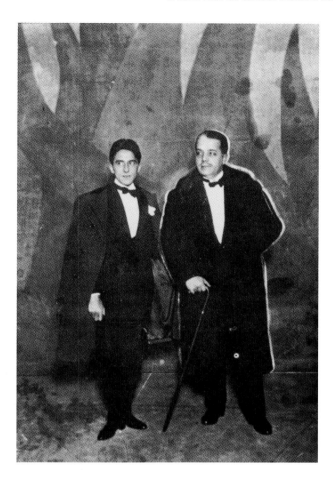

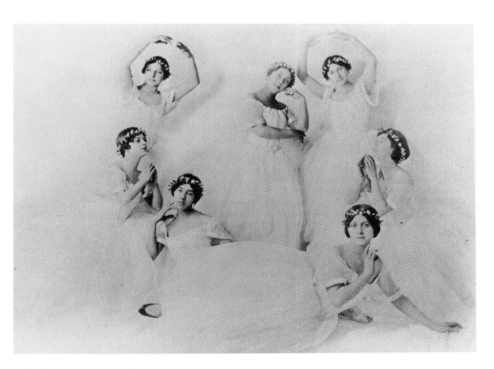

1 Jean Cocteau and Serge Diaghilev, probably at the première of *Le Train Bleu*, Paris, 1924

2 Publicity photograph for the Ballets Russes production of *Les Sylphides*, 1916. (Olga Koklova is in the foreground.)

charmed and moderately surprised, rather than offended by the injection of current light popular entertainment and a very mild rendition of Cubism into the ballet. The poet, Guillaume Apollinaire, said as much in the evening's programme notes when he wrote that *Parade* was the point of departure of a series of manifestations of the *esprit nouveau*, which will not fail to seduce the élite and which promises to completely modify the arts and manners in universal lightness [l'allégresse].[7]

As art historian Kenneth Silver writes, 'It may in part have been Cocteau's belief that 'exhilaration' [*l'allégresse*] would be acceptable during wartime, that accounts for the fiasco of *Parade*.' In an article that appeared on the day of the première, Cocteau explained: Our wish is that the public may consider *Parade* as a work which conceals poetry beneath the coarse outer skin of slapstick. Laughter is natural to Frenchmen: it is important to keep this in mind and not be afraid to laugh even at this most difficult time. Laughter is too Latin a weapon to be neglected.[8]

Thus, Cocteau's plan to 'lighten' ballet entertainment through the example of the popular theatre backfired. Instead of 'seducing', *Parade*'s 'skin of slapstick' outraged the *Ballets Russes*' genteel patronage who, during the trying war years, were in a conservative and reactionary mood.[9]

Contrary to common belief, however, it was not so much *Parade*'s Cubism (which was of the 'polite' variety the audience had anticipated) that shocked and disconcerted the ballet's patrons, but the introduction of low-brow popular entertainments to the sanctified realm of the ballet.[10] *Parade* ushered in a new phase for the *Ballets Russes*, one that signalled a shift away from Russian folklore, oriental or 'primitive' ballets and towards urbane, experimental productions which focused on contemporary life and relied heavily on *avant-garde* artists. This phase, labelled 'French' (as opposed to the initial 'Russian' phase) lasted from 1917 to 1929, the year of Diaghilev's death. It is in turn divided into two categories — the first from 1917 to 1926 is characterized by light, witty and topical productions such as *Parade*, *Le Train bleu*, *Les Biches*, and *Les Matelots*; the second, from 1926 to 1929, by such restrained and serious neo-classical works as *Apollon Musagète* and *Le Fil prodigue*. Parade's entire scenario and its characters were not sufficiently modified and transformed from their proletarian sources to allow Diaghilev's audience to feel comfortable. Witnessing the première, the composer Francis Poulenc later pronounced, For the first time . . . music-hall invaded Art with a capital A. A one-step is danced in *Parade*! When *that* began the audience let loose with boos and applause. . . . It was real bedlam.[11]

The outrage of the audience was provoked not only because patrons felt the ballet was an unsuitable vehicle for variety theatre, but also, and more importantly, because *Parade*'s characters mirrored specific and identifiable acts currently on view in Parisian circus, cinema, and music-hall (see chapters 5, 6 and 7). It was shocking to view thinly disguised imitations of popular headliners performed by highly-trained Russian dancers — artists whom one

dal. See Guilleminault and Poulenc, p. 49. Although neither Steegmuller nor Frederick Brown could uncover evidence of the riot and threats of bodily harm Cocteau reported, there were cries of outrage and people did leave the theatre. (Steegmuller, pp. 186–7., Brown, *An Impersonation of Angels: A Biography of Jean Cocteau* (New York, 1968), pp. 147–89.) According to Boris Kochno, who was told of the *Parade* première by Diaghilev and Picasso, Cocteau's 1917 account of the audience's reactions is accurate. Author's conversation with Kochno,

November 1985, Paris.
[7]Quoted in Pierre Cabanne, trans. Harold J. Salemson, *Pablo Picasso, His Life and Times* (New York, 1977) p. 203. See also Steegmuller, pp. 513–4. Salemson translates *allégresse* as 'lightness' while Silver prefers 'exhilaration'. Cassell's French/English Dictionary translates the word as 'gaiety, joy, mirth'.
[8]Quoted in Silver, p. 123. Cocteau's article was published in *L'Excelsior*, 18 May 1917.
[9]The French offensive on the Chemin des Dames had recently failed at the cost of 34,000 French lives. As a result of this débâcle and the fact that the

war had already dragged on three years, morale was low at the time of *Parade*'s debut.
[10]It is here that I disagree with the standard explanation that it was *Parade*'s Cubism which was found to be shocking. (This is the argument presented in nearly every account of the ballet including Axsom, Steegmuller, Silver and Douglas Cooper's *Picasso Theatre*, (New York, 1967). For example, Cooper writes: '. . . three years later it [*Parade*] was acclaimed in Paris, those who had at first booed it having forgotten their earlier reactions — for by that time, Picasso and Cubism were

accepted' (p. 54). Yet contemporary accounts, (including Poulenc's and Cocteau's cited here) invariably name the vaudevillian horse and the Little American Girl's ragtime as the incendiary elements.
The ballet's Managers were the only truly Cubist elements in the production and they were of a simplified 'synthetic' nature that was not particularly shocking or new by 1917. If anything was shocking about these figures it was their monstrous bearing and appearance. Their gigantic size, huge accordion arms, dehumanized faces and gestures were much more dis-

turbing than their Cubism. The set décor, often termed Cubist, bore a closer resemblance to amateur scene-painting than to Cubism. (see p. 152ff).
It is true that Cubism in any form was not popular during the height of the war, but the Managers alone, who were on stage only briefly, could not account for the prolonged protests of the audience which lasted through the 'turns' of the other *Parade* characters who, in visual terms, had nothing in the least Cubist about them.
[11]Francis Poulenc, *Moi et Mes Amis* (Paris and Geneva, 1963) pp. 88–9.

felt inhabited a higher realm and were not associated with the topical or mundane.

This topicality was entirely calculated on Cocteau's part. An overlooked notation on the score for *Parade* indicates that he intended the ballet to retain its modern-day flavour by being adjusted to local parlance each time it was performed. He writes on the first page: 'the cries of the Negro managers should be without text, must be translated into the language of the city where *Parade* is given. Submitting to the necessary transformations so that the public can recognize the ads of the day.'[12]

Cocteau's wishes were never fulfilled — the Managers' 'cries' never featured in any of the productions and the other characters in the ballet remained fixed. In 1921, when *Parade* was re-staged to great acclaim, its acceptance was due less to a new-found appreciation of Cubism than to the ballet's loss of specificity and topicality. In the intervening years the popular performers alluded to in *Parade* had disappeared from public consciousness and the characters of the Chinese Conjurer, the Little American Girl, the Acrobats, and even the two-man horse were viewed as either charmingly nostalgic or entirely fictional.

In an article published in *Vanity Fair* in September 1917, Cocteau outlined the ballet's plot and recounted audience reactions: The plot of 'Parade' is supposed to take place on a street in Paris, on a Sunday. Certain music-hall artists show themselves in the street, outside of a music-hall, in order to draw a crowd. This is always called a 'parade,' among the traveling circuses in France. The headliners are a Chinese magician, a little American girl, and two acrobats. The managers, in their atrocious language, try awkwardly to attract the crowd, but are unable to convince the people sufficiently to draw them into the theatre. The Chinaman, the American girl and the two acrobats come out onto the street from the empty theatre, and seeing the failure of the managers, they try the power of their charms; but all their efforts are to no avail. In short, the story of 'Parade' is the tragedy of an unsuccessful theatrical venture. Simple — innocent enough.

Picasso's curtain aroused no protest. By its irreproach-

able calm and grace it astonished those who came to hoot and hiss it. His scenery had the same effect. It was calm and beautiful where an unnameable extravagance had been expected of it.

The entrance of the first gigantic 'manager' passed without any remark — probably because he danced beautifully to the music . . .

Massine, who played the Chinaman, had a great ovation . . . Everyone applauded the marvellous technical skill of the great comic dancer and his brilliant costume caused enthusiastic comment.

The little American girl was played by Marie Chabelska. Of her role, I had aimed to make a union of grace and agility — a sort of uniting of the outdoor world with the music-hall. The little girl mimicked one thing after another . . . Her performance charmed many but revolted others.

When Picasso's horse made its entrance, I feared that the hall would collapse. I have heard the cries of a bayonet charge in Flanders, but it was nothing compared to what happened that night at the Châtelet Theatre.

Swerien and Lapokowa [sic], the acrobats, so sad and awkward, delighted almost everyone. The public did not, however, appreciate that we had combined in their act the accidental art of the circus with the happy remembrances of childhood.

The Finale in which the whole company breaks loose and collapses, resulted in a renewed and prolonged tumult . . .

We expected the unusual hilarity, but not the bad humour, which Abel Hermant had so cleverly explained is the result of the habitual seriousness peculiar to adults who disliked being entertained by a 'Punch and Judy' show, with all its traditions and perspectives.[13]

Thus, according to Cocteau's account, it was not the Managers or the Cubist set, described as 'calm and beautiful', that distressed the opening matinée audience, as is so often stated. Rather, patrons were disturbed by the Little American Girl's pantomime of music-hall and silent film (she jumped on a moving automobile, trembled like the flickering of a 'movie', chased a robber with a revolver and imitated Charlie Chaplin, among other stunts) and the appearance of the comical two-man horse (figs 3, 4)

[12]'Les cris des managers nègres volontairement déniés de littérature doivent être traduits dans la langue de la ville où *Parade* se donne. Subir les transformations nécessaires afin que le public y reconnaisse les réclames du jour.' Cocteau and Satie, copyist's score for *Parade*, The Frederick R. Koch Foundation, New York.
[13]Jean Cocteau, 'Parade Réaliste: In which Four Modernist Artists Have a Hand.' *Vanity Fair* (Sept. 1917) p. 90.

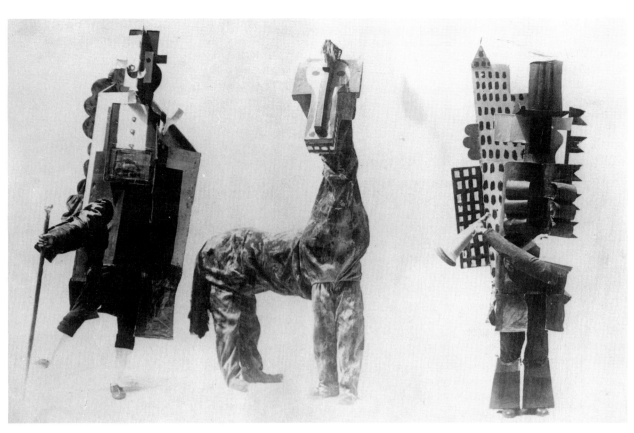

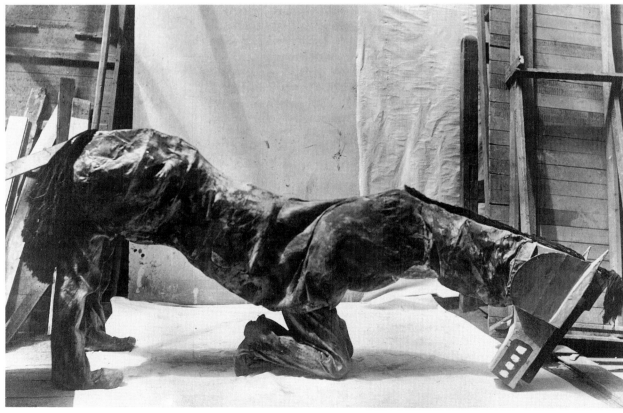

3 Managers and the horse
from *Parade*, 1917

4 Horse from *Parade*, 1917

– a circus and vaudeville staple of a type that was appearing in the Fratellini brothers act at the Cirque Médrano at the very moment of *Parade*'s première. The horse's dance was nearly identical to the antics of the *cheval jupon* from the act of the Fratellini and Footit clowns (figs 5, 6).

Cubism was not the cause of the shock and dismay experienced by *Parade*'s first audience. Cubism had been making inroads into non-bohemian circles since the large Section d'Or exhibition at the Galérie de la Boétie in October 1912. Four years later, in July, the Salon d'Antin exhibited more than 166 works by fifty-two artists representing a mix of nationalities and styles.[14] It was sponsored by Paul Poiret, the designer who had done the most to translate Bakst's exotic *Ballets Russes* costumes into wearable couture for Diaghilev's wealthy Right Bank matrons.[15]

In addition, the concerts and exhibitions organized for Lyre et Palette, a Montparnasse gallery and recital hall founded in November 1916, included works by Picasso and Léger, as well as performances by Satie, and poetry readings by Cocteau. Although considered *avant-garde*, the activities of Lyre et Palette 'attracted . . . rich and aristocratic art patrons from the Right Bank.' One newspaper reported that, 'splendid, shining limousines lined the sidewalk' at an opening of Cubist works.[16]

By 1917 Cubist disciples such as Albert Gleizes, André Lhote, Jean Metzinger, Louis Marcoussis, Jacques Villon, Roger de la Fresnaye, Henri Le Fauconnier and others had made less rigorous renditions of the style not only familiar, but also palatable, to a wide spectrum of viewers – particularly to the Right Bank art patrons who were the backbone of Diaghilev's enterprise.[17] These follow-

ers who unfortunately too often misunderstood Picasso and Braque's early experiments, nonetheless did much to win public acceptance for the style.

At the same time, Cubism's inventors, Picasso and Braque, began to move away from the difficult and demanding Analytic style (begun in 1909) characterized by shifting, insubstantial and fragmented planes. Instead, in 1912, prompted by their experiments with *papier collé* and collage, they began working in a more legible and simplified style known as Synthetic Cubism.

These two phenomena conspired to make Cubism more accessible and therefore more acceptable. For example Gleize's *Landscape*, 1912 is as, if not more, advanced in terms of Cubist devices than Picasso's painting of 1916 *Playing-card, Glass and Bottle on a Guéridon* (figs 7, 8).

The Cubism Picasso employed in his designs for *Parade* was not radical in terms of spatial ambiguities, distortion of forms, and general legibility. Close examination and formal analysis of these designs (p. 189ff.) in combination with first-hand accounts of the ballet's opening, provide ample proof that it was not *Parade*'s Cubism that offended its first audience.

In the years around the First World War when Cubism was undergoing simplification and gaining acceptance, the world of entertainment was also changing. Circus, vaudeville and variety theatre were becoming all the rage in Paris, while conventional stage drama and opera experienced a steady decline.[18] Popular culture had captured the imagination of Parisians from all classes to a nearly manic degree in the form of American cakewalk, jazz, early cinema, as well as a craze for Chinese-style magicians and circus clowns.[19] Moreover, Parisian

[14]The Salon d'Antin marked the first public showing of Picasso's famous proto-Cubist painting, *Les Demoiselles d'Avignon* (1907, Museum of Modern Art, New York). For more see Klüver and Martin, p. 76.

[15]Paul Poiret, in part because of his adoption of Bakst-like oriental costumes, was accused of German sympathies in 1915 by the magazine *La Renaissance politique, littéraire, et artistique*.

Poiret sued for slander and the magazine, whose charges against the couturier were totally unfounded, ended the matter by apologizing in print. The incident is an exemplar of the wave of xenophobia which swept Paris during the war years.

[16]'Vernissage cubiste', in *Cri de Paris*, cited in Klüver and Martin, p. 222, n. 4.

[17]Silver argues that *Parade*'s

Cubism was objectionable to its first viewers not so much on aesthetic grounds as on political ones, i.e. Cubism was viewed as foreign and therefore subversive during the war period (p. 115ff). However, while this may have been a common sentiment, it was by no means universal. Cubist works continued to be made, exhibited, and sold throughout the First World War. French artist/soldiers, like

Georges Braque, Fernand Léger, Albert Gleizes, Raymond Duchamp-Villon, and Roger de la Fresnaye, whose patriotism was beyond reproach, are among those who continued to paint in a Cubist style. Moreover, *Parade* was re-staged to wide acclaim in 1921 while French isolationism and conservatism were still in full-swing.

[18]See Huntly Carter, *The New Spirit in the European Theatre*,

1914–1924: The Origins of the Avant-Garde in France 1885 to World War I (London, 1925), p. 49. Also Roger Shattuck, *The Banquet Years* (New York, 1967) chpt. 1.

[19]'As the bistro or café took on grander proportions and received official permission to use costumes and props it grew into the *café concert* . . . whose prime concern was entertainment. The cabaret in contradis-

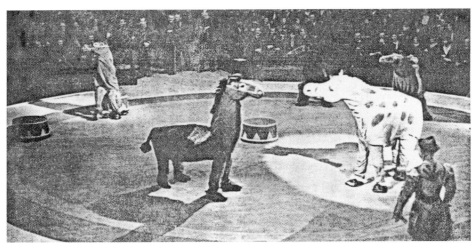

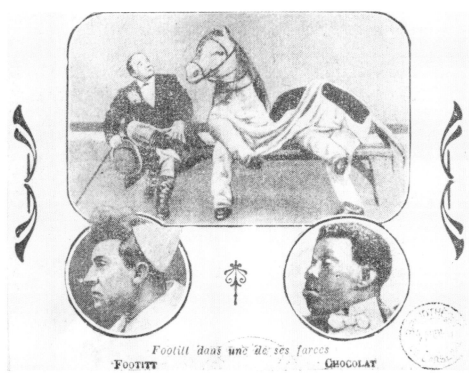

5 The Fratellini clowns
performing as Les sept
chevaux, c.1917

6 Footit and Chocolat, pre
1914

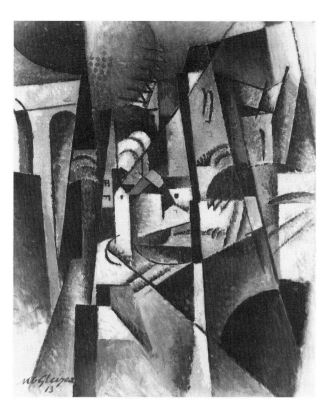

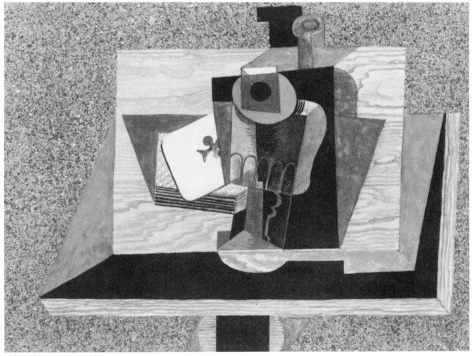

7 Albert Léon Gleizes,
Landscape, 1912, oil on
canvas

8 Pablo Picasso, *Playing card,
Glass and Bottle on a
Guéridon*, 1916, oil and sand
on canvas

cabarets, *café concerts* and music-halls, which have always been topical in their entertainments, served as cathartic forums for patriotic displays during the war. Torch singers such as Damia, Gaby Montreuse and Rose Amy made their reputations lamenting the loss of brave French soldiers and the wages of war upon lovers, as well as extolling the courage of the French people in the face of a bestial enemy. It was in the cabaret, not the opera house, that performers took risks, bantered with their audiences and responded to current events, ideas and sentiments. Against this, the ballet, opera, and dramatic theatre – where timely or political references were taboo – came to be viewed as being irrelevant and hopelessly out-of-touch by many Frenchmen.

This was not the case for Serge Diaghilev who, trained in the conservative tradition of the Russian Imperial theatre always maintained classical standards, even while introducing *avant-garde* elements into his productions. Although during the war he was forced to accept bookings in music-halls in order to keep his company afloat, he never warmed to popular entertainment and balked at presenting his jewel, the Russian Ballet, in the garish setting of variety theatre.[20] From 1915 to 1919 his highly-trained troupe of ballet dancers shared the boards with burlesque comics, pantomimic *ingénues*, trained animals, conjurers, acrobats, jazz bands and moving pictures, in music-halls such as the Empire, Coliseum, and Alhambra (fig. 9). Ironically, it was the experience of variety theatre and the acts that the company – especially Cocteau – witnessed first-hand, that provided the inspiration for *Parade*.[21]

Unlike Diaghilev, the four collaborators of *Parade*: Picasso, Cocteau, the composer Erik Satie and the choreographer Léonide Massine, were all

genuine devotees of popular entertainments. As patrons of music-hall, circus, and cinema they were the ideal collaborators for a project designed to inject the vitality and directness of popular theatre into ballet.

Picasso had long made a practice of looking to humble sources for inspiration. For him all materials and types of imagery, from kitsch postcards to refuse found in the street, were fodder for his creativity. His freedom from rules of what is appropriate for the fine artist allowed Picasso not only to create new art forms such as collage and construction, using hitherto unacceptable materials such as newspaper, cardboard, oilcloth and sheet metal, but also enabled him to re-invent and revitalize the structure and iconography of Western art. For example, the anti-high-art form of caricature was a key element in the birth of Cubism: Caricature . . . played a central role in the evolution of Cubism and thus, in the evolution of modern painting . . . The grammar and vocabulary of the high Cubist portrait need to be seen not as pure invention but as a *pas de deux* between high and low, between the Louvre and *Charivari*, a complicated exchange of dialects.[22]

Picasso was not, like Cocteau or Diaghilev, to the plush born. Throughout his life he preferred popular theatricals and took delight in entertainments such as the puppet show, travelling fair, circus, bullfight, café–concert and silent film slapstick comedy.[23] Those who knew him observed that his tastes ran to the coarse and earthy – a preference for low humour over refined theatricals.[24] Fernande Olivier, Picasso's mistress during the early years of the century, wrote: 'I never saw Picasso laugh so happily as at the [cirque] Médrano (fig. 10), he was like a child and quite unaware of the relative shallowness of the humour.'[25]

tinction to the *café concert* was more intellectual and self-consciously artistic – though laughter and entertainment were of its essence. . . . Oftentimes writers and poets would perform their works for one another. . . . The exchange of artistic ideas along with the adoption of the popular satirical or protest song were the initial ingredients which went into the

making of the cabaret.' Quoted from Lisa Appignanesi, *The Cabaret* (New York, 1976) pp. 11–12.
Café concert was gradually extinguished during the First World War. It was replaced by music-hall which featured the 'grand revue'. Gustave Fréjaville writes, 'En somme le music-hall absorbe peu à peu le café concert.' [In sum, music-hall little by

little absorbed the *café-concert*]. *Au music-hall* (Paris, 1923) p. 95.
[20]Diaghilev objected to music-hall out of a kind of aesthetic élitism, not social snobbism. He felt that the ballet and opera drew a type of patron that was trained to absorb musical presentation in which the varying components are all given due consideration and yet form an

artistic whole. In contrast, the music hall crowd was looking for laughs, variety, and thrills. They irritated Diaghilev by their lack of discernment and short attention span.
[21]Although Diaghilev detested music hall, Massine has recorded his own and the rest of the Russian Ballet's enthusiasm for variety theatre. Massine, p. 129.

[22]Adam Gopnik, 'High and Low: Caricature, Primitivism and the Cubist Portrait,' *Art Journal*, vol. 43, no. 4, (Winter 1983) p. 374. Charivari was a popular magazine with social and political cartoons.
[23]Several writers on Picasso have noted his admiration for Charlie Chaplin. See Gilot, p. 349ff. For Picasso's response to puppetry see chapt. 8.

As he 'loved the contrast between the trivial and the highbrow',[26] Picasso took delight in both debunking the sacred – witness his famous parodies of works by El Greco, Velazquez, Rembrandt, Manet and Ingres – and in elevating the base. It seems the commissions to design décor for the élitist Diaghilev enterprise, an enterprise sponsored and patronized largely by the *beau monde*, served to bring out the proletariat in Picasso and he relied on popular sources for not only *Parade* but also for all five ballets he designed for the *Ballets Russes* between 1917 and 1924.[27]

Picasso's association with Diaghilev brought him into contact with composers who were similarly inspired by popular art and music, in the form of hit tunes and folk melodies. Erik Satie's debt to and familiarity with such music grew out of his days as the piano player at the cabaret, le Chat Noir: Satie's career at the café-concert around the turn of the century had a great influence on his music, lightening it greatly in spirit. No musical style was too humble for him: that of the fair, the circus, the street corner. It is to his credit that he was among the first 'serious' musicians to realize that jazz was artistically worthy of his attention. He even wrote and published sentimental waltzes and hit melodies, one of the most charming of which is *Tendrement* (*Tenderly*) with words by the famous chansonnier, Vincent Hyspa.[28]

Igor Stravinsky, a long-time associate of Diaghilev and Picasso's collaborator on the 1919 *Ballets Russes* production of *Pulcinella*, was also indebted to folk and popular music. He used folk melodies in *Les Noces*, *The Firebird*, and *Le Sacre*.[29] The 'jambe en

bois' melody in *Petrouchka* was taken from a popular tune: A hurdy-gurdy played it every afternoon beneath my window in Beaulieu (near Nice), and since it struck me as a good tune for the scene I was then composing, I wrote it in. I thought the melody was in the public domain, but several months after the premiere someone informed Diaghilev that the tune had been composed by a Mr. Spencer of France. Since 1911, therefore, a share of *Petrouchka*'s royalties has gone to Mr. Spencer and his heirs.[30]

While still a young man in Russia, Stravinsky realized that the ballet and classical music were 'rigidly conventional', even 'petrifying'. He therefore felt that he could not regard them as 'exploitable musical mediums' and turned to non-élitist forms for inspiration.[31] Like Picasso, Stravinsky was egalitarian in his approach to source material. He explained it this way: My instinct is to recompose – not only student works, but old masters as well. . . . Whatever interests me, whatever I love, I wish to make my own (I am probably describing a rare form of kleptomania).[32]

Cocteau, who was born into the world of élite theatricals, became enamoured of popular entertainment during his childhood. As a lycée student he would skip classes to attend music-hall matinées, and it was during these years he became an ardent fan of the chanteuse Mistinguett.[33] In addition, perhaps because he frequently engaged in 'slumming', like his wealthy and titled friends (patronizing the circus, music-hall, fairground and vaudeville theatre as a lark) Cocteau assumed those in the élite *Ballets Russes* audience who did not frequent variety

[24]During his affiliation with the *Ballets Russes* Picasso often poked fun at the mincing daintiness of the ballet. For example note his drawing, *Two Ballet Dancers* (1919) in the Ganz Collection, New York, reproduced in Tinterow, *Master Drawings by Picasso*, (Cambridge, 1981) p. 154.

In 1923 Diaghilev approached Picasso to design a serious classical-style décor for Gounod's 1860 opera based on the Ovidian tale, *Philemon and Baucis*. Diaghilev arranged to have the score played for

Picasso, thinking that this might persuade him to accept. Picasso listened to the music, glum and scowling; he came to life only to make various comments that disconcerted Diaghilev. For example, he suggested that a chorus of music-hall girls come onstage to the music intended for a procession of bacchantes, and, in the heat of the discussion, he performed a French cancan number himself . . .' Boris Kochno, trans. Adrienne Foulke *Diaghilev and the Ballets Russes* (New York, 1970) p. 208.

[25]Fernande Olivier, *Picasso and his Friends*, trans. J. Miller (New York, 1965) p. 127. And later in 1932 Brassaï recounted a trip to the circus made with the Picassos: 'He laughed heartily at the clowns, seeming far more amused by their buffoonery than his son, who scarcely smiled all evening, or his wife, who remained taciturn and distant.' Quoted in Reff, p. 34. Also Gilot for a record of Picasso's admiration for Charlie Chaplin, pp. 349–51.
[26]Edward Quinn, *Picasso, Photographs from 1951–1972*

(Woodbury, New York, 1980) p. 86.
[27]See author's Ph.D dissertation *From the Street to the Elite: Popular Sources in Picasso's Designs for Parade* New York, Institute of Fine Arts, (New York University, 1990) chapt 1.
[28]James Ringo, 'The Irreverent Inspirations of Erik Satie' notes on jacket of *La Belle Epoque* (Angel Recording). For more on Satie and popular music and his specific popular sources for *Parade*, see pp. 106–13.
[29]Igor Stravinsky and Robert Craft *Memories and Commentaries*

(Garden City, New York, 1960) p. 91.
[30]Ibid. pp. 89–90.
[31]Stravinsky and Craft, ibid. pp. 30–1.
[32]Stravinsky and Craft, ibid. p. 104.
[33]Steegmuller, p. 15. On 23 November 1916, while in the thick of working on *Parade* he attended the Cirque Médrano with Paul Morand, who later wrote in his journal, 'Jean knows everybody, is madly amused by the rabbit hunt and the trapezists. He says, "I like clowns so much better than ac-

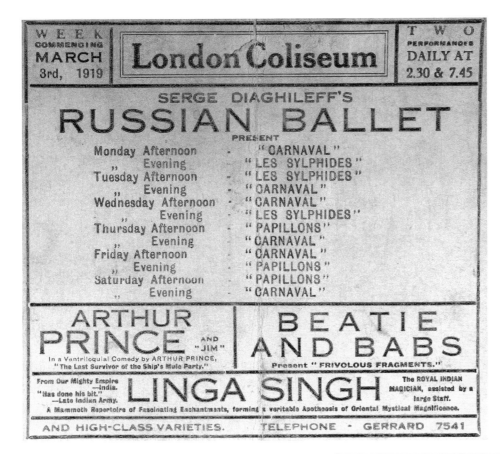

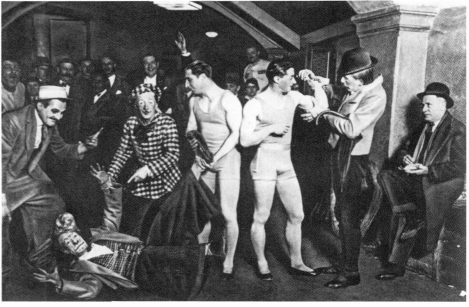

9 Play bill from the London Coliseum, week of 3 March 1919. Note the Ballets Russes is sharing the bill with a ventriloquist, a comedy team and an Eastern magician

10 Clown and acrobats from the Cirque Médrano in Paris, c.1900

houses and circuses would nonetheless be amused, and at the same time mildly astonished, by light music-hall divertissements transformed into something new through the artistry of stylized ballet.[34]

Unfortunately, Picasso, Cocteau, and company had miscalculated, the glamour-deprived, war-weary audience attending *Parade*'s première was not in the mood for *théâtre forain*, but for serious classical dance, through which to escape from contemporary life and French popular culture. The amateurish look and at times tinny sound of *Parade*, as well as its pantomime choreography modelled after acts playing at the Alhambra, the Cirque Médrano and current popular films, disappointed an audience expecting a modernity chastened by lavish décors like those of Bakst or Benois, sonorous music in the manner of Tchaikovsky, Rimsky-Korsakov, Debussy and Stravinsky, and virtuoso Maryinsky dancing as embodied by Nijinsky and Karsavina. It was one thing for the rich to go slumming – 'vulgar' popular entertainments were fine in their place – but, Diaghilev's patrons reasoned, vernacular variety theatre had no place amid the high cultural seriousness of the ballet.[35]

The fact that *Parade* was not variety theatre, but an artistic transformation of it, was apparently lost on its first audiences. They failed to discern the ways in which its creators fashioned something stylized and universal from a crude mode, while retaining its appealing simplicity. As Cocteau later wrote, '. . . the public took the transposition of music-hall for bad music-hall.'[36]

As the collaboration on *Parade* was getting underway in Rome in February of 1917, Cocteau wrote in his notebook: 'Picasso paints after nature choosing modest subjects, searching to express their exact essence. He innovates a new way of copying.'[37] One might say this was Cocteau's ambition for his music-hall-based ballet, he wished *Parade* to express the essence of a modest subject. He wanted his prosaic sources to remain recognizable and he wanted to preserve their child-like qualities, while at the same time transforming them into something that was of a higher order. As Léonide Massine, the choreographer for the production later wrote:

Parade was not so much a satire on popular art as an attempt to translate it into a totally new form. It is true we utilized certain elements of contemporary show business – ragtime music, jazz, the cinema, billboard advertising, circus and music-hall techniques – but we took only their salient features, adapting them to our own ends.[38]

tors; they are so much more intelligent''. Quoted in Steegmuller, p. 170.

[34]Cocteau continued to patronize non-élitist entertainments throughout his life.

[35]Silver makes the point that Bakst's orientalizing décors as well as Stravinsky's music, in fact the entire Diaghilev enterprise became *outré* during the First World War in the wake of French xenophobia and anti-cosmopolitan feeling. (Silver, *Esprit de corps*, p. 174ff.) Yet the patrons who had come to see *Parade* were for the most part staunch supporters of the *Ballets Russes*. That they were anticipating a ballet with at least some affinities with pre-war productions is attested to by the fact that the two familiar ballets which shared the programme with *Parade*'s opening performance were well received.

[36]Cocteau, *Entre Picasso et Radiquèt*, André Fermigier ed., (Paris, 1967) p. 32: '. . . le public prenait la transposition du music-hall pour du mauvais music-hall.'

[37]The passage reads: 'les futuristes peignent d'après des idées – Picasso peint d'après nature, choisit des sujets modestes et cherche à les exprimer ju[sque] au bout. Il innove une nouvelle façon de copier.' Cocteau carnet, Bibliothèque de l'Opéra, Fonds Kochno, pièce 24, p. 25.

[38]Massine, p. 103.

Chapter 2

Cocteau, Picasso, Apollinaire and

the origins of «Parade»

Cocteau's role in *Parade* has often been underestimated. In part this is due to Apollinaire's virtual disregard of the poet in his famous programme notes for *Parade* where the term 'sur-réalisme' was coined, and where Picasso, Satie and Massine were credited with successfully uniting painting, music and dance. Cocteau is mentioned only as 'the person who calls the spectacle a "ballet réaliste".'[1]

Yet it was Cocteau who not only created the project, wrote the scenario and attended to every aspect of the ballet's evolution, but who also, above all the other participants, was responsible for the very unity which Apollinaire praised. His notes on the copyist's score (in the Morgan Library), his several notebooks and loose sheets (facsimile in the Satie Foundation, in the collection of Edouard Dermit, and Bibliothèque de l'Opéra, Paris, and New York Public Library, Dance Collection) and his letters indicate the prodigious effort he poured into this project. Moreover it was Cocteau, not Diaghilev, who selected and then enlisted Satie and, most importantly, Picasso.

Jean Cocteau, born to an upper-middle-class family, was from childhood infatuated with the theatre. He recalled as a child watching his mother leave for the theatre bristling with aigrettes and swathed in red velvet. . . . She would give me programmes to read in bed, and I had toy theatres and would cut out scenery, and finally I caught an illness much more serious than scarlet fever or measles — what I call the red-and-gold disease: theatreitis.[2] This fever developed into a fascination not only for what happened on the stage, but also for what happened behind the stage and in the audience. He remained throughout his life interested in the difference between the view from the spectator's seat in the auditorium and that obtained backstage from the wings.[3]

At fifteen Cocteau ran away to Marseilles where he lived a marginal existence for a year in the city's sordid red-light district. There he developed an opium habit as well as an attraction to life on the fringe of society. Yet, once he returned to Paris at the age of seventeen, he began a relentless pursuit of fashionable, titled society, seeking to make his presence felt in all the right salons. For the rest of his life Cocteau remained comfortable in bohemian and blue collar as well as *haut bourgeois* worlds.

Cocteau's infatuation with the *Ballets Russes* which combined scandal, exoticism, eroticism, and élitism (Diaghilev's productions were sponsored and financed by members of *le tout-Paris*) was instant and is perfectly understandable. As his biographer, Frances Steegmuller writes: 'All the principal aspects of the ballet appealed to him, including the snob side so well exploited by Diaghilev, Astruc, and Madame Greffulhe.'[4]

In many ways *Parade* mediates between the dualities of Cocteau's persona: it brings music hall and fairground idioms together with classical ballet and music, and for the first time unites in collaboration a Right Bank élitist enterprise with a notoriously Left Bank bohemian artist.

Cocteau entered Diaghilev's entourage through the offices of Misia Edwards Sert in 1910. At first he designed posters for the *Ballets Russes*, and promoted Nijinsky in articles and cartoons. In 1912 Cocteau wrote the scenario for the poorly-received ballet, *Le Dieu Bleu*. Bakst created a lavishly beautiful décor for the production, but Reynaldo Hahn's score was less than inspired, and paled by comparison with Stravinsky's recent achievements. In the end the *Le Dieu Bleu* was poorly received by the public, so Diaghilev dropped it from the repertory and at the same time allowed his friendship with Cocteau to cool.

Parade was actually Cocteau's third proposal for a theatre piece inspired by the circus. About a year after *Le Dieu Bleu* Cocteau began work on an unrealized ballet called *David*, for which Stravinsky was to compose the score. *David* contained all the ingredients for *Parade*, including its short, twenty-minute length.[5] Cocteau retrospectively wrote of it: On the stage, in front of a booth at a fair, an acrobat would be doing a come-on for DAVID, a spectacle intended to be given inside the booth. A clown, who is later transformed into a box (theatrical pastiche of the phonograph played at fairs — modern form of the ancient

[1] For Apollinaire's entire text see Appendix I. Steegmuller and more recently Axsom have set the record straight documenting Cocteau's creation of the project.

[2] Quoted in Jean Cocteau, *La Difficulté d'Etre* (Monaco, 1947) p. 37.

[3] Ries *The Dance Theatre of Jean Cocteau*, pp. 2–3.
[4] Steegmuller, p. 72.

[5] Cocteau wrote to his mother in an undated letter: '*David* will be short (20 minutes) but, as Igor

mask), was to celebrate David's exploits through a loud-speaker and urge the public to enter the booth and see the show. In a way it was the first sketch for PARADE, but unnecessarily complicated by biblical references and a text.[6]

Stravinsky, who was starting to feel disenchanted with Cocteau's fawning, his overheated praise and demands, abruptly abandoned the project in the summer of 1914 after Diaghilev cautioned him against collaborating with Cocteau. Without Stravinsky, Cocteau felt there could be no ballet and so *David* was aborted.[7]

Cocteau's other unrealized circus-based project was a version of Shakespeare's *A Midsummer Night's Dream* to be staged at the Cirque Médrano and starring the circus clowns, Paul, François, and Albert Fratellini (see fig. 5) as Bottom, Flute and Starveling. Cocteau convinced Gabriel Astruc, Diaghilev's producer, to present *A Midsummer Night's Dream*. Albert Gleizes was to design the décor and Erik Satie was to compose the music. Rehearsals began during the summer of 1915 and according to Astruc everyone felt it was a wonderful project. He recalled that Cocteau decided that Oberon should make his entrance to the popular wartime tune, 'Tipperary.'

A manuscript score entitled *Five Grimaces for A Midsummer Night's Dream*, found among Satie's papers after his death, indicates that the composer was applying the same combination of classic and popular orchestration – what one critic described as 'half Rimsky, half dance-hall' – that he would later

use in his score for *Parade*. But in the autumn, work on *A Midsummer Night's Dream* suddenly ceased. Wartime conditions, including Gleizes's departure for New York on 10 September, are usually cited as causes for the abandonment of Cocteau's second circus theatrical.[8]

The overlapping conceits for these two productions – an emphasis on circus/fairground and a combination of popular and classical melodies or situations – indicate that Cocteau was aiming to develop dramatic themes within the lighter idiom of popular entertainment. He was interested in the intersection of 'high' and 'low' theatrical and aesthetic forms, just as in his life he seemed drawn to mingle the crude and the sublime.[9]

Cocteau's view of popular entertainment as having descended from classical theatre and vice versa, as well as his melding of the vulgar with all that is deemed most venerable in European culture is bound up with the writings and pronouncements of Guillaume Apollinaire. Even before he met Picasso, who also subscribed to these beliefs, Cocteau had adopted his fellow-poet, Apollinaire's point of view. Apollinaire believed Western culture's most cherished forms were born in the street and that the basis of Western 'high' culture derived from the soul of the common people.[10]

In line with this view, Apollinaire often conflated in his poetry the elevated, classical and erudite with the base, sleazy and vulgar. An extreme example in his pornographic novel, *Les onze mille verges*, are the two 'exquisite mythological sonnets' composed

says, this drop will poison an elephant of five acts.' Reproduced in Igor Stravinsky, *Selected Correspondence*, ed. and with commentaries by Robert Craft. (New York, 1982) vol. I, p. 82, n. 15.
[6]Steegmuller, p. 94. Cocteau's *'David'* notebooks' – four cloth-bound notebooks, 336 × 254 mm – containing written and drawn outlines for the project, are now at the Humanities Research Center of the University of Texas at Austin.
[7]Another factor which undoubtedly deterred Stravinsky was that Cocteau could not secure a

guaranteed sum for the composer's labours. On 15 Feb. 1914, Stravinsky wrote to Cocteau: 'I have just received an offer for a commission that, financially speaking, could be very advantageous. Since I am now in a state of considerable poverty, I must know immediately if the Théâtre du Vieux Colombier, in commissioning my work, would be willing to give me a sum of six thousand francs . . .' To this Cocteau replied [postmark 17 Feb. 1914]: 'The Vieux-Colombier is the theatre of the young, of the contemporary movement. Like

the *Nouvelle Revue Française* it manages to operate courageously and skillfully without a sou . . . *Mon cher petit*, I shall not even attempt to read your letter to them. Never. Too afraid of doing you a grave disservice before a group of young people who themselves are partly responsible for your present glory. . . .' Stravinsky, *Selected Correspondence*, ibid., vol. I, p. 77.
[8]Cocteau did eventually have the opportunity to enlist the Fratellini Brothers and other Cirque Médrano performers on 12 Feb. 1920, when they performed *Le*

Boeuf sur le toit, Cocteau's burlesque pantomime set to a Brazilian-inspired score by Darius Milhaud with sets and costumes by Raoul Dufy. Milhaud, trans. Donald Evans, *Notes without Music: An Autobiography* (New York, 1953) pp. 119–20.
[9]In a letter to his mother of 19 July 1922, describing the novel he was writing, *Le Grand Ecart*, Cocteau wrote: 'The hero is not me but resembles me in certain respects. A rich, pure nature involved in the low life of a city and moving at its brink like a sleepwalker along the edge of a roof.' Quoted in Steegmuller,

p. 286. Boris Kochno has also confirmed Cocteau's 'dualistic' nature – i.e. his attraction to the sordid and the élite. Conversation with the author, Nov. 1985.
[10]This is the case for the ballet. The eighteenth-century choreographer, Jean Georges Noverre, whose *Letters on the Dance* (see Noverre, *Lettres sur la danse et sur les ballets*, (rev. ed. St. Petersburg, 1803 and New York, 1968)) still serve as the ballet choreographer's bible, originally formed a company that performed at the Foire Saint Laurent – itself a

by the book's hero, Mony Vibescu, impressively titled *Hercules and Omphale* and *Pyramus and Thisbe*. They are, however, nothing more than pieces of vulgar, pornographic dialogue with a distinctly contemporary ring: 'The lady / Thisbe / Swoons: / ''Oh, baby!'' / Pyramus / Croons: / ''Oh, lady! She bends / Says ''Ooh!'' / He rends / Her bum / She's come / He too.'[11]

Many of Apollinaire's poems in *Alcools* allude to philosophy, religion and history, while at the same time rendering matter-of-fact details of Parisian life. Like Cubist canvases, his poems introduce street cries, signs, and contemporary urban intrusions within a format distinguished by formal austerity.[12]

Apollinaire believed that poetry resided not in the exotic, but in familiar aspects of daily life. He wanted his poems to reveal the latent or unobserved magic of commonplace elements by placing them in an unexpected context. This aesthetic creed was adopted by Cocteau and later formed the basis of Surrealism.[13] Unlike the Surrealists, however, who were rather dour and dogmatic, Cocteau was an advocate of the light touch. As one who gained so much through wit, he, like Apollinaire and Picasso, used humour and vulgarity as a means of reviving moribund forms. 'The spirit of buffoonery is the only one which authorizes certain audacities', Cocteau claimed.[14]

Another way in which Apollinaire's beliefs permeate *Parade* is in his bid for the commercialization of the *avant-garde*, which called upon artists to create a modern language based on leisure technology – such as films, phonographs and advertising.[15] These elements are evident not only in the finished ballet's allusions to contemporary cinema and modern media hype, but in the sounds and noises of twentieth-century technology – such as sirens, telegraph clicks and cinema bells – which Cocteau wrote into the scenario, but which Diaghilev excised from the final production.

Cocteau's *A Midsummer Night's Dream* died a quiet death. Besides the war, and the fact that his designer, Gleizes, was in New York, Cocteau was becoming obsessed with someone new to the exclusion of all other artists. In December of 1915 Cocteau arranged an introduction to Picasso by the composer Edgard Varèse. As Steegmuller has written, 'For Cocteau, it [the meeting] was nothing less than a *coup de foudre*. . . . He fell under Picasso's spell and remained there for the rest of his days.'[16] Throughout late 1915 and 1916 Cocteau set about cultivating Picasso's friendship. Shortly after his introduction to Picasso, and with typical flourish, Cocteau arrived on the artist's doorstep dressed in Harlequin costume. He knew of Picasso's identification with the *commedia dell'arte* character and correctly calculated that Picasso would be charmed by the gesture.

kind of 'parade' or fairground sideshow. Yet by 1762 his 'forain' became a state theatre complete with a letter of nobility.

[11] Guillaume Apollinaire, trans. Nina Rootes *Les onze mille verges* (New York, 1979) pp. 58–9. The other 'mythological sonnet' is in the same vein. In another passage the famous *Comédie française* actress Estelle Ronange is about to leave her illustrious company. When asked, 'But what do you intend to do after you have played before Franz-Josef?' she answers 'It is my dream to become the star of a *café-concert*'.

[12] Picasso and Apollinaire undoubtedly influenced each other. From the circus period through Cubism the concerns of their creative output run parallel and it is nearly impossible to determine whose ideas came first. Picasso's use of vernacular and low-grade materials was well-established by 1912.

Compare also the work of James Joyce and T.S. Eliot. For example in *The Waste Land*, Eliot juxtaposes the present world against the classical past, uses jazz rhythms against Spenserian backgrounds and attempts to capture the quality of speech on the vulgate level and use it for poetry. Witness line 128 of the poem where the line 'O O O O that Shakespeherian Rag –/ It's so elegant / So intelligent' is taken directly from an 'utterly tasteless' 1912 hit tune, 'That Shakespearian Rag' whose chorus went – 'That Shakespearian rag –/ Most intelligent, very elegant, / That old classical drag, / Has the proper stuff, the line 'Lay on Macduff,' / etc. See Bruce R. McElderry, Jr. 'A Game of Chess' in Jay Martin, ed., *A Collection of Critical Essays on 'The Waste Land'* (New Jersey 1968) pp. 29–31.

[13] Although similarities exist between Cocteau and the Surrealists, they were arch enemies, due largely to André Breton's blind hatred of Cocteau. For more on this see Elizabeth Cowling, '''Proudly We Claim Him As One of Us'': Breton, Picasso, and the Surrealist Movement', *Art History*, vol. 8, no. 1, (March, 1985) pp. 82–104.

[14] Axsom, p. 50. Francis Steegmuller, biographer of both Apollinaire and Cocteau, has commented on the fact that Cocteau's early poetry imitates that of Apollinaire. Steegmuller, p. 183. Marianne Martin cites specific instances of Cocteau's debt to Apollinaire. Marianne Martin, 'The Ballet *Parade*: A Dialogue between Cubism and Futurism', *The Art Quarterly*, 1977–8, pp. 87–9.

One should note too that Apollinaire's play using the theme of the need for more French children and treating it as burlesque – *Les Mamelles de Tirésias*, premiered several months after *Parade* on 24 June 1917, at a small theatre in Montmartre. It was a skit of two acts and a prologue with sets by Serge Férat.

[15] See for example Apollinaire's article in *Sic* where he speaks of the cinema as the new vehicle for the epic poet. (Oct. 1916). See also his lecture on *L'Esprit nouveau et les poètes* delivered at the Théâtre du Vieux Colombier, Nov. 1917 and published in the *Mercure de France*, 1 Dec. 1918.

T.J. Clark asserts that the *avant-garde* began grappling with this issue – i.e. searching for a new language to express the commodification of leisure activities created for a new mid-

Around the time he met Picasso, Cocteau was frequently obliged to set out from Paris as a member of Comte Etienne de Beaumont's army ambulance corps tending wounded soldiers at the front. During the winter of 1915/16 while stationed at Coxyde, Belgium, near the extreme western end of the Allied trenches, Cocteau began reworking *David* into *Parade*. When he returned to Paris in early April of 1916 he began to conceive the work more fully, writing on the cover of one of his notebooks a definition of the word *parade* from the *Dictionnaire Larousse*: 'A burlesque scene played outside a sideshow booth to entice spectators inside.'[17] Before his leave was over on 6 May, Cocteau sent Satie 'a big batch of work, a sheaf of notes and rough drafts'. These consisted in part of random jottings inspired by three characters whom he had invented to play the 'burlesque scene outside the sideshow booth' – 'the Chinese magician,' 'the American girl' and 'the acrobat'. The notes were meant to be megaphone monologues which described the various acts and catalogued in stream of consciousness their attributes and characteristics.[18]

It is not known precisely when Picasso was approached with the offer to design décor for the ballet. Diaghilev's librettist and right-hand-man, the poet Boris Kochno writes, Diaghilev had met Picasso in the spring of 1916, [was] taken to his studio in Montparnasse by their mutual friend, Mme. Eugenia Errazuriz; it was then that he commissioned Picasso to design the *mise-en-scène* for *Parade*.[19] But we know that as late as 24 July 1916, Picasso still had made no definite commitment. Cocteau wrote to his friend Valentine Gross on that day, 'I am not counting on Picasso, but he has certainly given me more pleasure than he could ever cause me pain.'[20] It was not until 24 August that Cocteau and Satie could jointly wire Valentine that 'Picasso is doing *Parade* with us.'

12 August 1916, the day Cocteau photographed Picasso, Modigliani, Salmon, Jacob and several other friends near the cafés Rotonde and Dôme, has recently been proposed as the exact moment

Picasso agreed to participate in the ballet on the basis of similarity to Cocteau's recollection of the event.[21]

At the time Picasso agreed to design the décor for *Parade* the artist had never set foot inside a Ballets Russes production, nor had he designed theatre sets or costumes. Rather he epitomized the bohemian artist, more at home in the cafés and music halls of Montmartre than in the high society world of the ballet. Cocteau described the situation this way: I understood that there existed in Paris an artistic right and an artistic left, which were ignorant or disdainful of each other for no valid reason and which it was perfectly possible to bring together. It was a question of converting Diaghilev to modern painting, and converting the modern painters, especially Picasso, to the sumptuous, decorative aesthetic of the ballet; of coaxing the Cubists out of their isolation, persuading them to abandon their hermetic Montmartre folklore of pipes, packages of tobacco, guitars and old newspapers; . . . The discovery of a middle-of-the-road solution attuned to the taste for luxury and pleasure, to the revived cult of 'French clarity' that was springing up in Paris even before the end of the war – such was the history of *Parade*.[22]

Actually, by 1916 Picasso was already moving away from his rather closed and ingrown bohemian circle. His closest friends, Braque and Apollinaire, were at the front; his German-born dealer Daniel Henry Kahnweiler was in exile; and his mistress, Eva Gouel (Marcelle Humbert) had died of tuberculosis after a long struggle in January 1916. Thus the war and personal experience had already facilitated a change of direction in his artistic and social life. During the summer of 1916 Picasso moved from Montparnasse to the suburb of Montrouge. He was seeing Pâquerette, a fashionable Poiret mannequin, as well as Gaby Depeyre Lespinasse, who came from a good family with private means, and he had begun to develop a friendship with a wealthy Chilean socialite Mme. Eugenia Errazuriz. Erik Satie, who had friends on both sides of the Seine, was also a frequent companion.

dle class – in the 1860s. *The Painting of Modern Life: Paris in the Art of Manet and his followers* (New York, 1985).
[16]Steegmuller, p. 137.

[17]Notebook in the collection of the New York Public Library, Dance Collection, Lincoln Center.
[18]See Axsom, app. 1, pp. 236–7.

[19]Boris Kochno, trans. Adrienne Foulke, *Diaghilev and the Ballets Russes* (New York, 1970) p. 119. We know he was taken to Picasso's studio on the rue

Schoelcher because the highly superstitious Diaghilev recalled Picasso's room as being 'sinister' because it overlooked a cemetery.

[20]Quoted in Steegmuller, p. 158.
[21]Billy Klüver 'A Day with Picasso' *Art in America* vol. 74, no. 9, Sept. 1986, p. 161.
[22]Quoted in André Fermigier,

In December 1915 Picasso exhibited at the shop of the couturière Germaine Bongard on the rue de Penthièvre, and in the following July he showed at the Salon d'Antin, in an exhibition which included Raoul Dufy, André Lhote, Albert Marquet, Serge Férat, Roger de la Fresnaye, Friesz and other artists considered less radical than he.[23] No doubt the circumstances created by the war caused artists to overlook their differences and broaden their circles. While the artists mentioned above were by no means conservative, their artistic outlook can be placed somewhere to the right of Picasso's.

Moreover, the declaration of the First World War precipitated a general renunciation of avant-garde affiliations on the part of many artists. Concomitant with the swell in patriotism was a backlash against foreign influences, especially Cubism, which for no valid reason was viewed as German.[24] The Parisian left began to be seen as un-French, hence unpatriotic and alien. Modern art was accused of being *boche* (a pejorative term for German).[25] Thus, for Picasso the opportunity of leaving France for a time, seeing Classical and Renaissance works *in situ*, challenging his creativity in a new way, and surrounding himself with a group of creative people who like himself were outsiders and non-combatant aliens, came at an ideal moment.

According to Cocteau, Picasso's fellow-artists were outraged when he accepted the invitation to design the décor for *Parade*: 'In 1916 a dictatorship hung heavy over Montmartre and Montparnasse. Cubism was going through its austere phase, and to paint a stage set for the Russian Ballet was a crime.'[26]

It is helpful in understanding Picasso to realize that this break with his fellow bohemians not only rescued him from a personal, professional and political impasse, but also was very much in keeping with his contrary personality. Picasso detested being categorized. He would not be dictated to, and flouted expectations even when such activity was under a leftist banner. Thus, just when he was dubbed the leader of the Montmartre/Montparnasse avant-garde, it was typical of him to turn about-face and embrace the other side – not the ultra conservatives, but the Right Bank avant-garde – the Ballets Russes.

On 17 February 1917 Picasso and Cocteau left Paris from the Gare de Lyon to begin work on *Parade* in Rome, where Diaghilev and the Ballets Russes were headquartered during the war. Cocteau reported, 'Picasso laughed to see our painter friends grow smaller as the train pulled away. I refer only to the 100 per-cent Cubists.'[27] Picasso later remarked to Francis Poulenc, 'Long life to our followers! It's thanks to them that we look for something else.'[28]

Jean Cocteau entre Picasso et Radiguet (Paris, Hermann, 1967) pp. 12–13.
[23]As part of the Salon, Apollinaire organized a poetry reading on 21 July, where Max Jacob and Beatrice Hastings read from their works. A second reading a week later was organized by André Salmon. In addition two musical programmes were given, featuring compositions by Satie, Stravinsky, Milhaud, and Georges Auric.
[24]One reason commonly offered is that Kahnweiler and Uhde, the main art dealers who sold Cubist works, were German-born. Less rational is the explanation that anything that was cosmopolitan and international in scope was seen as un-French and by extension, was dubbed German.
[25]See Chapt. 1, nn. 15, 17, 35, and Silver.
[26]Cocteau quoted in Steegmuller, p. 165. It should be noted, however, that it was not long before Picasso's critical colleagues were eating their words and vying to obtain commissions to design for Diaghilev. In the twenties Braque, Gris, Derain, Léger and Matisse all created décors for the *Ballets Russes*.
[27]Cited in Steegmuller, p. 174.
[28]Francis Poulenc, *Moi et Mes Amis* (Paris and Geneva, 1963) p. 82.

Chapter 3

The collaboration begins in Rome

then moves to Naples

Upon arrival in Rome Cocteau and Picasso met Diaghilev, and the choreographer Léonide Massine as well as other members of the Ballets Russes entourage. Erik Satie, the composer of the music for *Parade*, had already finished his score and so remained in Paris. Shortly after arriving Massine presented Cocteau with a leather notebook on which he inscribed: *'A mon cher Jean Cocteau premier jour à Rome, Massine,'* and Picasso wrote in his own small sketchbook: *'mon atelier 53B via margutta'*.[1] Many years later Massine gave this account: During that winter of 1916–17 our studio in the Piazza Venezia was the meeting-place of an ever-widening circle of artists, which now included Pablo Picasso, whom Diaghilev had invited to Rome to collaborate on a new ballet . . . we were seriously considering one of Cocteau's suggestions for a ballet incorporating elements of the circus and music-hall. We decided to set the scene in front of a circus tent, bringing on such characters as acrobats, tightrope walkers and conjurers, and incorporating jazz and cinematograph techniques into balletic form.[2]

When he first arrived in Rome, Picasso would often watch rehearsals in order to familiarize himself with stagecraft and theatrical production. He would sketch the dancers, and help established décor artists, such as Léon Bakst or Michel Larionov, paint props and arrange sets, all the while learning about stage design and set décor.[3]

Later, in his via Margutta studio Picasso set about designing *Parade*'s décor and costumes. Cocteau wrote to Misia Sert, 'Picasso amazes me every day, to live near him is a lesson in nobility and hard work.'[4] Picasso used a tiny cardboard box to create a maquette of houses, trees and a fair booth in accord with Cocteau's *mise en scène*.[5] On a table, looking out toward the Villa Medici, he drew the costume designs for the ballet's three characters – the Chinese Conjurer, the Little American Girl and the Acrobat, and began sketching out an idea of his own, which would evolve into the three Managers (see fig. 105). For both Cocteau and Picasso life in Rome was chiefly work. Cocteau wrote his friend, Valentine Gross: 'We snatch our meals between working and walking, and fall asleep exhausted.'[6]

This is not the whole picture however, for in between work and sightseeing, Picasso began to pursue in earnest one particular dancer. Olga Koklova was the well-bred daughter of a Russian army officer who had recently joined Diaghilev's troupe as a member of the *corps de ballet* (fig. 11). It was during the rehearsals for *Les Femmes de Bonne Humeur* (décor by Bakst) that Picasso spotted her.[7] Although others in the company foresaw a mismatch, the artist was captivated by Olga and in little over a year, on 12 July 1918, she became the first Madame Picasso.[8] In imitation of his new hero, Cocteau carried on a mock-romance with Marie Chabelska, a gifted seventeen-year-old who was the first ballerina to dance the role of the Little American Girl. The foursome would take long walks, dine, sightsee, shop in various galleries and spend long hours in cafés near the Campagna.[9]

Picasso and Cocteau also made contact with Futurist artists living in Rome. For several years Diaghilev had been interested in Futurism, a movement, begun in 1909–10, that found inspiration in the speed of urban life and machine technology. Late in 1916 the impresario commissioned Giacomo Balla to

[1] Cocteau's notebook, known as the *carnet romain*, a facsimile of which is in the collection of Edward Dermit, Paris. Picasso's notebook, MP1867 is in the collection of the Musée Picasso, Paris. The dating of this notebook in Arnold and Marc Glimcher, eds *Je suis le cahier: The Sketchbooks of Picasso* (New York, The Pace Gallery, 1986) no. 70, p. 321, is in error.

There are two Picasso notebooks from the 1917 trip to Italy in the collection of the Musée Picasso: MP1866 and MP1867, both contain material relating to the sojourn in Naples. MP1867 also has references to Picasso's stay in Rome.
[2] Massine, pp. 101–2.
[3] Gilot and Lake, p. 147ff. According to Gilot, Picasso worked with Larionov and Gontcharova and with Bakst and Benois. He said to her: 'Of course, what they did had nothing to do with what I was trying to work out . . . but at that time I had no experience of the theatre. For example, there are some colours that look very nice in a maquette but amount to nothing transferred to the stage. That was something that Bakst and Benois, on the other hand, had a lot of experience with. So in that sense I learned much from them.' pp. 147 and 148.
[4] Steegmuller, p. 177
[5] The maquette for *Parade*'s décor is recorded in a photograph in *Picasso in Italia* (Verona, June–Sept. 1990) p. 90. Picasso used the same type of tiny cardboard boxes for his other theatrical designs for Diaghilev. The maquettes for the sets of *Le Tricorne* (1919) and *Pulcinella* (1920) are preserved in the Musée Picasso, Paris.
[6] Steegmuller, p. 177.
[7] Massine, p. 101. Without great talent, Olga was one of the pretty girls of good social background Diaghilev customarily chose to pad the ranks of the ballet *corps*. Oftentimes these dancers would attract a following by virtue of their social standing or looks, rather than their dancing ability, and thereby increase the company's revenues.
[8] Conversation with Alexandra Danilova who said of Olga, 'She was nothing, nice but nothing. We could not discover what Picasso saw in her.' Jan. 1986, New York.
[9] Mentioned in Cocteau's carnet, Fonds Kochno, Bibliothèque de l'Opéra, Paris.

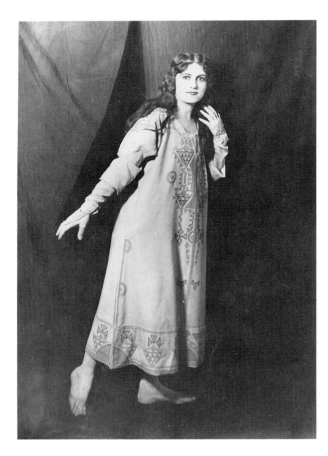

11 Olga Koklova as one of
the twelve princesses in
L'Oiseau de feu, 1916

12 Giacomo Balla, set décor
for *Fireworks*, 1917

create décor for Igor Stravinsky's new symphonic poem, *Fireworks* – a dancerless ballet consisting only of changing lights and moving three-dimensional abstract forms (fig. 12). Balla was working on *Fireworks* when Picasso and Cocteau arrived in Rome.[10] The three came to know each other at the Ballets Russes's basement atelier called the Cantina Taglioni on the Piazza Venezia.[11] Later, when Picasso's ideas for the Managers had coalesced, Diaghilev enlisted the aid of Balla and his fellow-Futurist, Fortunato Depero, in constructing the frames of the Managers' costumes.[12]

Although in letters home Cocteau dismissed the Futurists as 'provincial and bragging,' claiming they pursued him and Picasso 'wanting to learn the Paris styles', there are undeniable points of similarity between *Parade*'s conception and Futurist ideology.[13]

Years later Cocteau admitted, 'It was the Italian Futurists led by Marinetti who helped us.'[14] Filippo Marinetti, Futurist leader and spokesperson, had already in 1913 called for a 'new marvellousness' in theatre through the adoption of music-hall ploys such as improvisation, topicality and audience repartee.[15] Cocteau's desire to inject a 'spirit of buffoonery' into classical ballet owes a great deal to Marinetti's earlier pronouncements.[16]

In March 1917, Stravinsky arrived in Rome from Switzerland to conduct *Fireworks*, as well as his earlier ballet, *Firebird*. Cocteau had long been singing Picasso's praises to Stravinsky in correspondence, and now the two men met for the first time, felt a mutual regard, and spent much time in each other's company. Stravinsky scribbled two bars of music for clarinet in Picasso's honour on a piece of telegraph paper, inscribing '*pour PAOLO PI/CA/SS/O/ pour le postérité. IGOR STRAWINSKY/ Apprile/ Rome/ 1917*' (fig. 13).[17] In turn, Picasso paid homage to Stravinsky by drawing several portraits of the composer as well as sketching a number of musical still-lifes in the pages of his notebook (fig. 14).

Shortly after Stravinsky's arrival the entire Diaghilev entourage travelled to Naples where the Ballets Russes was to perform at the San Carlo Opera House. While Diaghilev and his entourage wined and dined Neapolitan society, Picasso took time to explore the less straight-laced haunts of the city. In his Italian notebook Picasso inscribes '*bordello – via Tornacelli 140*' – a location that still serves as the heart of Naples' red-light district. After several pages of phallic drawings Picasso scribbles, '*A Naples les demoiselles ont quatre bras*' [In Naples the girls have four arms].

While in Naples Picasso visited the Museo di San Martino, a repository for the city's lively popular culture. There he viewed the museum's famous crèche display of the Nativity and purchased post-

[10] *Fireworks* was extremely radical for the time and premiered and closed in a single performance at the Teatro Costanzi on 12 April 1917. Technical problems are given as cause for the ballet's single performance, but its extreme novelty may have also been a factor.

[11] While Futurism does not infiltrate Picasso's décor for *Parade*, Balla's mobile set for *Fireworks* with its rotating and swaying forms is a likely, and heretofore unnoticed, source of inspiration for Picasso's much later production, *Mercure* (1924). In a number of sets for *Mercure* the scenery is onstage alone, rocking and moving to the musical score, in effect taking the place

of actual dancers in a way presaged by Balla's 1917 dancerless décor.

[12] Bruno Passamani 'Depero e la scena', *Nadar*, 2, 1970, p. 61, n. 15, cites an entry in Depero's hand stating: 'Diaghilev . . . suspended my scenographic work [on *Le Chant du rossignol*]. . . . But in compensation Diaghilev provided me with some earnings . . . by asking me to construct three costumes for 400 [lire] for Picasso's Dance.'

[13] Letters to Misia Sert and Valentine Gross. Steegmuller, p. 178. For a discussion of this issue see Marianne Martin, 'The Ballet *Parade*: A Dialogue between Cubism and Futurism', *Art Quarterly* (1977) pp. 85–111.

[14] Jean Cocteau, 'Pablo Picasso,' in *My Contemporaries*, 1968, p. 71, (text of a talk delivered in Rome, 1953).

[15] See Marinetti's manifesto, *In Praise of Variety Theater*, 1913. R.W. Flint, ed., Marinetti; Selected Writings (London, 1971, 1972) pp. 117–22.

[16] Futurist notions had also infiltrated Apollinaire's writing as early as 1913. In his essay *L'Antitradition Futuriste* the ideals of purity and variety were to be achieved by the use of 'Free words /Invention of Words/ . . . Onomatopoeic Description/ Total Music and Art of Noises . . ./ Machinism/ Eiffel Tower/ Brooklyn and skyscrapers . . . Direct quivers at

great free spectacles circuses music halls, etc.' Apollinaire's stream-of-consciousness formula is too close to Cocteau's character descriptions for *Parade* (see chapter 7) to be mere coincidence.

Marianne Martin points out that another reason Cocteau would be drawn to Futurist theory is that Diaghilev, whom he was trying to impress, was an early supporter of Futurist music. Before the war put an end to his plans, Diaghilev had intended to arrange a performance of Russolo's *intonarumori* (noise intoners) in Paris after he, Stravinsky, and others had attended a private demonstration of Russolo's noise music in

Marinetti's apartment in Milan late in 1914. Many have seen Russolo's *intonarumori* as precursors for Cocteau's unrealized sound effects for *Parade* – the 'anonymous voice issuing from an amplifying orifice singing type phrases outlining the performers activity' as well as the *trompe l'oreille* sounds – foghorn, siren, typewriter, revolver, etc. – with which Cocteau intended to punctuate Satie's score.

[17] It is interesting to note that Stravinsky's grouping of the letters of Picasso's name is similar to the way Picasso arranges the word PA/RA/DE on the placard carried by the American Manager (fig. 66).

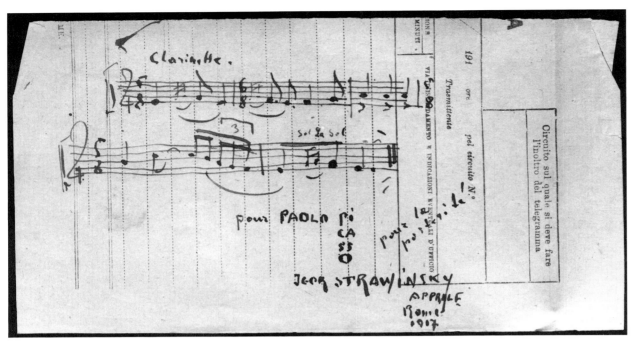

13 Igor Stravinsky, clarinet
music dedicated to Picasso,
1917 (MP 3669)

14 Pablo Picasso, page from
his Italian notebook, 1917
(MP 1866)

cards illustrating Neapolitan streetlife. (The importance of these objects for the *Parade* curtain is discussed in chapter 9.)

At the same museum Picasso also purchased images relating to Pulcinella, a *commedia dell'arte* character who is treated as a local hero in Naples (figs 15, 16, 17).[18] He inserted these images along with a list of characters, costumes and a thumb-nail sketch of an idea for décor into his Italian notebook (Musée Picasso 1866, fig. 18). This material, as well as some sketches of Pulcinella in his other Italian notebook (Musée Picasso 1867, fig. 19), revise the chronology for the 1920 Picasso-Stravinsky-Massine collaboration for Diaghilev's production of *Pulcinella*. Previously it has been thought Picasso was brought into the ballet near its completion.[19] It now becomes evident that Picasso had been involved in the project from its inception which took place in Naples in mid-March of 1917, under the direct inspiration of extempore performances of *Pulcinella* that the ballet's collaborators witnessed first hand. It is probably not accidental that the early study for a *Parade* Manager is given Pulcinella's distinctive profile and at the same time seems to resemble the equally distinctive contours of Stravinsky's face (figs 19, 20).[20]

Stravinsky later recalled that he and Picasso combed little shops and stalls for popular Neapolitan prints and cards. Some of these purchases can be seen pinned to the left and right wall of Stravinsky's study in Switzerland (fig. 21).[21] Most of the prints appear to be images of peasant girls dressed in regional costume. It is a type of image Picasso frequently selected for postcards (fig. 22) and one that probably served as the source for his painting *L'Italienne* (Buhrle collection, Zurich) as well as some smaller paintings and drawings (fig. 23) executed during his 1917 trip to Rome.[22] This type of postcard imagery featuring traditional folk costume represents another instance of Picasso's responsiveness to traditions that lay outside high culture, and that one might term the art of the underclass. Picasso had been collecting and sending such postcards since at least 1912 and continued to do so well after 1917.[23]

Together Picasso, Stravinsky, Massine and Cocteau made a pilgrimage to Pompeii where like typical tourists they photographed one another amid the ancient ruins. Cocteau's lines: 'Vesuvius is an / optical illusion belching smoke / the biggest cloud factory in the world / Pompeii closes at four o'clock / Naples never closes. CONTINUOUS PERFORMANCE.' conjure up the lively zaniness of Naples, with Pompeii's embalmed classical past providing a sharp contrast to the city's irreverent and colourful present.

Picasso, Stravinsky, Cocteau and Massine responded strongly to the vital popular culture still extant in Naples today (fig. 24). The extemporaneous performances of *commedia dell'arte* scenarios they witnessed on Neapolitan streets and in one-room 'theatres' embodied the instinctive and intuitive type of theatrical that Marinetti, Apollinaire and now Cocteau and Picasso envisioned.[24] The experience of Naples, particularly its improvised street theatre which was at once a centuries-old tradition and irreverent, vulgar display, inspired the entire group and was particularly appealing to Picasso. The spirit of the *commedia*, to which nearly all forms of anti-authoritarian and non-literary street entertainments such as circus, puppet theatre, carnival, and music-hall trace their origins,

[18]One of the postcards Picasso selected depicts a life-size reconstruction of the stage set and actors for San Carlino's final production – a play revolving around *Pulcinella* (fig. 16). The impressive reconstruction was on view in salon 40 of the Museo di San Martino at the time of Picasso's visit. The *paloscenico* as it is called, of the Teatro San Carlino was donated to the Museo Nazionale di San Martino in 1899 after being exhibited at the Turin exposition of 1898.
[19]Only Roland Penrose hints at an earlier date when he writes the idea for *Pulcinella* 'was broached as early as 1917'. He does not substantiate this claim. Penrose, p. 230.
[20]There is a drawing of a Pulcinella mask in the same notebook that contains the early Manager sketches (fig. 17).

[21]Note that photos of the Managers and two-man Horse from *Parade* also adorn Stravinsky's study – at the upper centre of the photograph.
[22]See the pencil drawings *L'Italienne*, and *Italian Peasants* dated 1919, Zervos, vol. III, pp. 362, 431. Picasso's use of regional Italian peasant art is discussed in Giovanni Carandente, 'Il viaggio in Italia: 17 febbraio 1917' in *Picasso Opere dal 1895 al 1971 dalla Collezione Marina Picasso*, (exhib. cat. Venezia, 1981) pp. 45–57. No mention is made of Stravinsky's purchases.
[23]See Gertrude Stein archive, Beinecke Rare Book Center, Yale University, and Musée Picasso, Paris.
[24]Although Pierre Cabanne cannot always be trusted, his account of the Neapolitan sojourn rings true and captures the exuberant vulgarity of Naples' street theatre. He writes: 'During one of their [Picasso, Stravinsky, Massine] walks in Naples they had happened into a small room jammed with people and reeking of garlic, where a farce was being played starring Punchinello [*sic*] as a swearing shouting drunk who whispered dirty words to the women as his hands roamed over them.' Cabanne, p. 210.

15 Postcard of Pulcinella purchased by Picasso from the Museo San Martino in Naples and inserted in his Italian notebook (MP 1866)

16 Postcard purchased by Picasso from the Museo San Martino in Naples and inserted in his Italian notebook (MP 1866) showing a reconstruction of the last performance at the Teatro San Carlino, Naples

17 Pablo Picasso, pencil
sketch of Pulcinella's mask
from his 1917 Italian
notebook (MP 1867)

18 Pablo Picasso, loose sheet
listing characters and noting
the set design for *Pulcinella*,
kept in his 1917 Italian
notebook (MP 1866)

19 Pablo Picasso, pencil
sketch of Pulcinella from his
Italian notebook, 1917 (MP
1866)

20 Igor Stravinsky
rehearsing *Histoire du
Soldat*, 1928, Amsterdam

21 Igor Stravinsky working
at *Les Diablerets*. Attached
to the wall and book shelves
are Italian postcards and
photographs of the
Managers and Horse from
Parade

22 Postcard sent by Picasso
to Gertrude Stein, 1914

23 Pablo Picasso, *L'Italienne*,
1917, oil on canvas

24 A Pulchinella comic
performing in the streets of
Naples, 1982

is deliberately injected into every Diaghilev production in which Picasso participated.[25] Massine has described the revelatory nature of these performances: . . . although I felt I had made great advances in technique, I was far from satisfied with what I had accomplished. Now that I had thoroughly absorbed the theories of Blasis, Feuillet and Rameau, I realized that mere mastery of their notations would not help me to go beyond the so-called ''technical régime'' of the classical tradition. In fact . . . [it] could limit the scope of my choreographic evolution.

I began to do some extensive researches into the *commedia dell'arte*, for I had an instinctive feeling that this Italian type of folk-theatre, with its emphasis on mime and its use of extempore acting, based only on a scenario, might hold the key to my artistic dilemma. . . . the importance of the expressive plasticity of the body [is] rendered imperative by the habitual use of masks. . . . in Naples I went often to watch the puppet-plays in which Pulcinella played the chief part. I delighted in his ever-changing gestures, his dangling legs, and his hook-nosed mask, with one side of the face laughing and the other crying. From an old Italian actor I bought an authentic Pulcinella mask which had originally belonged to Antonio Petito, the eighteenth-century *commedia dell'arte* actor and producer. I put it on and began trying to reproduce Pulcinella's gestures and movements.[26]

After Naples, the company played one night in Florence, and left for Paris on 30 April. In the eighteen days before the première of *Parade* at the Théâtre du Châtelet, Picasso and a team of theatrical decorators painted the immense drop curtain and scenery in a studio on the Buttes-Chaumont (see fig. 185). The costumes for the three acts were fabricated in Paris (purchased 'off the rack' in the case of the Little American Girl). The managers whose construction had begun in Rome were completed from cardboard and other materials that Picasso found lying around the basement of the Théâtre du Châtelet.

[25]See author's doctoral dissertation, *From the Street to the Elite*, chapt. 1.

Martin Green and John Swan writing about the *commedia dell'arte* note that it was intended to appeal to an unrefined and non-intellectual public. The *commedia* and its various descendants 'all represent a recoil from our society's dominant respectable values and attack them by nonserious means.' *The Triumph of Pierrot, The Commedia dell'Arte and the Modern Imagination* (New York, 1986) p. xvi.

[26]Massine, pp. 144–6.

Chapter 4

'Soyons vulgaires'

Even before he had experienced Naples, Cocteau emblazoned 'SOYONS VULGAIRES' across two pages of his Roman notebook and underneath in small letters he added '*puisque c'est impossible*' [since it is impossible] (fig. 25). Embracing the modern age with all of its vulgarity as well as vitality, he and Picasso wanted their ballet to parody music-hall entertainments while hinting at something of the sadness inherent in the lot of socially outcast performers (and, by implication, artists) whose lives are based on masquerade, imitation, and illusion. As stated, Cocteau shared with Picasso a sensibility which found poetry and magic in the commonplace and ordinary. In later life he credited Picasso with teaching him to look for beauty in unlikely places:

He [Picasso] is a rag-and-bone man of genius. He does not only pick up unused objects, junk, with his hands but with his eyes too. He notices the slightest thing, the elements that inattentive people do not notice, drawings chalked on pavements, shop windows and walls – the treasure from dust bins. From him I learned that a ditty sung by a street singer may prove more rewarding than 'Götterdämmerung'.[1]

In his Roman notebook Cocteau writes twice, *S'efforcer d'être vulgaire* [try to be vulgar]. On one page he writes, *Mon cher Massine, vous ne serez jamais moche, partez donc du moche. Vive le moche!* [My dear Massine, you will never be sleazy, partake therefore of sleaze. Long live sleaze]. Finally, after noting that the décor must recall streets like those in Naples, Montmartre, Clichy and Place Pigalle, he adds, *Ne pas oublier que la Parade se donne dans la rue* [don't forget Parade is given in the street]. Massine recalled that Cocteau told him to take crudity and tackiness to the limit in his choreography, adding that he could never be coarse enough.[2]

Another Cocteau notebook (collection of the Bibliothèque d'Opéra, Kochno bequest) is filled with crude drawings and phrases that poke fun at nearly everyone in Diaghilev's company. On one page (fig. 26) Cocteau draws a cubified phallus and labels it *pistout de Lhote dans le rêve de Picasso*, a reference to the Cubist epigone, André Lhote, who was supposedly Cocteau's friend. On another page Cocteau gives the Futurist, Giacomo Balla who as mentioned was working on Diaghilev's production of *Fireworks*, even cruder treatment (fig. 27).

Even Picasso, his new 'sacred monster' whom he addressed as *Cher Magnifique* was not exempt from Cocteau's private barbs.[3] There are numerous loose pages and notebook sketches mocking Picasso's magnetic *regard* and amorous nature. In one, Cocteau renders the artist's penetrating stare – what he termed 'eyes that bored out and in' (fig. 31).[4] In others he documents the behind the scenes romance developing between Picasso and Olga Koklova (figs 28, 30).[5] In a photograph taken at the same time of Olga, Picasso and Cocteau, we can see how acute were Cocteau's powers of observation. Olga pleasantly presents herself as an object of beauty, while Picasso 'zaps' her with his laser stare (fig. 29). In addition to being a logical way to render Picasso's famous magnetic stare, it is entirely possible that Cocteau was exploiting a conceit from popular advertising. For example, a poster promoting the mesmerizing powers of 'Le Commandeur Pietro' depicts the hypnotist with powerful rays emitting from his eyes (fig. 32). Pietro appeared throughout the 1910s at the Théâtre Salon Carmelli, a large fair booth dedicated to magic acts which also featured the sorcerer Foska, the magician Roskoff, the gypsy fortune-teller Milka, as well as the fantastic films of Georges Méliès.[6]

Taking 'crudity to the limit' Cocteau's unpublished Italian notebook features drawings of Managers copulating (fig. 33) as well as a number of pages depicting single phalluses. Picasso's Italian

[1] Cocteau, *Oeuvres Complètes de Jean Cocteau*, 'Picasso', vol. IX, p. 251.
[2] Axsom p. 45.
[3] Cocteau would frequently attach himself to idols, whom he termed 'sacred monsters', and would flaunt his friendship with them, sharing their limelight while simultaneously promoting their talent. Nijinsky, Diaghilev, Stravinsky and Picasso were at different times the objects of Cocteau's hero-worship.
[4] Cabanne, p. 176.

[5] Three drawings attributed to Picasso, of which fig. 30 is one, see Zervos, vol. XXIX, figs. 237–9, seem to the author on stylistic grounds to be by Cocteau.
[6] When Carmelli died in 1919, Pietro, whose last name was Morlass, bought the theatre, which seated 300, and renamed it Music-hall Pietro and then Magic-hall Pietro. Jacques Garnier, *Forains d'hier et d'aujourd'hui* (Orléans, 1968) pp. 288–90.

For the importance of Georges Méliès films in the development of Cubism see Natasha Staller, 'Méliès; "Fantastic" Cinema and the Origins of Cubism,' *Art History*, vol. 12, no. 2, June 1989, pp. 202–32.

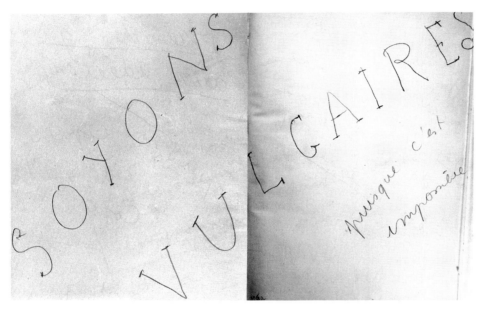

25 Jean Cocteau, pages from
the Roman notebook, 1917

26 Jean Cocteau, page from
his Italian notebook, 1917

27 Jean Cocteau, page from
his Italian notebook, 1917

28 Jean Cocteau, Cocteau,
Picasso and Olga, page from
the Italian notebook, 1917

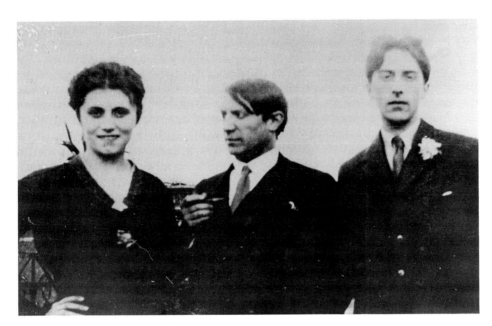

29 Olga, Picasso and
Cocteau, Rome 1917

30 Jean Cocteau
(traditionally ascribed to
Picasso), drawing of Picasso
and Olga in Rome, 1917

31 Jean Cocteau, page from
his Italian notebook, 1917

32 A poster of Pietro le
Commandeur, c.1915

sketchbook is similarly embellished with a section of phallic drawings (fig. 36). One wonders if this was some sort of schoolboy joke between Picasso and Cocteau as both notebooks contain six pages each of such drawings. Three of Cocteau's drawings are accompanied by the phrase *murs de Rome*, undoubtedly a reference to the graffiti he saw there, for on a fourth page he inscribes, *graffiti . . . Rome*. Cocteau's observation that Picasso notices elements inattentive people miss such as 'drawings chalked on . . . walls' naturally comes to mind. These doodles indicate another instance of Cocteau noting a convergence of the classical and the vulgar. In this case there is the amusement of seeing venerated ruins scribbled with obscenities.

Both Cocteau and Picasso enjoyed finding evidence to contradict the expectation that all that comes down to us from the classical epoch is noble and high-minded. Picasso had been struck by the explicit frescos adorning the walls of antique brothels in Pompeii. Taking what he saw there as a point of departure, he made a number of risqué drawings (fig. 34) and wrote to Gertrude Stein of them: 'I have done a lot of Pompeiian fantasies, a little on the improper side.'[7] This type of drawing recurs in Picasso's *oeuvre* years later in a string of etchings from the sixties portraying mythological creatures pursuing nymphs.

The libretto for *Parade* indicates that Cocteau understood with McLuhanesque clarity the power and pervasiveness of advertising as well as its vulgar associations. In his initial notes for the ballet he had a Barker shouting through a megaphone the amazing qualities of the three *parade* performers and promising miracles to customers who would pay to see the acts inside. Picasso later transformed the Barker into three Managers, who much to Cocteau's

dismay (see chapter 7) were never allowed to speak in the realized production.[8] The Barker/Managers' lines poke fun at the outrageous promises advertisers use to sell products, how they play on human vanity, frailty, and hope. For example at the end of the ballet the three managers were to exclaim together such lines as 'Si vous voulez avoir la toute puissance!, Si vous voulez qu'on vous aime!, Si vous voulez être riche! etc., Exigez le K!' [If you want to be all powerful! If you want to be loved! If you want to be rich! etc., Demand the K!] (fig. 37).[9]

Cocteau's cued exhortations for the Barker and later the Managers, mimic contemporary advertising as well as the patter of the charlatans who from the middle ages to Cocteau's day would sell miracle potions along with entertainment at fairs and *forains*. Just as Picasso responded to popular forms which nonetheless could lay claim to centuries-old tradition (such as the bullfight and the *commedia dell'arte*), so Cocteau's *Parade* including the Managers' come-ons respond to a phenomenon that is both vulgar and enduring. As historian Marian Hannah Winter notes, from the sixteenth century it was customary for a charlatan 'who might be a quack doctor, dispenser of "cure-alls" or "tooth puller," to present exotic people and animals in a short performance called the *parade* before the sales pitch began.'[10]

The claims of Cocteau's Barker are comparable to the ballyhoo shouted through megaphones by fair hawkers, travelling peddlers and quack doctors during a *parade*, accompanied by an assistant beating a drum (fig. 38). This age-old high-pressure salesmanship was taken up, virtually intact, by modern advertising. An endorsement for the Théâtre des Nouveautés inserted in one of Picasso's sketchbooks, mirrors in its use of superlatives the type of

[7]'J'ai fait beaucoup des fantaisies pompayennes qui sont un peu lestes.' Letter to G. Stein, Rome, April 1917, Beinecke Rare Book and Manuscript Library, Yale University.
[8]Rough drafts for the Barker/Managers' ballyhoo are preserved in two Cocteau notebooks, one in the Bibliothèque

de l'Opéra, the other in the Collection of Edouard Dermit, Paris. The final text, including where in the score each Manager's bavardage was to occur, is hand-written by Cocteau in Erik Satie's score for *Parade* in the collection of the Frederick R. Koch Foundation, New York. This document indicates that

Cocteau expected his vocal and noise effects to be part of *Parade* up until the actual production. We know from correspondence that Picasso asked Satie to humour Cocteau and pretend the vocal/sound effects were going to be included even though Diaghilev, Picasso and Satie had long decided they

would never be performed. See chapter 7.
[9]The cry to 'Demand the K' probably refers to Germany and identifies the Managers as evil and vulgar by association with the 'barbaric' national enemy. The letter 'K' is almost non-existent in French. During the war a 'K' was often substituted

for the 'C' in the word Cubism as a way of identifying the *avant-garde* style as *boche*. See Silver, p. 11.
[10]Marian Hannah Winter, *The Theater of Marvels* (New York, 1962) pp. 23, 70.

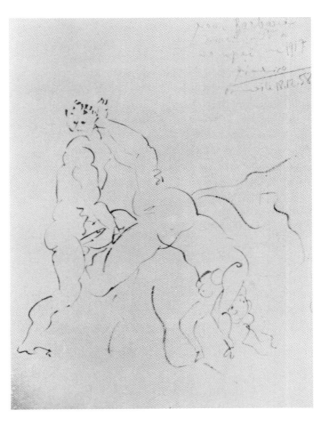

33 Jean Cocteau, the
Managers from *Parade*,
pencil sketch from the Italian
notebook, 1917

34 Pablo Picasso, pencil
drawing made in Pompeii in
1917 (with inscription dated:
'*18.12.58.*')

35 Jean Cocteau, pencil
sketch from his Italian
notebook, 1917 (Fonds
Kochno, Bibliothèque de
l'Opéra)

36 Pablo Picasso, pencil
sketch from his Italian
notebook, 1917 (MP 1867)

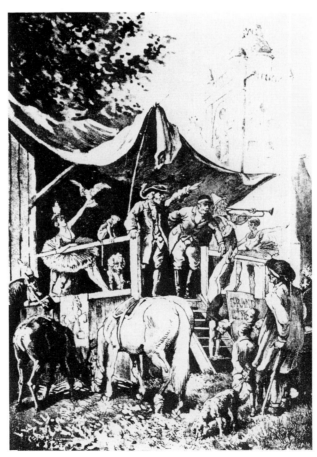

37 Jean Cocteau and Erik
Satie, copyist's manuscript of
Erik Satie's score for *Parade*,
1917

38 Comte de Passage, *Le
Cirque Forain*, watercolour,
c.1890

hype that Picasso used in his initial signboards for the Managers and that Cocteau poked fun at in his original character sketches. It reads: 'Ce soir mardi. Soirée de gala. Grands débuts . . . Grand succès, le plus beau et le meilleur chanteur du Music-Hall . . .' However, unlike their real-life counterparts, Cocteau's verbal résumés were far more bizarre and fantastic and were meant 'to expand' the personalities of the performers.[11]

Although in his ballet Cocteau condemns the Managers (whom he labels 'les grands managers sans coeur' [great heartless managers], as 'une race terrible – espèces de dieux vulgaires de la réclame', [a race of terrible vulgar divinities of advertising],[12] Cocteau was a born propagandist and popularizer. He realized intuitively that fame and fortune were as much, if not more, the result of good public relations, promotional campaigns and advertising than of talent. Initially he was admitted to Diaghilev's circle precisely because the impresario valued his ability as a promoter. Throughout his life he fought to achieve renown based on substance rather than the charm and promotional know-how that came so easy to him. In a sense the Barker/Managers of Parade can be viewed as representing the 'ad-man' or 'charlatan' aspect of his own personality, while the three acts translate into the side of himself that he cherished – his talent and artistry. Biographers Arthur Gold and Robert Fizdale have written: 'The characters [Managers] in Parade hawk their wares much the way Cocteau did . . . [using] coquetry, sleight of hand, acrobatics and slapstick with that overlay of mockery that was his own cynical, slightly sinister veneer.'[13]

Although he admired genius and creativity above all else, at times his courting of fame and high society threw Cocteau's artistic seriousness into question. A bid for his audiences, therefore, to look beyond superficial dazzle in order to uncover a

depth of thought and understanding is a leitmotif in Cocteau's life and indeed is the theme of Parade, whose 'skin of slapstick' masks poetry. In his own poetry and writings Cocteau repeatedly asserts that beneath a witty and carefree façade lies unnoticed a profound and often troubled intellect.[14] This holds true for Parade where the fictive audience fails to understand what is going on and where a disturbing quality lurks beneath a gay and simple surface.

Parade is subtitled 'ballet réaliste'. By that Cocteau meant that unlike other ballets whose libretti were based on myth, fairytales or folklore, Parade takes place in the present, on a Paris street, with street-fair characters. It is distinctly modern and unsentimental in its attempts to capture the brash, vulgar, and vital side of human nature. Unlike Petrouchka or Giselle, there are no supernatural elements. The choreography shows modern characters miming their occupations, and the music was intended to include 'realistic', everyday sounds. Cocteau later said of his efforts that he tried: 'to raise the realistic gesture to the level of dancing and to transform it into choreography . . .'[15]

Bearing this in mind it is not surprising that Cocteau pursued Picasso for the role of décor designer. Picasso had been responding to and incorporating 'the brash, vulgar and vital side' of modern life into his work since the beginning of the century. He above all other practising artists was truly non-élitist in both his personal and professional outlook – in most instances preferring the company of the working poor to titled aristocracy.[16] His ability to sidestep convention also freed him to see possibilities in materials and styles that were considered outside the sphere of high art. While Cocteau may have had to admonish Massine and others in the Ballets Russes troupe to 'be vulgar', no such admonishment was necessary for Picasso. In fact Cocteau would say in large part he learned how to be vulgar

[11]Axsom, p. 41. Axsom also compares Cocteau's style to Walt Whitman, perhaps known to Cocteau via Apollinaire who admired Whitman and was influenced by his poetry, p. 42.
[12]Cocteau notebook, Bibliothèque de l'Opéra, p. 29. The Managers are an outgrowth of

the winged jellyfish monster who was the title character in Cocteau's 1916 book, Le Potomak (The title is deliberately spelled with a 'k' instead of a 'c', see n. 9). The line following the one quoted above in the Opéra notebook confirms this. Cocteau writes: 'I have dis-

covered all in the Potomak. It will be have to be known one day – new malaise – the race, the morals of the managers.'
[13]Gold and Fizdale, Misia (New York, 1980) p. 195.
[14]As Steegmuller notes, one aspect of Cocteau's early novel, Le Prince Frivole is the insistence

that beneath the frivolity there is anguish. p. 49.
[15]Cocteau, radio broadcast May 1954. New York Public Library, Lincoln Center Dance Collection.
[16]Boris Kochno, in a conversation with the author in Nov. 1985, recalled that at the fancy dress

balls Picasso attended with Olga in the early years of their marriage, Picasso would leave shortly after he arrived and spend most of the evening talking and smoking with the chauffeurs outside.

from Picasso – his 'rag-and-bone man of genius'.[17]

The vulgar, commonplace quality of *Parade* was the main source of its originality. *Parade* was the first of the non-sublime, non-folkloristic, non-exotic spectacles that would so greatly influence ballet repertoire in the twentieth century. In this respect it was a true theatrical innovation, the first totally modern ballet, or what Lincoln Kirstein termed 'the first balletistic metaphor for the everyday'.[18] Picasso's fellow Cubist, Juan Gris ingenuously summarized, I like *Parade* because it is unpretentious, gay and distinctly comic. Picasso's décor has lots of style and is simple. . . . It is not figurative, has no fairy-tale element, no lavish effects, no dramatic subject. It's a sort of musical joke in the best of taste and without high artistic pretensions . . .[19]

[17]Gilot quotes Picasso as saying, '. . . in my work just as in Shakespeare there are often burlesque things and relatively vulgar things. In that way I reach everybody.' Gilot and Lake, p. 73.
[18]Quoted in Steegmuller, pp. 189–90. He notes that the Nijinsky ballet *Jeux*, about a love triangle enacted on a tennis court, had been rendered idyllic by Debussy's music.
[19]Juan Gris, trans. *Letters of Juan Gris (1913–1927)*, (London, 1956) p. 49.

Chapter 5 From the street to the élite: The characters and scene of «Parade»

Parade's milieu is the *forain* (fig. 41), a form of travelling fair that was popular in France from late in the seventeenth century. As early as 1763, its vulgarity and lowbrow appeal had been recorded in Léris's *Dictionnaire portatif des Théâtres* where the *parade* is defined as a farce or little comedy without any rule, artificial and ridiculous in style, full of jokes and gross antics, very indecent and satirical, which the mountebanks present upon an elevated platform [échafaud] at the entrance of their playhouse, in order to attract the populace.[1]

The *côté allée des attractions*, which consisted of a series of *baraques* or wooden shanties, lined the street and offered lotteries, shooting galleries, quack medical demonstrations, amusements and theatricals. Alongside the façade of the *théâtre forain* was an elevated platform or *parade*, where barkers would ballyhoo the merits of the performers who gave excerpts of their acts, in an effort to entice the audience to pay and see the full stage show inside the booths. Often the *parade* consisted of 'second string' players, the premier artists deigning only to perform for paying customers.

Parade's scenario centres on one such sideshow which takes place on a Parisian boulevard on a Sunday afternoon in July.[2] Originally an unseen barker was to acclaim the talents of three acts: a Chinese conjurer (see fig. 75), a little American girl (fig. 39), and an acrobat (fig. 40) who perform portions of their routines, but fail to lure the public inside the theatre booth. The crowd remains either indifferent or uncomprehending that this is not the complete show. In the end the barker – later transformed by Picasso into three Managers – and the three *parade* performers collapse in despair. Cocteau's scenario reads:

Parade. Realist ballet.

The décor represents the houses of Paris on a Sunday. *Théâtre forain*. Three music-hall numbers serve as the *Parade*.

Chinese prestidigitator.

Acrobats.

Little American girl.

Three managers organize the publicity. They communicate in their extraordinary language that the crowd should join the *parade* to see the show inside and grossly try to make it [the crowd] understand this.

No one enters.

After the last act of the *parade*, the exhausted managers collapse on each other.

The Chinese, the acrobats and the little girl leave the empty theatre. Seeing the supreme effort and the failure of the managers, they in turn try to explain that the show takes place inside.[3]

In reality a *parade*, or sideshow, is an example of what has been termed the 'Theatre of Marvels'. It belongs to the 'realm of the realized fantastic. . . . It vies with the supernatural by means of magic, legerdemain [sleight of hand], juggling and the defiance of gravity. Acrobats, ballet dancers, equestrians and animal trainers, stage designers and magicians are the ideal initiators and interpreters of the Theatre of Marvels which is a theatre not only of the fantastic but of the impossible.' Moreover, 'it is always spectacular and "popular".'[4]

The *théâtre forain* or travelling fair was far from a high-brow event. Similar to travelling circuses today, the performers who wandered from town to town were outside society's mainstream, and were considered outcasts by their colleagues of the established city circuses such as the Cirque d'hiver and the Nouveau Cirque. Considered the failures of the profession, these itinerant players were the equivalent of Picasso's Rose Period saltimbanques. Their cos-

[1] Quoted in Dora Panofsky, 'Gilles or Pierrot? Iconographic Notes on Watteau', *Gazette des Beaux Arts*, 1952, p. 325.
[2] In his Italian notebook, Bibliothèque de l'Opéra, fonds Kochno, pièce 24, Cocteau writes on p. 1: '*Parade – ballet Réaliste*' and above it: 'l'act se passe un dimanche en Juillet'.
The libretto for *Parade* consists of a number of documents: There is the material Cocteau gave to Satie between 1 April and 6 May, 1916 consisting of an empty notebook whose cover was inscribed with the Larousse definition of *parade*. (NYPL, Lincoln Center). Three sheets of onionskin which listed free-associations meant to 'expand' the characters.

(Mentioned by Brown, pp. 128–9 – who only translated the sheet devoted to the Little American Girl). The 'January notebook' which Cocteau sent Massine in January of 1917 filled with words to associate with the Chinese Conjurer. The Italian notebook formerly belonging to Boris Kochno and now in the collection of the

Bibliothèque de l'Opéra. The Roman notebook or *carnet romain* in the collection of Edouard Dermit, facsimile at the Fondation Erik Satie, Paris, which was a gift from Massine during Cocteau's visit to Rome (reproduced in Axsom, figs. 85–112) and assorted sketches on loose sheets of paper (Axsom, figs. 116–127).

The most complete 'libretto' consists of notations and 'spiels' Cocteau penned upon Satie's score for *Parade*. The score is in the collection of the Frederick R. Koch Foundation, New York.
[3] Cocteau, Roman notebook, Dermit Collection, Paris.
[4] Winter, foreword, unpaginated.

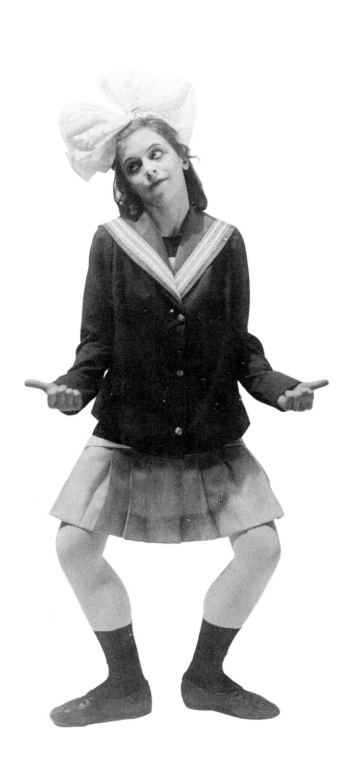

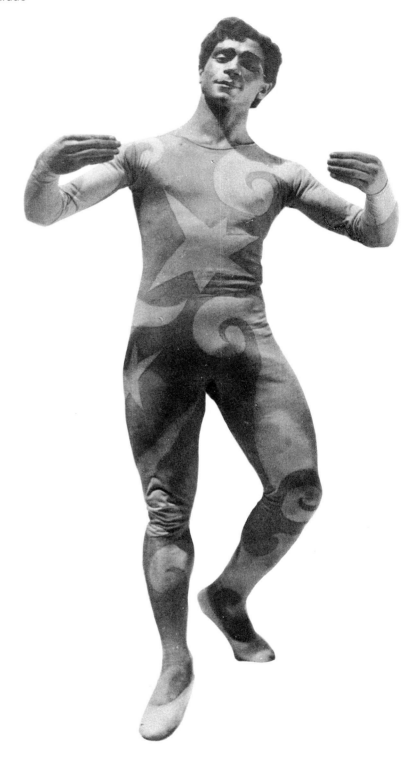

39 Marie Chabelska as the
Little American Girl in
Parade, 1917

40 Nicholas Zverev as the
Acrobat in *Parade*, 1917

tumes were usually tattered, their performances amateurish, and the illusion of glamour or fantasy associated with theatre was gamely attempted but rarely achieved.

The characters in *Parade* are taken from contemporary entertainment and are based on fact. The three *numéros* or turns were well known from music-hall, cinema, and circus, and specific counterparts for all three acts can be found in the music-halls and variety theatres of Paris in 1917.[5]

Of the five categories of *théâtre forain*, Cocteau chose *Théâtres de Magie*, *Variété-Music-Hall*, and *tableaux vivants et pantomimes* for his scenario.[6] These entertainments, described as being low and immoral as late as 1929[7], had been viewed with consternation by the ruling class since their debut in the years around 1700. An editorial in the *Gentleman's Magazine* for September 1817, for example, referred to the fair as the delight of apprentices, the abomination of their masters – the solace of maid servants, the dread of their mistresses – the encouragement of thieves, the terror of the Constables.[8]

One reason why those in power did not condone these forms of proletarian diversion – specifically the *parade*, fair, music-hall, or puppet show – was because they were anti-authoritarian in spirit, anarchic in content and represented a rejection of the dominant class's effort to keep the labouring poor under the yoke of church and state. Clergymen would frequently establish a pulpit at the fairground in an effort to restrain their wandering flock (fig. 42). As in the plays produced by its precursor, the *commedia dell'arte*, in most *forain* skits, prelates, fathers, doctors, lords and magistrates are ridiculed. The stock characters of the Italian Comedy were taken over by travelling fairs. Thus, the hero, be he Pulcinella, Harlequin, Punch or Scarpino, is in-evitably a member of the poor lower class who triumphs over authority.

In keeping with the tradition of the *forain* and fairground, *Parade* exhibits a distaste for figures of authority, embodied in Picasso's conception of the monstrous Managers, who stomp, bang and plea for money, (i.e. for the viewers to pay to see the show inside). They unwittingly undermine their three acts, missing the poetry and creative artistry symbolized by the three performances.[9]

Ironically these authoritarian figures were also intended to voice a critique of contemporary bourgeois values. With a combination of typical fairground ballyhoo, contemporary advertising ploys and poetic insight into the problems besetting a conservative or middle-class society, the Managers' unrealized spiels for the three acts promised the audience panaceas while pin-pointing their maladies as boredom, lack of curiosity, lack of perception, timidity, and being un-modern.[10] The Managers' commentaries for the acts read today like paeans to the unconventional life as defined by the avant-garde of 1917 – a life that is lived with an appreciation of mystery, a love of adventure, and a willingness to take risks in the name of personal freedom.[11] Each of the three acts embodies some of these desirable qualities: the Chinese Conjurer – wisdom and mystery (including the acceptance of man's potential for evil as well as for good); the Little American Girl – daring, optimism, resourcefulness and courage; and the Acrobats – imagination, inventiveness and a soaring spirit.

The importance assigned to the Chinese Conjurer in the ballet is in part explained by the prominence of magic acts in the circus and music-hall. Illusionists in Chinese or Hindu guise reigned supreme as the main attraction on the programmes of variety

[5]For example in reading of the evening's entertainment on the night of Saturday, 23 March 1918, when the Chinese conjurer, Chung Ling Soo was accidentally shot in the process of performing his famous Gun Trick, we read that he was preceded by acrobats, and that when his trick 'backfired' the curtain was immediately lowered, the cinema screen rapidly unrolled and in seconds the evening's movie running. Will Dexter, *The Riddle of Chung Ling Soo, Chinese Conjurer* (New York, 1976) p. 15–16.
[6]See Jacques Garnier, *Forains d'hier et d'aujourd'hui* (Orléans: Les Presses, 1968), chapt. III. The *thèâtre forain* comprised the following types: *théâtres dramatiques et lyriques*; *théâtres des spectacles de variétés, de music-hall*; *théâtres de magie*; *théâtres de tableaux vivants et pantomimes*; and the *théâtres des animaux savants*.
[7]See article from *Petit bleu* (no author cited) 'La Baraque Immorale; Fêtes Foraines et Pornographie' 3 July 1929, with sub-heading: 'ça tient toujours de la place, mais c'est encore plus sale qu'on ne croyait'. Fonds Rondel, Bibliothèque de l'Arsenal, Paris.
[8]Robert Leach, *The Punch and Judy Show: History, Tradition and Meaning*. (Athens, Georgia, 1985) p. 272.
[9]See Axsom, p. 89.
[10]Cocteau's hand-written Managers' cries are preserved on Satie's score for *Parade*, collection of the Frederick R. Koch Foundation, New York.
[11]See Billy Klüver and Julie Martin, *Kiki's Paris: Artists and Lovers*

theatres from about 1900 until well after the First World War.[12] From their beginnings, *forains* were not complete without an illusionist or conjurer: From the sixteenth century up to the *Foire de Trône* of today, magic has been inseparable from the great European fairs. Just as the wizard was inevitable in the magic plays of the Italian comedy and the French fairground theaters. . . . In 1791 conjurers and fortune tellers held forth in the public gardens . . . while the prestidigitator Perrin performed his magic feats at the Délassements-Comiques, the Revolution pursued its course.[13]

The prestidigitator transported his audience to the world of the marvellous and magical. His wizardry defied rational, mundane reality and in a sense offered hope to those trapped in a low rank within the social order. Cocteau's 'barvardage' for the Chinese Conjurer (fig. 43) which a Manager was to declaim while the magician was performing a 'terrible and perilous trick,'[14] capitalized on the barker's traditional methods of threatening, insulting, cajoling and making outlandish promises to his audience. Simultaneously it allowed Cocteau to comment on the state of an unsympathetic public and to create personal, mind-expanding associations for the Chinese magician:[15] A MAN WHO IS INFORMED IS WORTH TWO! If you want to become rich – if you feel sick – if you have attacks of langour – ENTER TO SEE THE WISE CHINAMAN – missionaries – dentists – the plague – gold – gongs – pigs who eat little children – the emperor of China in his armchair. People who have not entered from the beginning of the show can enter to see THE KING OF DRAMAS – the great success of laughter and of fright. The most beautiful theatre in the world, the most beautiful stage in the world, the most beautiful footlights in the world.

Beware Madame! Monsieur! Boredom is lying in wait for you! You are sleeping without being aware of it! Wake up! Enter, Enter! Everyone makes a play that he listens to, Enter to see a play about yourself![16]

The rage for Chinese magicians in vaudeville was begun by Ching Ling Foo (Chee Ling Qua) who was one of the few bonafide Chinese among the many magicians who performed in oriental guise. He was born in Peking in 1854, arrived in America in 1898, and performed at the Empire Theatre in London for an outrageously high fee. He toured the Continent in 1904 and appeared in Paris in 1909 with a troupe of eight women and ten men.

Foo's great rival was Chung Ling Soo (William Ellsworth Robinson) (figs 44, 76 and 77) who copied Foo's shaved forehead, long queue, and Chinese costume. Soo also appropriated certain tricks from Foo's repertoire. Soo took his impersonation so far as to dress in Chinese brocades off-stage, to furnish his home with oriental stuffs and even to speak through an interpreter (in reality he knew barely a word of Chinese – but neither did any of his interviewers). Both billed themselves as 'the original Chinese Conjurer' and in anger Foo challenged Soo to a contest to see who was the better illusionist – Soo won, and Foo returned to China in 1915. At that time Chung Ling Soo became the leading conjurer throughout Western Europe and had a host of imitators (see chapter 6, note 27). In the overblown manner of Cocteau's 'King of Dramas,' Soo billed himself as 'A Gift from the Gods,' the 'Marvellous Chinese Conjurer' and 'The Light of the World' (see fig. 44), the latter being an epithet usually reserved for Christ.

In addition to his skill as a magician Soo was an astute businessman and a master self-publicist who subscribed to the notion of media blitz. The Spring

1900–1930 (New York, 1989) for an account of life among the artists of Montparnasse, including Cocteau, Satie, Picasso, and their circle of friends. Klüver and Martin make clear that these artists and 'bohèmes' distinguished themselves from society at large by the premium they placed upon the individual's freedom.

[12]The list of Chinese conjurers in Paris in the years from 1905–25 in the Rondel collection of the Bibliothèque de l'Arsenal and the Collection Batty in Paris together numbers over fifty.

Natasha Staller has noted that the fantastic three-minute films of Georges Méliès, which were usually shown at street fairs, were in part responsible for the enormous popularity of magic in the years around 1900. See Staller, *Art History*, vol. 12, no. 2, June 1989, n. 76. Staller's article puts forward many examples documenting Picasso and his circle's immersion in popular culture. She writes: 'At this time, avant-garde artists, having embraced an anti-academic, anti-bourgeois ideology, looked to popular forms like these [film and *forain*] as a stimulus for subverting the conventions of high art.' ' '"Melies Fantastic" Cinema and the Origins of Cubism', *Art History*, vol. 12, no. 2, June 1989.

[13]Marian Hannah Winter, *Theater of Marvels*, (New York, 1962) pp. 45–6.

[14]See Cocteau's marginal entry 'un exercice périlleux *tour terrible du chinois* pendant que son manager recommence à crier *une seule fois* le texte!:' . . . the text for the Chinese Conjurer then follows. Satie Score, Frederick R. Koch Foundation.

[15]Things Oriental had fascinated Westerners since the Far East was opened up to trade in the late eighteenth century. China carried associations of mystery and intrigue in part due to the introduction of opium and other drugs to the West. Cocteau's opium addiction is well known and in certain ways his free-association character sketches for *Parade*'s three acts can be viewed as relating to opium dreams.

[16]From the score at the Koch Foundation. See the Roman notebook (Fondation Satie) for germs of the Chinese Conjurer's character sketch.

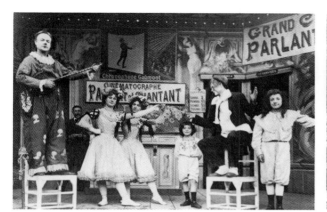

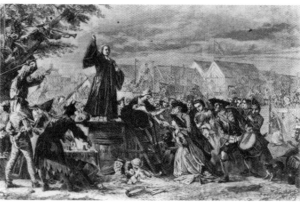

41 A *parade*, c.1900

42 W. Thomas, *Preacher at a fairground*, c.1800. (Note the conjurer and Harlequin in the foreground to the left.)

43 Jean Cocteau, spiel intended to accompany the Chinese Conjurer, copyist's manuscript of Erik Satie's score for *Parade*, 1917

44 Poster for Chung Ling
Soo, c.1915

45 A billboard advertising
Chung Ling Soo at the Palace
Theatre in London, 1916

1907 issue of *The Wizard* notes: 'Chung Ling Soo is a great believer in paper advertising. He can probably put up more different sheets [posters] than any other show at present...' Another biographer writes: 'When Chung Ling Soo's show came to town there was never any need to ask: What's on at the theatre this week? For a good week or more beforehand every available boarding and poster site had been covered with posters.'[17] A photograph of a billboard gives an indication of Soo's advertising technique (fig. 45). Cocteau and Picasso intended their ballet to draw attention to the crassness and hard-sell of contemporary advertising. The fact that hyperbolic claims of the French Manager for the Chinese Conjurer parallel those used in reality to spread the word of the 'marvellous Chinese Conjurer, Chung Ling Soo' may not be accidental.

Soo's fame was at its height at the time of his death in 1918 when he was accidentally shot on a London stage while attempting to catch a bullet in a plate. When he died his fans everywhere were astonished to learn he was not oriental.[18]

Did Cocteau, Picasso, or any of *Parade*'s other collaborators see Soo perform? Although he never shared the same bill with the Russian Ballet he was booked at the Alhambra theatre on the rue de Malte, several blocks from the Châtelet theatre where Diaghilev's troupe were in almost permanent residency from 1911–13 (fig. 46). Soo performed annually at the Alhambra in Paris from 1910 until the war intervened in 1914. He had a long-standing booking at the Hippodrome theatre in London every summer from 1906 until his death in 1918, and consistently appeared in other music-halls in London including the Empire, the Alhambra, and the Coliseum. The Ballets Russes also performed at all of these music-halls but not until the 1918–19 season when on several occasions they shared the stage with different exotic prestidigitators (see fig. 9). Although he did not perform on the same stage at the same time as the Russian Ballet, Chung Ling Soo was a celebrity who was generally known — even if not first hand — by most people living in Paris

in the years around 1915 and certainly by those associated with the theatre.

The Little American Girl is an amalgam of music-hall and fairground, as well as silent screen figures. Isadora Duncan had early in her career performed the kind of impudent and pert pantomime dancing that the Little American Girl essays. Cocteau created her from a combination of American silent movies and American music-hall acts, both of which filled the Parisian consciousness in the first part of the century (fig. 47; see also fig. 39).

American dance/pantomime acts had been a constant commodity in Parisian music-halls since the turn of the century. Ragtime and cakewalk performers, jazz bands, acts such as Bib and Bob, Barbette, and later Josephine Baker, were immensely popular with the French public who found their freedom from convention refreshing. Moreover, early Westerns, cliff-hanger serials, slapstick comedies, and footage of Manhattan and Chicago skyscrapers culled from early silent film fed the romantic myth of America as a land of freedom and adventure. The French viewed America as modern and daring, a country populated by outlaws, bandits, Indians, as well as larger-than-life heroes and heroines who defied authority, performed daredevil feats, and were well-springs of resourcefulness.

The Manager's cries for the little American Girl, (fig. 48) which were to be accompanied by a cinema's electric bells, the jingling of a tambourine, and periodic revolver shots, express the adventurous vitality and excitement of American life: IT IS A CRIME to kill your own curiosity — what do you need to make a decision? ONE MINUTE! You will have a LIFE of regret if you don't take the opportunity! Are you dead? NO? Then you must LIVE! Make sure you get this idea through your head! A timid man is a DEAD man. Enter to learn about American life — the fears — short circuits — detectives — the Hudson — Ragtimes — factories — trains that derail — ocean liners that sink!

I was pale, sulky, puny. I was poor, bald, alone. Then I became a *nègre rouge*. Hesitate and you will lose. If you

[17]Will Dexter writes that Soo's 1906 tour was marked by a tremendous poster campaign, noting that, 'from this year on, Soo's visits to any town were heralded by more posters than any other artist had thought of posting before. ... One poster site carried one thousand square feet of Soo's bills, of which there were no two alike.' Dexter, *The Riddle of Chung Ling Soo, Chinese Conjurer* (New York, 1976), pp. 69 and 154.

[18]I am grateful to Charles and Regina Reynolds, New York, for providing information on Foo and Soo, and suggesting bibliographic sources.

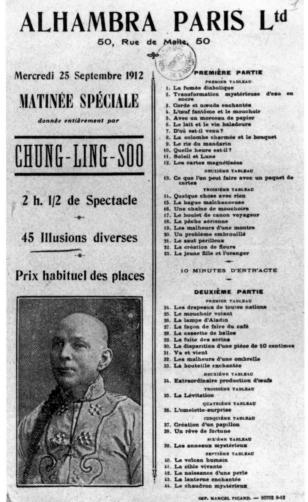

46 Advertisement for Chung Ling Soo, September 1912

47 Photograph of May Bell Marks, *Vanity Fair*, 1916. Caption reads in part: May Bell Marks is one of those cheery little soubrettes whom nothing can cause to subside. . . .'

48 Jean Cocteau, spiel intended to accompany the Little American Girl, copyist's manuscript of Erik Satie's score for *Parade*, 1917

do not leave here healed! Demand the K![19]

The list of images following – 'Enter to learn about American life', derive from the immensely popular film serials starring Pearl White, *The Perils of Pauline* and the *Exploits of Elaine* released by Pathé Studios from 1913 to 1916. Consisting of fifteen twenty-minute movies, the story would always begin with the heroine in a desperate predicament from which she either escaped or was rescued, only to find herself in a more life-threatening circumstance by the end of twenty minutes. Audiences were always left on the edge of their seats until the next instalment. Detectives and Indians were central to the plot of at least four episodes (fig. 49) and an advertisement in a trade journal nearly recreates Cocteau's description (fig. 50). The last paragraph reads: 'The action of the story includes flying machine accidents, thrilling rescues, fires at sea, train wrecks, automobile accidents. In fact, everything that can be introduced as a thrill.'

What is of interest for our purposes is the immense popularity of the serials in France during the War. Several clippings from the Robinson Locke scrapbooks in the Billy Rose Theater Collection, New York Public Library, report the success overseas of Pauline's perils and Elaine's exploits. One dated June, 1916 reads as follows:

PEARL WHITE THE IDOL OF THE FRENCH SOLDIERS
Pathé's 'peerless fearless girl,' Pearl White, has just received the most unique tribute ever paid to a picture or theatrical star.

Two million fighting Frenchmen, reading of her exploits in the great Paris newspaper 'Le Matin,' became eager to see her on the screen and while on their six days furlough from the front thronged the Parisian theaters where 'The Exploits of Elaine' was showing under the title of 'Les Mysteres de New York.' Unfortunately they were able in their six days to see but a few episodes. . . . However, their eagerness to see all the episodes was so great that representations were made before the Office of the Minister of War. In due time the house of Pathé in Paris was requested by the War Office to make arrangements to show the entire serial each week for the benefit of the soldier fans on furlough.

Accordingly a circuit has been arranged, and Pearl White now plays to vast audiences of bearded uniformed men, fresh from the shock of war, who find in the great Pathé serial that relaxation from strain which is so much needed.[20]

Cocteau and Picasso, as avid movie-goers, numbered among Pearl White's fans, and Massine mentions her as a source for the Little American Girl.[21] Her name later crops up in Cocteau's correspondence when in September 1919 he writes Raymond Radiguet a fourteen-page 'Pearl White Film' recounting his journey through the south of France.[22]

Beside Pearl White, Mary Pickford, 'America's Sweetheart' had also captured the affection of the French public.[23] Her little girl roles as in *Poor Little Rich Girl* or *Rebecca of Sunnybrook Farm* (both released in 1917) fed into Cocteau's conception of his child music-hall performer.[24] The widespread vogue during the war years for coquettish music-hall *ingé-*

[19]From the Satie score Morgan Library, Koch bequest. The character outline for the Little American Girl, which was refined into the Manager's spiel quoted above, and which Massine attempted to embody in his choreography, listed a series of images which as Axsom notes, 'wonderfully evokes America as seen through the eyes of a Frenchman':

'The Titanic . . . elevators – the sirens of Boulogne – submarine cables – tar – varnish – the machines of transatlantic steamers . . . *The New York Her-ald* – dynamos – airplanes . . . cinemas – the sheriff's daughter – Walt Whitman – the silence of stampedes – cowboys with leather and goat-skin chaps – the telegraph operator from Los Angeles who marries the detective in the end . . . the Sioux . . . Negroes picking maize – jail – the beautiful Mrs Astor, the declarations of the President Wilson, torpedo boat mines, the tango, gramaphones, typewriters, Brooklyn bridge . . . Nick Carter – Helene Dodge – the Hudson and its docks – the Carolinas – my room on the seventeenth floor – panhandlers – advertising – Charlie Chaplin – Christopher Columbus – metal landscapes – the victims of the *Lusitania* . . . the isle of Mauritius – *Paul et Virginie*'. From a loose sheet quoted by Frederick Brown, *An Impersonation of Angels: A Biography of Jean Cocteau* (New York, 1968) pp. 128–9.

[20]Pearl White Scrapbook, Robinson Locke Collection, Theater Collection, New York Public Library, Lincoln Center.

During the First World War, the European film industry was brought to a standstill, American films were the only movies available to the French. Thus, America's first movie stars became the idols of the European public as well.

[21]Massine, p. 104.

[22]Steegmuller, p. 250.

[23]Massine told Richard Axsom that the Little American Girl was based upon Mary Pickford. Axsom, p. 42. In his autobiography however, Massine writes of the American Girl, 'She then did an imitation of the shuffling walk of Charlie Chaplin, followed by a sequence of mimed actions reminiscent of *The Perils of Pauline* . . .'. p. 104. Actually the actions she performed were exact cribbings from the *Pauline* serials, rather than reminiscences. While the Girl's pluck and innocence are Pickfordesque, her dare-devil actions could have derived from no-one but Pearl White, who performed all her own stunts, in her roles as Pauline and Elaine.

[24]*Poor Little Rich Girl* was released in March but *The Little American*, which oddly enough was about a courageous young girl who survives the sinking of

49 Still of Pearl White in an episode from *The Perils of Pauline*, 1916

50 Advertisement for *The Perils of Pauline* from *Moving Picture World*, 25 March 1914

nues, who aped girlish innocence in cork-screw curls, flounced dresses, and big bows, derived from Pickford's popularity.

There was a French counterpart to this child-woman mania in the form of the popular *Claudine* novellas, written by Colette, but at the time of their publication between 1900–6, credited to her husband Willy (Henry Gauthier-Villars). The series was all the rage in Paris in the years around 1910 and Colette, who was also a music-hall performer, posed as the young schoolgirl in a costume similar to that of the Little American Girl on a group of postcards (fig. 51). The scandal surrounding Colette, Willy, and his mistress Polaire (who also played the part of Claudine on the stage and became part of the Willy ménage) only stoked the fires of public curiosity and resulted in several editions of the *Claudine* series. As might be expected Cocteau was in the thick of these goings-on, he knew Colette from early in her career and even sketched the infamous threesome at an ice-skating rink with Willy looking like a benevolent patriarch out with his two adolescent daughters (fig. 52).[25] It is tempting to think that there is some measure of Colette's *Claudine* in the character of the Little American Girl, particularly since Colette was in Rome working on a film adaptation of her novel *La Vagabonde* when *Parade*'s collaborators gathered there in 1917. There is new evidence that Picasso met Colette during his Roman trip. A page in his Italian notebook reads, 'Colette Willy told me that in her country [Burgundy] they say "empicasser" to cast a spell [prick the wax image of a person in order to injure him] and to "empicasser" it is necessary to make a sign around the person or object' (fig. 53).[26] This play on his name in association with black magic obviously delighted Picasso and one can speculate

that it was Cocteau who introduced Colette to Picasso while they were all in Rome.[27] Colette's well-documented love of independence and her inability to tolerate societal constraints are in accord with those of Picasso and Cocteau, and are reflected in the temperament of *Parade*'s Little American Girl.

Cocteau based the Little American Girl upon a combination of the American stars Pearl White, Mary Pickford and their numerous epigones (see fig. 47) on both stage and screen. Employing his oft-used formula of a classical allusion applied to a popular idiom, he wrote: The United States evokes a girl more interested in her health than in her beauty. She swims, boxes, dances, leaps onto moving trains – all without knowing that she is beautiful. It is we who admire her face, on the screen – enormous, like the face of a goddess.[28]

Clearly Cocteau's intention in *Parade* was to tap the positive feelings surrounding these popular cult figures – Pearl White, whose courage and mettle made her a heroine beloved by a fighting French nation, and Mary Pickford, whose sweetness, optimism, and childlike innocence disarmed a jaded public. Cocteau had every reason to expect his light parody of popular silent film stars and music-hall pantomimes would be received with delight.[29]

Parade's third act, the Acrobats, derives from contemporary music-hall as well as circus and fairground. Cocteau's initial notes to Satie poetically evoke modern man's desire for gravity-free states through the conquest of air or sea while hinting that this conquest may prove to be an empty victory: Médrano – Orion – two biplanes in the morning . . . the archangel Gabriel balancing himself on the edge of the window . . . the diver's lantern . . . Sodom and Gomorrah at the bottom of the sea . . . the meteorologist

the *Lusitania,* postdates *Parade.* It was released in July 1917. Co-incidentally, in some of his notes on the Little American Girl, Cocteau mentions the sinking of the *Lusitania* (see n. 19).

[25] Cocteau remained a close friend of Colette's throughout her life. The sketch first appeared in Cocteau's *Portraits*

Souvenirs 1900–1914 (Paris, 1935) p. 86ff.

[26] 'Colette Willy m'a dit que dans son pays on dit empicasser pour envouter et que pour empicasser il faut faire ce signe autour d'une personne ou d'un objet.' Musée Picasso, MP1867.

[27] Colette was staying at the Palace Hotel in Rome during the spring of 1917. Her biographer

writes, 'In 1917 Rome, with its mild climate and calm was the playground of Europe. People took every possible political or diplomatic pretext to go there and to forget the horrors of war for a while.' Geneviève Dormann, *Colette Amoureuse* (Paris, 1984) English trans. p. 192.

[28] Steegmuller, p. 166.

[29] Even though by 1917 films were entirely respectable, they too had a low-brow provenance. When the medium was new, in the last years of the nineteenth and early years of the twentieth century, films were shown at fairs, *forains* and other marginal establishments: 'la première clientèle du cinéma qui fut une clientèle foraine,

composée de spectateurs incapables d'apprécier autre chose que les farces énormes, les poursuites échevelées et les culbutes ahurissantes.' G. Méliès, '*Mes Mémoires*', in M. Bessy and Lo Duca, *Georges Méliès image* (Paris, 1961) pp. 171. Quoted in Natasha Staller, *Art History,* vol. 12, no. 2, n. 5 (June 1989) pp. 219–20.

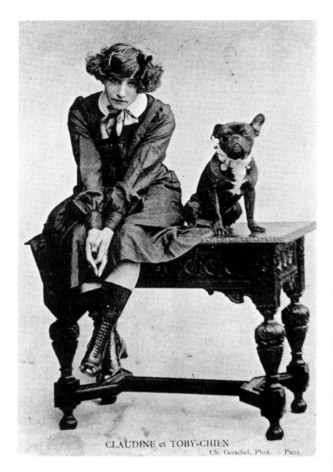

CLAUDINE et TOBY-CHIEN

Ch. Gerschel, Phot. — Paris.

Willy – Polaire
Toby chien et Colette au
palais de glace

Jean

51 Colette poses as
Claudine, the naughty
schoolgirl, *c.1903*

52 Jean Cocteau, drawing of
Willy, (Henri Gauthier-
Villars), Polaire, Colette and
Toby Chien at the palais de
glace ice-skating rink, *c.1903*

53 Pablo Picasso, page from
his Italian notebook, 1917
(MP 1867)

– the telescope . . . the parachutist who killed himself on the Eiffel Tower – the sadness of gravity – soles of lead – the sun–man slave of the sun.[30]

A marginal note written by Cocteau beside the Acrobat's turn on the Koch Foundation score indicates that despite his earlier mention of the Cirque Médrano, he came to have variety theatre, rather than the circus, in mind for the Acrobats. Imitate the classic music-hall scene: Mad laughter of the Negro Manager – the acrobat stops. Smiling he wipes his hands, continuing to smile he shows the Manager to the public and shrugs his shoulder (you know what I mean).[31]

This notation shows Cocteau trying to capture something of the way music-hall performers interacted with their audience in a conspiratorial manner – a kind of communion across the footlights unheard of in classical theatre or the ballet. As mentioned, in Filippo Marinett's 1913 essay, *In Praise of Variety Theatre*, one of the aspects of variety theatre, cabaret and café-concert which the Futurist author admires is the lack of barriers between performer and audience.[32]

There were hundreds of acrobats who performed in music-halls and variety theatres during the war. Cocteau's description of the Acrobat is the least specific, and other than a music-hall acrobat, it is difficult to determine if he had a particular performer in mind.

The Acrobat's Manager was envisaged ballyhooing to the sound of an airplane engine and a steam machine. His spiel proclaims the rebellious modernity of *Parade* (fig. 54): Hurry up and run, get away from boredom! The most beautiful spectacle in the world. The past! The present! The future! A film of 50,000 metres! A great success of laughter and fright. THE MAN OFFERS a cure against all the affections of the heart, the brain, the spleen. This is the consequence of a wish! THE MODERN MAN is entering our world.[33]

[30]Martin, 'The Ballet *Parade*: A Dialogue between Cubism and Futurism', *Art Quarterly*, 1977-8; p. 88.
[31]'Il faudrait [illegible] du silence aéroplane de l'acrobate pour pasticher la scène classique au Music Hall: Fou rire du nègre – arrêt de l'acrobate qui s'essuye les mains et le désigne au public en souriant et haussant les épaules (vous savez ce que je veux dire)'. Satie Score, Frederick R. Koch Foundation, p. 32 bis.

[32]There is also an affinity with Cubist collage in the abrupt shift out of character – and the questioning of identity the shift implies – in Cocteau's written stage direction for the Acrobat.
[33]Satie score, Frederick R. Koch Foundation.

Chapter 6

The music and choreography

The composer Erik Satie was ideally suited to capture the sleazy charm of the circus and music-hall for a classical ballet. As a young man he supported himself by playing the piano at the Montmartre cabaret, le Chat Noir, while by day he composed sacred ballets, gothic operas and meditative chorales for his religious sect, the Rosicrucians.

At le Chat Noir he composed and played popular tunes, and witnessed variety entertainments first hand on a nightly basis. He wrote the music to the lyrics of the chansonnier, Vincent Hyspa and provided background effects for comedians, monologists, and occasionally for Symbolist poetry readings.[1] In addition Satie composed many popular tunes such as 'Pst, Pst, Pst, Je te veux', and 'Tendrement' under various pseudonyms.[2] He also was fond of inserting, in a manner analagous to collage, well-known popular melodies into his classical compositions. For example the careful listener will find fragments of 'Au clair de la lune', and 'Frère Jacques' in Satie's ponderous 'Geneviève de Brabant'.[3]

Although wit and humour are an essential part of his *oeuvre* (witness his amusing titles such as 'Morceaux en forme de Poire' and unconventional musical directions such as *gracieusement* or *ennuyeux*) Satie, or Esoterik Satie as he was once dubbed, was a very serious musician. It is well known that he returned to the Schola Cantorum at the age of thirty-nine to study composition. After three years of applied study, he graduated with honours. Satie's music is filled with irreverence and play, but at the same time it is extremely refined and subtle – qualities which made him, Picasso, and Cocteau ideal collaborators. Despite his mastery of polyphonic music, simple, unadorned, almost monotonous sound is the hallmark of his style.

Satie's score for *Parade* has been dubbed 'Cubist' on the basis of the abrupt shifts in the music from one 'act' to another.[4] While these disjunctions may be thought of as Cubist, they are also standard for music-hall evenings where one act follows rapidly on the heels of another, without any attempt at continuity. The quick shifts, discontinuity, coarse jokes and puns, and especially the violation of expectations that are part and parcel of the Cubist aesthetic, were also characteristic of the cabarets where Satie entertained and where Picasso, Jacob, and Apollinaire often sat in the audience or participated. In the tradition of the chansonnier established by Aristide Bruant at the Chat Noir and the Mirliton, artists, writers, and poets would encounter an evening of bawdy songs, slang expletives, stories told in argot, as well as audience insult and provocation. At the Lapin Agile and the Closerie de Lilas, for example, it was not unusual for serious poetry readings to be interrupted by a boisterous song or joke.[5]

In a similar way, the city and fairground noises as well as the Little American Girl's jazz tune – which Satie lifted from an existing ragtime score – function as unexpected, comic, collage-like intrusions into the subdued and melancholy melody of the score. This Cubist mentality informs *Parade*'s score from the beginning, for the solemn, church-like 'Choral' and melancholy 'fugato' of the 'Prélude du Rideau Rouge' are immediately followed by rinky-tink and then sentimental melodies standard for circus, fairground, and variety-show music.

The intrusion of ragtime into a ballet was not without precedent, but it first occurs in vaudeville rather than in grand theatre, and the ballets in question were not of the skilled Russian variety. For example, *The Garden of Punchinello* starring the 'toe artiste' Mlle. Dazie and performed throughout the winter of 1916/17, was a pantomimic dance production in five scenes. The story, involving the *commedia* figures, Punchinello, Harlequin, Columbine and Pierrot, is set forth as the dream of a little girl (Mlle. Dazie). When the little girl awakes: . . . overjoyed to find all the trouble a fantasy of slumberland, Dazie jumps up and merrily dances to a modern ragtime tune. This jaunty bit of dance contrast caps the act just

[1] The Catalan painters, Ramón Casas, Miguel Utrillo and Santiago Rusiñol were daily patrons of le Chat Noir. They later based the Barcelona café, Els Quatre Gats – Picasso's earliest haunt – upon their memory of the Montmartre cabaret.
[2] I am grateful to Ornella Volta for sharing her vast knowledge of Satie with me. See her exhibition catalogue for the Musée des Arts et des Traditions populaires, 10–30 May 1988, *Erik Satie & la Tradition Populaire* (Paris, Fondation Erik Satie, 1988).
[3] Volta claims Satie used childrens' songs and popular tunes as a catalyst for inspiration when he began a new piece, whether it was classical or popular. Conversation with author, March 1982.
[4] David Drew, ed. Howard Hartog, 'Modern French Music' in *European Music in the Twentieth Century* (New York, 1957) p. 250.
[5] See Lisa Appignanesi, *The Cabaret* (New York, 1976) p. 64ff.

right for vaudeville, as vaudeville likes the artistic with a sugar coating of the popular, and enjoys the beautiful much more if thoroughly convinced it isn't 'high brow.'[6]

Unlike the vaudeville audiences who appreciated the rag sequence in *The Garden of Punchinello*, Diaghilev's 'high brow' patrons levelled multiple criticisms against the jazz sequences inserted into *Parade*'s otherwise restrained score at its May 1917 début.[7] Jazz music was still new to Europeans at the time of the ballet's première. The immensely popular chanteuse, Gaby Deslys, did much to familiarize the Parisian public with jazz. In 1916, after a tremendously successful engagement in the United States she returned to Paris with American music and costumes incorporated into her act. She was the first to import a jazz band with instruments ranging from saxophones to revolver shots (perhaps where the always up-to-date Cocteau got the idea of using gun shots among his sound effects for *Parade*). It was, however, *Parade* which introduced American jazz and ragtime to the legitimate stage.[8]

In theory, *Parade* includes noises heretofore thought inappropriate for the concert stage. Bowing to Cocteau's desire, Satie allowed his economical score to include sounds new to twentieth-century life such as those made by movie bells, steam engines, airplanes, dynamos, typewriters, telegraphs, sirens and revolvers as well as the fairground noises from the lottery wheel, klaxon, and calliope (a type of circus organ).

Cocteau's handwriting occurs throughout Satie's original score (fig. 55), indicating the places where these 'aural and verbal enhancements' were to take place. Throughout the Chinese Conjurer's turn Cocteau inserted what he termed sonorous puddles – *flaques sonores* – which were to sound like 'a large cymbal falling flat on marble.[9] At the end of the Conjurer's turn Cocteau's musical direction reads: 'Here the orchestra stops as in the circus.'[10]

Cocteau's verbal commentary and noises were suppressed for the 1917 première (some sounds were restored in the 1921 and in later revivals.) He often complained that at its première *Parade* had been 'performed incomplete and without its crowning piece', especially since in its initial stages Satie's score was to serve merely as a musical background for Cocteau's modern city noises and popular fairground ambience.[11] Before his barker's come-ons and comtemporary noises had been excised from the ballet, Cocteau had written on the first page of Satie's hand-written final score: Le piano à quatre mains de Parade ne présente pas l'oeuvre exacte mais le fond musical destiné à mettre en relief un premier plan de *batterie* et de *bruits scéniques*. [the music for *Parade* is not presented as a work in itself but is designed to serve as background for placing in relief the primary subject of sounds and scenic noises].[12]

Cocteau had wanted his ballet to evoke not only the look, but also the sounds of modern life, the clickings and tickings of machinery which punctuate and set the staccato pace of contemporary life. His vocal inscriptions too are an anthem to the excitement and vitality as well as the mechanization of the modern age. Without his descriptions and everyday noises, Cocteau rightly felt this crucial point was lost.

The topicality of *Parade* is accentuated by the recently uncovered fact that Satie did not compose the ragtime music that accompanies the turn of the Little American Girl, rather he cribbed an existing rag score that had wide currency in the popular sector and was thus probably familiar to Diaghilev's first audience. Satie appropriated Irving Berlin's jazzy ragtime tune, 'That Mysterious Rag' published by Ted Snyder and Company in New York in 1911 (fig. 56). 'That Mysterious Rag' had been sung and danced in Paris at the Moulin Rouge in the revue *Tais-toi, tu m'affoles* in 1913, and was published the

[6]Review by Nellie Revell, 'Acts and Artistes in Vaudeville', *The Theatre*, vol. XXV, April 1917, p. 224.
[7]Silver, p. 120.
[8]Stravinsky and Cocteau were both jazz enthusiasts. It is well known that Cocteau was a drummer for the jazz group which played at Le Boef sur le

Toit in 1922. Stravinsky's *Ragtime*, for which Picasso designed the score illustration, and his *Histoire du Soldat* were composed after he had amassed a number of American jazz scores. Like Picasso, who admitted to taking whatever appealed to him from other art, Stravinsky said he felt free to

'steal' music that he loved be it Mozart or jazz. (Excerpt from *Great Performances*, 'Balanchine', Lincoln Center Dance Collection). For more on the importance of jazz for the *avant-garde*, see Mona Hadler, 'Jazz and the Visual Arts', *Arts*, June, 1983, pp. 91–101. Also Theodore Reff discusses the import-

ance of jazz for Picasso's *Three Musicians*, 1921 (Museum of Modern Art, New York), in *Three Musicians* . . . p. 136.
[9]Satie score, Frederick R. Koch Foundation, p. 12.
[10]'ici l'orchestre s'arrête comme au cirque.' Satie Score, Frederick R. Koch Foundation, p. 12.
[11]Satie is credited with being the

first composer deliberately to write background music. Several of his compositions are intentionally unobtrusive and have been termed 'quality muzak'. Satie called this type of music *Musique d'Ameublement*.
[12]Satie Score, Frederick R. Koch Foundation, p. 1.

same year by Salabert.[13] This insertion of a popular melody which was associated with a rather vulgar revue could only have fuelled the anger of those who objected to the ballet's topicality.

Cocteau inscribed Satie's score, *'Tout le numéro de la petite fille américaine est accompagné par un timbre electronique cinéma ininterrompé'*. [The Little American Girl's entire number is accompanied by the uninterrupted chime of an electronic cinema bell.] Halfway down the same page of the score Cocteau added *'ici l'orchestre accompagne le solo de 20 machines à écrire ...'* [here the orchestra accompanies a solo of 20 typewriters] and at the bottom of the page just before the rag melody begins Cocteau's cue reads: *'coups de révolver des films du Far West'* [revolver shots from Westerns].

Parade's appropriated rag tune which came to be called the 'Rag-time du Paquebot' or 'Steamboat Ragtime' was initially and with apparently a little too much black humour entitled 'Ragtime du Titanic'. Along the margin of musical notes Cocteau writes, *'l'océan, lame de fond'* [tidal wave] and at the bottom of the score *'Silence, ici on entend: l'appareil Mors tout seul'*: [Silence, here one hears: the telegraph machine all by itself:] -. -. .-. .. -..- .. - -.-. --- .. .-.'[14] These Morse-code dots and dashes actually translate into the message 'Sinistres. Au Secours.' [Disasters. Help.]. At the end of the 'Titanic Rag' Cocteau inserted more *paroles supprimées* [suppressed utterances]: *'tic tic tic le ti tan ic s'enfoncé et clairé dans la mer'*. [tic tic tic the ti-tan-ic deep and bright in the sea.]

Cocteau had planned much more of a narrative around the Little American Girl and her rescue from the Titanic than has ever been realized. Thus a macabre and menacing aspect which is an undercurrent running throughout the ballet – seen in the Conjurer's grimaces, the monstrous Managers and their grotesque posturing, the horse's dual aspect (see p. 186ff.), the near fall of the acrobats, and ultimately in the fate of the *Parade* itself – was in-

tended to be echoed in the turn of the Little American Girl.[15]

In fact it emerges from a close examination of Satie's score, Cocteau's notebooks and video tapes of the performance, that Cocteau intended a much more unified and coherent production than has heretofore been realized. The noises which seem random and unattached to specific acts, make sense and expand the profile of each character when accompanied by the Barker's ballyhoo. Thus the lottery wheel, 'sonorous puddles' of cymbals, and missionary cries evoke the charlatan's fairground milieu as well as the exotic background of the Conjurer who had a capacity to frighten, commit barbarous acts and also to impart wisdom. The electric cinema bells, typewriters, revolver shots, steamship siren, and Morse-code S.O.S. amplify the cinematic provenance of the adventurous Little American Girl and create a narrative around the sinking ocean liner. The sounds of an airplane engine, vapour machine, and organ pipe that were to punctuate the Acrobats' turn, comment upon the airborne nature of their stunts as well as the fairground/music-hall setting. All these noises expand character associations in a poetic, stream-of-consciousness way rather than in a logical fashion.

In addition to the musical score, Cocteau was equally involved in the choreography. Léonide Massine, who had arrived from Russia in 1914, was not familiar with the world of the Western European *forain* and music-hall. Not only was he new to Western culture, but at the age of twenty-one in 1917, he was also new to the art of choreography. He had studied acting and dancing at the Imperial School in Moscow and had decided to become an actor when Diaghilev, seeking a replacement for Nijinsky, spotted the sixteen-year old Massine dancing a small part in *Don Quixote* and invited him to join the Ballets Russes company. *Parade*, the sixth ballet Massine choreographed, demonstrates his rapid

[13]This information was discovered by Ornella Volta and I am grateful to her for calling it to my attention. See Volta, *Erik Satie & la Tradition Populaire*, exhib cat., Musée des Arts et des Tra-

ditions populaires (Paris, 1988) pp. 26, 28, no. 61.
[14]Satie score, Frederick R. Koch Foundation, p. 30 bis.
[15]Cocteau had intended the Chinese Conjurer's turn to be simi-

larly accompanied by macabre elements which were never included in the ballet. According to his marginal notes on Satie's score, while the conjurer enacted a gesture of cutting his

own throat, the audience was to hear the suppressed cries of missionaries being attacked by Chinese natives who punched out their eyes and pulled out their tongues. (see fig. 55 and n. 22).

The importance of black humour in Picasso's art is discussed by Patricia Leighton in *Re-ordering the Universe: Picasso and Anarchism, 1897–1914* (Princeton, 1989) pp. 139–41.

development into a gifted choreographer. None-theless, before Massine could devise dance steps, he needed Cocteau to provide outlines and demon-strate movements typical of variety entertainment. Cocteau instructed Massine in the ordinary, every-day movements and music hall performer's gestures which were then integrated into a more conven-tional balletic context. He wrote to Valentine Gross: 'Massine is a Stradivarius . . . I think up every slight-est gesture, and Massine executes it choreograph-ically,' And to his mother he joked: 'You would laugh to see the dancer I have become. Massine wants me to show him every slightest detail, and I invent the roles, which he then immediately trans-forms into choreography.'[16]

Cocteau later wrote his '. . . role was to invent re-alistic gestures, to exaggerate and order them, and thanks to the science of Léonide Massine, to elevate them to the level of the dance.'[17] Cocteau was not known for false modesty, but Serge Lifar credits him further: Massine's felicitous touches in Parade and sub-sequent ballets go back directly to Cocteau, with their lit-erary flavor and their circus-like stylization. . . . Everything that is now current in ballet was invented by Cocteau for Parade which he knew by heart, and every step of which he had suggested.[18]

Massine had been trained in acting before taking up dance in Russia, thus he was always considered more a 'character' dancer who relied to a great degree on pantomime, rather than a purely classical ballet artist. By its nature Parade called for a strong element of pantomime since conventional ballet formulae could not accommodate the activities of the Managers and the three fairground acts.

Massine's inventiveness as a choreographer was tested to the limit in devising steps for the ten-foot Managers who marched and stamped about the stage holding their arms out stiffly, like robots or gigantic puppets rather than classical ballet dan-cers. Picasso created the Managers to substitute for the unseen voices Cocteau had envisioned, but

which none of the other collaborators wanted to use. Massine had them perform a short dialogue where their stamping of feet and canes appears as if they are speaking to each other. Needless to say, wearing the huge Managers' carcasses meant that the dancers were severely limited in their move-ments. At first Cocteau was incensed by the deletion of his 'voices' and did not like Picasso's solution of Managers. But once rehearsals began he started to change his mind; in his notebook he writes: 'Picas-so's managers by their size and their weight have obliged the choreographer to leave behind old for-mulae.'[19] The Managers' slow and ponderous ges-tures as well as their huge stature caused them to seem more 'real' than the other dancers who looked toy-like by comparison (fig. 18). Shortly after the première of Parade Cocteau totally reversed his initial opposition to Picasso's Managers and rewrote his own original reaction to the idea: When Picasso showed us his sketches, we understood how effective it would be to exploit the contrast between the three 'real' characters as 'chromos' (cancelled postcards) pasted on a canvas and the more solemnly transposed inhuman, or superhuman, characters who would become, in fact, the false reality on stage, to the point of reducing the real dancers to the stature of puppets.[20]

For the three parade acts Massine, under Coc-teau's instruction, looked to currently popular music-hall and circus performers and then stylized their movements and routines. For most critics and viewers at the time there was more circus/music-hall than ballet in all three acts. Except for portions of the Acrobats' pas de deux, none of the characters performed anything near traditional ballet.

In the course of staging a reprise of Parade for Great Performances – Dance in America in 1976, Massine recalled: In 1917 we were mainly concerned with creating something new and representative of our own age. Every innovation – the sound effects, the Cubist costumes – would set off a freight train of ideas for the choreography.

[16]Both letters quoted in Steeg-muller, p. 177.
[17]Jean Cocteau, Les Foyers des artistes (Paris, 1947). p. 49.
[18]Serge Lifar, Serge de Diaghilev, Sa Vie, Son Oeuvre, Sa Légende Monaco, 1954), pp. 268–9.
[19]Jean Cocteau, Italian sketch-book, Fonds Kochno, Biblioth-èque de l'Opéra, Paris.

[20]'Lorsque Picasso nous montra ses esquisses, nous comprîmes l'intérêt d'opposer à trois per-sonnages réels, comme des chromos (cartes postales rayées) collés sur une toile, des person-nages inhumains, surhumains, d'une transposition plus grave, qui deviendraient en somme la fausse réalité scénique jusqu'à réduire les danseurs réels à des mesures de poupées.' Cocteau, ed. André Fermigier, Entre Picasso et Radiguet (Paris, 1967) p. 64.

We decided to set the scene in front of a circus stand, bringing on such characters as acrobats, tightrope walkers and conjurers, and incorporating jazz and cinematograph [sic] technique in balletic form.

We began the ballet with the entrance of the French manager, danced by Woidzikowsky, who moved in a jerky, staccato manner to match Satie's opening phrases, stamping his feet and banging his walking-stick on the floor to attract the attention of the crowd.

Then came the *parade*, a curtain was drawn and in music-hall fashion a placard appeared announcing 'Number One', this was the cue for my entrance as the Chinese Conjurer, whom I envisaged as a parody of the usual pseudo-oriental entertainer with endless tricks up his sleeve.[21]

Thus the Chinese Conjurer appeared first, entering in a series of pinwheel leaps with his arms kept tightly by his side. He marched stiffly around the stage, jerking his head at each step, he then through slow Tai Chi-like movements proceeded to mime his 'act'. This consisted of a nine-part sequence outlined in Cocteau's Roman notebook (fig. 58). The Conjurer bowed, showed with his hands that there was nothing up his sleeves, pointed to his hands and moved his feet, and gestured with a fan; he produced an egg from his sleeve, swallowed it with great flourish, then retrieved it from his toes (fig. 59) and blew fire from his mouth. He then repeated these motions and mimed the use of a fan. Before leaping off stage he ended his bow on his knees, his mouth wide open in a contorted grimace (fig. 62).[22]

Massine has written of the Conjurer: Cocteau . . . suggested that I should go through the motions of swallowing an egg. The idea appealed to me. With an elaborate flourish I pretended to produce an egg from my sleeve and put it in my mouth. When I had mimed the action of swallowing it, I stretched out my arms, slid my left leg sidewards till I was almost sitting down, and with my left hand pretended to pull the egg from the toe of my shoe. The whole thing took only a few minutes, but it had to be done with the most clearly defined movements and broad mime. When I had retrieved the egg I leaped round the stage again, then paused, puckered up my lips and pretended to breathe out fire. One last march round the stage, a final deep bow, and I disappeared.[23]

Massine mentions that he envisioned the Conjurer as 'a parody of the usual pseudo-oriental entertainer.'[24] The music-hall chronicler, Jacques Damase has noted that 'Chinese magicians enjoyed a tremendous vogue during the first quarter of this century.'[25] It seems Cocteau, Massine, and Picasso modelled their character on one of the many 'oriental' illusionists active in Paris at the time who included Maskelyne, Alber (fig. 61), Benevol, de Bierre, de Ryss, Horace Goldin, de Steens, Canterelli, le Grand Robert (clearly some were oriental in costume only) and the genuine Chinese act with the piquant name of 'Tschin Maa and his Seven Holy Grave Watchers and Necromancers'.[26] The magician closest to *Parade*'s Conjurer, Chung Ling Soo was also the most famous prestidigitator during the war years (see figs. 46 and 76).[27] He was probably the model for the Chinese Conjurer and the audiences who attended *Parade* could hardly miss the intended parody of the celebrity magician. The long queue and silk brocade costume (usually in red and yellow) complete with black slippers, white leggings and gloves, are only two points of similarity. In glancing over his 45 illusions we see Chung Ling Soo, like *Parade*'s Conjurer, performed fire acts, one entitled the 'Diabolic smoke', another the 'Human volcano'; and three egg tricks – the 'Phantom egg', the 'Extraordinary production of eggs', and the 'Surprise omelette' (see fig. 46). In addition Soo was known for his frightening grimaces and facial con-

[21] From the video *Great Performances – Dance in America*, first aired 21 Jan. 1976. Dance Collection, Lincoln Center.

[22] Cocteau intended several 'tricks' and vocal accompaniments for the Chinese Conjurer which were never used. His written instructions on the score in the Koch Foundation read: 'il emprunte un chapeau et en fait sortir un cheval' (he borrows a hat and has a horse come out of it) and at the end of the act 'il se coupe la tête et salue' (he cuts off his head and bows). In addition to these unused choreographic cues, Cocteau included 'paroles supprimées' to be screamed by mis-

sionaries toward the end of the conjurer's act; 'they punch his eyes out and they pull out his tongue'; after these phrases the noise of a lottery wheel was to follow ('ils lui crevèrent les yeux lui arrachèrent la langue . . . bruit de la roue de loterie'). p. 16.

[23] Massine, pp. 103–4.

[24] Nesta MacDonald notes, 'Massine must have had plenty of fun working out these tricks with a double meaning as he also made it look as if he, the performer, were a "mime" taking off a conjurer – a double *tour de force* of which few dancers are capable.' p. 239.

[25] Jacques Damase *Les Folies du*

Music Hall: The History of the Music Hall in Paris from 1914 to the Present Day (London, Spring Books, 1970) p. 142. See also chapt. 5.

[26] Bibliothèque de l'Arsenal, Fonds Rondel.

54 Jean Cocteau, spiel
intended to accompany the
Acrobat, copyist's manuscript

of Erik Satie's score for
Parade, 1917

55 Jean Cocteau, copyist's
manuscript of Erik Satie's
score for *Parade*, 1917

56 Original cover for the
sheet music of Berlin and
Snyder's *That Mysterious
Rag*, 1911

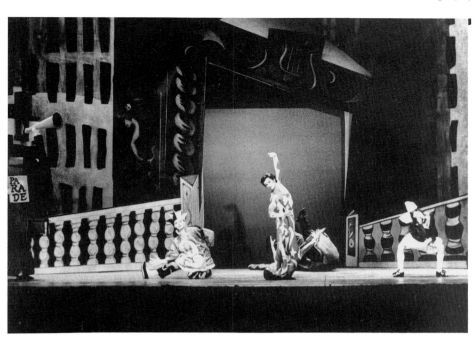

57 Performance of *Parade*
restaged by the Joffrey
Ballet, New York, 1973

58 Jean Cocteau, pages from
his Roman notebook, 1917

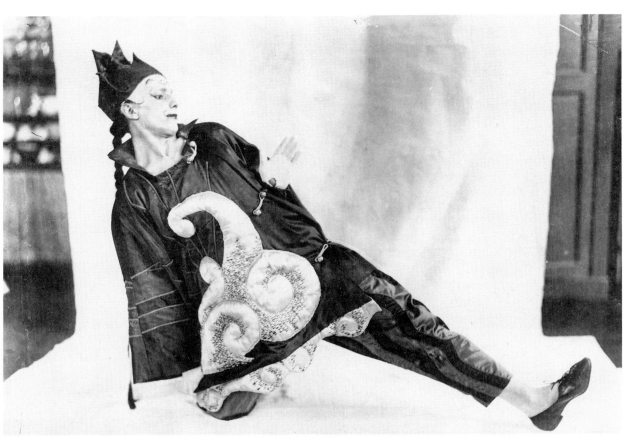

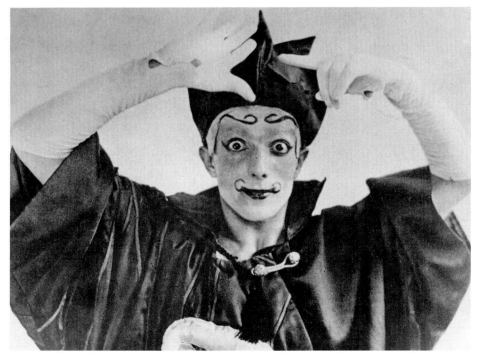

59 and 60 Léonide Massine
as the Chinese Conjurer in
Parade, 1917

61 The prestidigitator Alber,
1914

tortions which *Parade*'s Conjurer also adopted (figs 62, 63; see also fig. 60).

As mentioned, like the Chinese Conjurer, the second act, the Little American Girl, was also entirely topical and based on an amalgam of the current movie idols, Pearl White and Mary Pickford. In a send-up of the *Perils of Pauline*, where most of the action was made up of rides and jumps, *Parade*'s Little American Girl performed at breakneck speed a dizzying number of pantomime movements to Satie's syncopated 'Steamboat Ragtime'. These included jumping and leaping across the stage, riding a horse, jumping on a train, cranking up a Model T Ford, peddling a bicycle, swimming, playing cowboys and indians, acting in a movie (where a robber is driven away at gunpoint), snapping the shutter of a Kodak, dancing a ragtime, imitating Charlie Chaplin, getting seasick, almost sinking with the *Titanic*, and finally relaxing by the sea-shore, playing in the sand.[28]

Massine devised his choreography from Cocteau's crazy quilt character description but, except for the Charlie Chaplin and the snapping of a Kodak,[29] which only added to the cinematic soup, each of the actions actually occurred in the *Pauline* serial, or in a Pickford film. (See fig. 50).

All of the ballerinas who danced the part complained it was a gruelling role. Lydia Sokolova, who danced it in later performances, after Marie Chableska (the original Little American Girl) had left the company wrote: It was lucky that the short, white-pleated skirt and blazer which the American girl wore were easy to move in, because her entrance and exit were extremely difficult. These consisted of sixteen bars of music; and with each bar she had to jump with both feet straight out together in the front and almost touch her toes with her outstretched arms. This is hard enough to do on the same spot, but when it was a question of moving around a vast stage at full speed it was no mean feat. When it got to dancing ragtime in this part, whacking myself on the head and tripping myself up with the back foot in true Chaplin style, I began to enjoy myself.[30]

The incongruity of the exquisite Russian dancers performing slapstick turns was not lost on the critics. One English journalist who in 1919 observed the prima ballerina Tamara Karsavina in the role of the Little American Girl had this to say: There are dozens of music-hall performers who can do this sort of thing better, because they are more to the impudent manner born. Of course there is a curious sort of interest in seeing Karsavina at all in such a part, just as there would be in seeing Mr. Asquith as Charlie Chaplin.[31]

For the final act Cocteau envisioned an acrobat who is 'on close terms with the stars'. Massine requested a female acrobat as well so that he could choreograph a *pas de deux*.[32] In this turn the dancers imitate tightrope walking, trapeze and high wire stunts, and even mime a near fall. These segments, where the dancers mimic circus/music-hall acrobat preparations and routines, punctuate what is basically a classical ballet *pas de deux*.[33] This is as it should be, for although Cocteau may not have realized it, classic ballet's basic vocabulary of pirouettes, jetés, ronds de jambe and entrechats are derived from the movements and attitudes first performed by tightrope walkers and acrobats (figs 64, 65). 'It was rope dancers (and later equestrians) who cleared with ease the barrier between fairground booth and great opera houses.'[34]

[27]Chung Ling Soo had imitators touring the music halls all over Europe. They even copied his name. Will Dexter lists acts playing under the names of Ching Ling See, Ching Ling Sen, Chung Ling Sen, Chung Ling Fee, Ching Ling Fee, Ling Lang Hi, Li Chang Hi, Ching Foo Soo and the Little Chung Ling Soo, and Chung Ling Hee. Will Dexter, *The Riddle of Chung Ling Soo*. (New York, 1976) p. 56.

[28]Massine writes: 'Wearing a blazer and a short white skirt, she [the American Girl] bounced onto the stage, crossing it in a succession of convulsive leaps, her arms swinging widely. She then did an imitation of the shuffling walk of Charlie Chaplin, followed by a sequence of mimed actions reminiscent of *The Perils of Pauline* . . .' p. 104.

[29]Billy Klüver, 'A Day with Picasso', *Art in America*, Sept. 1986, no. 9, pp. 97–107, 161–3, suggests that 12 August 1916, the day Cocteau met Picasso for an afternoon of dining, café-sitting, and impromptu picture-taking using Mme. Cocteau's camera, was the same day Picasso agreed to design the décor for *Parade*. (p. 161). It is tempting to think Cocteau's cue for the Little American Girl to mime taking photographs with a Kodak, was a private reference to that memorable day. As will be seen personal and autobiographical allusions permeate the entire ballet.

[30]Quoted in Steegmuller, p. 185.

[31]Ernest Newman *Observer* (23 Nov. 1919) quoted in MacDonald, Newman went on to say that after his second visit to see *Parade* he was certain that, 'if anyone but Diaghilev had put it on it would have been dismissed as music hall or pantomime stuff.'

[32]The Satie score also contains notations by Massine written in Russian.

[33]Film archive, Dance Collection, Lincoln Center. In this tape which was shot during rehearsal of a 1964 restaging by Massine, the acts were presented in a different order with the Acrobats first, then the Little American Girl and the Chinese Conjurer last.

[34]Winter, p. 108.

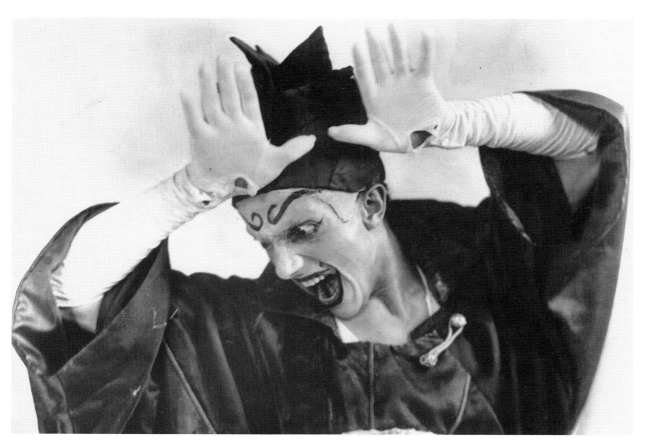

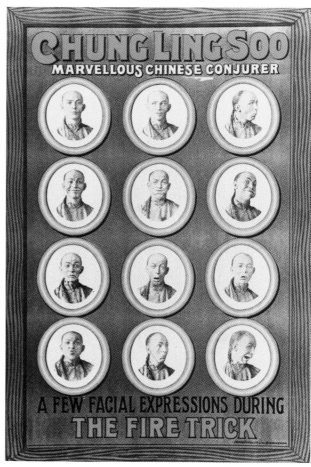

62 Léonide Massine as the
Chinese Conjurer in *Parade*,
1917

63 Poster for Chung Ling
Soo, c.1915

Lydia Lopokova and Nicholas Zverev danced the Acrobats who entered in a series of pirouettes and arabesques. Massine recalled: . . . to give the illusion of a performer delicately posed on a tightrope I made Lopokova balance herself for several seconds on Zverev's bent knee. This was followed by another flurry of pirouettes, after which Zverev lifted his partner and carried her off-stage.[35]

On one page of his Roman notebook Cocteau writes, 'Pour l'acrobate les exercices de barre' [For the acrobat exercises at the barre] indicating that at some point in the routine Cocteau envisaged a behind-the-scenes peek at the ballet dancer in rehearsal – thereby shattering the illusion of the character and reminding the viewer that this is a ballet and not a *parade*. Massine never incorporated this Pirandellian segment into the ballet, and instead opted for showing mundane acrobatic preparatory gestures – when they enter the Acrobats mime the action of covering their hands in chalk- dust, and then pretend to climb a rope up to the high wire.[36]

The Acrobats are the most generalized of the three acts and if Cocteau had specific performers in mind it is difficult to determine who they were. Gustave Fréjaville, in his book, *Au Music-hall*, writes that acrobatic acts were as much a staple of the music-hall as they were of the circus.

Regardless of who Cocteau had in mind it is clear the game of parody was to be continued. Cocteau gives this direction to Massine: 'qu'il doit parodier les acrobates les plus lentes' [one must lightly parody acrobats].[37] Another written cue to Massine for an Acrobat indicates Cocteau had music-hall acrobats in mind: Imitate the classic music-hall scene: Mad laughter of the Negro Manager — the acrobat stops. Smiling he wipes his hands, continuing to smile he shows the Manager to the public and shrugs his shoulders (you know what I mean).

As mentioned, Cocteau's scenario called for three acts. Picasso contributed the idea of using Managers, instead of the disembodied voice of a barker, to introduce the acts. He designed costumes for three

Managers, one to announce each turn: The French Manager introduced the Chinese Conjurer, the American Manager introduced the Little American Girl, and a Manager in blackface was to introduce the Acrobats. In the course of rehearsals the Manager in blackface, which was a dummy atop two dancers in horse costume, fell off the horse. The horse profited from the third Manager's misfortune: he so delighted Diaghilev's troupe that his role was expanded. Instead of simply walking across the stage with a placard announcing the Acrobats, he was given his own turn before them. This consisted of prancing about, raising his front legs, crossing them, and then moving his front and rear in different directions, dancing pigeon-toed, and looking over his shoulder at the audience with a disarming, cross-eyed expression.[38]

Needless to say while some in the audience found the horse charming and amusing, others felt they could have seen the same thing at the Cirque Médrano (see figs 5, 6) for a fraction of the price of a ticket to the Ballets Russes. The Horse proved to be the last straw for a number of Diaghilev's 'cher snobs' whose irritation was mounting with each act. When the Horse began his 'one-step', several patrons got up and left, others in the audience booed and hissed. Picasso, Cocteau, and Massine had expected the Horse to elicit the same degree of laughter and affection from audiences that it had from the troupe during rehearsals, instead the Managerless horse turned out to be the most incendiary element of the ballet.

In the end, *Parade* was above all a parody. The play on words was not lost on the collaborators who have the American Manager carry a sign reading PA/RA/DE (fig. 66). The ballet was half send-up, half tribute to topical, popular celebrities and common music-hall/circus entertainments. It is this aspect of the ballet which is necessarily lost in revivals, for the fame of such popular celebrities is by definition short-lived. One reason later revivals of the ballet met with approval was because with time the cha-

[35]Massine, pp. 104—5.
[36]From the 1964 rehearsal movie of *Parade* restaged by Léonide Massine for the *Ballet of the XX*
Century, Théatre de la Monnaie, Brussels. Dance Collection, Lincoln Center. Also Joffrey Ballet production of
Parade, New York, Nov. 1986.
[37]Satie score, Frederick R. Koch Foundation, p. 38.
[38]1964 *Parade* tape, Lincoln Cen-
ter, and Joffrey Ballet production, November 1986.
 Since Satie had already written the score, the Horse per-
forms in silence, unaccompanied by the orchestra.

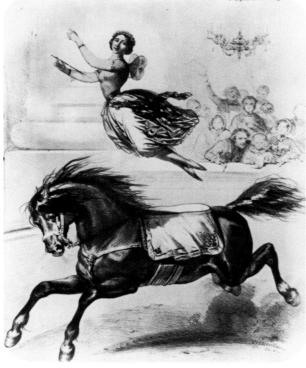

64 Carlotta Grisi in act II of
Giselle, lithograph from a
drawing by Challamel,
1841–49

65 Coralie Ducos performing
at the Cirque Franconi, 1849

66 The American Manager
from *Parade*, 1917

racters of the Conjurer, the American Girl, the Horse, and perhaps the Acrobats, had acquired a patina which gave them a quaint, charming, and thoroughly imaginary appearance. In 1917 however, these acts were alarmingly familiar, specific, and low-brow – analogous today to having the Metropolitan Opera perform a work based on a situation comedy such as *Alf*. It was not *Parade*'s Cubism which first audiences found so shocking, rather they found disquieting the unmistakable allusions to well-known performers from the lower end of the cultural spectrum transformed into a stylized art form. Tamara Karsavina, who was also cast in the role of the Little American Girl, put it this way, '*Parade* projected so far into the topical as to strip it of ballet's essential virtue – its own creative material. It came nearer to an imitative art.'[39]

Throughout its history variety theatre has delighted in the parody of ballet, opera, and other highbrow cultural entertainments. Wagner's Brünn-

hilde or the gestures of Tschaikovsky's Swan Princess were often satirized on the vaudeville stage. With *Parade* for the first time this was reversed; instead of debasing the high, *Parade* elevated the base. Through simplification and stylization Cocteau, Massine, Picasso and Satie transformed the popular entertainments they enjoyed and admired into something possessed of enduring artistic merit. Their aim was to retain the vitality and excitement of music-hall theatre while lending it an artistry they had first observed in performances of the *commedia dell'arte*. The collaborators of *Parade* were not interested in simply the wholesale adoption of popular entertainments, they wanted to elevate circus and variety theatre to the level of serious art. Cocteau later wrote: When I say about certain circus and music-hall shows that I prefer them to everything that is done in the theatre, this is not to say that I prefer them to everything that *could* be done in the theatre.[40]

[39]Quoted in MacDonald, p. 240.
[40]Cocteau, *Oeuvres Complètes de* *Jean Cocteau*, vol. 3, (Lausanne, 1946–51) p. 28.

Chapter 7

The costumes and décor

As each of the three acts in *Parade* found a counterpart in the popular entertainments of the day, so the costumes Picasso designed for the Chinese Conjurer, the Little American Girl and the Acrobats mirrored circus or music-hall attire. This manifestation of interest in the topical and current was not a new direction for Picasso, rather he had always been totally 'engaged with the iconography of contemporary life.'[1]

Picasso's costume for the Chinese Conjurer is one of the most beautiful and memorable he designed for the stage (figs 67–74). Diaghilev often reproduced it on programmes and playbills and by 1919 it had become a symbol for the modernity of the Ballets Russes enterprise.

The costume consists of a quilted tunic with side toggles and mandarin collar (fig. 67) over floppy calf-length trousers and a multi-peaked skull-cap worn over a long, braided queue. Picasso limited his palette to an intense red and yellow with the addition of black-and-white accents. The designs quilted on to the tunic and trousers such as the spiral swirls over yellow rays on the tunic's front and back evoke elemental imagery such as clouds, ocean waves, sun or moon. On the right trouser leg, wavy yellow stripes are set diagonally against a black ground. On the left trouser leg this motif is reversed and black stripes undulate vertically over a yellow ground. White gloves, stockings and facial make-up, which Picasso applied himself (see figs. 73, 74), as well as the white quilting (now discolored) on the tunic, throw into relief the intense red, yellow and black of the costume and lend an eerie, somewhat frightening air to the character.

As stated, of the countless Chinese prestidigitators who filled the music-halls during the second decade of the century, Chung Ling Soo was the most famous (see pages 76f, 91). His costume not only differed from standard magician's garb, it was very similar to the one Picasso created for *Parade* (figs 67 and 76). While most Chinese magicians active around the war years wore floor-length robes (in which they concealed apparatus) Chung Ling Soo, like *Parade*'s Conjurer, favoured a shorter, Mandarin jacket over calf-length trousers. Most interesting, Soo's trademarks were his braided queue and his tunics of red and yellow.[2] Like Picasso's conjurer, Soo wore a peaked cap, white stockings and black slippers. In addition, although the designs were not as bold or stylized as Picasso's, the patterns on his costume were often composed of celestial and elemental imagery — stars, moons, and suns. (See for example the yin/yang symbol in fig. 77).[3] It is worthwhile noting that among the several metaphysical-sounding titles in Chung Ling Soo's repertoire of illusions is act number 11, the handkerchief trick entitled 'Soleil et Lune' [Sun and Moon] (see fig. 46).

Picasso's silk costume adheres to the criteria described by music-hall chronicler, Jacques Damase in his chapter on magicians: Magicians are traditionally mysterious or foreign; they must wear Chinese or Hindu silk costumes . . . Their décor must be elaborate, exotic, or frightening. As dealers in miracles, everything they do must be wonderful and their audiences must be overwhelmed by their splendour and magic.[4]

But, Picasso was not out merely to copy the variety hall prestidigitator, rather he intended *Parade*'s Conjurer to function on a number of levels. Superficially he imitated the current vogue for exotic illusionists in music-hall and *forain*. Specifically, he parodied the famous Chung Ling Soo. And on a deeper level he functioned as a 'metaphor for the creative spirit' symbolizing the artist who is also a 'manipulator of illusion.'[5] In this respect the Conjurer operates as a self-portrait, for since childhood Picasso had used the power of art to manufacture illusion and in effect to create magic.[6]

[1]Patricia Leighten 'Editor's Statement — Revising Cubism', *Art Journal*, no. 4, (Winter 1988, vol. 47), pp. 269–750. See Robert Rosenblum, eds Penrose and Golding, 'Picasso and the Typography of Cubism' *Picasso in Retrospect* (New York, 1973).

[2]Besides the obvious fact that the colours of the Chinese flag are red and yellow, it is interesting to note that an article which appeared on Soo in *Conjurors' Magazine* (March 1947), written by Fulton Oursler was entitled, 'Riddle in Red and Yellow: A Story about Chung Ling Soo.'
[3]Although it is impossible to tell the colour of costumes from the black-and-white newspaper clippings in the Rondel Collection of the Bibliothèque d'Arsenal, it is clear that celestial imagery was common for many a 'Chinese' prestidigitator.
[4]Damase, p. 142.
[5]Quoted from Kirstein, *Movement and Metaphor: Four Centuries of Ballet*, (New York, 1970) p. 183 and Axsom, p. 69.
[6]See Lydia Gasman *Mystery, Magic and Love . . .* (New York, 1981) and Mary Mathews Gedo, *Picasso, Art as Autobiography . . .* Gasman discusses at length Picasso's belief that his art could actually change events and was, like tribal art, magic.

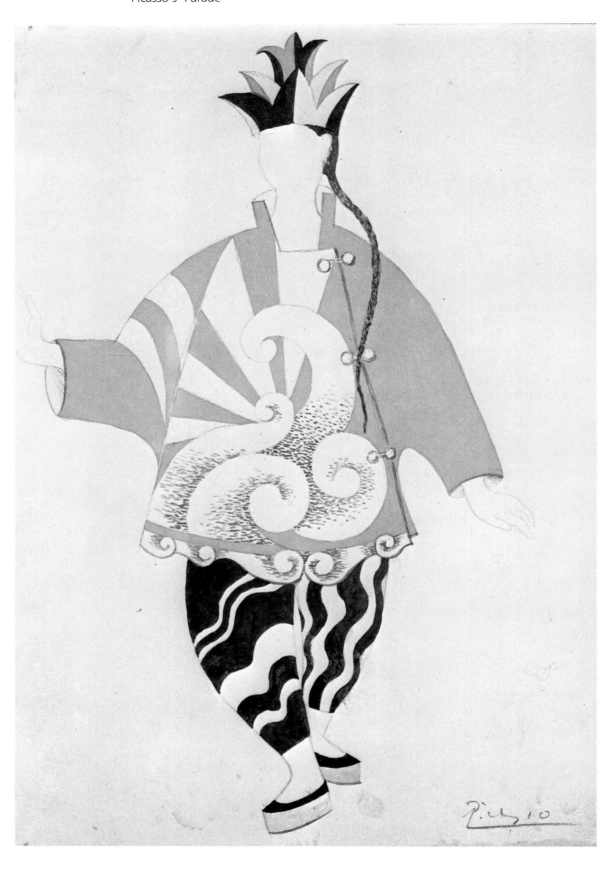

67 Pablo Picasso, study for
the Chinese Conjurer's 280 × 190 mm (see colour
costume, 1917, watercolour, illustration on p. 13)

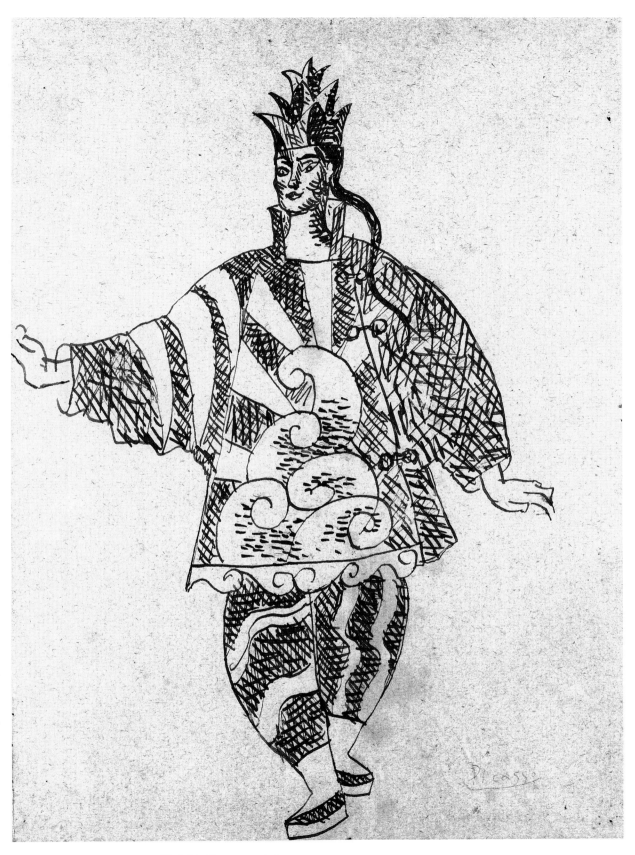

68 Pablo Picasso, study for
the Chinese Conjurer's
costume, 1917, pen and ink,
265 × 196 mm

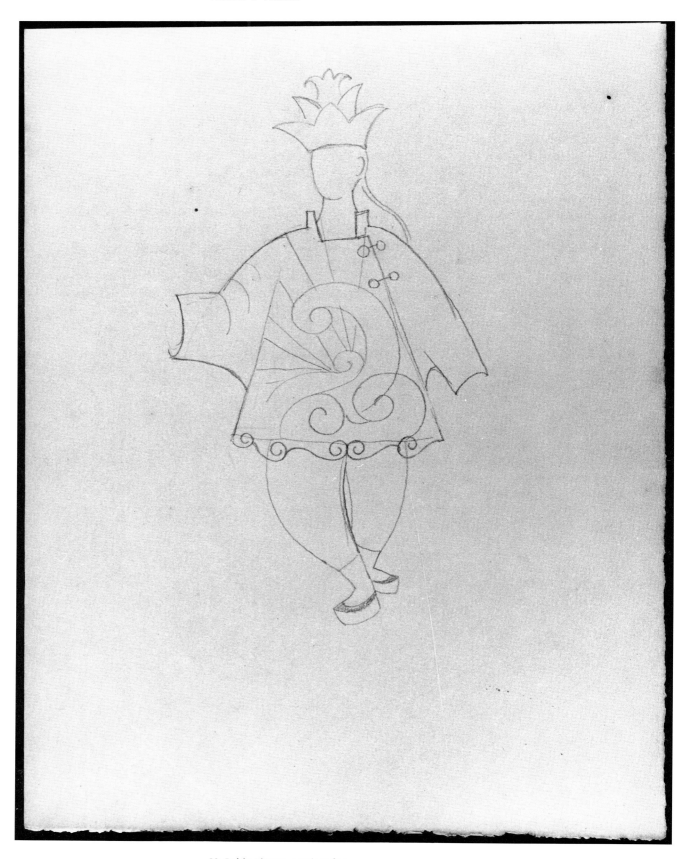

69 Pablo Picasso, project for
the Chinese Conjurer's
costume, 1917, pencil, 280 ×
206 mm (MP 1578)

70 Pablo Picasso, study for
the Chinese Conjurer's
costume, back view, 1917,
pencil, 295 × 190 mm

71 Pablo Picasso, study for
the Chinese Conjurer's
costume, back view, 1917,
pencil, 261 × 195 mm

72 Pablo Picasso, project for
the Chinese Conjurer's
costume, 1917, pencil, 276 ×
206 mm (MP 1579)

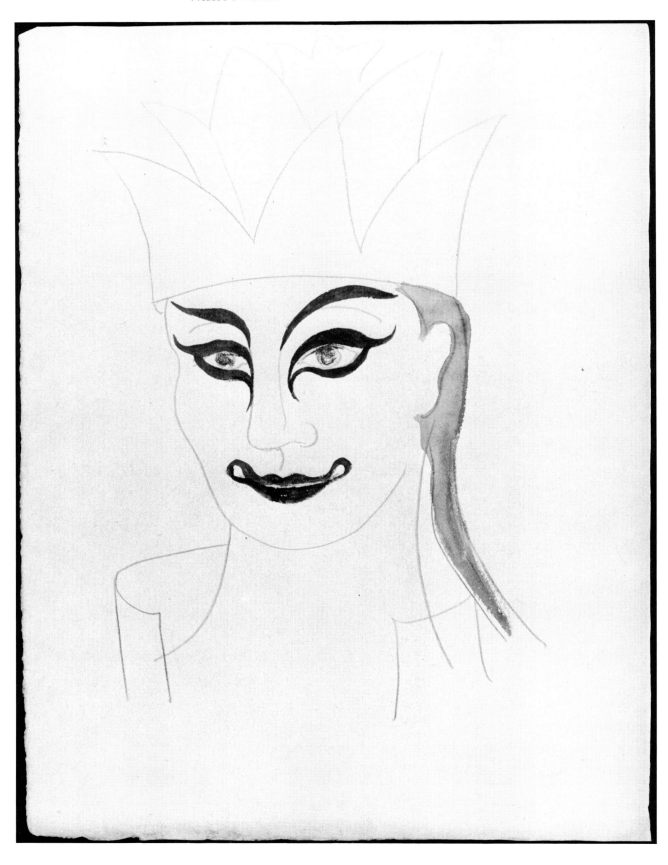

73 Pablo Picasso, study for the make-up of the Chinese Conjurer, 1917, pencil and ink wash, 280 × 207 mm (MP 1576) (see colour illustration on p. 14)

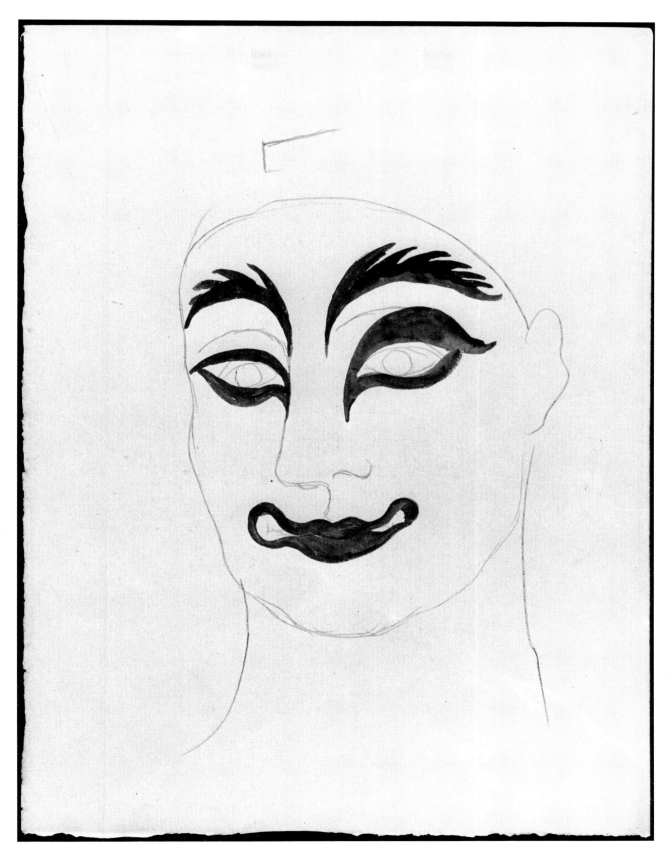

74 Pablo Picasso, study for the make-up of the Chinese Conjurer, 1917, pencil and watercolour 281 × 205 mm (MP 1577) (see colour illustration on p. 15)

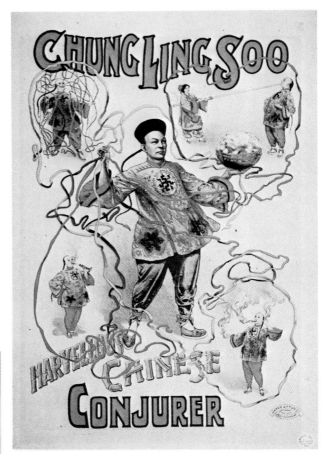

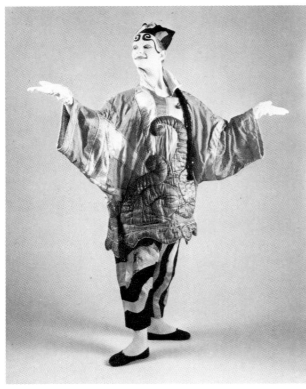

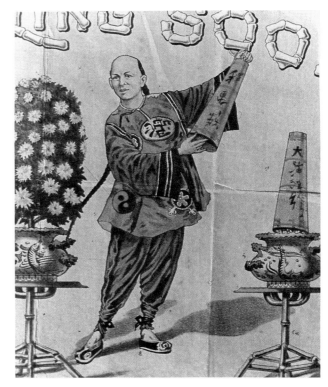

75 Léonide Massine's
original costume for the
Chinese Conjurer in *Parade*
(see colour illustration on p.
25)

76 Poster for Chung Ling
Soo, *c.*1916 (see colour
illustration on p. 25)

77 Poster for Chung Ling
Soo, *c.*1915–16

The Conjurer also stood for the mysterious and frightening aspects of life itself; particularly the cosmic and elemental forces to which humankind is subject.

The conjurer is a mysterious figure. Since mystery is an acknowledged national characteristic of both China and Spain, it makes sense that Picasso would inject elements of his own 'Spanishness' into his self-referential conception of the Conjurer. Red and yellow are Spain's national colours and ones (along with black and white) which Picasso clearly associated with his homeland (see for example his *Spanish Still-life* (spring, 1912, Musée d'Art Moderne, Villeneuve d'Ascq) and his numerous lithographs and ceramics of the bull ring from the 1950s and the 1960s rendered in red and yellow).

Even the Conjurer's peaked cap encompasses autobiographical allusion. In addition to mirroring the type of caps actually worn by Oriental magicians performing in Paris at the time (see fig. 61), it also refers to the 'tricorne' or three-cornered hat native to Spain and therefore identifiable with the artist.[7]

Less tangibly, the conjurer's actions and gestures imply a demonic nature. Cocteau's character description and Massine's choreography make clear that the audience is to be frightened by him. Picasso too, cultivated an image of himself as a somewhat sinister being of extraordinary powers. He not only fostered the notion, but also wholeheartedly believed that the artist was a magician who could miraculously change events and alter the world.

In general China and Spain are viewed as exotic countries by Western Europeans. Picasso must have identified himself with the Conjurer, a being whose 'otherness' is inescapable by virtue of his uncommon powers as well as his nationality. Thus, the eminently simple design for the Conjurer, as is so often the case with Picasso, accommodates a multiplicity of associations – personal, topical, national, philosophical and so forth.

It has been assumed that Picasso never designed a costume for the Little American Girl because the outfit she wore, consisting of a navy blue sailor jacket and short white pleated skirt, was purchased the day before the première at Williams Sportswear Shop in Paris (fig. 78; see also fig. 39). However, there are two loose sheets (figs 79, 80) and seven pages in Picasso's 1917 Roman Sketchbook that contain sketches for the character of the Little American Girl (see figs 81–87). She skips through several pages always dressed in a flounced frock, usually with pantaloons and sometimes with polka dots, sporting a large bow in her hair (the exaggerated bow was retained in the actual costume).

Cocteau reputedly had Mary Pickford in mind when he created the Little American Girl. Picasso's sketches mimic Pickford as she appeared in *Poor Little Rich Girl* and *Rebecca of Sunnybrook Farm* – from large bow to flounced dress and skipping feet. (figs 89, 90). The fact that Pickford plays a child runaway who joins a third-rate circus similar to the travelling fair of *Parade* (see fig. 89) makes the connection of the Little American Girl to Pickford still more compelling. Yet even if Picasso or Cocteau had not seen these films at the time these sketches were made, in the Spring of 1917, the films were released in the United States in January and March of that year, they would have been familiar with the type of heroine Pickford symbolized.[8]

Like Jean Harlow, who caused millions of women to bleach their hair in the thirties, or Marilyn Monroe, who set the style for the fifties, Mary Pickford was the model for a whole generation of women. Aspiring movie stars as well as variety hall *ingénues* patterned themselves on 'America's Sweetheart'. An act like that of the Little American Girl – consisting of dancing and pantomime – was a frequent turn in music-halls and the *forain* (see fig. 47). Dressed in flounces, bows, and 'Mary Jane' shoes, with hair worn in long ringlets, women anywhere from fifteen to fifty years of age would impersonate a coquettish child to song and dance.[9]

[7] The Conjurer's hat also calls to mind Georges Seurat's famous 1890 painting *Le Cirque* (Musée d'Orsay, Paris (see fig. 183). Seen from the back the foreground clown's tri-peaked hair-do has the same silhouette as that of the Conjurer's cap. Called to my attention by Ornella Volta. Conversation May 1990.
[8] I have not been able to ascertain the release date for Pickford's films in Paris and Rome.
[9] Gustave Fréjaville cites May Marks and Elsie Janis as two American music-hall dancers who are able to pull off the illusion of girlish modesty: 'Nous devons croire que cette "star" précédée de tous les buccins de la réclame, n'est en réalité qu'une douce jeune fille très timide, qui se trouve sur la scène tout à fait par hasard . . .' *Au Music Hall* (Paris, 1923) p. 83.

78 Marie Chabelska as the
Little American Girl from
Parade, 1917

79 Pablo Picasso, study for
the Little American Girl's
costume, 1917, pencil, 277 ×
225 mm (MP 1575)

80 Pablo Picasso, study for
the Little American Girl's
costume, 1917, pencil, 280 ×
205 mm (MP 1574)

81 Pablo Picasso, pencil
study in his 1917 sketchbook
of the Little American Girl
172 × 115 mm (MP 1867)

82 Pablo Picasso, study for
the Little American Girl's
costume, 1917, pencil, 172 ×
115 mm (MP 1867)

83 Pablo Picasso, study in his
1917 sketchbook for the
Little American Girl, pencil
(MP 1867)

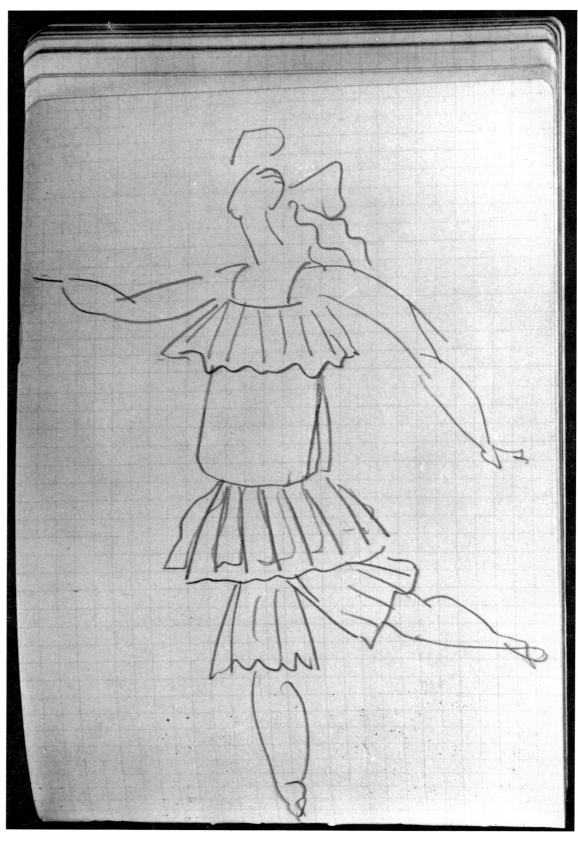

84 Pablo Picasso, study from
his 1917 sketchbook of the
Little American girl, pencil,
172 × 115 mm (MP 1867)

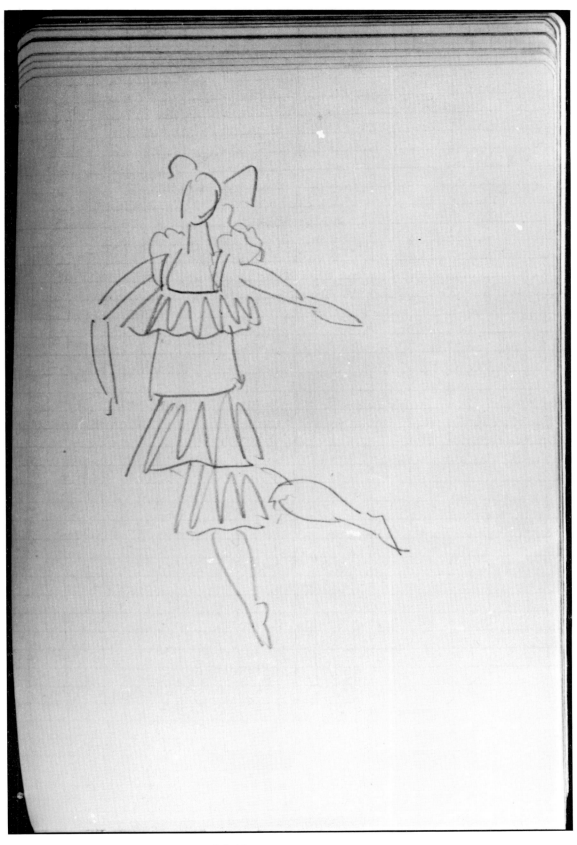

85 Pablo Picasso, study in his
1917 sketchbook of the Little
American Girl, pencil, 172 ×
115 mm (MP 1867)

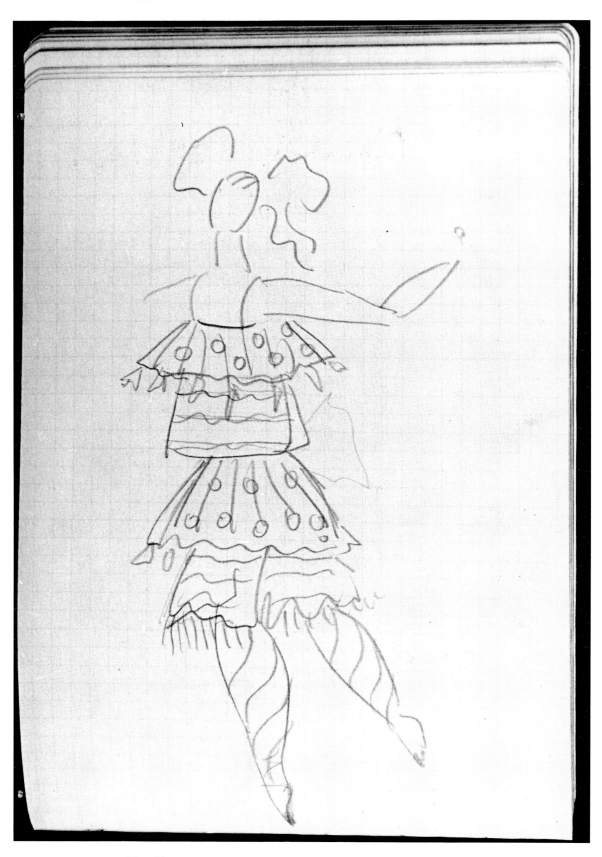

86 Pablo Picasso, pencil
study in his 1917 sketchbook
of the Little American Girl
172 × 115 (MP 1867)

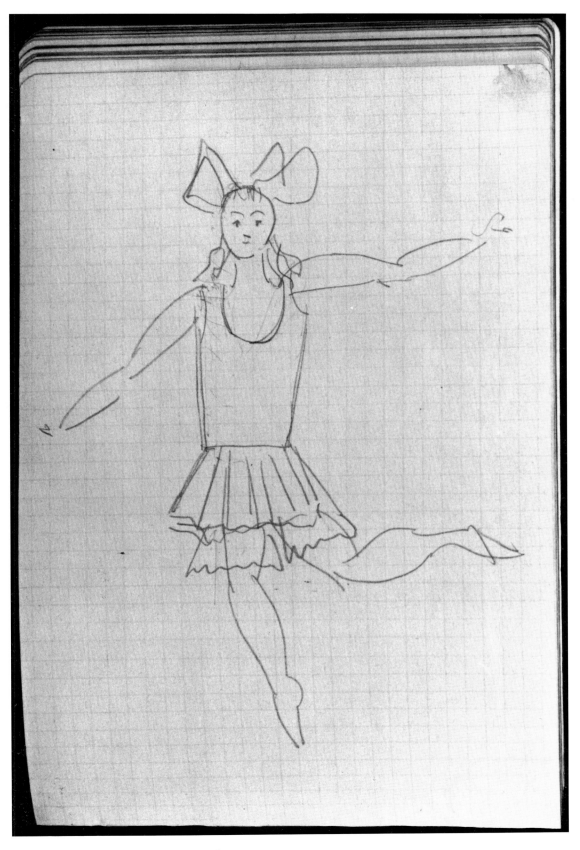

87 Pablo Picasso, pencil
study in his 1917 sketchbook
of the Little American Girl
172 × 115 mm (MP 1867)

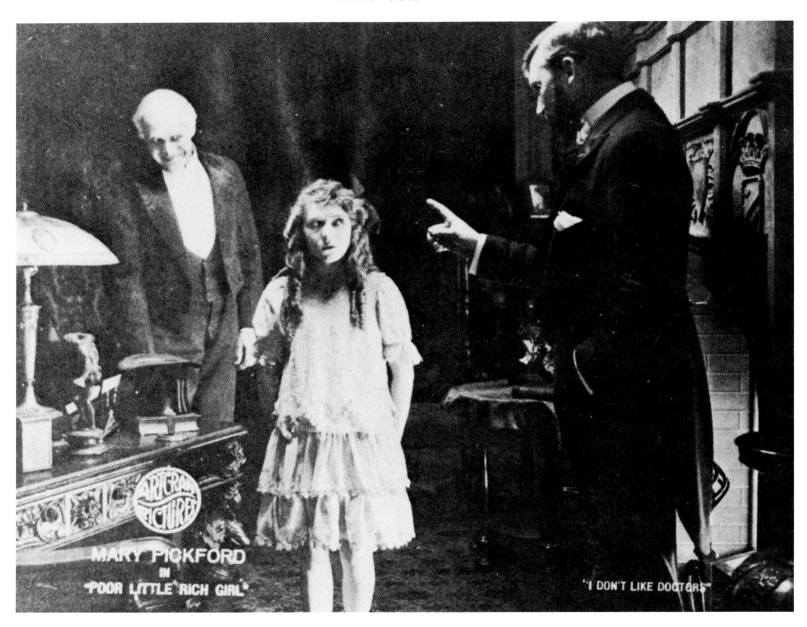

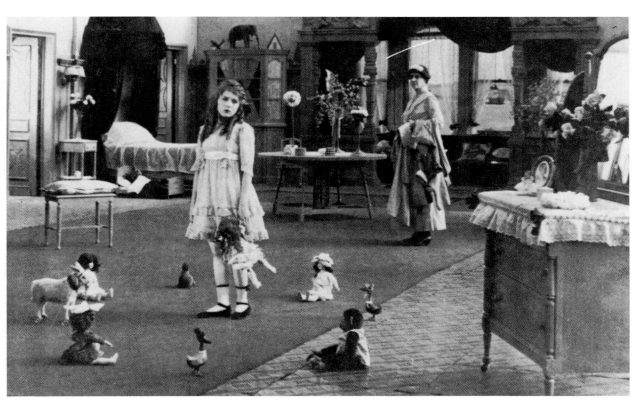

88, 89 Stills of Mary Pickford
in *Poor Little Rich Girl*,
released 1917

90 Still of Mary Pickford in
*Rebecca of Sunnybrook
farm*. Captioned lower right:
'The Queen of the Circus',
released 1917

This rage for child-women reached other variety entertainments as well. Picasso's costume designs are identical to the flounced, polka-dot frocks and large hair bows worn by the female members of the expatriate American acrobat team – the Eight Allissons (fig. 91). Gustave Fréjaville in his 1922 publication *Au Music-hall* describes their act as being typically American in origin, with very few French practitioners. It consisted of 'flips, somersaults and pirouettes without stop', a routine certainly in keeping with the frenetic antics of *Parade*'s Little American Girl.[10]

The costume eventually used by the Little American Girl is one that is quintessentially childlike. Middy sailor blouses were standard little girl's dress in the early years of the century. Nonetheless it is worth noting that in her role as the resourceful and clever 'child of misfortune' in the popular serials *The Perils of Pauline* (1914–15), and *The Exploits of Elaine* (1916), Pearl White often wore a similar sailor suit (fig. 92). As discussed previously, the dare-devil feats Miss White performed (the actress insisted on doing all of her own stuntwork) were a model for the hair-raising pantomime enacted during the Little American Girl's 'Steamboat Rag'. The use of a costume identified with the movie heroine would certainly clinch the association of Cocteau's character with a specific popular personality.

The swirling white scrolls and stars which play boldly over the cobalt blue of the Acrobats' tights were again taken by Picasso from contemporary designs as they were standard motifs used by acrobats (fig. 99). Picasso's sketches for the male Acrobat also continue the celestial imagery introduced by the Chinese Conjurer's costume. Since Massine's choreography pantomimed airborne stunts such as walking the tightrope and flying on the trapeze, Picasso's stellar iconography, as actual trapeze artists had long realized, was particularly apt.

It has been mentioned that the female Acrobat was added to Cocteau's *dramatis personae* upon his arrival in Rome, a bow to Massine's desire to choreograph a *pas de deux*. Two sketches by Picasso, one in colour, appear to be an early idea for the female Acrobat's costume. Painted in the same shade

of blue as the male Acrobat's tights (see figs 94, 95), the corseted bodice, and star-decorated trunks complete with gold tassels, worn over tights is identical to costumes worn by numerous female trapeze artists, aerialists and tightrope walkers during the years around 1900 (figs 100, 101). Picasso had created a drawing of just such a performer in 1905, which seems to have been observed from life (Zervos, vol. 6, fig. 699).

Picasso discarded this early idea (perhaps because it appeared too old-fashioned) and decided instead that the female Acrobat costume should be 'an exact duplicate of the male's costume' (see fig. 93).[11] A record of the costume at this stage exists in a drawing by Cocteau in the Satie Fondation in Paris (fig. 102). A snag was encountered, however, when Lydia Lopokova, who was to dance the part of the female Acrobat, refused to wear the body-tights because they revealed too much of her bosom. Diaghilev agreed that the costume looked inappropriately suggestive on her. Therefore at the last minute Picasso improvised a loose-fitting white tee-shirt tunic and short blue and white vest which covered and concealed the dancer's torso and silk shorts (figs 97, 98). The shirt and vest were appliquéd with swirling motifs while the dancer's tights were painted with blue and white vertical stripes. The costume has always appeared awkward and the various dancers who wore it modified its components, either leaving out vest or shorts. Indeed even Picasso was not satisfed with it. Years later when the Joffrey Ballet was planning a revival of *Parade*, Picasso gave permission to duplicate the male Acrobat's costume for the female dancer instead of the one used in Diaghilev's production.[12]

Like the Chinese Conjurer's costume, the designs for the Acrobats' costumes operate on several levels. They are in accord with circus and music-hall reality, yet the designs are so bold and stylized as not to be mistaken for a contemporary acrobat's costume. The stellar imagery as well as the acrobats' feats of nimbleness beg for symbolic interpretation. Again a parallel with the creative artist, in this case those possessed of an agile imagination who enjoy an ease of execution seems likely, particularly since both Cocteau and Picasso's skills were marked by deftness, facility and an innate sense of timing or

[10]Gustave Fréjaville, ibid., p. 138.
[11]Axsom, p. 70.
[12]Axsom, pp. 70 and 225, n. 10.

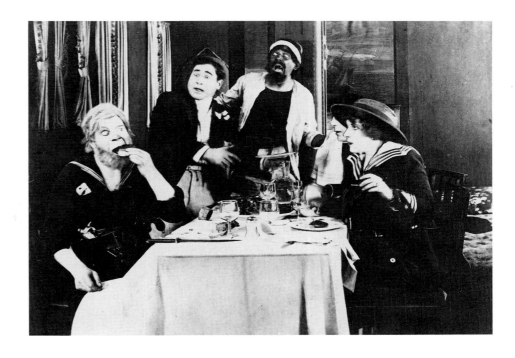

91 The Eight Allissons, an
American acrobatic troupe
active in Paris c.1916

92 Still of Pearl White in *The
Perils of Pauline*, 1916

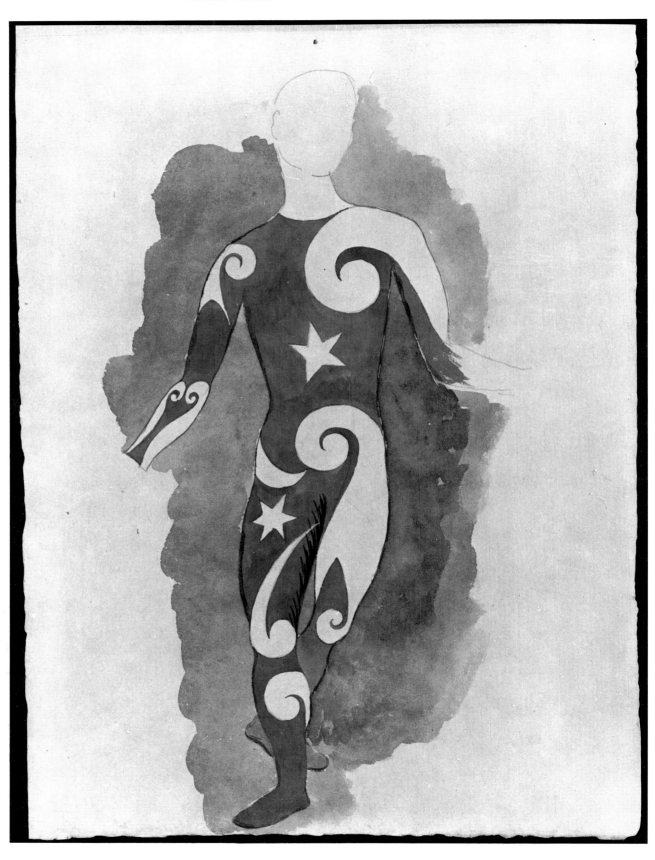

93 Pablo Picasso, project for the male Acrobat's costume, 1917, watercolour and pencil, 280 × 205 mm (MP 1573) (see colour illustration on p. 16)

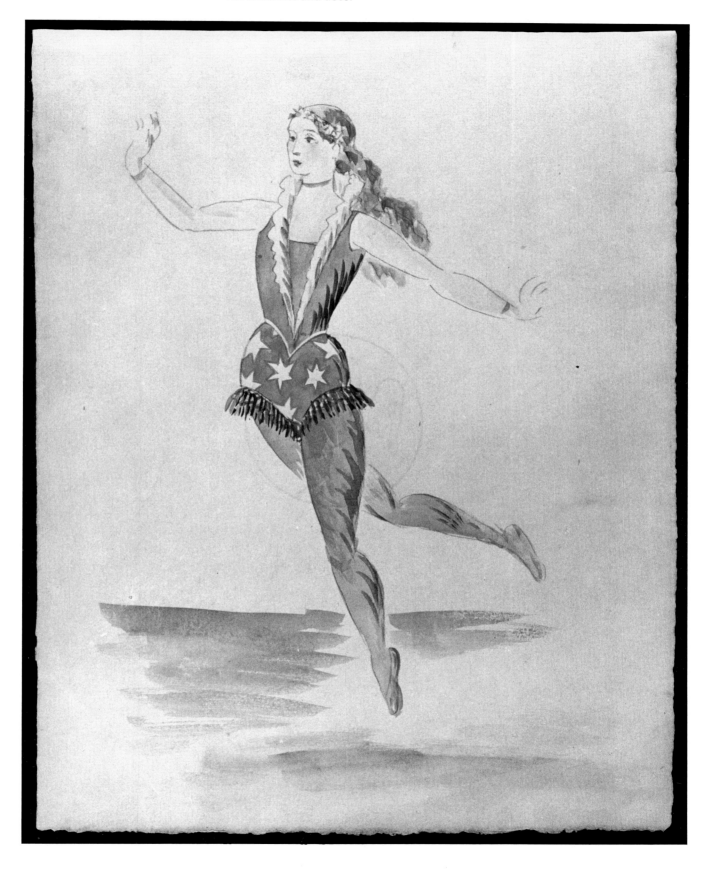

94 Pablo Picasso, project for the female Acrobat's costume, 1917, watercolour and pencil, 275 × 207 mm (MP 1571) (see colour illustration on p. 17)

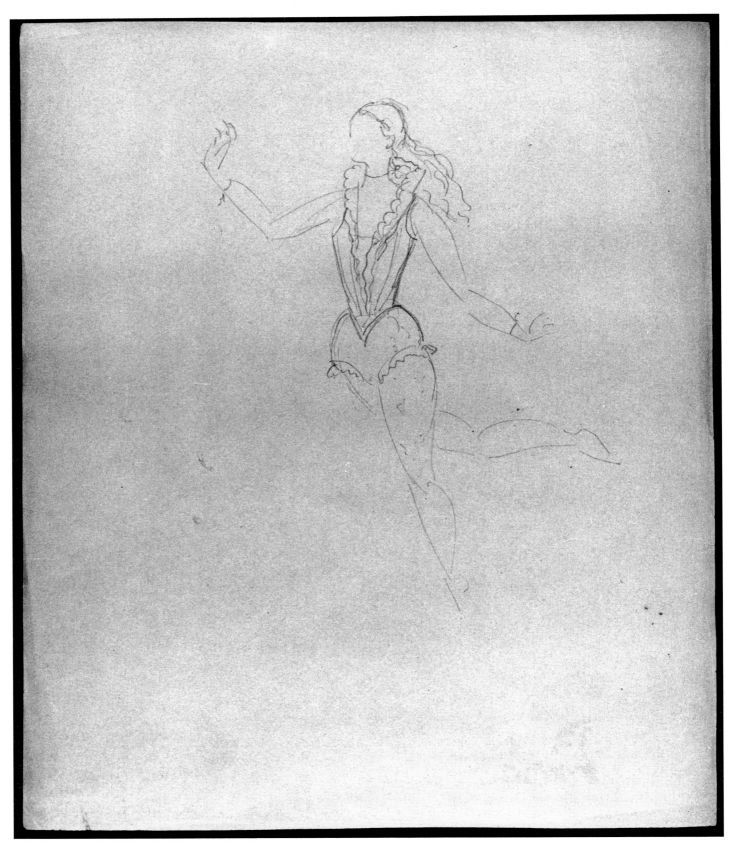

95 Pablo Picasso, study for
the female Acrobat's
costume, 1917, pencil, 280 ×
225 mm (MP 1570)

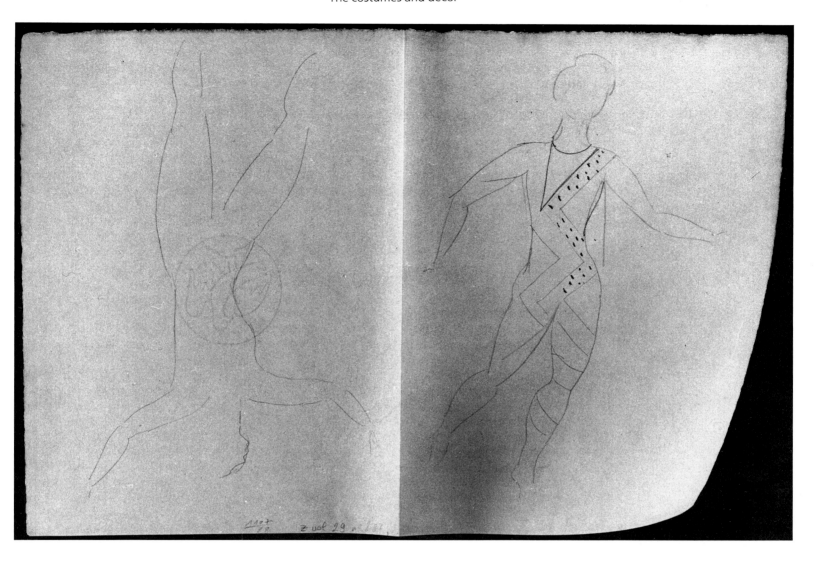

96 Pablo Picasso, study for
an acrobat's costume and
study of a nude, 1917, pencil
on one sheet folded in two,
275 × 205 mm (MP 1572)

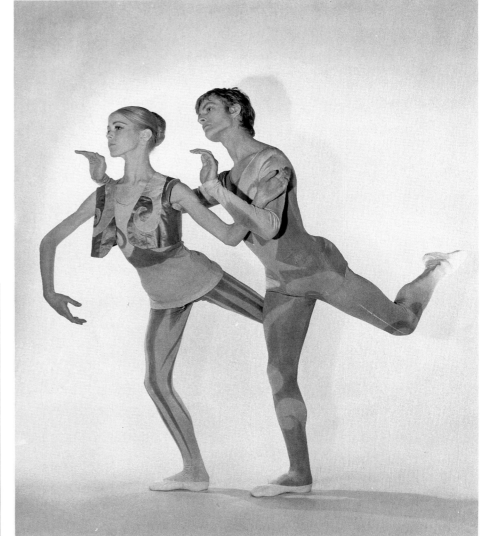

97 and 98 Pablo Picasso's Acrobat's costume, 1917. The female acrobat's original costume combined shorts and a tunic, the vest was added later

99 Circus acrobat, c. 1900

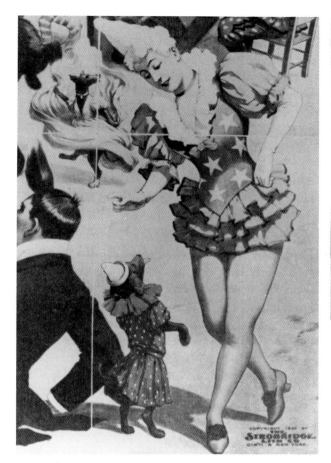

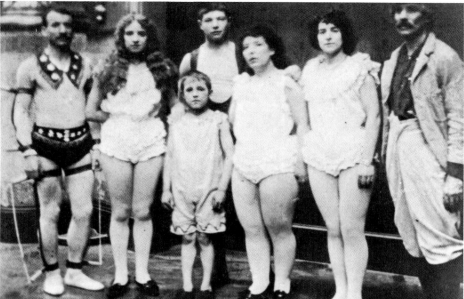

100 Detail from Barnum and
Bailey's poster for the
'Greatest Show on Earth'

101 A troupe of acrobats,
1880

102 Jean Cocteau, pencil
drawing of the female
acrobat, 1917

balance. Unlike the average clod, Cocteau believed the artist/acrobat to a certain extent defies gravity in both his imaginative and technical brilliance. Picasso had already been described as an 'equilibrist who always falls on his feet'.[13] In notes on *Parade* Cocteau scribbled 'for the acrobat look at Picasso' and described the Acrobat as being 'on close terms with the stars', an allusion to the artist's spirit and imagination which operates high above the crowd.

The three acts comprising *Parade* and the additional turn of the two-man horse (*cheval jupon* or *cheval dressé*) (compare figs 3 and 4 to 5 and 6) found counterparts in 1917 on the Parisian popular stage or in the circus. Just as Picasso used bits of newspaper and scrap in his 1912 collages to undermine traditional notions of what materials were suitable for art, so the intrusion of circus and music-hall into the élitist domain of the ballet, served the same purpose of upsetting conventional attitudes and expanding the boundaries of acceptable décor, costumes, set and choreography for the ballet. In both instances Picasso went against classical tradition by pin-pointing his works in time and place. Like the collaged newspapers, which by their very nature are topical and specific, the costumes and characters for *Parade* fly in the face of the classical dictum that a work of art be timeless and general. The irony is that with time Picasso's costumes and décor for *Parade*, like his collages and constructions, have become 'classic' and 'élitist'. Intended to challenge the effete world of high art, to embrace the vitality and freshness of popular culture, and to be treated with the same nonchalance accorded everyday commercial products or ephemera, they have instead been put behind glass in gilt frames or reserved for balletomanes and opera-house audiences.

As discussed, Cocteau's original scenario called for a disembodied voice issuing from an amplifier or megaphone announcing each act with phrases and sounds designed to evoke poetically the personal-

ities of the performers while offering a critique of bourgeois values.

For Cocteau the sounds and phrases designed to 'extend the characters' — that is, to indicate some of the qualities that they would have demonstrated in the 'real' spectacle inside the fair booth, of which *Parade* is a mere sample and come-on — were the heart and soul of his ballet.[14] These phrases, spoken by an invisible 'Barker', outlined each performer's activity and were to be transmitted by a megaphone or 'amplifying orifice' placed directly on the stage.

It is not surprising that Cocteau felt betrayed when Picasso and Satie, shortly after they began working together in September of 1916, decided the ballet would be better without 'Jean's noises'. Satie wrote to his and Cocteau's mutual friend, Valentine Gross, on 14 September: *Chère et douce amie* — If you knew how sad I am! *Parade* is changing for the better, behind Cocteau's back! Picasso has ideas that I like better than our Jean's! How awful! And I am all for Picasso! And Cocteau doesn't know it! What am I to do? Picasso tells me to go ahead, following Jean's text, and he, Picasso, will work on another text, his own — which is dazzling! Prodigious! I'm half crazy, depressed! What am I to do? Now that I know Picasso's wonderful ideas, I am heartbroken to have to set to music the less wonderful ideas of our good Jean — oh! yes! less wonderful . . .[15]

Cocteau continued to lobby for his vocal effects and noises through the autumn and winter of 1916. It was not until he arrived in Rome, that Diaghilev once and for all dashed all hope. Although the impresario was always courting novelty, newness still had to meet certain classical standards. In this instance Diaghilev's conservative, Maryinsky background prevailed as it was taboo to include the spoken word in ballet. Massine writes: Cocteau told Diaghilev that he wanted to incorporate into the ballet every possible form of popular entertainment . . . He wanted the Managers to deliver lines through megaphones and to introduce a number of realistic sound

[13]Cited in Silver, p. 287 by critic André Mare.
[14]Cocteau's vocal inscriptions can be found in several sources. There are loose sheets in the collection of William Lieberman

which compare to the passages cited in Axsom's app. 1, 'Jean Cocteau's "Libretto" for *Parade*, pp. 236–7. These also compare with notes Cocteau made in his two Roman note-

books (Satie Foundation and Bibliothèque de l'Opéra) as well as inscriptions in the original score of *Parade* (Frederick R. Koch Foundation). Reis cites similar notations from Massine

collection holographs (fn 34, p. 211) a source this author has not been able to locate.
[15]Quoted in Steegmuller, p. 167.
[16]Massine, pp. 102–3.
[17]Cocteau persistently held on to

the vocal portion of the ballet even after Picasso's Managers were a *fait accompli*. He 'met the change in his scenario by placing three actors in the orchestra pit, stridently screaming

effects, such as the clicking of a typewriter, the wail of a ship's siren, and the droning of an aeroplane engine because 'they were in the spirit of cubism, and helped to portray the feverish inanity of contemporary life'. Diaghilev would not allow the megaphone, pointing out that the spoken word was entirely out of place in a ballet.[16]

Picasso's idea of three Managers was substituted for Cocteau's aural effects.[17] Cocteau never forgave this defection, yet if he could have put hubris aside he would have realized that although they were never performed, his character descriptions remained the backbone of the ballet – the basis for Satie's music, for Picasso's conception of the Managers as well as for Massine's choreography of the three *parade* turns. Picasso knew exactly what he was doing when he told Satie to continue working from Cocteau's notes (even though they had all decided Cocteau's 'effects' would not be used in the actual ballet), for the poet's conception of the three variety acts, and more importantly his disembodied barker, was translated by Picasso into concrete form without loss of the qualities Cocteau was eager to communicate. It is a tribute to Picasso's artistry that the mystical, adventurous, spiritual characteristics of the Conjurer, Little American Girl, and Acrobat, as well as the monstrous, disturbing anonymity of the Barker/Managers, survived translation into visible form with their Coctelian elements not only intact, but also enhanced.

Thus, Cocteau's sound effects and barker's pitches were deleted for *Parade*'s 1917 debut (some of the noises, such as typewriter clicking, a siren, a wheel of fortune, and revolver shot, were restored in the 1921 restaging). In their place, Picasso produced a different idea for personifying the sideshow barker. He probably had Alfred Jarry's Père Ubu in the back of his mind when he created the ten-foot Cubist

Managers which, (along with the aforementioned two-man horse) in the end proved to be the most startling and memorable part of the ballet (fig. 103; see also figs 3, 66).[18] As a villainous foil to the three performers, these huge parodies of advertising and authority stomped, banged and moved in slow motion across the stage as they introduced each act.

Picasso began his designs by utilizing the flat, overlapping planes he had been working with since 1915 and typified by *Harlequin* (fig. 104) whose sandwich-board forms called to mind Cocteau's characterization of the Managers as 'terribles divinités vulgaires de la réclame'.[19] Several early studies for the Managers also utilize the periscope stylization of the head encountered in the 1915 *Harlequin* as well as in numerous studies and drawings from the years around 1915 (figs 109–11). This type of head was realized in three-dimensional form in the short-lived papier mâché dummy which was mounted on the two-man horse but which fell off before the première (fig. 159). Picasso used it later in his schematic décor of the 'Three Graces' for the 1924 production of *Mercure* where, like a functioning periscope, the heads moved up and down. (fig. 134).

Relying on the witty use of advertisements and logos essayed in his Cubist paintings and collages, Picasso first envisioned the Managers as comical figures based on the sandwich-board men who walked their employers' advertisements through the streets of Paris (fig. 135). One placard which reads: 'Ce Soir – Grand Concert – Miss Merd' not only mimics music-hall publicity, but pokes fun in the vulgar way Cocteau encouraged, at *Ballets Russes'* patroness, Misia Sert, who at one point tried to sabotage the *Parade* collaboration. (see fig. 111).[20] Through Cubism's topsy-turvy way with typo-

out their come-ons and character descriptions of each act . . . Ultimately, all of Cocteau's suggestions for a spoken or sung element in the ballet were overriden by the objections of Picasso and Satie [and especially Diaghilev], who felt that the literary aspect would interfere with the music, choreography, and decor.' Axsom, pp. 43–4.
[18]Jarry's play, a precursor of Sur-

realism and the Theatre of the Absurd, was produced in Paris in 1896. It tells the story of the gross Père Ubu, who at the instigation of his equally repulsive wife, Mère Ubu, decides to acquire the throne of Poland, murdering everyone who blocks his way. The play expressed Jarry's disgust with the greedy and dim-witted human race through broad and grotesque

action. Vulgar, shocking and funny when it first opened, the play caused riots and ran for only two performances. *Ubu Roi* was, however, tremendously influential on young playwrights and artists including Jean Cocteau whose book, *The Potomak* of 1916, is a direct descendant.
[19]The similarity between Picasso's 1915 figures and the *sandwich-*

board man is noted by Gary Tinterow in *Master Drawings by Picasso*, (Cambridge, 1981) fig. 53, p. 138 where writing of the 1915 gouache, *Dancing Couple*, he writes: 'In it, Picasso depicts in Cubist terms a couple, reduced to weightless planes, pushing their sandwich-board forms around a joyless, claustrophobic room.'
[20]While Diaghilev was in America

continued on p.165

in early 1916, Misia Natanson Edwards Sert became angry when she discovered Cocteau and Satie had divulged their idea for *Parade* with Valentine Gross first. Afterwards she tried to extinguish the project. Gold and Fizdale, *Misia*, (New York: Knopf, 1986) p. 188.

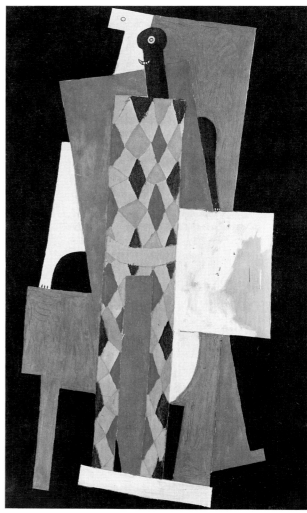

103 French manager from
Parade, 1917

104 Pablo Picasso,
Harlequin, late 1915, oil on
canvas

105 Pablo Picasso, pencil
sketch for the Manager from
his Italian notebook, 1917
(MP 1867—24)

106 Pablo Picasso, page
from his Italian notebook,
1917 (MP 1867)

107 Pablo Picasso, study for
a Manager, 1917, pencil,
280 × 225 mm (MP 1603)

108 Pablo Picasso, study for
a Manager, 1917, pencil,
281 × 225 mm (MP 1601)

109 Pablo Picasso, study for
the Musician manager, 1917,
pencil, 277 × 225 mm
(MP 1608)

110 Pablo Picasso, study for
the Managers, 1917, pencil,
280 × 225 mm (MP 1605)

111 Pablo Picasso, study for
the French manager, 1917,
pencil, 278 × 226 mm (MP
1615)

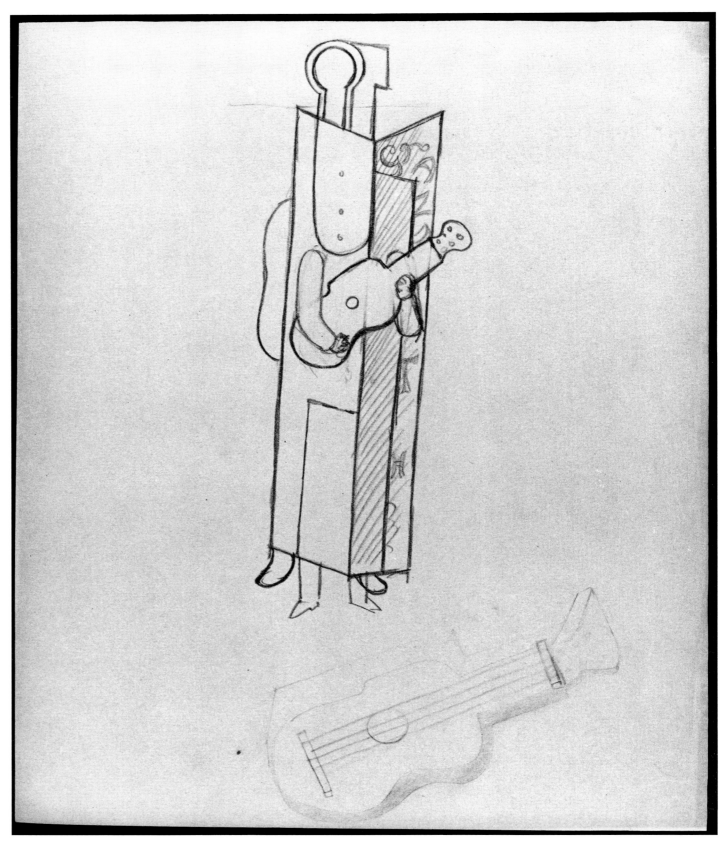

112 Pablo Picasso, studies
for a Musician manager and
his instrument, 1917, pencil,
277 × 225 mm (MP 1610)

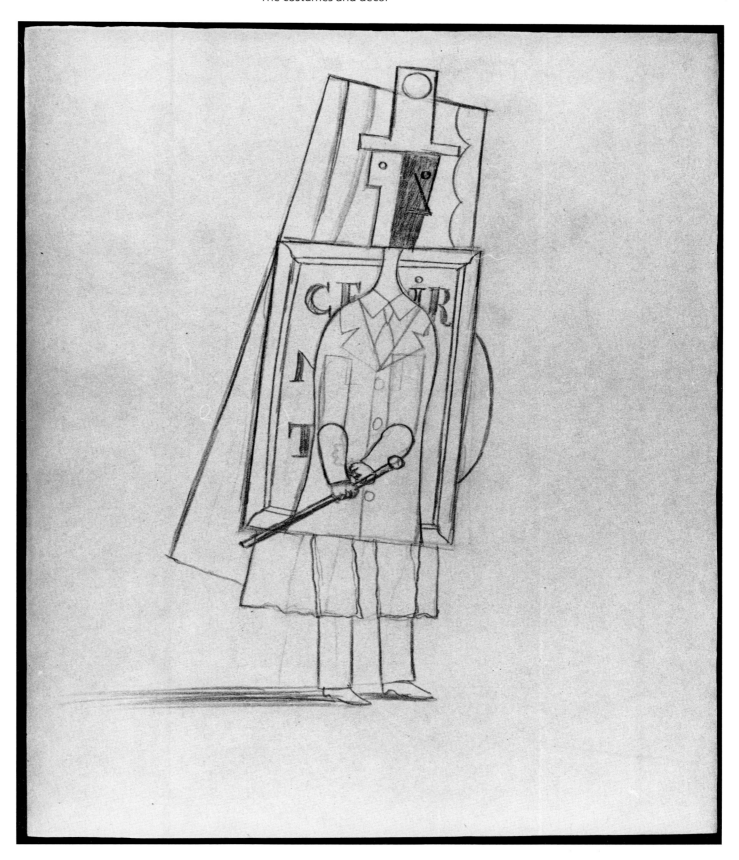

113 Pablo Picasso, study for
a Manager, 1917, pencil, 276
× 225 mm (MP 1614)

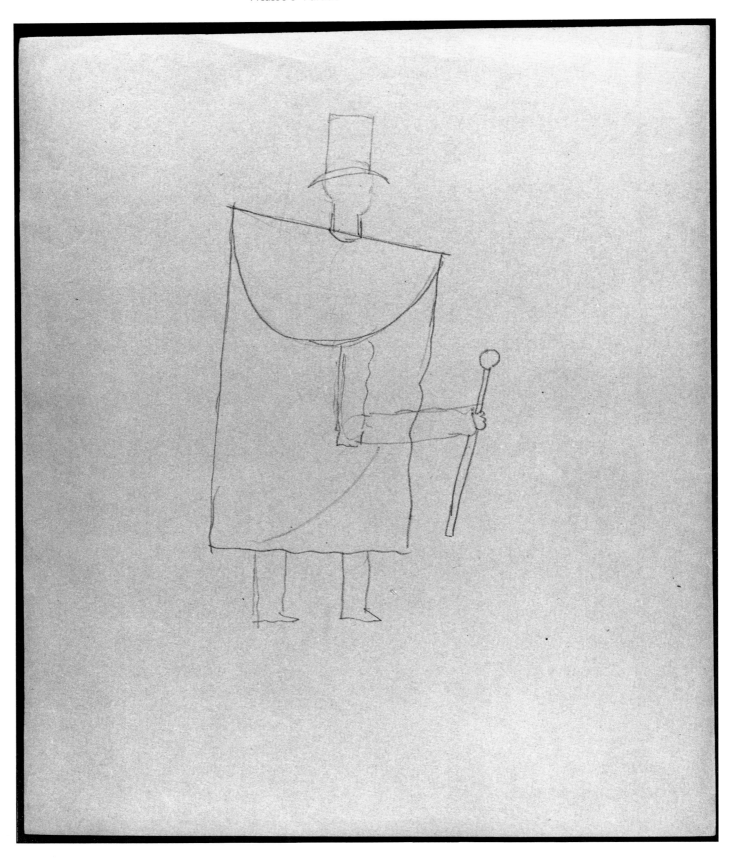

114 Pablo Picasso, study for
a Manager, 1917, pencil,
280 × 225 mm (MP 1604)

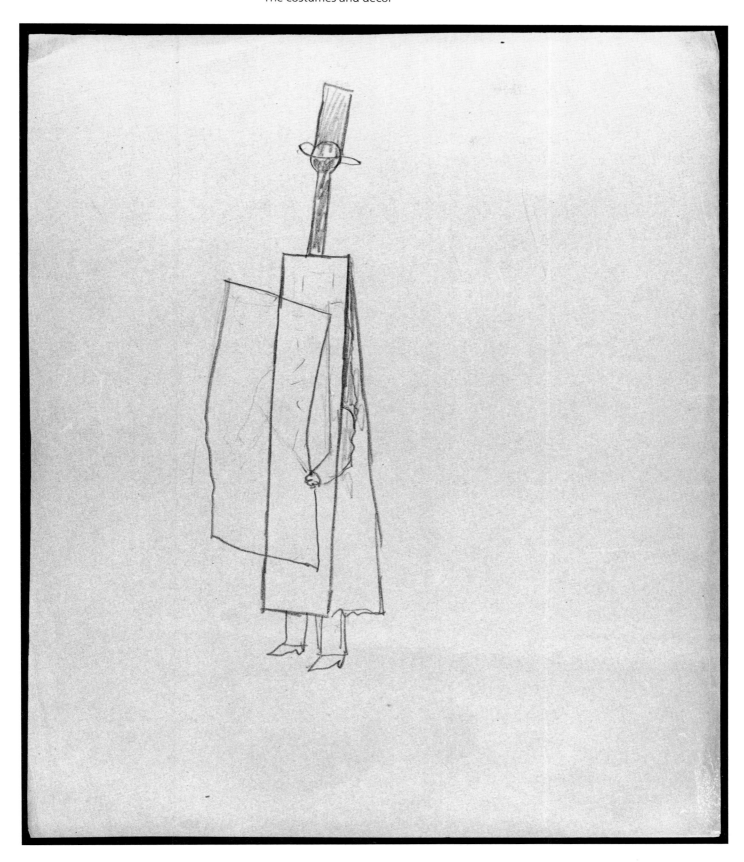

115 Pablo Picasso, study for
a Manager, 1917, pencil 275
× 225 mm (MP 1606) (V)

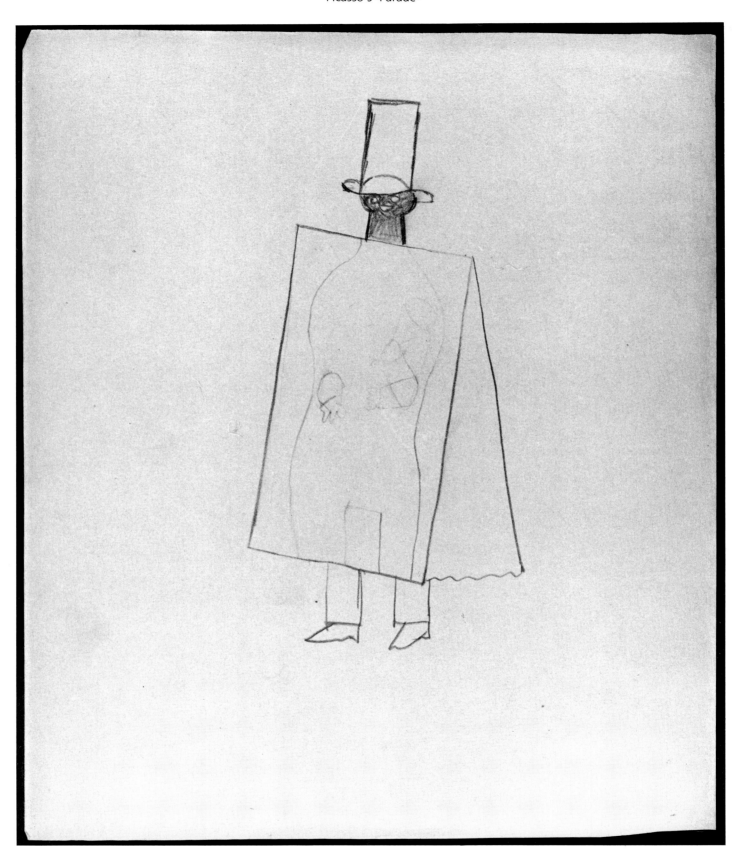

116 Pablo Picasso, study for
a Manager, 1917, pencil,
280 × 225 mm (MP 1609)

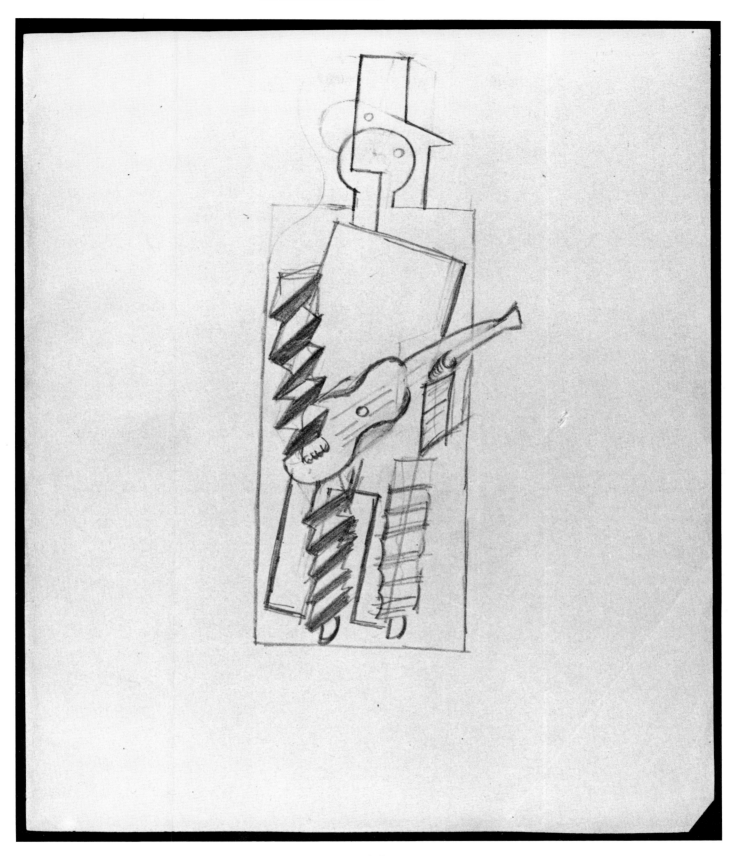

117 Pablo Picasso, study for
a Musician manager, 1917,
pencil, 280 × 225 mm
(MP 1612)

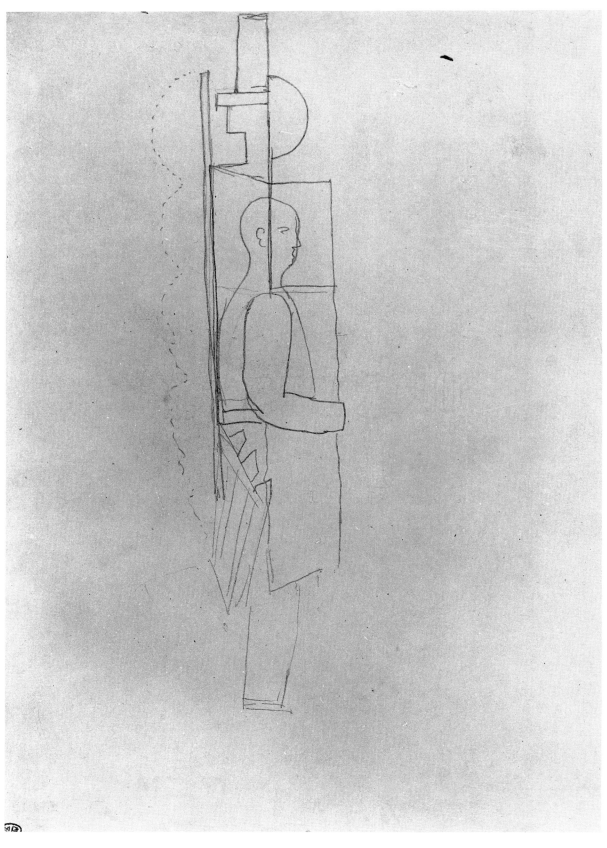

118 Pablo Picasso, study for
the French Manager, 1917,
pencil, 280 × 210 mm (MP
1591)

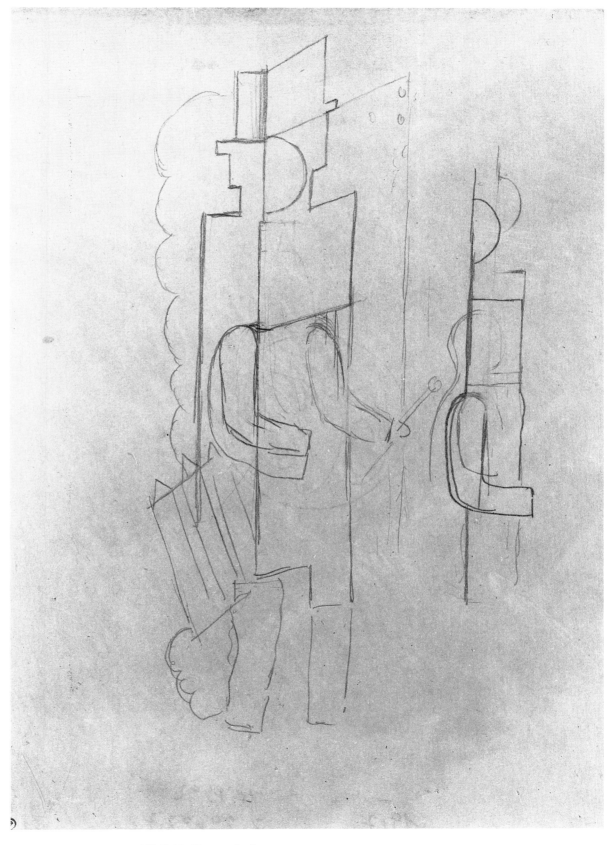

119 Pablo Picasso, studies
for the French Manager,
1917, pencil, 282 × 210 mm
(MP 1592)

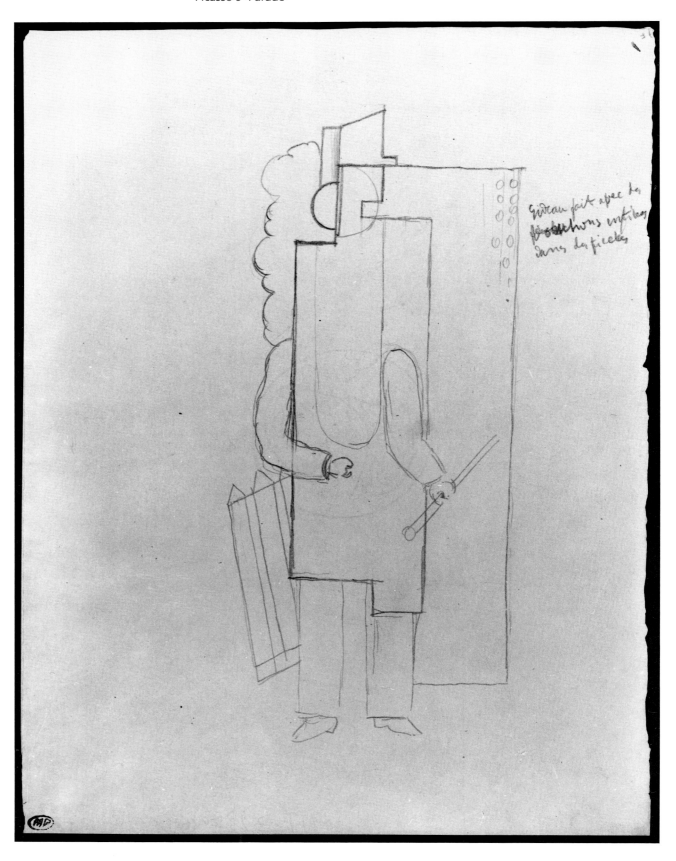

120 Pablo Picasso, study for
the French Manager and the
backdrop, with manuscript
notations, 1917, pencil,
280 × 208 mm (MP 1597)

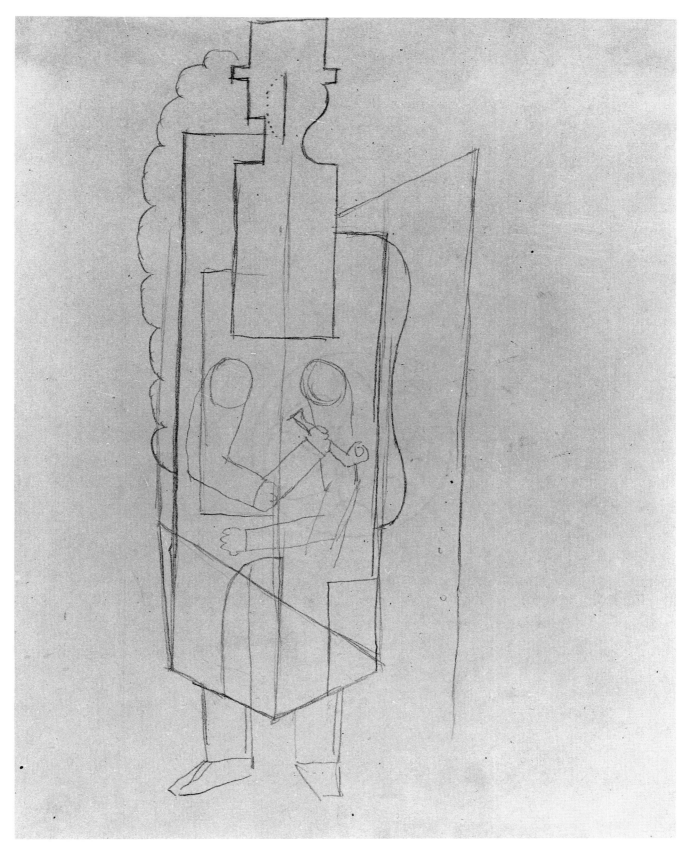

121 Pablo Picasso, study for
the French Manager, 1917,
pencil, 280 × 207 mm (MP
1599)

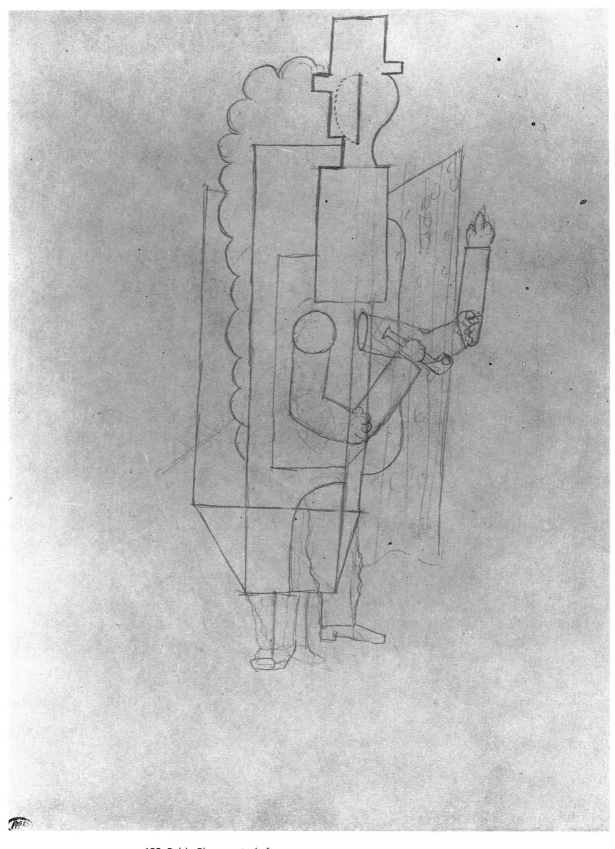

122 Pablo Picasso, study for
the French Manager, 1917,
pencil, 281 × 205 mm (MP
1600)

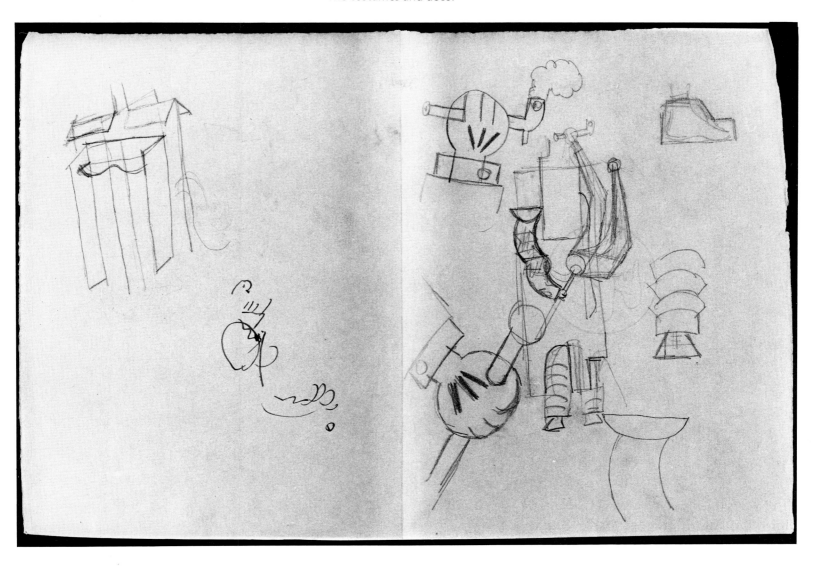

123 Pablo Picasso, studies of
details for the French
Manager, 1917, pencil and
brown ink on an unfolded
double sheet, 275 × 210 mm
(MP 1617)

124 Pablo Picasso, studies of
arms and hands holding Manager, 1917, pencil,
pipes for the French 275 × 210 mm (MP 1616)

125 Pablo Picasso, study for
the French Manager, 1917,
pencil 275 × 210 mm
(MP 1594)

126 Pablo Picasso, study for
a Manager, 1917, pencil,
275 × 225 mm (MP 1611)

127 Pablo Picasso, study for
a Manager and a pig, 1917,
pencil, 277 × 225 mm (MP
1613)

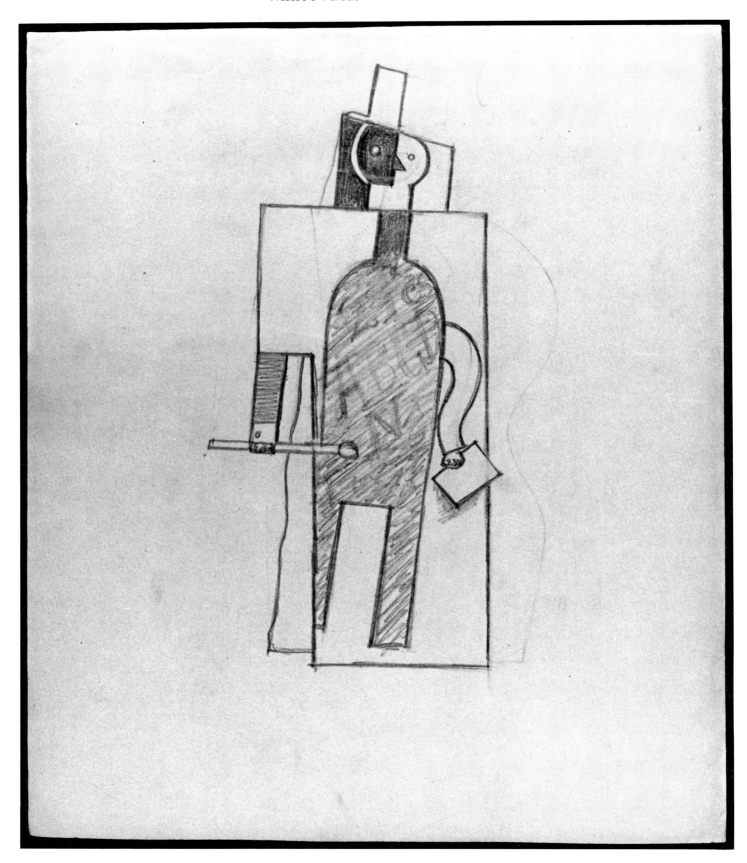

128 Pablo Picasso, study for
a Manager, 1917, pencil,
277 × 225 mm (MP 1607)

129 Pablo Picasso, studies of
costume elements for the
French Manager, 1917,
pencil, 275 × 210 mm (MP
1619)

130 Pablo Picasso, project
for a dancer's costume, 1917,
pencil, 275 × 225 mm (MP
1606) (V)

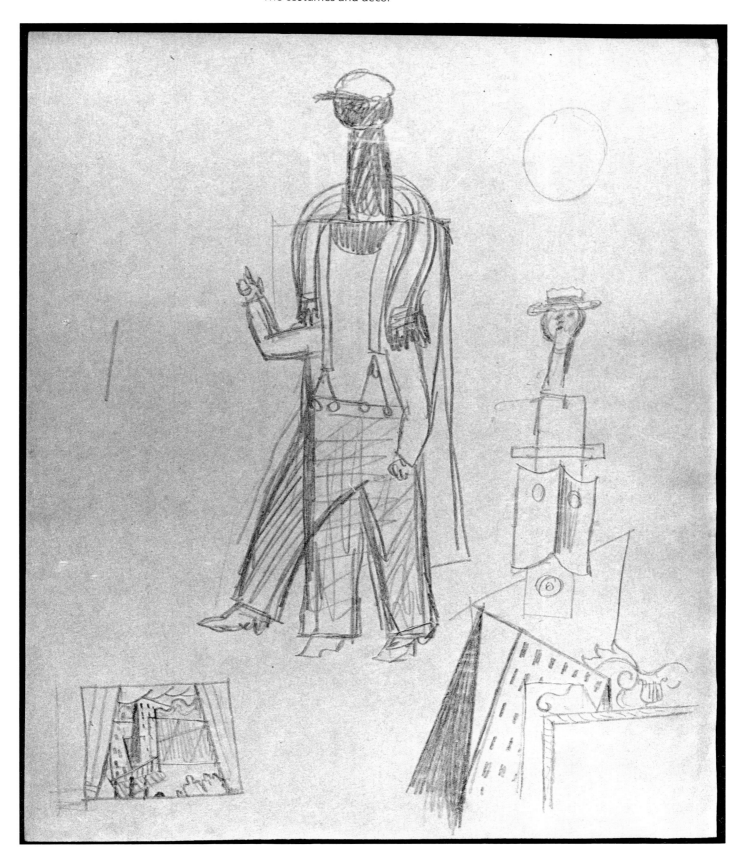

131 Pablo Picasso, studies 1917, pencil, 275 × 225
for the set and costumes for (MP 1602)
the American Manager,

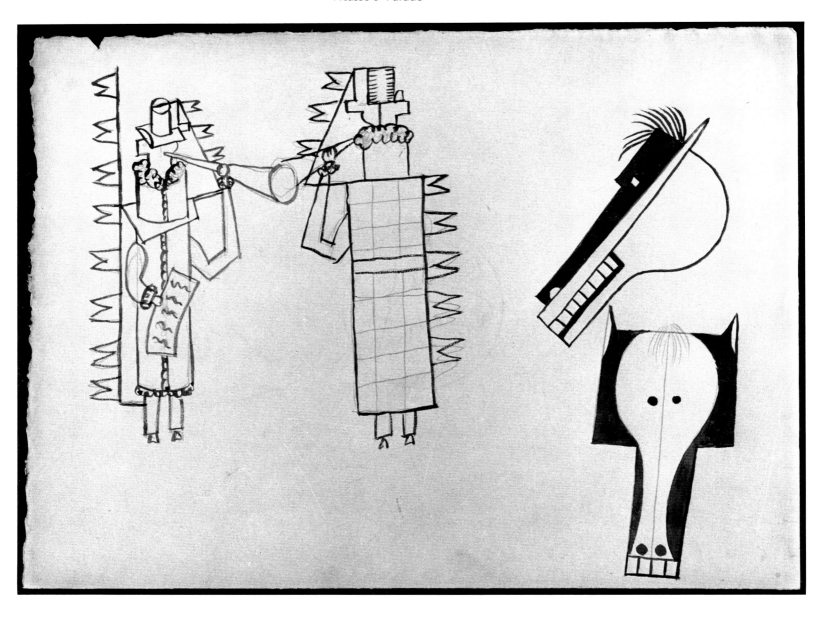

132 Pablo Picasso, study for
the American Manager and
the head of a horse, 1917,
gouache and pencil, 205 ×
280 mm (MP 1598) (see
colour illustration on p. 23)

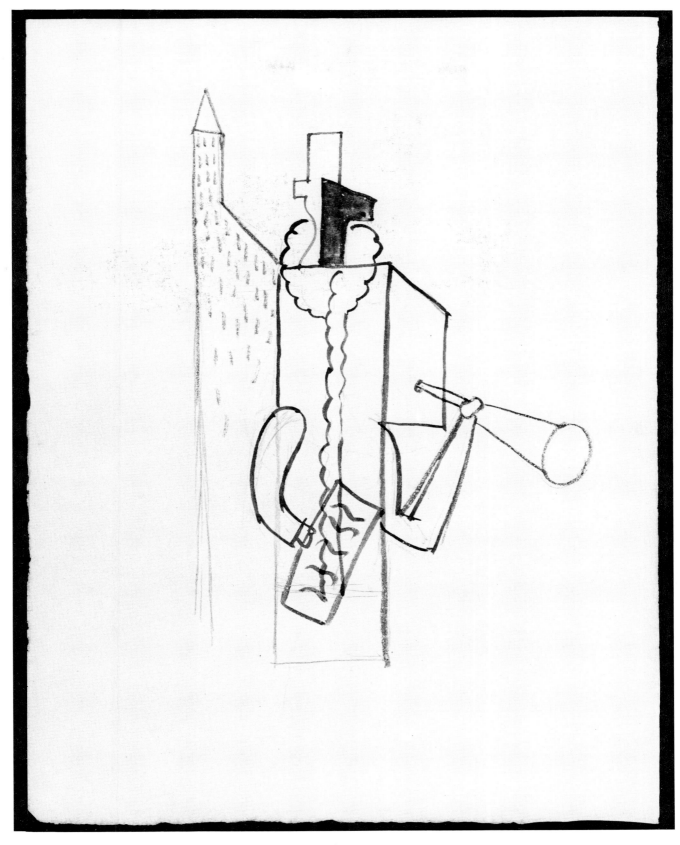

133 Pablo Picasso, study for
the American Manager,
watercolour and pencil,
280 × 205 mm (MP 1596)

134 Pablo Picasso, set décor
for *Mercure*, La Cigale, 1924;
wood, cardboard, wicker and
metal

135 Street vendor, Paris,
Second Empire

graphy the placard can read: 'Miss . . . Cert . . . Grand Con . . . Miss Merd'.[21]

Massine relates that when the collaborators first worked together in Rome, *Picasso was delighted by the whole concept [of a ballet incorporating elements of the circus and music-hall] . . . and he quickly produced some rough sketches, the most striking being those for the French and American managers, whom Picasso visualized as animated bill-boards suggesting the vulgarity of certain types of show-business promoters.'*[22]

Picasso's sandwich-board Managers gradually evolved into figures that rely more fully on Cubist construction. One Manager (see fig. 113) appears to be an early stage of the French Manager (note baton and top hat). The placard is now behind the body, and elements from the surroundings (the stage curtain in this instance) begin to be incorporated into the figure. The face is divided into realistic/abstract, frontal/profile aspects much as it appears in the final French Manager.

Picasso made numerous preliminary sketches for the Managers; some examples of these show a Manager straddling a pig (see fig. 127), a choice possibly suggested by the common use of wooden pigs in fairground rides for children or perhaps by Cocteau's description of the barker introducing the Conjurer which includes, 'pigs who eat little children'. Finally he arrived at sketches which serve as the basis for the initial three Managers (see figs 118–25, 129–30, 132–33).

The forty-odd sketches of the Managers in the collection of the Musée Picasso not only trace their evolution, but also document how carefully Picasso thought-out every detail of the costumes, from the French Manager's spats (see fig. 129) to the way a dancer would fit inside the construction (see

fig. 118). After arriving at his final design he drew the Managers from various points of view (see figs 121, 122). From these sketches Picasso began to construct the Managers' costumes using cardboard, canvas, metal and, according to Massine, improvising with any scraps that were at hand in and around the Châtelet theatre.[23] The eight foot 'shells' or 'carcasses' that emerged were difficult for the dancers who wore them to support, a factor which in part conditioned Massine's choreography of stomping and slow angular movements for the Managers.

Many scholars have asserted that seeing Futurist sculpture in Rome on his 1917 trip, particularly that of Umberto Boccioni and Fortunato Depero (fig. 136) was a key influence on Picasso in his conception of the Managers.[24] Since the spring of 1912 Picasso had, however, been working towards the specific solutions attained in the Managers.[25] His collages and constructions from that time show him undermining accepted notions of the boundaries between figure and ground. Initially he realized these ideas in sketches and wall-relief constructions, rather than three-dimensional figures, but this seems a minor quibble and one need look no further than Picasso's earlier work to find the inventions embodied in the Managers that are generally credited to Futurist influence, namely the inclusion of environmental motifs into Cubist constructions, and the use of non-traditional materials.[26]

Picasso's move toward figure-cum-environment structures is dramatically demonstrated by the photograph which he had pinned to his atelier wall from 1913 showing a construction of a guitar player incorporating an actual guitar, a table, a bottle of wine, and a newspaper as part of the work (fig. 137).[27] Christine Poggi writes, The tendency in

[21]See Rosenblum, eds Penrose and Golding, 'Picasso and the Typography of Cubism',*Picasso in Retrospect*, (New York, 1973) p. 53.
[22]Massine,p. 102.
[23]Told to the author by Kermit Love who recreated the Managers according to Massine's specifications for the March 1973 revival of *Parade*. Several Futurist artists aided in building the frames for the original Man-

agers while the troupe was in Rome, i.e. before they arrived in Paris at the Châtelet. See Jean Cocteau, 'Pablo Picasso', in *My Contemporaries*, (Rome, 1968) p. 71, where Cocteau notes: 'At the time the Futurists consisted of Prampolini, Balla and Carrà. They were kind enough to help us build the frames for Picasso's costumes and to make the work possible.' See also chapter 3, n. 12.

[24]For example, Axsom writes, 'it is fairly clear that Picasso looked to Futurism for aspects of the costumes he designed for the Managers.' Axsom, pp. 81–6. See also Volta, *Erik Satie e gli artisti del nostro tempo* (exhib. cat. Spoleto, 1981), pp. 60–1, and Martin, 'The Ballet *Parade*: A Dialogue between Cubism and Futurism', *Art Quarterly*, 1977. Martin views *Parade* as a deliberate parody of Futurism,

perpetrated by both Cocteau and Picasso.
[25]Axsom writes that Boccioni's call for new materials in his *Manifesto of Futurist Sculpture* was published in Paris in April 1912, thereby pre-dating by one month Picasso's *Still Life with Chair Caning* (a painting that contains collage elements such as oilcloth and rope, Musée Picasso, Paris, p. 82). While this makes for a neat

argument, it shows little understanding of the creative process. It is unlikely Picasso rushed to create a work of art based on a theoretical paragraph he may have read. Axsom, p. 82.
[26]Picasso had used non-traditional materials – oilcloth, rope, spoons, sheet metal, newspaper clippings – long before the Futurists.
[27]See also the many sketches for a guitarist created at Sorgues

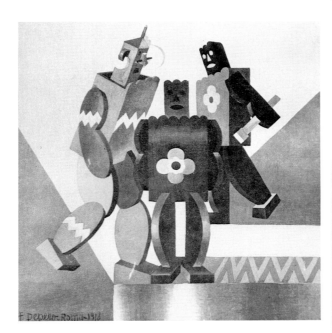

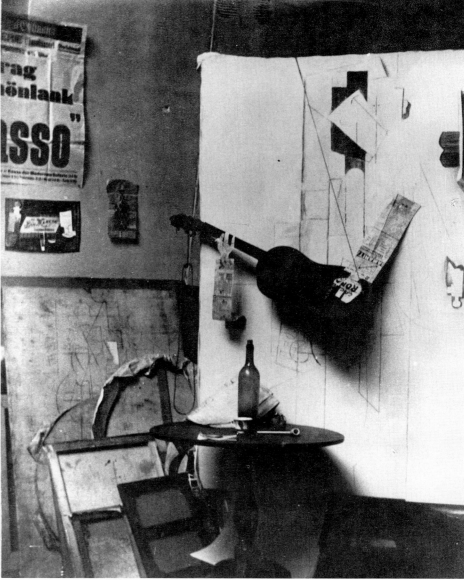

136 Fortunato Depero, study
for futurist puppets, for
I piccoli selvaggi, 'Balli
plastici', Rome, 1917—19

137 Pablo Picasso, *Guitar
Player*, wall construction,
1913, Paris, Boulevard
Raspail, destroyed

Picasso's post-1912 work for collage elements to break through literal or figural frames became especially marked in his constructions. Most of these extremely fragile works, made of humble and unlikely materials . . . are known only through photographs.[28]

Many drawings from 1915–16 not only depict figures conflated with their surroundings (as figs 138–40), they are also stylistically much closer to the Managers than works by Futurist artists. Specific features such as an elongated arm paired with a small one on the same figure (compare fig. 138 to American Manager fig. 66), the rectangle upon rectangle manner of describing a tuxedo (compare fig. 139 to French Manager fig. 103) or the use of a simplified 'L-shape' standing for a profile (see figs 140, 141) were present in Picasso's work long before his trip to Rome and his contact there with the Futurists.[29] Specifically Picasso's 1915 painting *Harlequin* (see fig. 104) where the figure's head is divided into black and white planes that are bridged by a macabre smile, is recapitulated in the head of the French Manager with his upturned moustache visually taking the place of Harlequin's smile (see fig. 103).

It has been suggested that in their final form the Managers rely to some degree on a type of *image d'Epinal* or naïve popular print, known as the *'Cris de Paris'*, that portray itinerant merchants carrying their wares on their back.[30] Indeed, we know as early as 1901 Picasso saw and appreciated these crude, folkloric popular prints: Max Jacob recalled that soon after they met, 'He . . . admired my *images d'Epinal*, which I think I was the only person collecting at that time . . .'.[31] The awkward, naïve style of *images d'Epinal* is especially relevant to the *Parade* curtain (see Chapt. 8). Another type of popular print, a kind of cousin to the *Cris de Paris*, is pertinent to the Managers. Called *architectures vivantes* these prints, which depict peddlers or labourers constructed from the tools of their trade, are still sold on the streets of Paris today. The *architectures vivantes*, like the *Cris de Paris*, were used as advertisements by itinerant merchants and as such possess an intellectual logic as sources for the Managers, characterized by Cocteau as 'vulgar divinities of advertising.' Along the same lines and more to the theatrical point are the prints made of Jean Berain's designs from the second half of the seventeenth century for stage costumes that combined scenery and figure such as the *Habit de musicien* (fig. 142). One can only speculate whether Picasso was familiar with any of these popular images which, like the Managers, are composed of environmental and personal emblems and like them make liberal use of witty *double entendre*.

Just as Cocteau's Little American Girl was a kind of free-association of a foreigner's view of the United States, so Picasso's American Manager (see fig. 66) encapsulated the artist's and Cocteau's notion of a country they had never seen. It was a notion derived largely from cinema and advertising, which combined stereotypes of the rural West (fig. 143) and the urban East. The American Manager sports cowboy chaps, a cowcatcher, and an oversized bullet holster vest, as well as a skyscraper complete with a smoking chimney. Nautical flags of the type found on passenger boats run down his left side, he holds a megaphone in his left hand and a placard reading 'PA/RA/DE' in his right.

No doubt Picasso was using Cocteau's free-association character sketch of the Little American Girl, whose act the American Manager introduces, since

during the summer of 1912 which are clearly models for a three-dimensional work. In fact, they materialized as such in the form of a small paper construction Picasso brought as a dinner gift to Gertrude Stein in the spring of 1913. See William Rubin *Picasso and Braque Pioneering Cubism* (New York, The Museum of Modern Art, 1989) pp. 242–3, and p. 282 lower right.

[28]Christine Poggi 'Frames of Reference: 'Table' and 'Tableau' in Picasso's Collages and Constructions,' *The Art Journal* (Winter 1988, vol. 47, no. 4), p. 317. Poggi identifies the guitar player as Harlequin and is convinced that *Head of a Man* (oil, charcoal, ink, pencil on sized paper, New York, Richard S. Zeisler Collection) is the surviving portion of the backdrop of *Assemblage with Guitar*

Player (Poggi, n. 35).
[29]Even if one argues that Boccioni's 1912 sculptures (where figure and environment are attached) pre-date the constructions and drawings cited above, it must be remembered that initially the Futurists had taken their cue from Picasso and Braque's 1909 Cubism which had already expressed a concern with the impingement of environmental events and sen-

sations upon objects or individuals (albeit in a more ambiguous and illegible way). Picasso continued probing figure-ground relationships in Cubism's second 'Synthetic' phase using a new vocabulary of flat, simplified and opaque forms.
[30]The coloured broadsides of the *image d'Epinal* had been produced since the sixteenth century in Epinal, a town in the

province of Lorraine in Eastern France. See Kenneth Silver, 'Jean Cocteau and the *Image d'Epinal*: An Essay on Realism and Naïveté' in *Jean Cocteau and the French Scene* (New York, 1984) p. 93ff.
[31]Quoted in Marilyn McCully, ed., *A Picasso Anthology: Documents, Criticism, Reminiscences* (Princeton, 1982) p. 37.

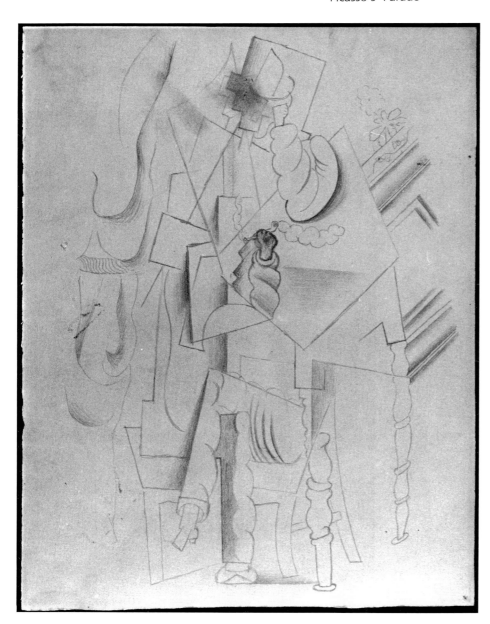

138 Pablo Picasso, *Man with pipe seated at table*, pencil, 1914–15, Avignon (MP 755)

139 Pablo Picasso, *Actor with cane and glove*, 1916, pencil, Paris

140 Pablo Picasso, *Seated
man with a cane*, 1916,
drawing, Paris

141 Pablo Picasso, *Woman
standing*, 1916, drawing,
Paris

142 Jean Berain, *Habit de musicien*, second half of seventeenth century, Paris

143 Article on William Hart, from *Motion Pictures*, March 1916

his iconography adopts a number of the images Cocteau mentions: 'cowboys with leather and goat-skin chaps . . . the sheriff's daughter . . . the silence of stampedes . . . the 144 express . . . Pullman cars which cross the virgin forest . . . my room on the seventeenth floor, posters – advertising . . . the list of the victims of Lusitania.'[32]

By contrast the French Manager (see fig. 103) epitomized the haughty elegance of a cosmopolitan dandy, complete with the tree-lined boulevard along which he might stroll, attached magnet-like to his back. In black top hat, tie and tails, a ballet master's baton in hand, he was a thinly disguised caricature of Diaghilev – the facial division into black and white a reference to the impresario's distinguishing streak of white hair (see fig. 1). The ballyhooing manager was a fitting role for the Russian impresario who was constantly trying to garner support for his enterprise, and who bullied and terrified his troupe with frequent displays of temper. In fact in a famous statement Diaghilev once referred to himself as 'an unusually enthusiastic charlatan'.[33] It was of course the fairground charlatan or hawker whom Cocteau originally had in mind when he created the character that evolved into the Managers.

The identification with Diaghilev is confirmed in one of Picasso's early sketches for the Managers – at a stage before they were divided into a French and an American – where the figure wears a fur-trimmed coat and a hat too small for his huge head, both of which were among Diaghilev's sartorial trademarks (fig. 144; see also fig. 132).[34] It has been suggested that the nautical flags refer to the incessant travelling of the *Ballets Russes* enterprise. To this one might add the allusion to Diaghilev's well-known fear of water and of venturing overseas.[35]

Picasso scholar Richard Axsom has suggested the French Manager was meant to represent the com-

père, or Master of Ceremonies in variety theatre.[36] As such he was the ideal figure to introduce the Oriental conjurer whose act was an essential component of all music-hall repertoires. The association of Diaghilev with the music-hall compère must have amused those who understood the hidden identity of the French Manager, for Diaghilev detested variety theatre. Massine recorded of their 1919 run at the London Coliseum: 'Diaghilev was irritated by the music-hall acts. He clearly resented having his productions sandwiched between performing dogs and acrobats and clowns'.[37]

Picasso's Managers, which seemed so radical at the time, were before too long homogenized for mass consumption. Hollywood, the inspiration for the Little American Girl, repopularized that which Picasso and Cocteau had elevated and transformed (fig. 145). With the movie musicals *Broadway* of 1929 and *Forty-Second Street* of 1933, *Parade*'s Managers had come full circle. The 'skyscrapers' worn by the chorus girls as costumes are meant to be clever and extravagant in the manner of Busby Berkeley's musical spectacles, but contain nothing of the complexity that marked the American Manager as a comic/tragic creation. One set décor which comes close to the spirit of the Managers in its montage of urban views is the set and costumes for the opening scene of *Flying Colors* by Norman Bell Geddes (*c.* 1930) where birds-eye and worms-eye views, advertising logos and high-kicking chorus girls create a fitting metaphor for the hustle and bustle of city life.

The French Manager introduced the Chinese Conjurer, the American Manager announced the Little American Girl, and initially a third Negro Minstrel Manager was to present the Acrobats.[38] While the collaborators were in Rome, it was decided that the Negro Manager should be mounted on horseback.

continued on p.186

[32]Brown, pp. 128–9.
[33]L'Ancienne Douane, *Les Ballets russes de Serge Diaghilev* (Strasbourg, 1969), p. 16.
[34]Boris Kochno has described how, for as long as he knew him, although Diaghilev always appeared wealthy, in fact he had only one suit, one tuxedo and one coat (which in later years he fastened with a safety pin). Conversation with Kochno, Paris, Nov. 1985.
[35]Diaghilev was extremely superstitious. As a child a fortune-teller had told him he would die by water. As a result he was terrified of sea travel. The prediction eerily came true but in an unexpected fashion as in 1929 Diaghilev died in Venice, from diabetes not drowning, but surrounded by water nonetheless.
[36]Axsom, p. 76. He notes that 'With his bow-tie, top hat, dickey, [knee] breeches and hose, the French Manager was dressed in the formal evening clothes of a Compère . . . With his turned-up moustache, he bore an uncanny resemblance to Seurat's ringmaster in *Le Cirque*.' (See also the compère to the right in Seurat's *Parade* (fig. 184).
[37]Massine, pp. 129, 131.
[38]Picasso renders a stereotypical image of the black entertainer, whom Joseph Boskin in a recent study terms 'Sambo'. This pop-

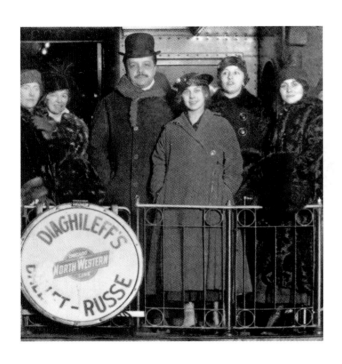

144 Serge Diaghilev, 1916;
note Olga Koklova on the far
right

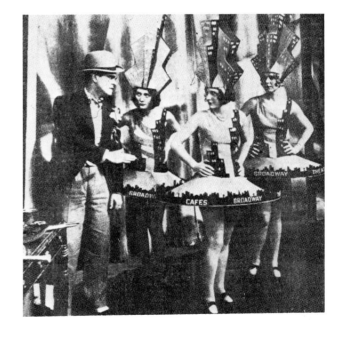

145 Still from the film
Broadway, 1929

146 Pablo Picasso, study for the Manager on horseback; still life on a table before an open window, 1917, pencil on sketchbook sheet, 310 × 155 mm (MP 1583)

147 Pablo Picasso, study for
the Manager on horseback,
1917, pencil, 270 × 212 mm
(MP 1582)

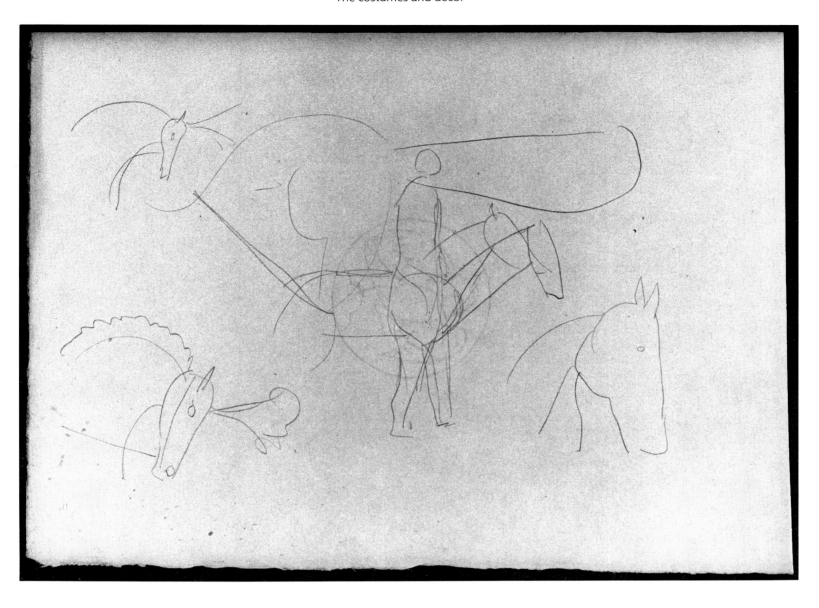

148 Pablo Picasso, studies
for the Manager on
horseback, 1917, pencil,
204 × 280 mm (MP 1585)

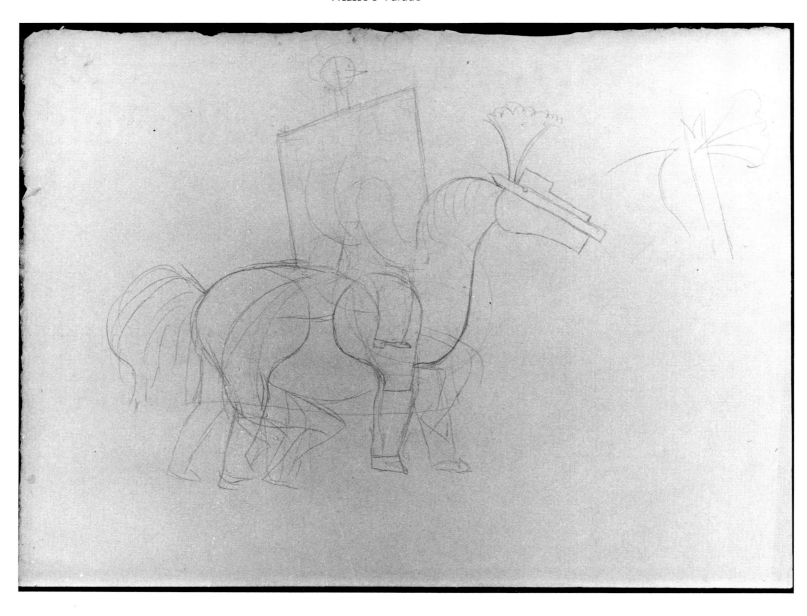

149 Pablo Picasso, study for
the Manager on horseback,
1917, pencil, 205 × 280 mm
(MP 1588)

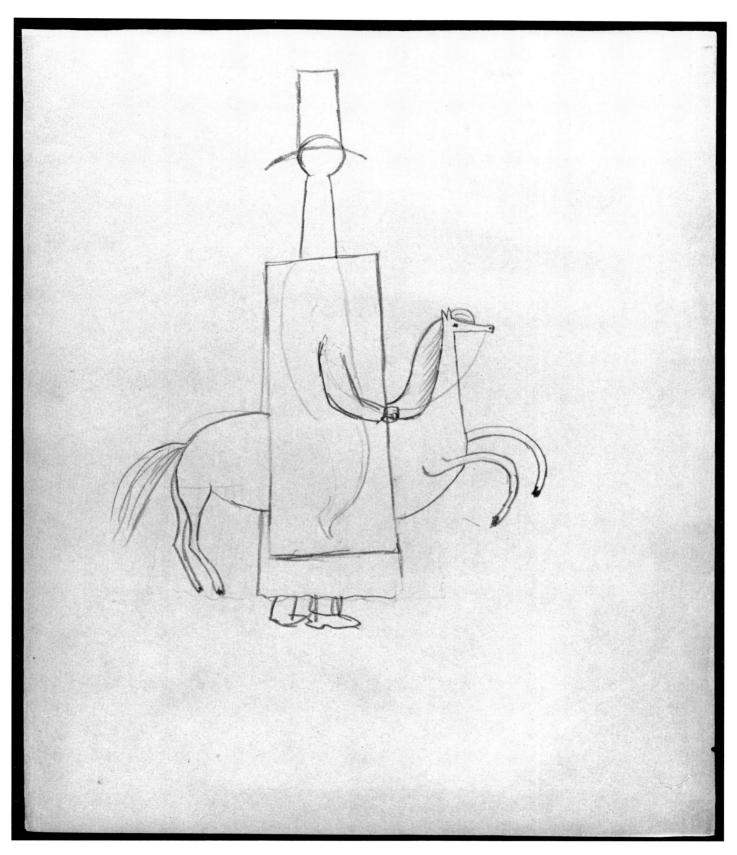

150 Pablo Picasso, study for
the Manager on horseback,
1917, pencil, 280 × 225 mm
(MP 1581)

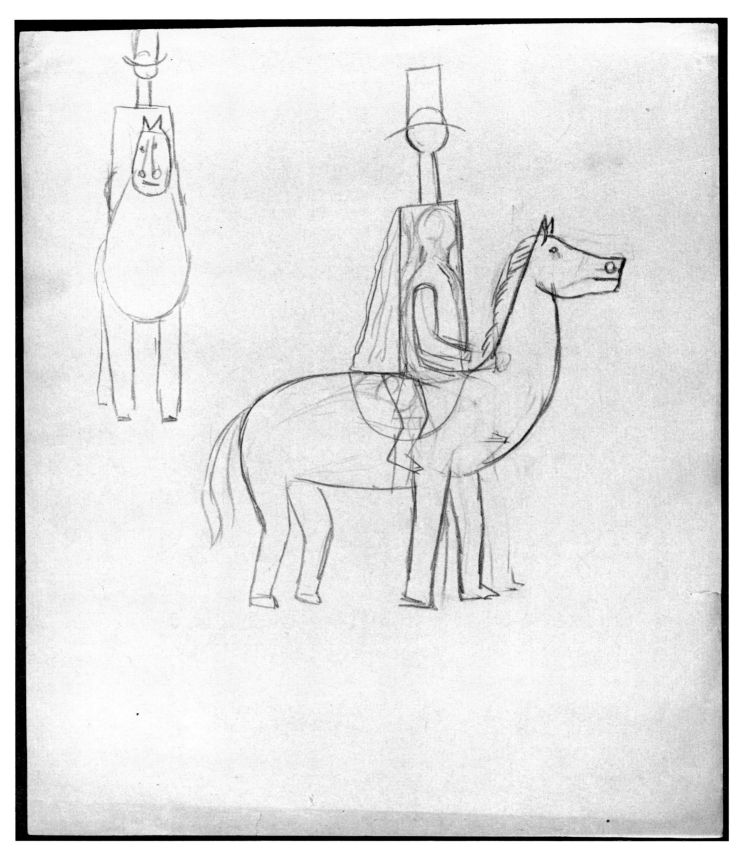

151 Pablo Picasso, study for
the Manager on horseback,
1917, pencil 280 × 225 mm
(MP 1580)

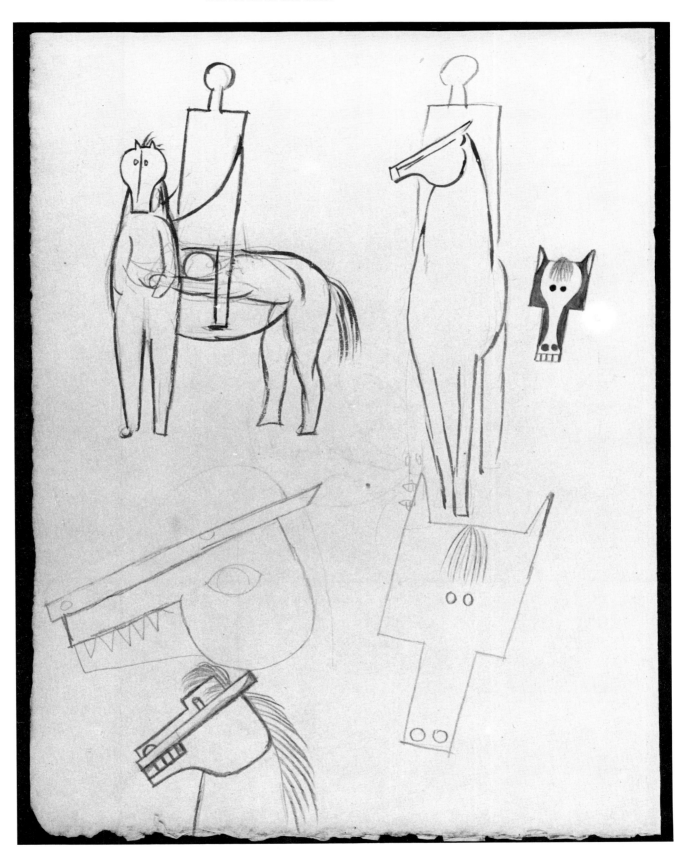

152 Studies for the Manager
on horseback, 1917, pencil
and watercolour, 275 ×
210 mm (MP 1593)

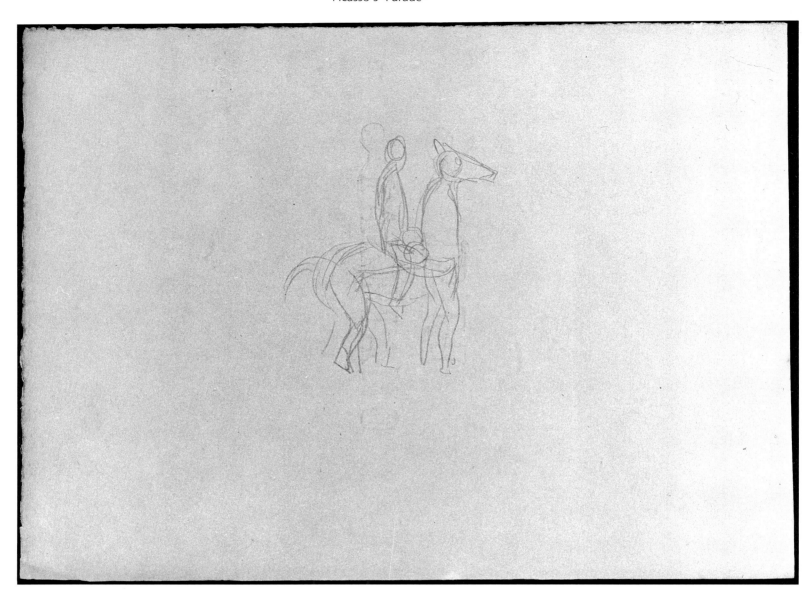

153 Pablo Picasso, study for
the Manager on horseback,
1917, pencil, 205 × 280 mm
(MP 1618)

154 Pablo Picasso, studies
for the Manager on
horseback and musical
instruments, 1917, 205 ×
280 mm (MP 1584)

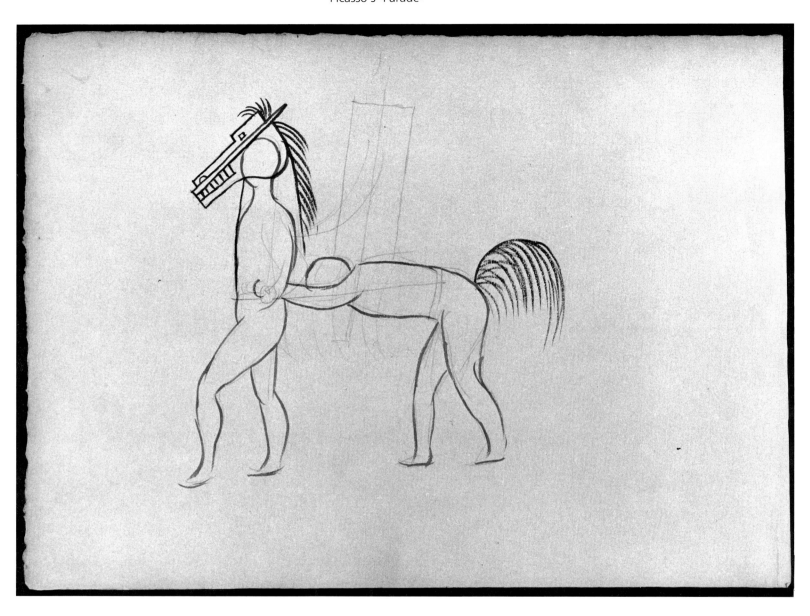

155 Pablo Picasso, study for
the Manager on horseback,
1917, brown and blue ink,
pencil, 207 × 280 mm (MP
1587)

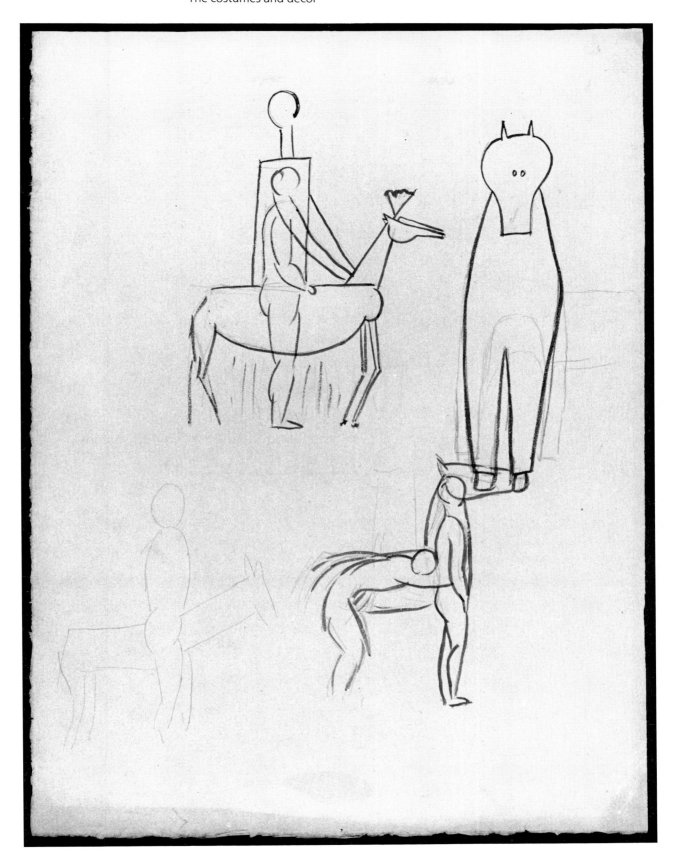

156 Pablo Picasso, studies
for the Manager on horse-
back, 1917, watercolour and
pencil, 280 × 204 mm
(MP 1590) (see colour
illustration on p. 24)

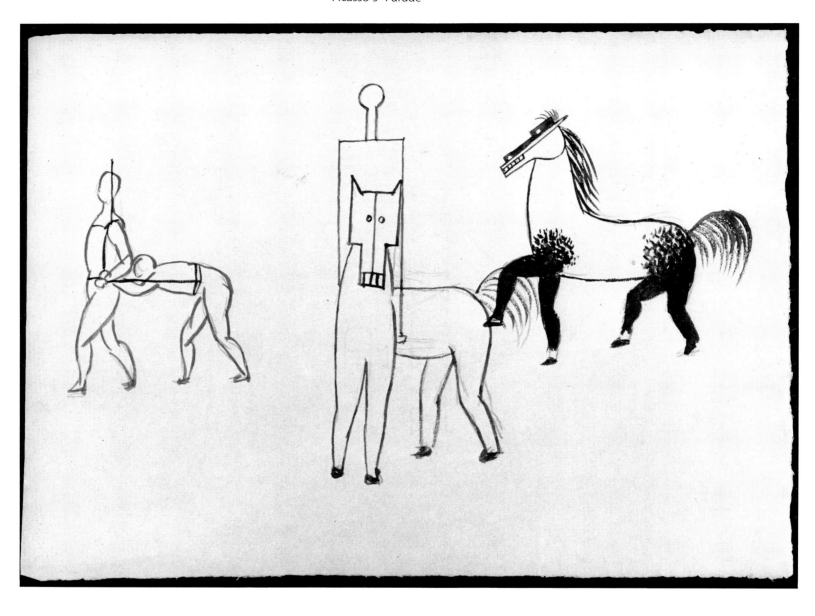

157 Pablo Picasso, studies
for the Manager on
horseback, brown and blue
ink over traces of pencil, 205
× 282 mm (MP 1589) (see
colour illustration on p. 22)

158 Pablo Picasso, studies
for the Manager on
horseback, 1917, pencil and
gouache, 200 × 270 mm

Picasso considered attaching a dummy horse to a signboard man (see figs 146, 150, 156). But in the end, he decided on a costume where two dancers in typical vaudeville fashion made up the horse on which was mounted a dummy of a Manager in blackface and evening dress (see figs 147, 159). The resulting papier mâché manager was modelled on blackface cakewalk dancers, then all the rage in Paris (fig. 160). When the dummy fell off the horse in rehearsal, Picasso bowed to popular consensus and decided to keep the horse in the ballet unmounted. Massine devised a short dance for him executed without musical accompaniment.

The horse added fuel to the scandal of *Parade* precisely because it was so obviously of circus and music-hall provenance. The *cheval jupon* – where two people assume the front and hind quarters of a horse under a single costume – is as old as civilization, being a common element in primitive rituals as well as a familiar presence in fairs and folk festivals since antiquity (fig. 162).[39] It has been noted that the horse's head makes undisguised reference to tribal sculpture: 'Picasso made no effort to eliminate or disguise his sources when he used an animal mask as a model for the head of the horse in his costume for *Parade*.'[40] The Goli and Baule helmet masks and Fang masks from the Cameroon as well as the ape masks of the Senufo tribe from the Sudan (fig. 161) share unmistakable similarities with *Parade*'s horse. In addition to formal similarities they share the important characteristic of appearing simultaneously ferocious and disarmingly awkward.

Prototypes for *Parade*'s Horse in Picasso's own work date back to 1913 in the many elongated heads that narrow at the bottom to terminate in a chinless mouth which contain unquestionable references to Fang masks, and Senufo and Bambara animal masks.[41] One study from 1912–13 anticipates two, if not three, major components for *Parade* –

the Horse, the Managers, and possibly Harlequin (fig. 163). The head and body parts of these two figures are reconstructed from a guitar with the soundbox serving as head and breasts, and the fingerboard as the nose. These sketches appear to be studies for a three-dimensional work which would be constructed, much like the Managers, by intersecting flat boards. Note too the elongated arms and blocky legs.

At the time of *Parade*, the music-hall *cheval jupon* was among the most common and amateurish of vaudevillian devices. The famous clown Footit used just such a horse in his programme and it was a frequent act in the repertoire of the famous Fratellini Brothers performed at the Cirque Médrano. In fact the *cheval jupon* skit was being performed by the Fratellini clowns at the time of *Parade*'s première. In this act the horse engaged in many of the same posturings as Picasso's horse such as standing pigeon-toed, kicking, sitting, dancing a cross-legged jig.[42] (see figs 5, 6).

As with the costumes for the Conjurer, Acrobats and Managers, Picasso's realization of the Horse/Manager reveals his mastery in transforming the everyday and popular into a complex and multi-levelled work of art. Viewed frontally (see fig. 3) the horse has a comical cross-eyed expression, but seen from the side, with teeth bared (see fig. 4) he looks distinctly menacing. In an instant we are accorded the shock of seeing the demonic where we least expect to find it among the playful and buffoonish. Just as Harlequin is known to wave his hand across his face and abruptly change from jester to demon, so the *Parade* Horse creates the same psychic displacement and disturbance: What is significant about the Horse's head is that the two aspects conveyed abrupt changes in expressiveness . . . In the head alone, Cubist ambiguity is displayed: a back and forth between a passive and an aggressive mood . . .[43]

Such dual and contradictory aspects suggest a

ular racist notion characterized the Negro as drawling, smiling, eager to serve, ever ready with a song and dance. Boskin claims by the early twentieth century Sambo was *the* American icon.

The black figure's toothy grin beamed from innumerable postcards and advertisements and the minstrel show (where whites impersonated Sambo) reversed the direction of the

theatrical trade making an imprint on English and French stages. See Boskin, *Sambo: The Rise and Demise of an American Jester* (New York, 1986).
[39]There is a permanent display of

the *cheval jupon* at the Musée de la ville de Paris, Bois de Boulogne, Paris.
[40]William Rubin, ed., *Primitivism in Twentieth Century Art. Affinity of the Tribal and the Modern*

(New York, 1984) vol. 1, p. 318.
[41]Rubin, ibid., p. 316.
[42]Fonds Rondel, Bibliothèque de l'Arsenal.
[43]Axsom, pp. 73–4.

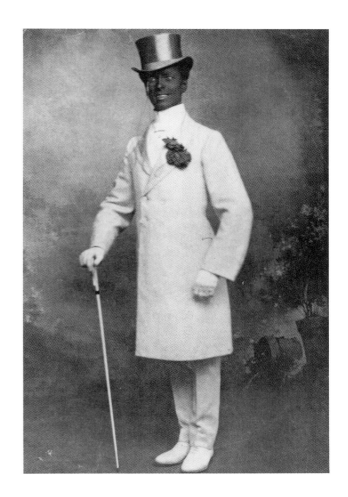

159 Manager in blackface
on the horse, 1917

160 Minstrel in blackface,
c.1910

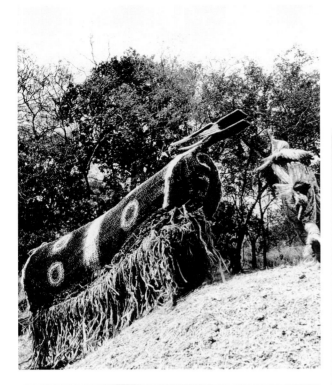

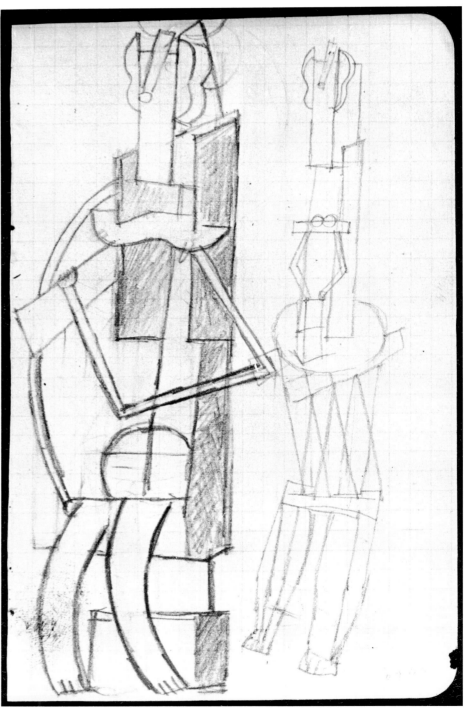

161 Senufo mask from the
Sudan

162 Ritualistic two-man
horse from Baule in the
Cameroons

163 Pablo Picasso, page
from sketchbook, 1912–13
(MP 1865–4)

complex nature and would never be found in a true music-hall or circus *cheval jupon*.

At the time of *Parade* Picasso was consciously experimenting with double faces which created disturbing psychological tensions. Not only did he make sketches emphasizing the horse's dual aspect (see figs 132, 152), he also explored this issue in a major painting, *Harlequin and Woman with a Necklace*, which he executed in Rome in February-March 1917 (fig. 164). In the painting Harlequin presents a calm face to the woman beside him, but a disturbed countenance facing the opposite direction, appears to be screaming. A tormented soul existing behind Harlequin's amusing public façade (and actual mask) is suggested. It is interesting to see that this is precisely the element Cocteau focuses on when in his unpublished Italian notebook he copies the Harlequin's face and notes beside it that 'here via Margutta Picasso painted his masterpiece *Harlequin and Woman*' (fig. 165).

The evocation of a feeling of disquiet under a frivolous and witty façade – seen concretely in the horse, in the entertaining yet frightening Conjurer, and in the simultaneously ridiculous and terrifying Managers – is in fact the key sentiment underlying *Parade*. In spite of the frenetic high-jinks of the various acts, it must be remembered that the theme of the ballet is artistic frustration as the performers *fail* to entice the audience to enter the real show inside. At the conclusion of the first performances the Managers and actors collapsed in despair on stage, and a placard was lowered reading: 'The drama which did not take place for those people who stayed outside was by Jean Cocteau, Erik Satie, and Pablo Picasso'. Thus, the outcast *Parade* performers stood for the creative artists themselves, while the misapprehending audience of the scenario represented an uncomprehending public. In a neat dovetailing of art and reality, the outraged opening night audience was true to its cast role.

The Set

Picasso's set conformed to Cocteau's specifications of depicting a fair booth in a city setting. Originally the action was set in Paris, but Cocteau later modi-

[44] Picasso's initial ideas for the *Parade* set are anticipated by a 1915 drawing executed from his studio window on the rue Schoelcher (see fig. 179) where a panoramic view of the city includes a nearly vertical row of trees.
[45] See p. 33 for full text.

fied the locale to any city where the choreography of perspectives is inspired not by what moves but by immobile objects, around which one moves, especially by the way buildings turn, combine, stoop, get up again, and buckle according to one's walk down a street.

He later added, 'You must form streets by combining the perspectives of the buildings which bob like buoys in Naples, Paris, Montmartre, Clichy, Place Pigalle, etc . . .'.

Cocteau's sketches executed in Italy in 1917 (fig. 178) illustrate what he had in mind, Neapolitan buildings (in some sketches a laundry, palm trees and billowing Vesuvius appear) bob and buckle in a Cubist fashion. In fact, Cocteau's sketches are more Cubist than Picasso's final décor. For the set Picasso toned-down the topsy-turvy arrangement of buildings, seen in his own (as well as Cocteau's) initial sketches (see figs 167, 168), attuning them instead to a Newtonian universe, where architectural elements flank rather than float in odd ways around the proscenium (see fig. 182).[44]

In this way Picasso negated what could have been properly termed a Cubist set décor. The ambiguity and irrationality present in the set sketches where one cannot find one's bearings, or make sense of what is in front and what is behind, where lines are blurred and distinctions evaporate, was renounced in the final décor for a set which is legible and except for the inverted perspective of one balustrade and the impossible angle and size of the proscenium, rational. The vertical buildings surrounding the proscenium are perpendicular to the ground.

Critics and scholars have often cited the Cubism of *Parade*'s set, along with the Managers' costumes, as the provocative aspects of the ballet. This argument makes some sense with regard to the Managers whose appearance is frightening regardless of style, but it does not hold up when applied to the set décor. Cocteau reported after the première that the set 'aroused no protest . . . It was calm and beautiful where an unnameable extravagance had been expected of it.' (see fig. 182)[45] A close look at the set reveals that in the end Picasso decided to leave the more radical aspects of his Cubist style at the stage door. Thus, by 1917 it is extremely unlikely that the French public could have been shocked by the

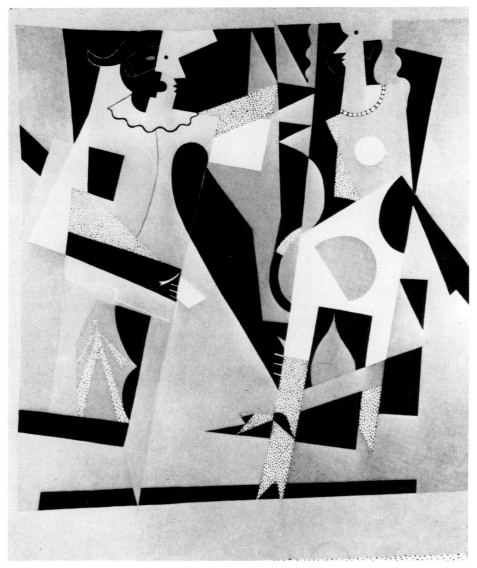

164 Pablo Picasso, *Harlequin and Woman with a Necklace*, 1917, oil on canvas, Rome

165 Jean Cocteau, page from the Italian notebook, 1917

166 Pablo Picasso, study for
the set, 1917, pencil, 210 ×
280 mm (MP 1567)

167 Pablo Picasso, study for
the set, 1917, pencil, 277 ×
225 mm (MP 1565)

168 Pablo Picasso, study for
the set, 1917, pencil, 170 ×
185 mm (MP 1564) (r)

169 Pablo Picasso, study for
the set, 1917, pencil, 226 ×
280 mm (MP 1560)

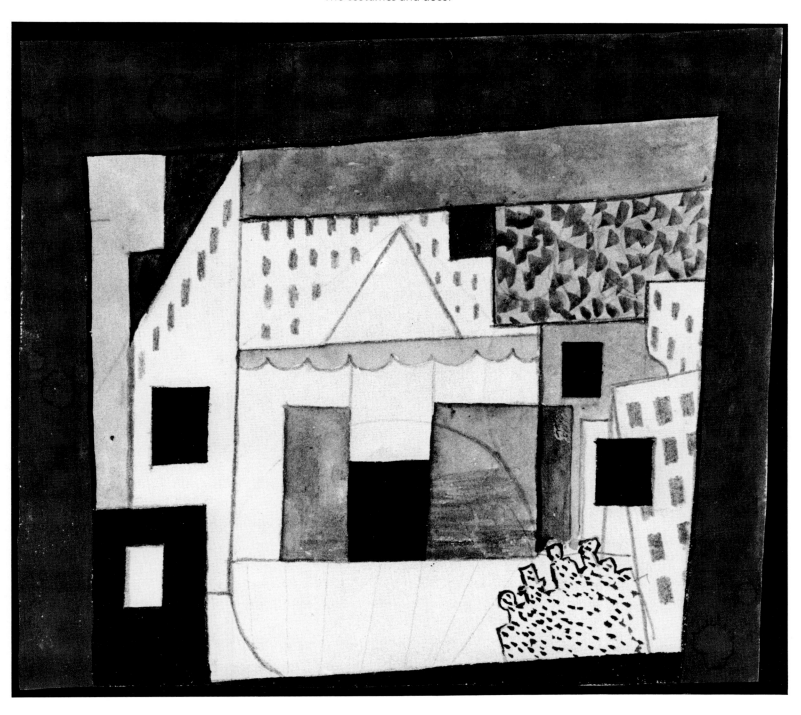

170 Pablo Picasso, study for
the set, gouache and pencil,
1917, 120 × 140 mm (MP
1561) (see colour illustration
on p. 18)

171 Pablo Picasso, study for
the set, 1917, pencil 275 ×
225 mm (MP 1566)

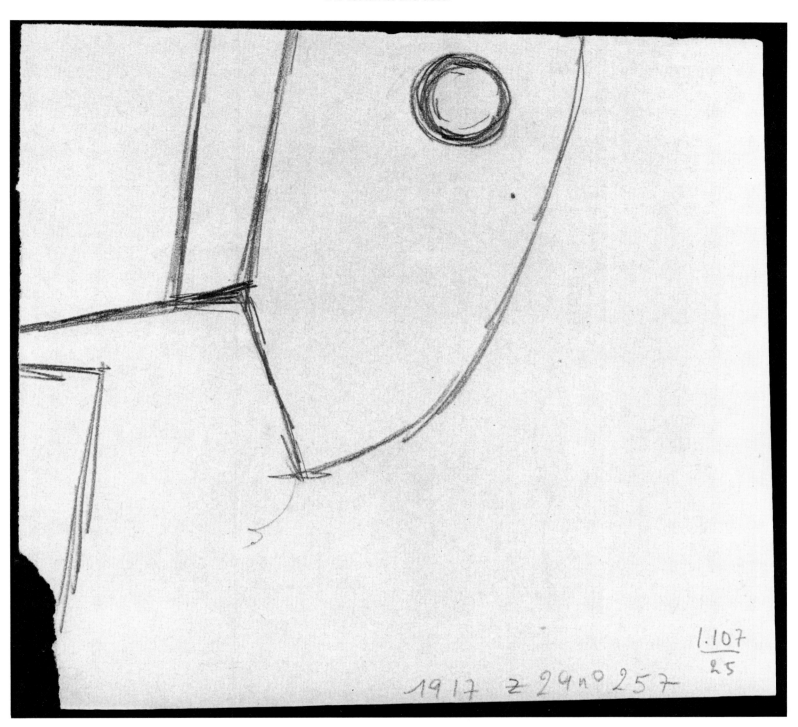

172 Pablo Picasso, fragment,
1917, pencil, 170 × 185 mm
(MP 1564) (V)

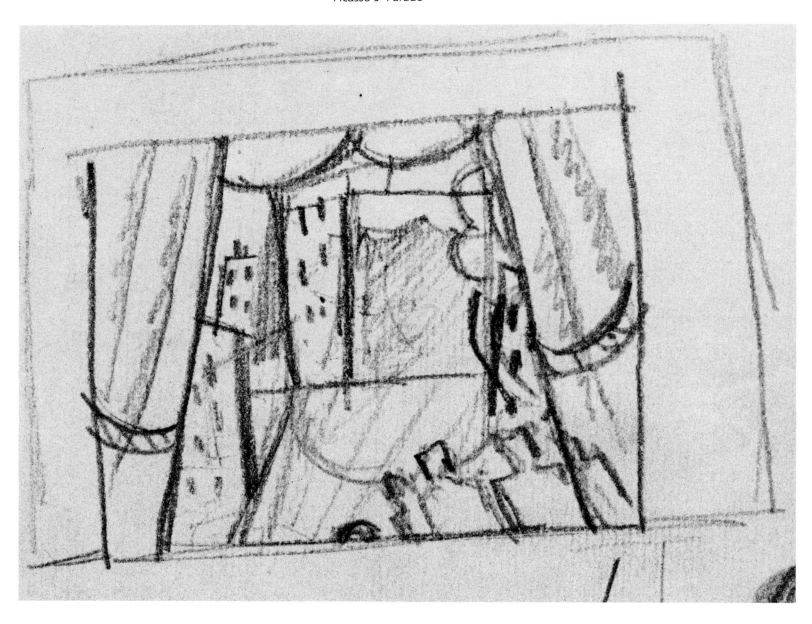

173 Pablo Picasso, detail of
fig. 174

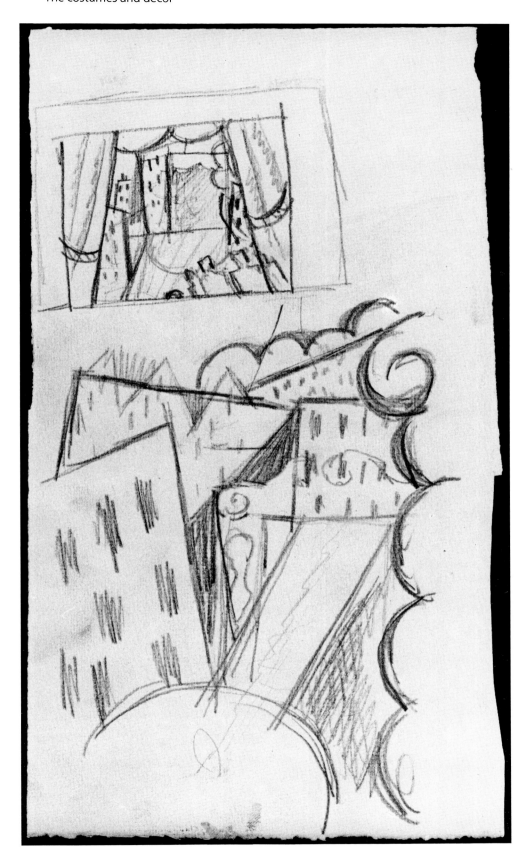

174 Pablo Picasso, study for
the set, 1917, pencil, 255 ×
140 mm (MP 1563)

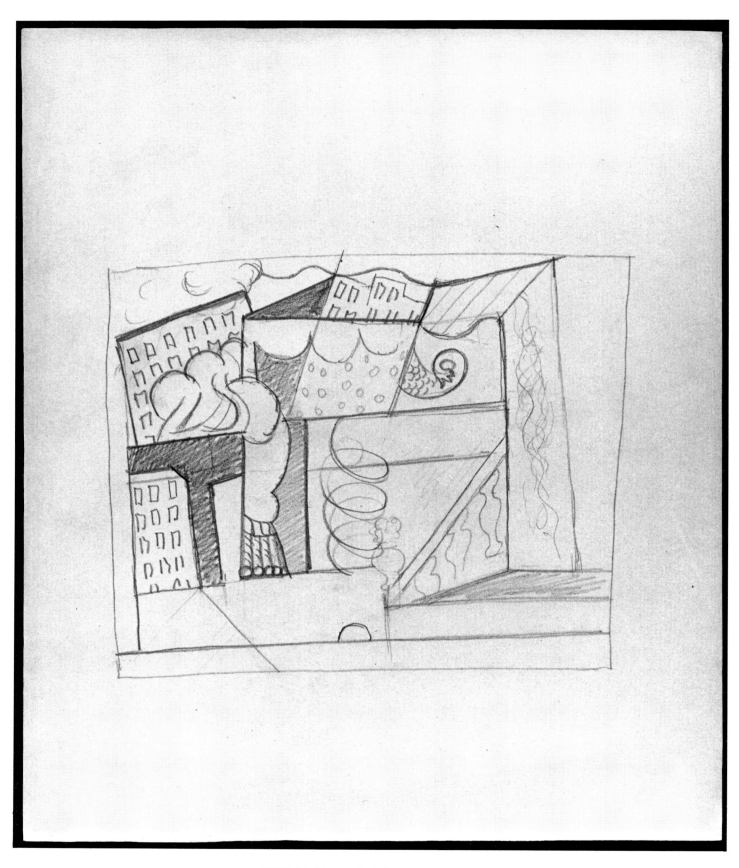

175 Pablo Picasso, study for
the set, 1917, pencil, 277 ×
225 mm (MP 1562)

176 Pablo Picasso, study for
the set and for the curtain,
pencil, 1917, 280 × 225 mm
(MP 1568)

177 Pablo Picasso, study for
the set, 1917, pencil, 280 ×
225 mm (MP 1569)

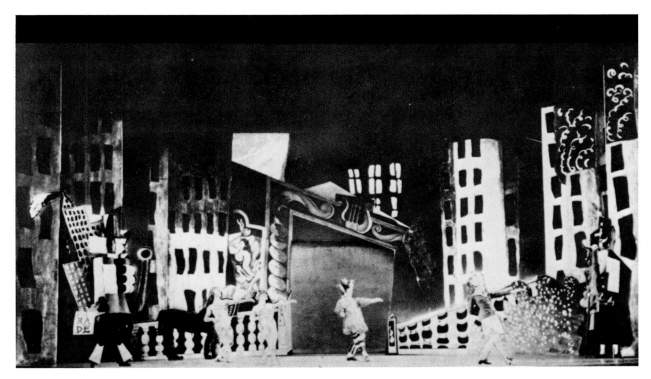

178 Jean Cocteau, pencil
sketch of buildings from his
Roman notebook, 1917

179 Pablo Picasso, drawing
from the Schoelcher studio,
1915

180 *Parade* in performance,
1973, reconstruction by
Edward Burbridge

décor's mellow Cubism. In spite of the dispro-portionate size and angle of the proscenium, the inverted perspective of the balustrade, or even the sense that we are seeing a montage of aspects rather than a one-point perspective view, the set was perfectly legible and in accord with the prin-ciples of gravity. In fact the set was closer to the styl-ized and out-of-proportion sets seen in amateur theatricals, than to Cubism (fig. 181). Picasso exag-gerated perspective in a deliberately gauche fash-ion and added gaudy Baroque details in keeping with the ballet's third-rate fairground setting.

It has not been noted that Picasso's early sketches for Parade's set echo the play of curvilinear against angular forms that one finds in the costumes of the Conjurer, Acrobats and Managers, indicating he in-tended a visual correspondence between the set and the actors. Compare for example the balloon-ing forms in the sketches (see figs 167, 168) to the arabesques of the Conjurer's and Acrobats' cos-tumes, the shrubbery attached to the French Man-ager's back or the bullet holster and the cloud behind the skyscraper of the American Manager. For the actual décor most of these undulating forms were subdued. Yet the Baroque swirls of the prosce-nium, the curves of the railing balusters, and the wavy and pointillist trees of the set preserved to some degree the play of the dancers' costumes against their background (fig. 180).[46]

The final décor was close to Picasso's preliminary drawings, yet there were a number of changes; most important was the dilution of Cubist effects noted above. Picasso also deleted a fairground tent which had appeared on two sketches (see figs 166, 169). And he moved the acute angle of the prosce-nium from right to left. He transformed the sil-houette of a crowd (described by Cocteau in his scenario) into a group of pointillist bushes (at an intermediary stage they were pointillist spectators (see fig. 170).

This pointillist element and the echo of curvili-near forms recall Georges Seurat's 1890 painting, Le Cirque (fig. 183), a connection buttressed by the re-semblance of the French Manager to the figure of the Circus ringmaster and by the similarity of the Chinese Conjurer's pointed hat to that of the fore-ground clown's peaked orange hair-do in Seurat's painting. Seurat had himself created a famous ren-dering of a Parade (fig. 184) where a crowd of spec-tators, like the one initially intended for the ballet's set, watch a forain performance while a mousta-chioed impresario haughtily looks on. Several sketches indicate Picasso had considered fretting the top of the proscenium with gas lamps in another allusion to Seurat's painting (see figs 168, 169, 171). Picasso's references constitute a deliber-ate bow to Seurat, particularly since a major thrust in Seurat's work was the ennobling of the Parisian lower middle-classes and their amusements – the suburban park, circus, music-hall and parade. Seu-rat's desire to bestow monumentality upon the world of the everyday and non-élite by painting their diversions in an enduring artistic style was certainly in line with the motivations of Parade's creators, especially Picasso.[47]

In the actual décor the false stage was embel-lished with gilt scrollwork and a lyre (see fig. 182). Its opening was covered with a cloth through which an anonymous white-gloved hand held out the number of each act, retracting it when the perform-ance began, a take off of the way acts were intro-duced by number in variety theatres and music-halls. The Managers made their entrances from the wings. To the left of the proscenium Picasso inserted a cropped panel depicting a bare-foot woman running or dancing with a tambourine or some round object held overhead. A free-stand-ing balustrade enclosed the false stage, and termin-ated in two triangular pillars decorated with the Cubist icons – a violin and mandolin.[48] The prosceni-um's elaborate gold scrollwork and the adjacent cropped panel poke fun at the persistent vogue for overblown Baroque interiors in theatrical architec-ture, especially inappropriate for music-halls and

[46]At one point Picasso had con-sidered using pointillist dots on a zig zag strip bisecting the Acrobat's costume that would have echoed the stippled bushes in the foreground (see fig. 93).

[47]Picasso had been experimenting with pointillism since 1914, see for example the Céret still life, Vive la France (Bloch Collection, Chicago). There is a water-colour study of the Majorcan Woman from the Parade cur-tain executed in pointillist tech-nique (see fig. 194).

[48]See Axsom, pp. 92–3 and app. 2, 'Picasso's Stage Set for Parade' for the layout of the backdrop, flats and legs.

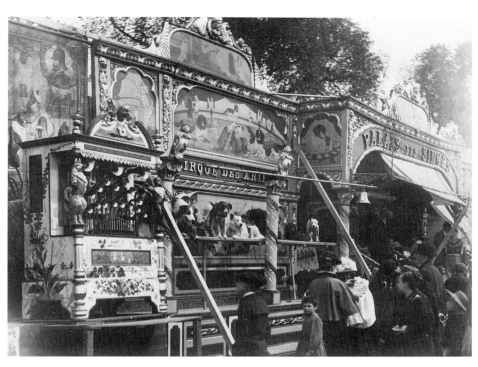

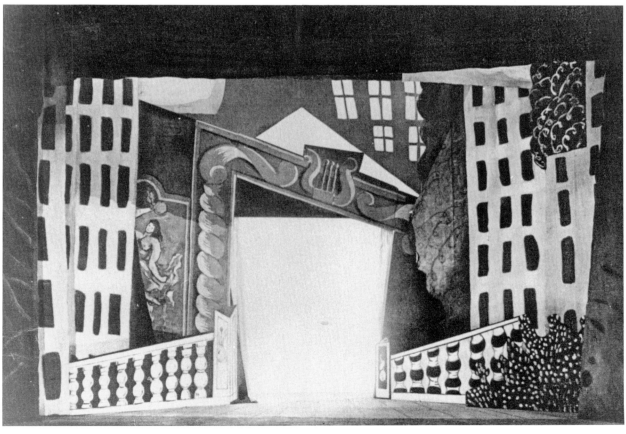

181 Eugene Atget, a
travelling *forain*, Fête des
Invalides, 1898

182 *Parade* set, 1917

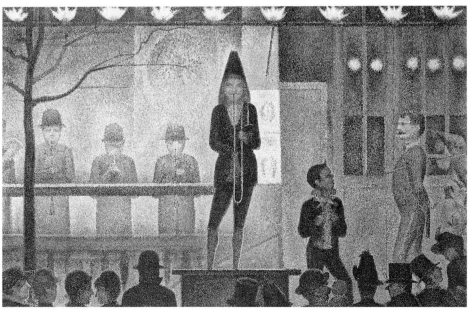

183 Georges Seurat, *Le Cirque*, oil on canvas, 1890. 1.85 × 1.53 m

184 Georges Seurat, *Parade* oil on canvas, 0.99 × 1.50 m

théâtre forain where they were nevertheless inevitably the style of choice.[49]

It is difficult to reconstruct the colours of the set since no elements of it survive. Yet from one colour sketch (see fig. 170) and eyewitness accounts, it appears that the colours were subdued sepias and sombre greens and golds. This near-monochrome background proved an excellent foil for the intensely coloured costumes of the Conjurer and Acrobats as well as the black and white outfit of the Little American Girl. Most impressive in performance were the Managers who appeared as the set come to life, but in a more vivid and colourful three-dimensional form.[50]

In the course of rehearsals *Parade* evolved from Cocteau's narrative ballet into something more abstract and enigmatic.[51] By deleting the Barker's ballyhoo and related noise-effects, the characters' actions and the Managers' appearance remained puzzling to initial audiences. Similarly, Picasso pared down his original set designs, leaving out the audience silhouette, fairground tent, and advertising placards that Cocteau had initially envisioned. In becoming more generalized, *Parade* was able to accommodate more interpretations and meanings

than in its former, narrative form. In the end, beneath a naïve and vulgar surface, the ballet functions on a head-spinning number of levels — serious, frivolous, personal, universal, political, popular, allegorical, and mystical. This Cubist ethos where one form accommodates multiple, fluctuating identities, informs not only the ballet but the curtain as well. Here too, coarse and prosaic associations mingle with, and are transformed into, artistic and poetic ones.

Picasso in his first theatrical décor showed himself to be in perfect accord with Cocteau's aim of presenting a work which 'conceals poetry under the wrappings of *guignol* [puppet theatre]'. His long friendship with Apollinaire whose *Esprit Nouveau* was based on the notion that poetry is found in the familiar and the everyday would have conditioned him to Cocteau's goals.

Many years later Cocteau assessed Picasso's contribution to stage décor: '...before him the décor was not an actor in the drama; it was a spectator.'[52] With his designs for *Parade* Picasso enlarged upon the content of the ballet, instead of merely providing a visual adjunct to it. He thus 'asserted an aggressive, new role for the scenic designer'.[53]

[49]Picasso would again parody Baroque theatre architecture in his set designs for *Pulcinella* and *Cuadro Flamenco*.

[50]Penrose writes, 'The Managers fulfilled the function of scenery. Their size reduced the dancers, whom they introduced to the unreal proportion of puppets.' p. 215.

The American Manager's skyscrapers alternated light windows against dark ground and visa versa just as the set's skyscrapers did.

[51]It becomes evident from a study of Picasso's working methods as pieced together from sketchbooks and drawings that often he would begin with a narrative idea which in the process of refinement would be transformed into something iconic and allegoric. To some degree the same *modus operandi* was at work in *Parade*. See William Rubin 'From Narrative to 'Iconic' in Picasso: The Buried Allegory in *Bread and Fruitdish on a Table* and the Role of *Les Demoiselles d'Avignon*', *The Art Bulletin*, Vol. LXV, no. 4, Dec. 1983, pp. 615–9.

[52]Jean Cocteau, *Entre Picasso et Radiguet*, ed. André Fermigier (Paris, 1967) p. 123.

[53]Axsom, p. 67.

Chapter 8

The «Parade» curtain

The overture curtain for *Parade* is Picasso's largest painting, measuring over ten by seventeen metres. It is not strictly speaking a curtain, but a stretched flat canvas painted in tempera (figs. 185, 186). In performance, it appeared in the proscenium arch of the Théâtre du Châtelet after the traditional red-velvet house curtain was raised. Picasso's painted curtain was seen for one and a half minutes while the orchestra played Satie's 'Prélude du Rideau Rouge'.

Usually *Parade*'s overture curtain, or *rideau de scène*, is not reproduced in its entirety; the painted red draperies that frame the scene are often excluded. However, the fact is that the inclusion of these foreground curtains is important as they introduce an ambiguity that is otherwise absent. Without the framing curtains, the viewer is a back-stage participant in what is presumably an outdoor theatre with the pulled curtains visible in the background opening on to a green meadow. When seen in its entirety, however, these curtains appear to exist in both the front and rear of the stage, confusing the orientation and identity of the spectator in relation to the depicted figures (i.e. the spectator can be located behind the scenes or in the audience). Further confusion arises from the fact that the two sets of curtains can be understood in a variety of ways: both 'real' curtains, both 'painted' backdrops, or 'real' foreground and 'painted' backdrop. This ambiguity is just one of many contained in *Parade*. Indeed, ambiguity and a conjurer's 'now you see it, now you don't' point of view are leitmotifs of the ballet. Picasso's aim seems to have been to keep the audience on their toes, never allowing viewers to feel secure in what they know or understand. Instead, multiple interpretations and possibilities are continually presented.

The figures in the *Parade* curtain are divided into two groups (figs. 187 and 188). On the right seven theatrical characters and a dozing dog gather around a table. This group consists of two Harle-quins (one in the foreground wears a red and black costume, the other seated behind the table wears a blue and yellow costume); Columbine (the far Harlequin's companion); a guitar-playing toreador; a Neapolitan sailor; a bare-chested and turbaned black man, usually identified as a Moor; and a figure identified as a Majorcan woman because the straw hat she wears is typical of eastern Spain. With the exception of the foreground Harlequin who sits apart, the figures around the table are linked by hands and arms or visual proximity. Their gestures indicate that they are on familiar terms with one another. These comrades drink, smoke, embrace, play an instrument, and look at the group on the left where a white mare, dressed as Pegasus with strapped-on wings, suckles her foal.

The mare is surmounted by a winged female figure in a white tutu who has both hands raised. A monkey, his head wreathed in laurel, climbs up a red, white and blue ladder and grasps the equestrian's wrist. The overall whiteness and the two winged figures lend an other-worldly appearance to the left-hand group, which contrasts with the more mundane cluster of revellers on the right. The wooden stage floor is littered with circus properties including a ball, a drum, and a mat. The sailor sits upon a large trunk, an indication that the performers are a group of travelling players.

It is unclear whether this is a staged drama, or entertainers relaxing, practising, and performing among themselves backstage.[1] Because of its relaxed mood, most of the critical literature on the curtain assumes that it depicts the latter, with the monkey and equestrian entertaining the rest of the troupe while they dine and rest. This interpretation is the most likely, allowing Picasso's curtain to function as a witty and fitting prelude to the actual performance that follows when the curtain is raised.[2]

The curtain's overall tenor of calm and simplicity masks a work that is stylistically as well as contextually disjunctive, complex, and ambiguous. As the

[1] The background is equally ambiguous for it can be understood as a painted backdrop or a real landscape. It depicts a distinctly Mediterranean scene of a ruined Roman viaduct, a calm sea and a mountain in the distance.
[2] Steegmuller for example writes of, 'Picasso's romantic, tender drop-curtain, a huge, fairy-tale-like picture of a backstage party of harlequins and circus folk . . .', p. 185. Like many, Sacheverell Sitwell interpreted the scene as 'a whole company of actors at a fair having their supper in the scenery just before the performance.' (introduction to Beaumont p. xvi). However Sitwell's interpretation of the *dramatis personae* is unique and probably derives from some familiarity with Cocteau's libretto; he writes: 'To the usual maskers of comedy Picasso has added four more: an American negro boxer, a man and a girl from the films of Texas and the West, and a Spanish guitarist' (ibid).

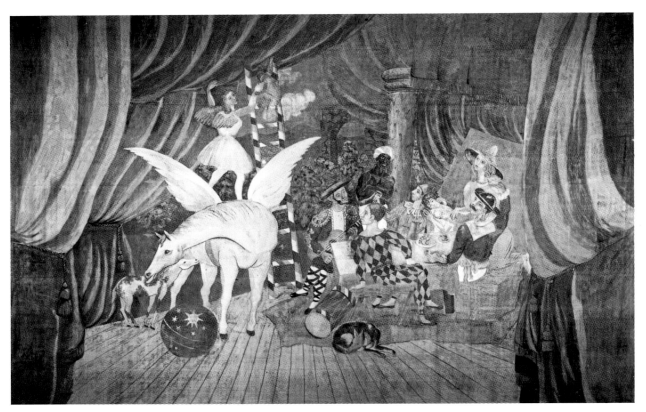

185 Pablo Picasso, overture
curtain for *Parade*, 1917
tempera on canvas,
10 × 17 m (see colour
illustration on pp. 20–21)

186 Pablo Picasso with
assistants during the creation
of the overture curtain for
Parade, 1917, Paris (MP 40)

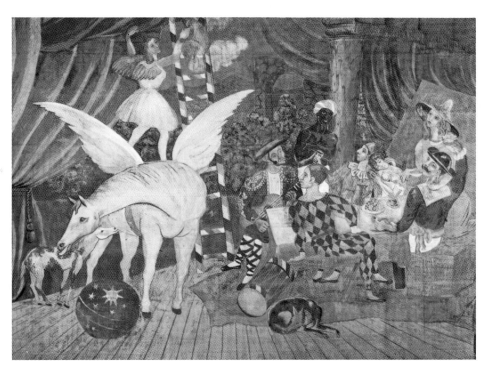

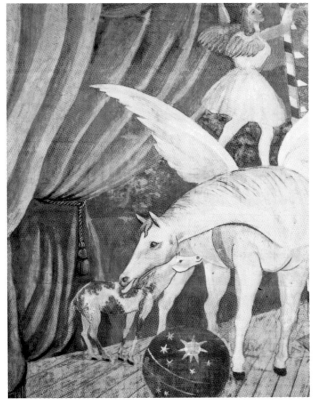

187 Pablo Picasso, overture
curtain for *Parade*, 1917
(detail)

188 Pablo Picasso, overture
curtain for *Parade*, 1917
(detail)

remarks of Picasso scholars indicate, initially, we are aware only of a naïve rendering in the manner of folk art: Alfred Barr compared the curtain to provincial scene painting: 'The style is cruder and more mannered, a skillful parody of popular scene painting ...'[3] Sir Roland Penrose felt the curtain, '... owed its inspiration ... to the popular art of the circus poster.'[4] And Douglas Cooper has written: 'This [the overture curtain] is popular imagery at its most decorative and enchanting, and the sophisticatedly naïve style of painting emphasizes the point.'[5] Traditionally, the overture curtain has been viewed as a sweet and alluring prologue to the audacious Cubism that followed in the costumes and décor of the ballet proper.[6] This is, however, an instance of something not being what it at first appears. In rejecting absolutes, embracing ambiguity and elusiveness, defying expectations and accommodating multiple meanings, it is the curtain rather than the décor that is Cubist. 'In spite of the apparent lack of a Cubist look to the curtain, its figure style, like that of Picasso's recent new realistic mode of 1914, was created not against but through a Cubist sensibility.'[7] Parade's 'simple and charming' curtain is more truly Cubist than its mise en scène. The sharp angles and geometries of the set contrast with the more fluid shapes and pleasing contours of the curtain. But, as has been discussed, the set's Cubism is superficial, amounting to little more than a topsy-turvy conglomeration of angles and skewed perspectives. By contrast, a more substantial Cubism obtains within the ballet's curtain.

The flatness of Picasso's figures on the overture curtain – they do not cast shadows, nor are they modelled by chiaroscuro – is combined with a three-dimensional rendering of atmospheric perspective with overlapping modelled curtains and perspectival floorboards. This sort of juxtaposition of different styles within a single painting had interested Picasso since the early 1900s (note for example the

collision of styles in The Demoiselles d'Avignon, 1907, Museum of Modern Art, New York). It is also a common feature of Cubist painting and collage where illusionistic or trompe l'oeil elements are incorporated into a fractured Cubist setting. The combination of different styles within a single format engrossed Picasso throughout his life, but particularly in the years around 1917 when he made hundreds of studies of a flat, Cubist still-life before an illusionistically rendered window and background seascape (fig. 189; see also the lower section of fig. 146).

A number of other disjunctions, besides stylistic ones, operate within the Parade curtain, but they are not immediately apparent. For example, according to the orthogonals of the floorboards, the horse and the ladder should be at least twelve feet apart, making the hand-holding of the monkey and equestrian an impossibility. The right-hand group is similarly compressed and pushed up toward the front plane of the canvas. The guitar-strumming toreador should be closer in size to the Harlequin who is sitting on the same side of the table. Picasso cleverly disguises his subterfuge by placing obstacles where our vision would detect something amiss. Hence the table-cloth, the floor mat and the flat diamond shape behind the standing woman not only aid spatial compression, but also smooth-over spatial abnormalities.

The awkward treatment of the faces can be traced to a style Picasso had been using since the autumn of 1914 and which seems to have been influenced by popular prints such as images d'Epinal (see p. 167), and the naïve style of the Douanier Rousseau. The unfinished canvas, Painter and Model is rendered in the flat, somewhat misaligned style employed on the curtain (fig. 190).[8] The flatness and awkward drawing of the figures lends a charming naïveté to the curtain, but it is also the means through which Picasso performs sophisti-

[3]Alfred H. Barr, Picasso: Fifty Years of His Art (New York, 1946) p. 98.
[4]Penrose, p. 212.
[5]Douglas Cooper, Picasso Theatre, (New York, 1967) p. 24.

[6]Abel Harmant wrote two days after the Châtelet premiere: '...the curtain is not cubist to the same extent as the set which the curtain momentarily hides from our eyes.' 'Les ballets russes.' Excelsior, May 29,

1917, p. 13.
Roland Penrose later wrote, 'There was a sigh of pleasure and relief ... The curtain was a delightful composition in a style which was only indirectly cubist; ... The delightful hopes

offered by the drop curtain were to be shattered as the curtain rose.' p. 212.
[7]Axsom, pp. 102–3.
[8]The seated artist in the unfinished painting looks at the model with the same intensity

as the Harlequin who looks at the equestrian. This seated male figure is related to those discussed in the previous chapter.

189 Pablo Picasso, *Table and guitar in front of a window*, 1919, construction, cut-out and painted cardboard, paper and crayon

190 Pablo Picasso, *Painter and Model*, 1914, pencil and oil on canvas (MP 53)

cated visual tricks. For example, the mare's body and elongated neck are at odds with one another – according to the position of its head and neck, its body should be turned in the opposite direction. We see too much of the back and left arm of the equestrian figure atop the horse given the position of her face and legs. Moreover her right arm abuts her neck, leaving her without a right shoulder.

Similar oddities occur in the group around the table. The table itself is tilted up and its straight edge broken at a juncture blocked by the foreground Harlequin. The matador's torso is at odds with the position of his head. The sailor's right arm is too long, his left, too short. While we see the far Harlequin's feet under the table, the sailor's feet are left out. Columbine's neck is severely truncated and her head is wrenched sideways so that it nearly surmounts her bared breast. The far Harlequin's left hand, which strokes Columbine's cheek, does not match his left arm. The figure on the far right, traditionally identified as the Majorcan woman, is out of scale as she is nearly double the size of the far Harlequin/Columbine group which she touches with her right hand.

Most drastic are the liberties taken with the foreground Harlequin who presents frontal and dorsal views simultaneously. Picasso is able to disguise this equivocation by leaving the neck and shoulders unmodelled, by keeping the Harlequin's costume on one plane, by concealing his fingers, and leaving the feet undifferentiated.

Three surviving sketches for the curtain in the Musée Picasso, Paris (figs 191–193) show that initially the foreground Harlequin was unequivocally seen from the back. Picasso must have deliberately and carefully arranged the figure so that the elements that indicate front or back were side-stepped in order to achieve the resulting ambiguity.

The curtain operates in a Cubist fashion not only in that it defies one-point analysis but in that it foils expectations. For after being lulled into a state of calm by the idyllic scene accompanied by Satie's relaxing overture, the curtain is raised upon the harsh forms of the set and the entry of the disturbing-looking French Manager accompanied by the odd and cacophonous musical score that is the Manager's theme. No wonder *Parade*'s first audience felt 'set up', Picasso had expanded the use of his maddening 'Cubist' devices into a realm of the temporal and sequential via live theatre.

Sources for the curtain's imagery

The action depicted in the curtain, itinerant players entertaining each other (and at the same time practising their routines), was not based on fiction, but existed as a fairground reality that was frequently written about and illustrated in the popular press. It was common for itinerant actors to perform among themselves while dining or relaxing. A photograph from a 1906 article entitled 'installations of modern forains' (fig. 195) is captioned 'family meal'. The article sheds light upon the factual basis of Picasso's conception for the *Parade* curtain, documenting the behind-the-scenes life of itinerant *forains*. Here two gypsy caravans formally set a table for performers, children, and animals to dine together. Mention is made of the special attention given to the monkeys who it says often entertain the diners during their meal. At other times various troupe members spontaneously perform. Picasso, who had been on close terms with Spanish gypsy and Médrano circus performers in his early Paris years, had first-hand experience of backstage life.[9] The fact that he was experiencing this life again with Diaghilev's company, admittedly on a loftier scale, may have been the stimulus for the curtain's iconography.

More than one writer has construed the action of the curtain as entirely fanciful, claiming that the characters portrayed on the overture curtain would not exist in a real *parade* as the Harlequin, sailor, ballerina, blackamoor and Spaniard are not typical

[9]There are numerous accounts of Picasso's regular attendance at the circus. The Médrano family of the Montmartre circus which Picasso frequented during his first years in Paris were Spaniards who began as acrobats and trapeze artists before becoming clowns. See Henry Thétard, *La Merveilleuse Histoire du Cirque* (Paris, 1947) p. 258. One reason Picasso cultivated their friendship was that like himself they were 'outsiders' not only by virtue of their profession but also because they were foreigners. In addition, at a time when his French was not yet fluent, their companionship gave Picasso a chance to converse in Spanish. The same is true for the saltimbanques Picasso painted in these years, who were often Spanish gypsies.

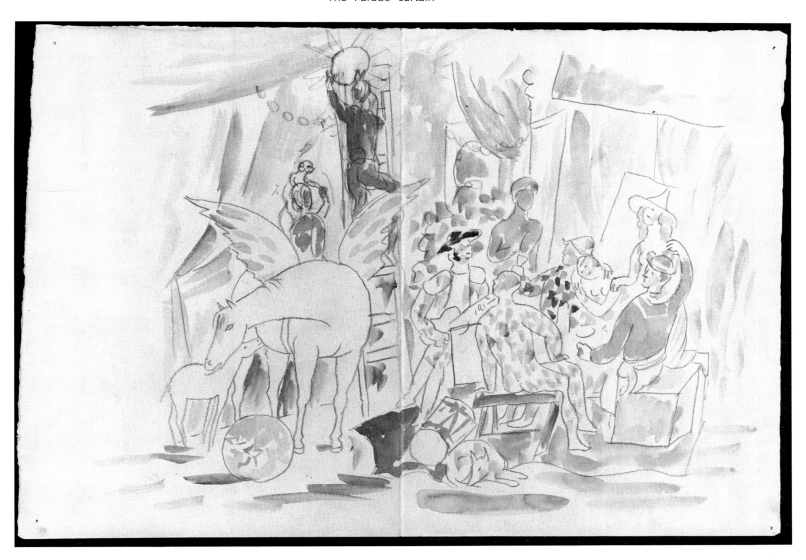

191 Pablo Picasso, project
for the overture curtain,
1917, watercolour and
pencil, 273 × 395 mm (MP
1557) (see colour illustration
on p. 19)

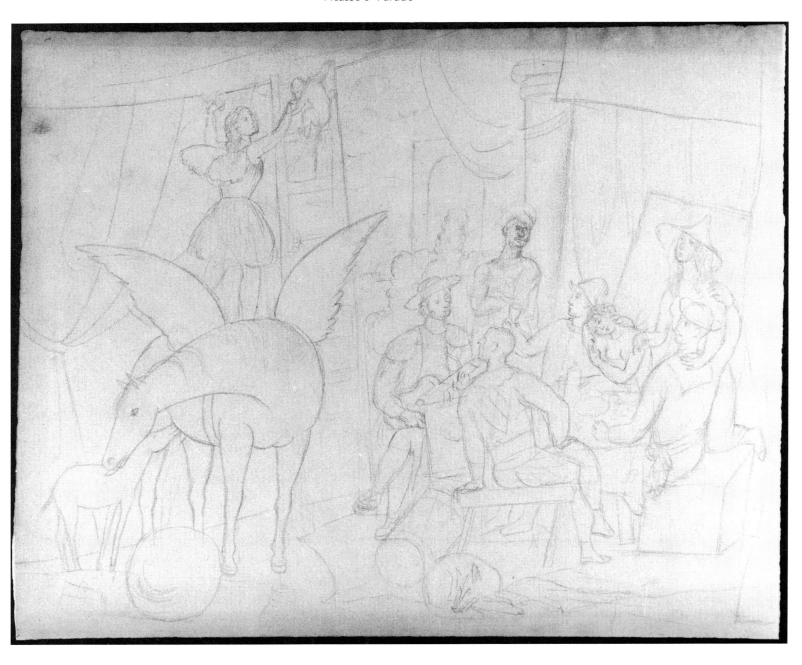

192 Pablo Picasso, project
for the overture curtain,
1917, pencil, 247 × 270 mm
(MP 1556)

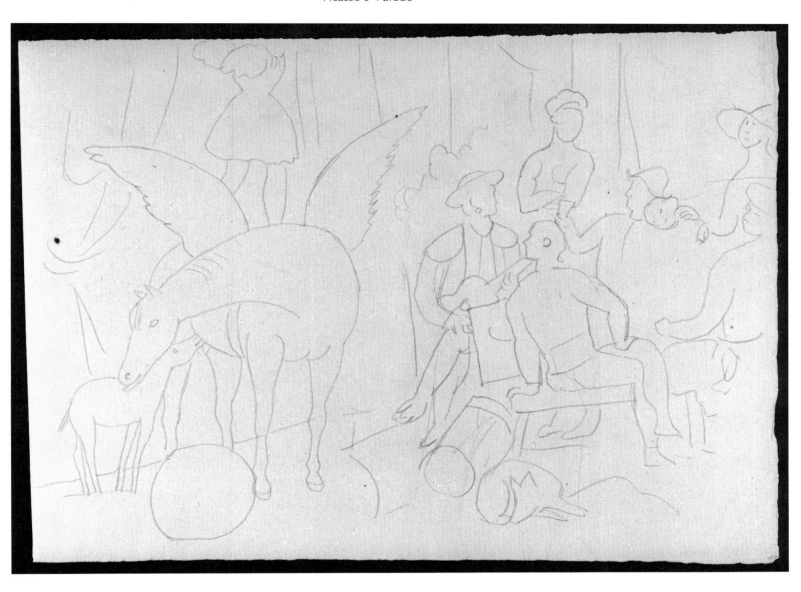

193 Pablo Picasso, project
for the overture curtain,
1917, pencil, 200 × 270 mm
(MP 1555)

194 Pablo Picasso, study for the curtain: head of a Majorcan woman, watercolour and pencil, 275 × 204 mm (MP 1558)

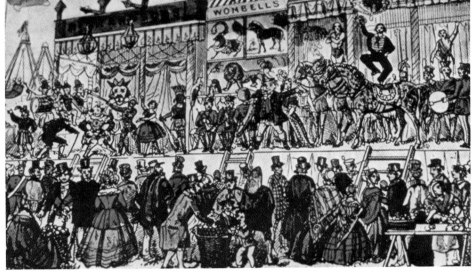

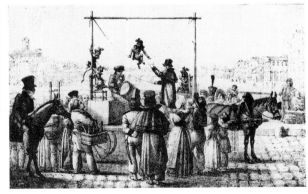

195 'Installations of modern *forains*', from 1906 newspaper article 'La Fortune en Roulette . . .' in *Lectures pour Tous*, 1906

196 Scene from *Harlequin Red-Riding-Hood*, catchpenny or *parade* for John Richardson's travelling circus, *c.*1830

197 Jean Henri Marlet, 'A Parade', hand-coloured lithograph from *Les Tableaux de Paris c.*1830

forain characters.[10] This also is not true; popular prints indicate Picasso's motley troupe were entirely typical of itinerant spectacles. Prints of the nineteenth century depicting *parades* show barkers hawking the talents of none other than a Harlequin, ballerina, sailor and exotic Moorish figure (fig. 196; see also fig. 38). These prints and others like them accurately document the cast of *forain* players. Marian Hannah Winter, who has traced the boulevard provenance of classic ballet writes of *parade* characters: The public had its first exotic visions spread before it on the fairground; Turks and African Moors were a great curiosity in Europe in the 18th century. From the beginning of the 17th century, exotic people and animals were a feature of the travelling charlatan's retinue. The charlatan himself, who might be a quack doctor, dispenser of 'cure-alls' or tooth puller, was usually Italian . . . A 'Moroccan' or 'Turk', the one no more authentic than the other, accompanied the master and joined in a short performance called the *parade* before the sales pitch began. A trained monkey usually completed the team.

The *parade* grew in importance and by the mid-18th century it had become so elaborate that Noverre [considered the father of ballet] was able to write of the ballets which had been incorporated: '. . .the tricksters and quack medicine peddlers count more on the appeal of their ballets than on that of their nostrums; the *entrechats* are what attract the public.'

The musical accompaniment . . . and the exotic aspect of the troupes' female contingent — which the charlatan would recruit from Spain, Italy or England — lured the idlers.[11]

It is ironic that in the *Parade* overture curtain Picasso pays tribute, perhaps intentionally, to the humble, mud-show beginnings of grand ballet. In any case, Picasso's curtain with its Moor, equestrian/

tightrope-walker ballerina, monkey, and trickster [Harlequin] fits the description of actual *parades* as they have existed since the eighteenth century.

The trained monkey was the universal crowd-pleaser of the *forain* and so his prominence within the *Parade* curtain is also in keeping with reality.[12] Winter notes, 'The gambols of the little monkeys were among the chief delights of the travelling fair.' The monkey's specialty was walking the tightrope, and there are scores of images illustrating this portion of the show (fig. 197).[13] Along with the Harlequin, Moor or female dancer the monkey also served as the mountebank's attendant helping him ply his drugs and potions (fig. 198).

The *Parade* curtain, like most of Picasso's major works, not only corresponds to reality, but also resonates with references to other art. It was during the years around 1700, that *parades* performed by *commedia dell'arte* players, 'always presented in the open air and free of charge' received enormous stimulus and became a favourite subject for artists.[14] Jacques Callot, Antoine Watteau, and a host of lesser known or anonymous artists had made the *commedia* a genre unto itself.

Of the many artists in the years around 1700 who look to the *commedia dell'arte* for subject matter, Watteau is the one who endows it with a new gravity and seriousness. The identification of the socially estranged individual with the lot of the travelling or second-string player traces its pictorial beginnings to him, and Picasso no doubt refers to Watteau's nostalgic treatment of the foreign travelling performer in the *Parade* curtain. Watteau's depictions are not only about merry-making and enjoyment, but contain an undercurrent of melancholy and isolation to which the *Parade* curtain as well as Picas-

[10]See for example Axsom who writes, 'Still the Blackamoor, the Toreador, and the Sailor resist specific placement within a fair environment . . .' pp. 111–12, and Nesta MacDonald, 'What circus includes a blackamoor, a Spaniard with a guitar, a Harlequin from the Commedia dell'Arte, a sailor who looks about to dance a hornpipe . . .' *Diaghilev*

observed by Critics in England and the United States, 1911–1928 (New York, 1975), p. 241.
[11]Marian Hannah Winter *The Theatre of Marvels*, (New York, 1912) p. 23. Winter proves that the circus and fair were the breeding grounds for new and revolutionary forms of entertainment which eventually became legitimized into ballet,

opera, and grand theatre.
[12]Rather than the ladder shown in the overture curtain, the monkey usually shinned up the rope's supporting pole, or was lifted by his trainer.
[13]Winter, p. 25.
[14]Winter, p. 22. Since its inception in the sixteenth century, the *commedia's* troupe of players belonged to the poorest social class, lacking social

refinement and literary education. The *commedia's* reputation and quality of production increased throughout the seventeenth century, but it suffered a critical blow in 1697, when Madame de Maintenon, offended by the play, *La Fausse Prude*, insisted Louis XIV expel the Italian Comedians. By the eighteenth century the *commedia* had deteriorated into mot-

ley bands of spurious talent who made their performances an 'open parade of the vilest obscenities . . . The Church, which had regarded with an unfriendly eye the *commedia dell'arte* from its inception now classed it on the level of thieves and brigands.' Beaumont, pp. 81–2.

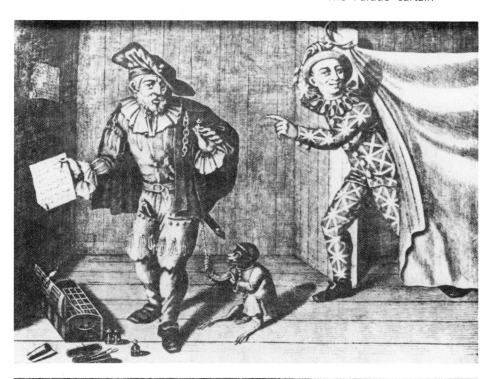

198 Harlequin and mountebank, reproduction of a popular seventeenth century broadside, '*The Infallible Mountebank*', printed by H. Hills

199 Antoine Watteau, *The Shepherds*, *c.*1710, oil on canvas, 560 × 810 mm

200 H.G. Ibels, *La Parade*, illustration to Georges d'Esparde's *Demi-Cabots: Le Café-Concert, Le Cirque, Les Forains*, 1896, Paris

so's early paintings of Saltimbanques allude. For example, the foreground Harlequin in Picasso's *Parade* curtain appears both physically and psychologically isolated from the rest of the diners. His expression lends a thoughtful, meditative quality to the scene and bestows depth and humanity upon what is usually a two-dimensional stock character. In view of this, it is not surprising to learn that the foreground Harlequin in the *Parade* curtain is generally identified as a self-portait of Picasso.

Similarly, Watteau's famous picture of *Gilles* (Louvre) is also accepted as a self-portrait of the artist.[15] It has been suggested that Watteau painted *Gilles*, who is a type of Pierrot restricted to *forains*, as 'a placard or poster *à la porte d'un Théâtre de la Foire*', that is, as an advertisement for a specific *parade*.[16] Assuming both *commedia* figures are self-portraits, Watteau and Picasso share the conceit of presenting private and introspective aspects of their own persona within the most public of formats – theatre curtain and advertisement – and both for *parades*.[17]

In addition, both Watteau and Picasso considered the monkey as yet another *alter ego*, and invested their depictions of these creatures with the same isolation and introspection as their other allegorical self portraits. Thus Picasso and Watteau share not one, but two *alter egos*, identifying themselves as artists with both *commedia* characters and apes.[18]

There are other similarities between the curtain and the work of Watteau; in *The Shepherds* (fig. 199), for example, it is uncertain whether the characters are performing in a play or merely entertaining themselves. The pastoral setting, the amor-

ous couple, and the reclining male figure on the far left who, like the foreground Harlequin in the overture curtain, has a dog at his feet, is dressed predominantly in red and looks more intently than the others at the performing group to the right, are other points of similarity. Like Picasso, Watteau often bisects the composition, juxtaposing idle watchers and active performers. The pervasive pink and blue tonalities of the curtain also occur frequently in Watteau's compositions (as they do in many works of the Rococo period). Most important for Picasso though, is Watteau's 'intermingling of music and theatre, dance and open air, wine and love, the real and the imaginary.'[19] Like Watteau's *fêtes galantes*, Picasso's curtain poetically evokes feelings of sadness at the passing of worldly pleasure.

The number of artists who responded to Watteau's treatment of the estranged and/or itinerant player is long and illustrious and includes Giambattista Tiepolo, Honoré Daumier, Edgar Degas, Georges Seurat, Henri Toulouse-Lautrec, and Edouard Manet. Picasso's knowledge of these artists' work has been examined in detail by Theodore Reff and others.[20] More germane for this study is the fact that saltimbanques, dressed as *commedia dell'arte* characters, abound in popular art from the late eighteenth century onwards.

Since Watteau's time Harlequin, Pierrot and the other *commedia* players had come to be universally identified with rejection from society and in particular to be associated with the outcast poet/artist.[21] In the nineteenth century the popular press took up the subject and images stressing the loneliness and

[15]Margaret Morgan Grasselli and Pierre Rosenberg wrote that although it may not be a true self-portrait: 'However, there is in the work an obvious feeling of self-identification.' *Watteau 1684–1721* (Washington, 1984), p. 434.
[16]Panofsky, pp. 325, 328–329. Dora Panofsky believes *Gilles* was an advertisement for the skit, *L'Education de Gilles*. The often-posed question of what was the difference between *Gilles* and *Pierrot* was solved by

Panofsky who discovered that they were the same character but that Pierrot performed within the *Salles de spectacle* of the *Commedia* stage while Gilles was strictly a *parade* or *forain* player, p. 331.
[17]John Richardson describes Picasso's use of *alter egos* such as Harlequin as, 'A form of secret exhibitionism, that is self-exposure in the form of allegory.' 'L'Amour Fou', *New York Review of Books*, 19 Dec. 1985, p. 60.

[18]For Watteau's use of a monkey as an *alter ego* see Panofsky, pp. 333–4.
[19]Morgan Grasselli and Rosenberg, *Pierre Watteau 1684–1721* (Washington, 1984), p. 339.
[20]See Theodore Reff, pp. 30–43; and 'Picasso and the Circus', ed. L. Bonfante, in *Essays in Archeology and the Humanities: In Memoriam Otto J. Brendel* (Mainz, 1976) pp. 237–48; Pierre Daix and Georges Boudaille, *Picasso: The Blue and*

Rose Periods (Greenwich, 1967); Jean Starobinski, *Portrait de l'Artiste en Saltimbanque* (Geneva, 1970); E.A. Carmean Jr., *Picasso, The Saltimbanques* (Washington, 1980), pp. 20–7; Ellen Bransten, 'The Significance of the Clown in Paintings by Daumier, Picasso, and Rouault,' *Pacific Art Review*, no. 3 (1944). p. 26ff.
Daix has noted that Manet's *Old Musician* was on view at the October 1905 Salon d'Automne and Picasso most likely

saw it while he was putting the finishing touches to *Family of Saltimbanques*. Note the similarity of down-and-out, psychologically-detached figures in a barren landscape setting.
[21]Ronald Johnson 'Picasso's Parisian Family and the "Saltimbanques"', *Arts Magazine*, vol. 51, Jan. 1977, p. 90.

bitter-sweet poetry of the life of any type of itinerant player became ubiquitous. Picasso looked to these popular images as had Courbet, Manet, and Seurat before him.[22]

The lot of the travelling player held great interest for Spanish and French newspapers such as the journal *La Illustracion artistica*, which in 1892 and 1896 published illustrations documenting the street performer's offstage life. In 1899 *Le Courrier Français* carried a series on the marginal existence of itinerant players. Commercial artists also capitalized upon the interest in the day-to-day life of the wandering performer: H.G. Ibels' 1896 print for *Le Café Concert, Le Cirque, Les Forains* (fig. 200) captures the boredom of *parade* performers awaiting their turn as well as the lack of glamour surrounding the entire enterprise. Many illustrations show the strong bonds which obtain among vagabond performers who turn to each other for a sense of community that is not available to them in the world at large.

Most important for Picasso was the fact that many of the Catalan artists of the *modernista* group who gathered at *Els Quatre Gats* were involved with the theme of the travelling *forain*.[23] Ricardo Opisso's 1904 illustration to Juan Pons y Massaveu's *En Mitja Calta* (fig. 201) depicts a common subject – the domestic ordinariness of the off-stage moments in the circus performer's life. Here a husband and wife adjust and sew their costumes amid circus properties.

Another friend of Picasso's, the Catalan artist and writer Santiago Rusiñol, wrote and produced in 1898 a popular one-act play on the subject of saltimbanques called *L'alegria que passa [Happiness that Passes]* at the Teatre Intim in Barcelona. The members of the troupe include a clown, a strongman, a monkey, a horse, and an exotic singer and dancer named Zaira. Rusiñol designed a poster for

the event and the 3 June 1899 inaugural issue of the Catalan art journal *Pél i Ploma* dedicated an article to the play and reproduced related drawings by Rusiñol and Ramon Casas.[24]

In view of Picasso's open-minded approach to all manner of visual material be it 'high' or 'low', it is likely that popular imagery dealing with outcast/itinerant performers influenced his representations of the subject.[25] These popular sources are particularly evident in the close-knit domestic and communal life present in Picasso's work from the Circus period (fig. 202) where saltimbanques are shown going about quotidian domestic tasks, eating, practising, and child-rearing.[26] Picasso continues to make use of such illustrations for the *Parade* curtain. Aside from the specific source discussed below (Neapolitan postcard, fig. 227), earlier popular influences re-emerge in the general flavour of the curtain's back-stage context and its focus upon the sense of a close-knit community among a group of marginal figures (fig. 203).

The wealth of visual material regarding itinerant players found in both high culture and the vernacular, stems from a fascination with people who live without roots, on the fringe of society.[27] The freedom of the drifter is romanticized by those who live structured lives, for there is a heroic aspect to living in the present, taking what each day brings, without the security of permanent income, employment, or dwelling. The drifter's heroism stems from a commitment to freedom and creativity at the cost of material comfort and emotional security.

Throughout his life Picasso responded to this bohemian stance, identifying with those who lived outside society's expectations. The saltimbanque represented the freedom from societal strictures that Picasso saw as common to both painter and circus performer.[28] Even though Picasso was never a homeless person, one might say he shared with the

[22]See Robert Rosenblum and H.W. Janson, *Nineteenth Century Art*, p. 402.
[23]Nonell's cretins and Canal's gypsies are other examples of interest on the part of *modernista* writers and artists in marginal groups.

[24]See Marilyn McCully, *Els Quatre Gats: Art in Barcelona around 1900* (Princeton, 1978), p. 131 for a reproduction of Rusiñol's poster.
[25]Picasso was himself a commercial illustrator providing most of the illustrations for *Juventual*

and *Cataluna Artistica* in 1900 and *Arte Joven* in 1901, as well as articles in *El Liberal* (Zervos, vol. 21, no. 374).
[26]See also Zervos vol. 1, nos 289, 292; vol. 22, nos 120, 121, 154, 158–61.
[27]Movies like *La Strada, Le milieu*

du monde, Vagabond, attest to the persistence of this fascination with the drifter or outsider in Western culture.
[28]Reff has pointed out that the saltimbanques Picasso portrays in the Rose period (as those in the *Parade* curtain) are the 'low-

est' of several classes – the so-called *postiches*, who have neither tent nor platform for mounting a sideshow, but must perform on a rug or *tapis* laid down in a city square or at a suburban fair. Reff, p. 33.

201 Ricardo Opisso,
illustration for the 1914
novel *En Mitja Calta* by Juan
Pons y Massaveu

202 Pablo Picasso
Harlequin's Family, ink and
watercolour, 1905

vagabond a certain detachment as well as a lack of interest in the usual trappings of middle-class success.[29]

During the period from 1899 to 1904, Picasso's own interest in gypsies, street performers and music-hall entertainers was stimulated by his contact with the group of artists at the Barcelona café *Els Quatre Gats*. Later, during his first years in France, Picasso cultivated friendships with performers at the Cirque Médrano and with saltimbanques, clowns, jugglers, acrobats and strong-men (many of whom were Spanish gypsies) who performed along the boulevards as well as in the outskirts of Paris.[30] This is the reality of his life against which what are proposed as sources in visual art must be viewed.[31] Picasso continued to admire and befriend circus and street entertainers after the Circus period and no doubt drew directly from his own experience as much, if not more, than from visual sources. In 1910 Fernande wrote Gertrude Stein from Cadaques: 'We are now very friendly with some clowns, bare-back riders, and high wire dancers whom we met at the café'.[32] During the summer of 1913 Max Jacob, who was on holiday with Picasso in Céret, wrote to Apollinaire that they had become friends with performers in a small travelling circus.[33] A sketchbook dating from 1917—18 contains pencil drawings of a strong-man and a monkey, indicating Picasso was still attentive to *forain* characters around the time he was creating the designs for *Parade*.

As has been mentioned, stylistically, the overture curtain refers to folk tradition, particularly that of the *Images d'Epinal*. The figures of the *Parade* curtain share with these popular woodcuts simplified contours, unmodelled surfaces, and the awkward, at times disjointed, rendering of facial features and anatomies (fig. 204).[34] Moreover the curtain's spatial compression of near and far find a parallel in the naïve imagery of popular prints.

The characters depicted on the *Parade* curtain are common to another kind of popular open-air vagabond entertainment which also has a folk art component – the puppet and marionette theatre. At one point Cocteau even referred to *Parade* as a 'Punch and Judy show.'[35] Often puppet shows performed the same function as *parades*, i.e. they were 'come-ons' or 'catchpennies' for the main show inside.[36] Seventeenth- and eighteenth-century itinerant puppeteers based their scenarios on *commedia dell'arte* performances, since the characters were well-known and since the physical slapstick humour of the *commedia*, involving much clobbering, lent itself to puppetry. This is why even today so many puppets, including Punch and Judy, Harlequin, and Scaramouch are, or derive from, *commedia* characters.

Picasso encountered Harlequin in the puppet and marionette shows whose booths dotted both the seaside and the streets of Barcelona in the 1890s, and at the café Els Quatre Gats which had a puppet theatre and sponsored puppet and shadow plays.[37] A small passage on a sheet of illustrations for Els Quatre Gats – probably recording a scene Picasso saw enacted there – depicts a woman manipulating

[29]Ironically, the one period in his life when he strayed from this philosophy was during the Diaghilev years. During this time he was briefly seduced by material wealth and the social whirl of high society. Françoise Gilot writes: 'With Diaghilev he was introduced to another world. Even though basically he disliked that kind of social nonsense, it tempted him for a time and his marriage with Olga corresponded, in a sense, to that momentary temptation. . . .' Picasso is quoted as saying, 'A demon gave me things. Wealth disgusts me. I thank God for

having given me poverty for part of my life'. *Picasso's Diary* shown on the Public Broadcasting Station, Oct. 1981.
[30]Gary Tinterow writes: 'Picasso's identification with Harlequin is well-documented and his love of all clowns and actors is no less obvious; he felt he shared with them a societal license to inspire and amuse, but always from the outside.' Cooper, Douglas and Tinterow, Gary, *The Essential Cubism* (London, 1983) no. 16.
[31]Reff cites Penrose and Cooper, p. 34. There is evidence that these street entertainers, who

comprise the *dramatis personae* of the circus period, were Spanish gypsies. For example in one drawing Picasso identifies the corpulent figure who is central to *Family of Saltimbanques* and a number of other drawings and prints as 'El Tio Pepe Don José' (Zervos, vol. 22, no. 217) and in several ink drawings, figures are rendered in poses associated with Spanish dance. Reff speculates that Picasso may have sought out these performers for companionship because his French was not yet fluent.
[32]Olivier, Letter 17 June 1910, Gertrude Stein Archive, Bei-

necke Rare Book and Manuscript Library, Yale University.
[33]Letter dated 2 May 1913. Cited in Penrose, p. 193.
[34]Silver has pointed out that the Epinal style became common for wartime imagery and was acceptable to both the right and left since it was quintessentially French and therefore patriotic as well as crude, and primitive enough to be acceptable to *avant garde* artists. Silver writes: 'For the avant-garde painter, who had trafficked in any one of a number of primitive-influenced styles before the war, the *image d'Epinal* al-

lowed one to be both a patriot and, in some sense, to remain true to the esthetic concerns of the late nineteenth and early twentieth century advanced art circles'. Silver, *The Great War and French Art, 1914—1925* (Yale, Ph.D. dissertation, 1981) (pp.48—9).
[35]See chapter 1, p. 33.
[36]Leach, *The Punch and Judy Show: History, Tradition and Meaning* (Athens, 1985) p. 33.
[37]Beaumont, p. xvi and Marilyn McCully. *Els Quatre Gats: Art in Barcelona around 1900* (Princeton, 1978). J.F. Rafols, *Modernismo y modernistas* (Barcelona,

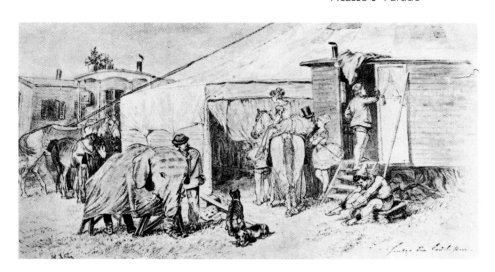

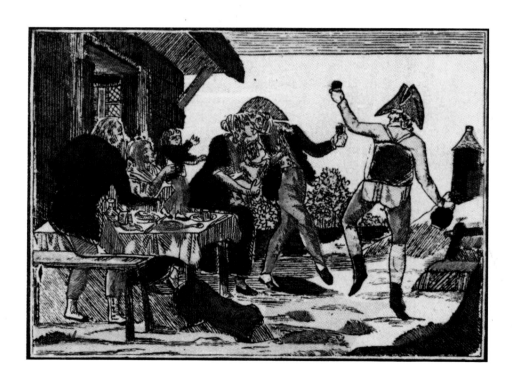

203 Henri Lang, *Derrière les Coulisses*, prints of pencil and ink drawings in *Equitation et Gymnastiques*

204 Fabrique Pellerin, *Images d'Epinal*, woodcut, *c.*1800

a Harlequin string puppet, known as a jumping-jack or *pantin*, for a child (fig. 205).

Pantins were manufactured in many places, but the standard for the moving paper puppets was established at the Imagerie or Fabrique Pellerin at Epinal (the same press that produced the famous popular prints). The Epinal *pantins* are comprised of seven stock characters: Harlequin, Columbine, Pierrot, Pierrette, Chinaman, Polichinelle, and Blackamoor – characters familiar by now from the *Parade* curtain or the ballet proper (fig. 206). Picasso apparently owned a Harlequin *pantin* which Françoise Gilot recalled seeing in the storeroom of his rue La Boétie apartment, 'where suspended on the face of a wall was a charming seventeenth-century Italian puppet, strung together with wires and dressed as Harlequin, about four feet high.'[38] Many years later Picasso made operable Harlequin *pantins* to entertain his children, Claude and Paloma (fig. 207).

The fact that Stravinsky's *Petrouchka*, which was at the top of the *Ballets Russes* repertoire, featured a drama based on puppets derived from the *commedia* (Petrouchka is the Russian equivalent of Pierrot) could not have been lost on Picasso. He drew several sketches of Alexandre Benois's famous *mise en scène* while the ballet was in rehearsal in Rome.[39] In a sense Stravinsky's ballet accomplished what Picasso and Cocteau were striving for with *Parade*, in that it elevated and transformed a popular fairground idiom into high art. A ballet about Russian puppets, however, had the benefit of seeming exotically foreign and charmingly folk-like to Parisian audiences, while *Parade* was entirely urban, familiar, and topical. Moreover, there was the supernatural element of the puppets coming to life

that rendered *Petrouchka* entirely fanciful.

The Blackamoor who slays Petrouchka bears comparison with the turbaned Moor in the overture curtain.[40] As in *parades* the Blackamoor is a standard character for puppet theatre: 'Whether liveried servant or inscrutable 'schalabala' the black man provided an exotic touch that was deemed a necessary feature of puppet shows since the eighteenth century.'[41]

Among the sources for the *Parade* curtain's circus iconography a large place must be reserved for Picasso's earlier work. Many have noted the curtain's recasting of characters from the 1905 Rose period, but even before, in 1900, he had painted a fair booth *parade* (Daix V.63). As mentioned it is likely Picasso's personal experience of backstage circus life was the stimulus for his early saltimbanque and Rose period imagery.[42] In 1917, finding himself once again in a 'back-stage' theatrical milieu, with a commission to design décor for a ballet about itinerant players, the saltimbanque years and the characters that populated them were readily recalled to Picasso's imagination. Moreover, Picasso continued to call upon these theatrical players – as if they were a repertory company – throughout his life. Harlequin, equestrian, white mare, toreador, etc. make appearances and then are not seen for long stretches at a time, only to reappear years later in Picasso's *oeuvre*.

First and foremost among the characters and props of the circus period that the overture curtain re-introduces is Picasso's well-known *alter-ego*, Harlequin.[43] Picasso paints himself wearing Harlequin's motley in the 1905 painting, *At the Lapin Agile*

1949) p. 131. See advertisement for Els Quatre Gats by Roman Casas showing the proprietor Père Romeu manipulating a Punchinello puppet in McCully, ibid. p. 69.

In keeping with their anti-authoritarian beginnings (initially Punch and Judy were created as a critical response to England's oppressive penal system) these puppet plays were subversive of order and civilization, an anarchic challenge to

respectability and conventional morality.
[38] Gilot and Lake, *Life with Picasso* (New York, 1964) p. 151.
[39] *Petrouchka* premiered 13 June, 1911 at the Théâtre du Châtelet (the same theatre as *Parade*). It was billed as 'Burlesque scenes in four tableaux by Igor Stravinsky and Alexandre Benois.' The drawings by Picasso are in the collection of John Carr Doughty (Surrey, England) and were described to the author by Melissa

McQuillan, but not seen.
It is interesting to note that Hélène Parmelin reported of Picasso that while he generally liked popular tunes as opposed to classical music, 'There is however, a melody that he often hums, always the same one, and joyously: an air from *Petrouchka* and all his eyes gleam in the footlights.' One can speculate if it was the 'jambe en bois' melody which Stravinsky appropriated from a

popular tune. *Intimate Secrets of a Studio at Notre Dame de Vie* (New York, 1966) p. 26.
[40] Reff, MacDonald and Martin, Marianne, 'The Ballet Parade: A Dialogue between Cubism and Futurism', *Art Quarterly* (1977–8); see a portrait of Stravinsky in this figure. Axsom compares the Moor of the *Parade* curtain to the Moor in *Scheherazade*, another Diaghilev ballet. Axsom, p. 115ff.
[41] Leach, p. 57.

[42] See also Reff, 'Picasso and the Circus', for quotes from Olivier, Stein and Picasso testifying to the artist's intimacy with 'clowns, jugglers, the horses and their riders', p. 237.
[43] See Reff, pp. 30–41 and Penrose and Golding eds, 'Themes of Love and Death in Picasso's Early Work' in *Picasso in Retrospect* (New York, 1973), pp. 11–47.

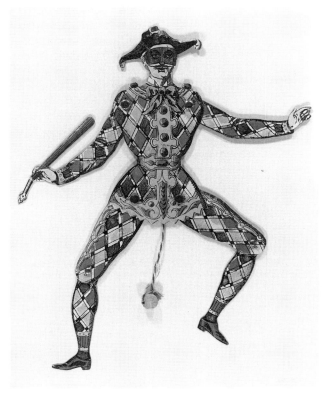

205 Pablo Picasso, study for menu of Els Quatre Gats (detail lower right), Barcelona, 1899

206 Fabrique Pellerin, *Pantin*, reproduction of a conjurer/harlequin jumping-jack dating from *c.*1770, Epinal

207 Pablo Picasso, Harlequin *pantin*, *c.*1952, cardboard, crayon and coloured pencil

(private collection, New York). He appears again idealized as the Harlequin on the left in *Family of Saltimbanques* (1904–5, Washington) and in *Circus Family* (1905, Baltimore), (figs 208, 209).[44] More recently William Rubin has found proof that Picasso alluded to himself when he painted the seated Harlequin in *Carnaval au bistrot* (1908, private collection).[45]

Some critics have seen Picasso's identification with Harlequin as an offshoot of his interest as an artist in balance. Meyer Schapiro writes: '…the experience of balance vital to the acrobat … is here assimilated to the subjective experience of the artist, an expert performer concerned with the adjustment of lines and masses as the essence of his art.'[46] While this may be true, Picasso must have also identified with Harlequin's other attributes. A description of Harlequin's character traits reads like Picasso's autobiography, he is 'at once insolent, mocking, clownish and, above all, obscene. I think with all this he mingled an agility of body which made him appear always in the air …'.[47] Harlequin is a trickster, a figure known in most mythologies as both a clown and a genuine devil possessing magic powers (fig. 210). In particular Harlequin is known for being mercurial and inventive, sometimes coarse, sometimes gentle but always dominated by his tremendous sexual appetite. Harlequin's personality with its associations of magic, eroticism and most importantly elusiveness and lightning-fast transformation, shares so much with Picasso's own persona as to confirm a comprehensive identification.[48] Picasso's remarks regarding his stylistic

eclecticism bring Harlequin to mind: Style is often something which locks the painter into the same vision, the same technique, the same formula during years and years … I myself thrash around too much, move too much. You see me here and yet I've already changed, I'm already elsewhere. I'm never fixed and that's why I have no style.[49]

Also noteworthy from the standpoint of Picasso's involvement with the theatre (as well as his politics) is the fact that from antiquity to the present, Harlequin has been the product solely of popular entertainment and is always of low status. He is dedicated to flouting authority, shaking up the *status quo* and undermining entrenched beliefs.[50] The trickster's singular potential is to underline the absurdity of social structures in such a way as to open up a more expansive, creative reality, marked by delight in the uniqueness of the self.[51]

This is certainly analogous to the task Picasso set for himself as an artist.

It has been convincingly argued that the foreground Harlequin in the *Parade* curtain represents Picasso, while the one on the other side of the table bears Cocteau's features.[52] For one, the far Harlequin looks like Cocteau, sharing his long face and pointed features. In addition, it should be remembered that Cocteau arrived dressed as Harlequin for his second meeting with Picasso, 'demonstrating an immediate recognition of Picasso's love for costume and charade'.[53] Given Harlequin's quicksilver nature, he is an appropriate *alter ego* for both Cocteau and Picasso. Beside his ability to transform the banal into the marvellous, Harlequin is noted for his

[44]William S. Leiberman, *Pablo Picasso: Blue and Rose Periods* (New York, 1952) p. 18.

[45]See Rubin for other references to Harlequin in Picasso's Cubist period. See also *Seltzer Bottle* 1912 (Najonalgalleriet, Oslo) and *Guitar* 1912 (Zervos II*, 357). Christine Poggi identifies the guitar player in the photograph of the *Assemblage with Guitar Player* of 1913 as Harlequin and writes that it, '…may be interpreted as a self-portrait. Ironically, however, the harlequin is partially unmasked; …

But the "self" thereby revealed is shown to consist only in another schematic representation, as if the "self" for Picasso were a layering of masks, of paper-like surfaces without interiority or depth.' Poggi, p. 320. The macabre *Harlequin* of 1915 (fig. 104) painted at the time of Eva's death is probably also autobiographical.

[46]Meyer Schapiro 'The Nature of Abstract Art' *The Marxist Quarterly*, (vol. 1, 1937), p. 92. See also Reff, 'Picasso and the Cir-

cus', pp. 239–40. Reff has noted that by the late nineteenth century the acrobats who wore Harlequin costume knew little about the *commedia* and Harlequin's other accomplishments as an actor, mime, and clown. Reff, p. 33.

[47]Luigi Riccoboni writing in 1728, quoted in Beaumont, p. 50.

[48]There are many accounts of Picasso's 'trickster-like' personality wherein he alternated between bawdy clown and powerful demon. See Gasman, Gilot and Geneviève Laporte,

trans. Douglas Cooper, *Sunshine at Midnight* (New York, 1975).

[49]Quoted in Richard B. Woodward, 'Not confined to a signature style many artists explore diversity', *Vogue*, July 1989, p. 104.

The comments of the authority on *Commedia* studies, Pierre Louis Durchartre also bring Picasso to mind: 'He (Harlequin) is the unwitting and unrecognized creator of a new form of poetry, essentially muscular, accented by gestures,

punctuated by somersaults, enriched with philosophic reflexions and incongruous noises.' *The Italian Comedy* (New York, Dover, 1966) p. 161.

[50]Leach, p. 174.

[51]Leach, p. 174. Other tricksters are Pan, Pulchinella and Puck. Tricksters are often amoral schemers but also possess magical visionary powers.

[52]Axsom, p. 112ff.

[53]Costello, p. 137.

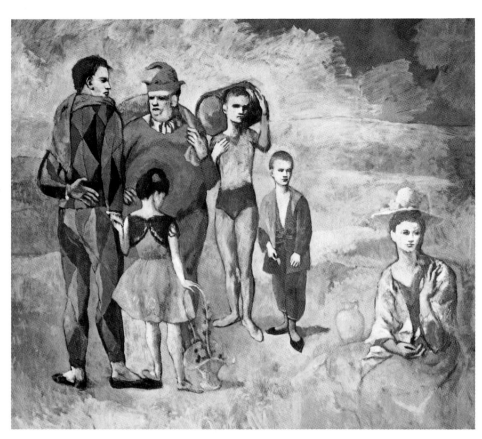

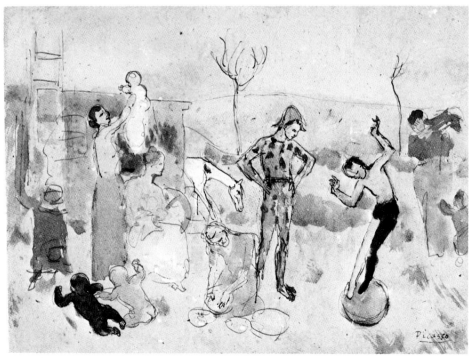

208 Pablo Picasso, *Family of
Saltimbanques*, 1904—5, oil
on canvas, 213 × 230 mm
(see colour illustration on
p. 26)

209 Pablo Picasso, *Circus
Family*, 1905, pen and black
ink, brush and gouache on
brown composition board,
252 × 312 mm (see colour
illustration on p. 27)

cunning, Machiavellian personality; he is sly and often cruel, qualities both Picasso and Cocteau possessed.

Harlequin recedes and emerges throughout Picasso's career. He dominates Picasso's sketchbooks for the years 1915 and 1916, just before he undertook the *Parade* commission, where Harlequin is rendered in both flat, Cubist (studies for the 1915 painting in the Museum of Modern Art (see fig. 104) and realistic styles.[54]

In the artist's later years Harlequin crops up in scenes of circus and theatrical performance (beginning in 1961, see Zervos 19, figs. 433, 444). In 1970 Picasso made over seventeen drawings of Harlequin in the company of a nude beauty. By turns he paints her, attacks her with his slapstick, offers her flowers, serenades her with a guitar, and passively watches as she performs an arabesque (Zervos 32, figs. 131–143, 318–333). Picasso's lifelong identification with Harlequin comes to a close in a series of fifteen self-portraits executed between 7–12 January 1971 (fig. 211). There is poignancy in the image of the masker unmasked, for the first time Harlequin's face reveals vulnerability and fear, rather than the usual moods of ascetic withdrawal or malicious devilry. He seems undone by the one thing he cannot elude – his own imminent mortality.

The female figure on the curtain is usually identified as an equestrian; however, true *parades* were too modest and poor to accommodate this type of performer. The women in tutus who appeared in most *parades* were either third-rate ballet dancers or tightrope walkers (fig. 212). The equestrian who executed ballet movements on a galloping horse was a highlight of the circus and of the larger fairground where *parade* baraques were often installed. Typically for Picasso, it is impossible to determine exactly the sort of performer the woman on the white horse in the curtain is.

The equestrian/acrobat performing upon a white steed is the subject of over twenty drawings and watercolours by Picasso from 1905 (Zervos, vol. 22, nos 248, 250–65, 270–2). Unlike the overture curtain, in many of the 1905 *écuyères* the rider is a girl rather than a woman. The equestrian does not appear in Picasso's *oeuvre* from 1906 until the *Parade* curtain. In both 1905 and 1917 the acrobatic

[54]See *Je suis le cahier*, nos. 57–9.
[55]From Edmond de Goncourt's description of a bareback acrobat in *Les Frères Zemganno* cited in Theodore Reff, 'Degas and the literature of his time' in *French 19th century Painting and Literature* (Manchester, 1972), pp. 200–2. A contemporary parallel with the equestrian is the white-clad ice-skater – the idealized fantasy woman – in Mike Nichols' film, *Carnal Knowledge*.

horsewoman is portrayed as weightless and ethereal. After 1917 she disappears for some years, only to re-surface with a vengeance in the prints and drawings of Picasso's late years where she occurs over fifty times. Skilful, accomplished, confident and pure she stands for ideal womanhood – 'A modern goddess of grace and freedom.'[55] She is the symbol of romantic love, the girl who is so beautiful, so light, so pure that she is unattainable. Often she is watched by an impotent clown or Harlequin who seems overpowered by her strength and beauty (for example from 1967–9 Zervos 27, figs. 43–4, 84, 126, 269, 274). In several instances the watching, dwarf-like figure is a self-portrait (see especially Geiser 1481, March 1968). In one series of etchings from May 1970, the equestrian is not only given wings, she actually merges with the horse – a pair of horse legs sprout from under her arms and she has hooves for feet (fig. 213). The equestrian makes her final appearance in an ink wash dated 12 May, 1972, just under a year before Picasso's death. She is depicted standing nude on a horse while a group consisting of two Spanish men, a female acrobat and a nude Spanish woman (wearing a mantilla) stand on the ground below (fig. 214).

The white mare upon which the ballerina stands is also a regular member of Picasso's repertoire. Associated with kindness and gentleness during the circus period, in later years it becomes a metaphor for suffering and victimization as in Picasso's many bullfight scenes of the late twenties and thirties. In these works the horse is often depicted after it has been gored by the bull. The horse is screaming, mouth open and tongue pointed upward like a knife. The white mare reaches its apotheosis as the main character in *Guernica*. After that it most often appears, as on the *Parade* curtain, paired with the equestrian.

Like the equestrian, the winged horse is true to circus reality, for performing horses were often strapped with wings (fig. 215) but, if we suspend belief, the horse also operates in the realm of classical allegory as the winged white Pegasus of Greek mythology (see chapt. 10).

The monkey is another frequent participant in Picasso's circus scenes. Like Harlequin, it is one of the personal symbols Picasso returns to in his work

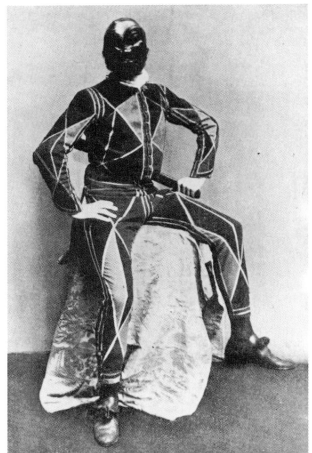

210 Italian eighteenth-
century harlequin's costume,
including mask and slapstick

211 Pablo Picasso,
Harlequin, oil pastel on
paper, 1971

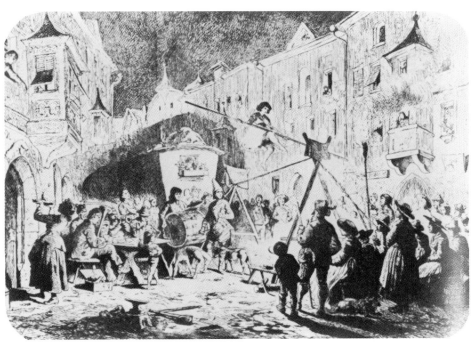

212 Theodore Knesing,
Tightrope walker at night,
wood engraving, n.d.

213 Pablo Picasso, untitled,
etching, May 1970

214 Pablo Picasso, pen and
ink drawing, May 1972

215 Popular print showing
winged horses, c.1880

from youth until old age. The artist caricatured himself as a monkey in a 1903 drawing and inscribed it, 'Picasso par lui même' (fig. 216) indicating that the monkey or ape served as another *alter ego*. The drawing underscores the monkey's and Picasso's own hyper-sexuality and baseness as well as his imitative facility (note the paint brushes tucked behind his ear). The graphic rendering of the Picasso/monkey's genitals as well as his scratching gesture 'lend the self-portrait a certain brazen vulgarity.'[56]

In the 1905 gouache, *The Acrobat's Family with a Monkey*, (Göteborgs Konstmuseum, Sweden) and the print, *Family of Saltimbanques with Monkey* (Geiser, vol. I pl. 13), the monkey appears to be a creature apart, separated from the others by the fact that he is almost, but not quite human. The monkey in the *Parade* curtain displays a similar 'heightened consciousness' and seems about to transcend his base nature as indicated by the poet/hero's wreath he wears and his elevated position.

It has recently come to light that the monkey or baboon occurs a number of times during the years 1916−18. Four pages of Picasso's *c.* 1917 sketchbook depict line drawings of a baboon (see fig. 217).[57] They are similar to studies of monkeys he made in 1905 which were incorporated into several circus scenes. Most interestingly for our discussion, Picasso cut out an advertisement for toothpaste from a newspaper depicting a monkey brushing its teeth, drawn by Benjamin Rabier, and kept it in his *c.* 1917 sketchbook (fig. 218). Like the Neapolitan postcards inserted in his Italian notebook, the Gibbs advertisement shows Picasso interested in 'low' scale art, in this case commercial illustration. Perhaps Picasso was attracted by the Gibbs' monkey's similarity to his own 1903 drawing, but more likely it appealed to Picasso by virtue of its mocking, somewhat vulgar and grotesque expression.

In later years Picasso cast the monkey as an artist seated before an easel (Zervos, vol. 16, figs. 175, 207 [1954]) and toward the end of his life he portrays himself as a monkey-like old man looking up a ballerina's skirt (Zervos, vol. 27, fig. 262 [8.3.68]). Picasso associated the monkey, like Harlequin, with a theatrical setting, with sex, and with artistic creation (Zervos, vol. 16, figs 102, 146−53, 163; vol. 19, fig. 433; vol. 31, fig. 18; vol. 33, fig. 495). Both Harle-

quin and monkey are tricksters, clownish performers of exaggerated sexuality who are gifted with not only the ability to imitate and mimic, but also to perform magic. In his fable, 'The Monkey and the Leopard', La Fontaine has the monkey declare: 'In magic arts I am at home . . . I can speak, you understand; Can dance, and practice sleight-of-hand; Can jump through hoops, and balance sticks; In short, can do a thousand tricks; . . .'[58] Picasso identified with Harlequin and ape as performers whose buffoonish looks and actions belie keen wit, depth of feeling, and supernatural abilities.

Because of the hat she wears, the woman who stands behind the sailor with one knee resting on the trunk at the far right of the *Parade* curtain has been seen as a reprise of the Majorcan woman from the *Family of Saltimbanques*, (National Gallery, Washington, D.C.). She first appears in the corner of a sketch Picasso made on a visit to Spain in May 1905, (a drawing which has the quality of first-hand observation (fig. 219), and in a gouache on cardboard drawing in the Pushkin Museum in Moscow. She emerges after the overture curtain in a 1919 drawing where she appears to lead Pulchinella away from two taunting Harlequins (fig. 220). In this drawing, as in the figure of Harlequin on the overture curtain, it is difficult to tell what direction Pulchinella is facing − since the head, left arm and feet face the two Harlequins, while the neck, chest and right arm face the Majorcan woman. Ambiguity as well as a sense of motion results from the overlaying or re-thinking of hand and foot positions for the other figures.

It is likely that the Majorcan woman embodied for Picasso the ideal Spanish woman − modest, beautiful and sensitive. Unlike the equestrian, she is not skilled, strong and active but passive and ladylike. Moreover, unlike the idealized equestrian, the Majorcan woman is an attainable love object. It is worth noting that in summer/autumn of 1917 Picasso portrayed Olga in a mantilla, perhaps indicating that he saw in her modesty and reserve, the qualities he identified with a well-bred Spanish lady (collection Mme. Paul Picasso, Paris).[59] There also exists a watercolour study of the Majorcan woman from the *Parade* curtain (the hand and face of the adjacent sailor is lightly sketched in pencil (see

[56]Axsom, p. 126.
[57]See *Je suis le cahier* no. 64.
[58]Jean La Fontaine, 'The Monkey and the Leopard' in *A Hundred Fables of La Fontaine* (New York, 1983) p. 126.
[59]Mme. Danilova in conversation with the author testified to Olga's modesty and reserve. Picasso's comment to Gertrude Stein is recalled, where he describes Olga as 'une vrai jeune fille'. Stein archive, Beinecke Rare Book Library, Yale University.

216 Pablo Picasso, caricature of the artist, 1903, pen and ink, Barcelona

217 Pablo Picasso, page from a notebook, pencil sketch of a baboon, *c*.1917–18

218 Benjamin Rabier, *Les Animaux de Gibbs (Série des Singes)*, newspaper advertisement for Gibbs' toothpaste kept by Picasso in his 1917 notebook

219 Pablo Picasso, detail
from a page of sketches from
a notebook, Gosol, summer
1905

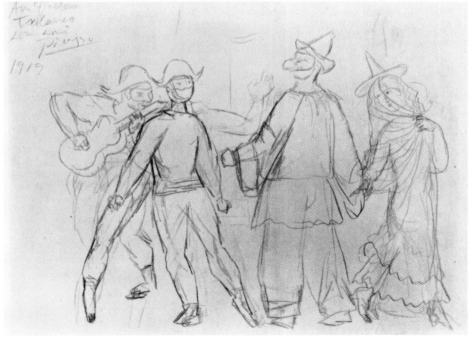

220 Pablo Picasso, pencil
drawing, 1919

fig. 194) and an oil painting of another woman in Spanish dress, *La Salchichona*, 1917 (Museo Picasso, Barcelona) both in pointillist style.

There are countless guitar players and matadors in Picasso's early *oeuvre*, but not combined in a single figure as the guitar-strumming toreador of the *Parade* curtain. The conflation of these two quintessentially Spanish characters, as well as the presence of the Majorcan woman can be understood as references to the artist's homeland. Perhaps nostalgia for Spain was stimulated by being in Italy, another Mediterranean country, and in particular, in Naples which shares many qualities with Iberian culture (see chapt. 9, n. 16).

There is modest precedent for the sailor from the overture curtain: a 1903 watercolour which depicts a group of three Catalan sailors next to a small boy who stands slightly apart (Zervos, vol. 1, no. 376) and there is also a study of a sailor from 1907, presumably one of Picasso's initial ideas regarding the cast of characters for the *Demoiselles d'Avignon*.[60]

In general the earlier composition by Picasso that comes closest to the curtain is *The Circus Family* (see fig. 209), 1905 (Baltimore Museum of Art). It has the same rose and blue tonalities (as do many of the Circus period works) and behind-the-scene point of view as the curtain. It also shares the specific features of a ladder on the left, a white horse, and a Harlequin watching another figure peforming an acrobatic feat. Picasso stresses the Harlequin and the object of his concentrated gaze through pictorial devices: heightened colour saturation and stronger outline in the 1905 gouache and composi-

tional separation in the 1917 curtain. In both works the Harlequins sufficiently resemble Picasso's physiognomy to claim them as self-portraits.

The ladder, ball, drum, and *tapis* [mat] turn up frequently, as would be expected in Picasso's 1905 circus properties, (Zervos, vol. 1, nos 292, 289; vol. 22, nos 154, 158–61). In the *Parade* curtain too, these props operate on a prosaic level but they also invite symbolic interpretation. The blue ball, spangled with stars, and particularly the ladder accommodate celestial or other-worldly interpretations. There is evidence in Picasso's earlier and later work indicating that the ladder symbolized spiritual ascension, a symbolism which is in accord with Christian and mystical inconography.[61] In particular, Picasso's 1906 gouache, *Person on a ladder* (Musée Picasso, Paris) depicting a figure climbing a ladder up to a skylight communicates a sense of metaphysical transcendence. Later the figure of Christ climbing a ladder in the *Minotauromachy* of 1935 (Geiser 288) unequivocally suggests a similar interpretation.[62]

The characters Harlequin, equestrian, white mare, monkey, toreador and Majorcan woman are symbolic types that recur throughout Picasso's work and confer a unity upon his *oeuvre*. At various junctures in his life Picasso re-introduces them to enact dramas that reflect preoccupations and reveal a paradoxical need to both unveil and hide autobiographical references. Although Picasso's symbolism cannot be pinned down precisely, these dramas often centre around the creation of art, the demands of desire, and their attendant conflicts, frustrations, and fulfilments.

[60] *Je suis le cahier*, no. 44, p. 2.
[61] Axsom, p. 130ff.
[62] See also prints 1966–8 in Bloch, Georges, *Pablo Picasso: Catalogue of the painted graphic work 1904–1967*, vol. 1 (Berne, 1968) nos 1469, 1485 (here again the figure on the ladder is Christ), and 1518.

Chapter 9 Picasso and the dining theme:

Neapolitan and Mediterranean

influences

Half of the *Parade* curtain is given over to a scene of dining. Although it has not been the subject of study, the dining theme and the personal associations attached to eating and drinking with friends and lovers holds an important place in Picasso's *oeuvre*. It is clear from photos and accounts of friends and acquaintances that café-sitting and dining were among Picasso's chief leisure activities (figs 221, 222).[1]

A recent article documents an afternoon of café dining and conversation among Picasso, Cocteau, and number of friends: During the war the Rotonde ... was the café where all the artists still in Montparnasse would meet. Its owner, Libion, was friendly to his clientele ... He let artists sit in the café for hours with only one 20-centimes cup of coffee and looked the other way when they broke the ends off the long breads in the bread basket. Picasso, whose studio was less than half a mile away from the Rotonde, spent a lot of time there after the death of Eva in December 1915 until he moved to the suburb of Montrouge in the fall of 1916 ...[2] **And later the author adds,** '... there is no doubt Picasso was one of the centers of café life at the Rotonde. As one Swedish artist remembers, 'Picasso and his people filled a whole table. He amused himself visibly by making fun of his admirers.'[3]

Indeed, the greater portion of Picasso's pre-war Cubist works reflects the intimate world of bohemian Paris as it revolved around dining and the café. The iconography of pipes, tobacco packets, newspapers, liqueur bottles and glasses, guitars, snippets of popular songs, advertisements, and menus found in Cubist paintings, prints, and collages documents the milieu where Picasso spent most of his time when he was not working.[4] These are images of amusement and camaraderie filled with clever jokes, puns, political and social references that conjure up the cacophonous atmosphere of the cafés themselves.[5]

As a Spaniard Picasso would have been trained to this form of sociability early. In Spain social life revolves around the café: lunch 3.00–4.00, dinner 10.30–1.30. Between 6.00–8.00 is the time of the *paseo* or evening promenade which is watched from small tables outside cafés. Entertaining among Spaniards is almost always done at these cafés and rarely at home. The cafés are also the venue for the evening *tertulia* which is a meeting among comrades to discuss and debate every subject imaginable from bull fighting to politics.

Picasso's first bohemian circle was based at the café Els Quatre Gats. In a drawing from 1900 by Ricardo Opisso we see a young Picasso seated among his friends at the Barcelona café (fig. 223). Picasso's own pen and ink design for a poster or advertisement, dated 1902, shows the artist and his friends seated around a table smoking and drinking (fig. 224). Note that Picasso separates himself from the rest of the group and has a dog at his feet in a configuration similar to the foreground Harlequin/self-portrait in the *Parade* curtain. Moreover the ink drawing has 'the same celebratory and memorial character' that later informs the *Parade* overture curtain.[6]

The *Wedding of Pierrette* (private collection) (dated 1904 in Zervos and Daix, but more likely spring, 1905) like the overture curtain, depicts *commedia* players dining. Harlequin is again removed from the rest of the group. As in the overture curtain one figure has its back toward the viewer and leans on one arm (the pose is the mirror image of the foreground Harlequin of the *Parade* curtain). Opposite her sit a couple with the man's arm draped around his lover's shoulder in a way that

[1] The area of sociology known as commensalism holds that sharing food universally carries social and cultural significance. The theory of commensalism maintains that breaking bread with another person indicates equality, or at least a willingness to pretend equality for the duration of the meal.

[2] Klüver, 'A Day with Picasso', *Art in America*, no. 9, vol. 74, p. 101. See also Klüver and Martin p. 63.

[3] Ibid., p. 107. Klüver too describes Marie Vassilieff's canteen which Picasso also patronized 'The place would be full again by 10 o'clock. Whisky and wine were available. Picasso and Matisse would drop in; and Modigliani, Zadkine, Kisling, and when they were on leave Braque, Derain, Léger, Apollinaire. The hours of talk in ten languages would occasionally be interrupted for impromptu musical performances. 'Gunnar Cederschiöld, *Efter Levande Modell*, Stockholm, Natur och Kultur, 1949, pp. 170–2. Quoted in Klüver, p. 102.

[4] Rosenblum writes, 'Most often Picasso's selection of commonplace words, like his selection of commonplace objects belonged to the milieu of the French café (whose ambiance provided the richest stimulus for cubist art). Robert Rosenblum, Penrose and Golding eds, 'Picasso and the Typography of Cubism,' *Picasso in Retrospect* (New York, 1973) p. 55.

[5] See Rosenblum, ibid and Patricia Leighten, *Re-ordering the Universe: Picasso and Anarchism 1897–1914* (Princeton, 1989).

[6] Numerous dining and café-sitting scenes occur in Picasso's production during the years around 1900 (Zervos, vol. 1, nos 20, 23, 33, 41, 178; vol. 21, no. 174; vol. 22, no. 301.

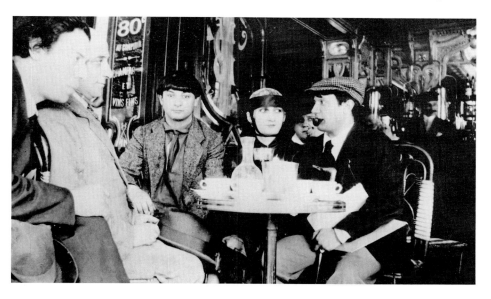

221 Photograph taken by Jean Cocteau at 2.30 on 12 August 1916 on the terrace of the Café de la Rotonde in Montparnasse. From left: Ortiz de Zarate, Max Jacob, Moise Kisling, one of Poiret's fashion models, Paquerette, Marie Vassilieff and Picasso.

222 Pablo Picasso, self portrait with Angel de Soto and Sebastian Junger-Vidal, 1901, ink drawing

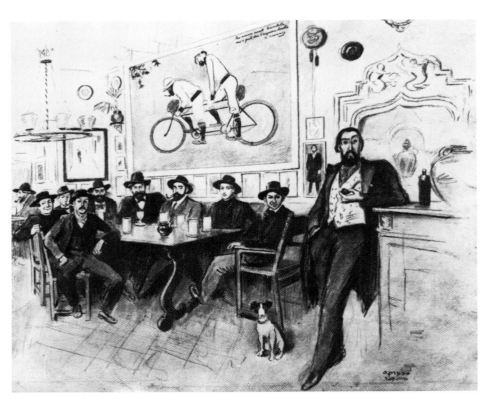

223 Ricardo Opisso, *Els Quatre Gats*, 1900. Picasso is seated far right

224 Pablo Picasso, *Père Romeu – 4 Gats*, 1902, ink and pencil on paper

parallels the far Harlequin/Columbine group of the curtain. The woman with her hand to her face wears the characteristic head-dress of the Majorcan woman and repeats the gesture enacted by that figure in the *Family of Saltimbanques* (see fig. 208).

A watercolour of 1908, *Carnival au bistrot* (private collection), again depicts Harlequin breaking bread with lovers and friends.[7] The central Picasso/Harlequin figure, with his head tilted toward a bare-breasted female, echoes the group of Harlequin and Columbine on the far side of the table in the *Parade* curtain. Like the curtain, the small 1908 watercolour projects a religious atmosphere due to the iconic frontality of the figures and the hat/halo of Gilles on the left. Aware of artistic and cultural associations, Picasso no doubt realized that placing hieratic figures around a table could not help but recall The Last Supper to the viewer's conscious or subconscious mind.[8]

The idea of imaging himself and close friends or lovers in the guise of *commedia* figures was not new to Picasso in 1917, nor was the overture curtain the last time he would create a major allegorical painting involving himself, friends, or heroes in carnival guise seated around a café table. The monumental *Three Musicians* (1921, Museum of Modern Art, New York) represents another instance of the artist creating a 'memorial to his lost friends and bohemian youth'.[9]

Most often these major works evolve from narrative studies to a final realization that is generalized, allegorical and symbolic. The progressive disengagement from anecdote, the motionless introspection of figures, and intense concentration in the play of pictorial forces are Picasso's standard procedure in the evolution of such paintings.[10]

The *Parade* curtain fits in with this procedure, having undergone a similar transition from narrative to iconic. By comparing the finished curtain to a watercolour study (see figs 185, 191), we see that Picasso tightened the groups, making the action more focused and intense and at the same time more ambiguous and generalized. The watercolour must have preceded two pencil studies that show the curtain at a point that is close to its final state (see figs 192, 193). Initially Picasso positioned the equestrian and the monkey off to the side and behind instead of on the horse. In their place is a figure wearing blue tights, climbing a ladder and holding up a star as if he were about to attach or detach it from something unseen above. This figure, seen from the back, serves as the focus of attention for the group around the table, as well as for the equestrian and monkey to the left. By removing the blue-clad figure Picasso pared down and condensed his composition. He also created a greater contrast between the all white group on the left and the more colourful group on the right.

The compositional division of the *Parade* curtain into two groups – one of diner/observers and another of performers – also has precedents in Picasso's work. Among them is a watercolour from 1903 *Practising the 'Jota'* (fig. 225). Like the overture curtain, the drawing depicts a simple tavern table placed before a rounded arch that opens on to a blue background. Picasso includes himself standing on the far right and drinking from a carafe/poron.[11] He is part of a group that consists of a figure sitting on the table strumming a guitar, an old 'procuress' sitting on the right and two other men.[12] This group around the table, with the exception of Picasso, intently watch a couple dancing on the left. As in

[7] In a complex analysis, William Rubin has convincingly identified the haloed figure on the left as Henri Rousseau, and the figure on the right as Cézanne – the two major influences on Picasso at this time. See Rubin.

The association of the saint-like Rousseau with Gilles is also relevant for Picasso's relation to Watteau discussed in Chapt 8.
[8] Reff, 'Three Musicians', p. 130. Reff writes that *Carnival at the*

Bistro suggests a Last Supper.
[9] ibid, p. 125ff. Reff claims that the painting represents Picasso, Apollinaire and Max Jacob. Rubin accepts this reading but suggests the figure of Pierrot could also be read as a disguised reference to Henri Rousseau. Rubin, *Henri Rousseau* (New York, 1985) p. 54ff.

See also the series of gouaches painted in 1920 (Zervos, vol. IV, figs 64, 67, 70, 72)

after the commission for *Pulcinella* was completed showing 'Harlequin and Pierrot sitting together in a cafe, frontal and side by side, as they will appear in the *Three Musicians* one year later.' (Reff, ibid., p. 128).
[10] See Rubin, pp. 626–7.
[11] Picasso sent Gertrude Stein a number of postcards from Spain in the years 1912–13. He often chose photographs showing peasants seated around a

table. On two occasions he sent Stein the same image, showing a group of men smoking and drinking from a poron gathered around a table. On one of the cards he inscribed *Portrait de Matisse* over a seated figure who does bear a striking resemblance to Picasso's friendly rival. On the back of the card Picasso wrote: 'Ma chere Gertrude[,] Je vous envoi le portrait de Matisse en Catalan . . .' (card post-

marked 12 March 1913, Beinecke Rare Book and Manuscript Library, Yale University).
[12] She is similar to *Celestina* of 1903 (Zervos, vol. 1, no. 183) and is related to the old woman who appears as a procuress of young beauties in Picasso's late works.

225 Pablo Picasso, *Practising the 'Jota'*, 1903, watercolour (MP 435)

226 Pablo Picasso, etching from the *Suite Vollard*, 1933

the overture curtain the intense gaze of the watchers confers significance upon the left-hand group that is being observed.

Tavern and café scenes occur less frequently after the early 1920s, no doubt because the artist's life revolved around the café less and less.[13] One example however, an etching from the Suite Vollard of 1933, brings to mind the *Parade* curtain in its focus on woman as object of desire and inspiration (fig. 226). A group of men including a sailor and a guitar-player gather around a wooden table and gaze at the classically beautiful nude woman who poses before them (is she a real woman, a statue, a mirage?). Their expressions range from the lecherous leer of the semi-nude bacchic figure to detached admiration reflected in the gaze of the sailor on the far right. In his self-absorption this figure recalls the Harlequin/Picasso of the *Parade* curtain as he watches the equestrian.

The dining theme clearly played an important role in Picasso's *oeuvre* and very often signalled autobiographical references to friends, lovers, and esteemed colleagues, be they living or dead. The *Parade* curtain partakes of this iconography and constitutes a heretofore unnoticed episode in a series of works which pay tribute to camaraderie among kindred spirits, while at the same time commenting upon the artist's essential loneliness and isolation.[14]

Neapolitan and Mediterranean influences

Having established the importance of the dining theme, a postcard inserted into Picasso's Italian notebook takes on a new significance as yet another source of inspiration for the overture curtain (fig. 227). The postcard entitled *La Taverna* is a reproduction of a watercolour by Achille Vianelli — one of thirty-six he created in 1831 for a book illus-

trating Neapolitan street life.[15] Picasso purchased the card, and two others by Vianelli (figs 228–229) in Naples when he, Massine, Stravinsky and Cocteau visited the Museo di San Martino, a museum dedicated to preserving Neapolitan culture. Vianelli's prints represent scenes that were probably familiar to Picasso from his youth, as Naples and Eastern Spain are culturally very close.[16]

The compositional bisection of Vianelli's *Taverna* postcard conforms to the entertainers versus the entertained configuration of the *Parade* curtain. An amorous couple, the man's arm wrapped around the woman, parallels the far Harlequin group, while a musician and a figure wearing a cloth belt — like the Neapolitan sailor's in the curtain — are also comparable. In addition, the wooden benches, the positioning of the column and the mountain — here clearly Mount Vesuvius — share similarities with the curtain. Although the postcard Picasso owned was in sepia tones, the original print as illustrated in Vianelli's book (which Picasso may have known) was coloured, like the *Parade* curtain, predominantly in tones of blue and rose. Finally, the overall feeling of companionship and the enjoyment of simple pleasures — food, drink, friendship, romance, and song — are sentiments conveyed by both works.

One may ask whether such a humble object, a popular postcard of little artistic merit, measuring 76×127mm, could possibly have played a part in the conception of the monumental curtain.[17] For another artist it might be doubtful, but for Picasso it is more than likely. As Cocteau had observed, Picasso was a 'rag-and-bone man of genius' who utilized everything, especially what others saw as insignificant, as grist for his artistic imagination. It was customary for Picasso to derive inspiration from the most banal of commonplaces. He once said: 'I like all painting. I always look at the paintings — good or bad — in barbershops, furniture stores,

[13]For the importance of the café in the years around 1900 see Roger Shattuck, *The Banquet Years* (New York, 1967) pp. 3–28 and Georges Bernier *Paris Cafes, Their Role in the Birth of Modern Art* (New York, 1985).

[14]*The Dance* in the Tate Gallery seems to be the last work which refers to the friendships of Picasso's youth.
[15]Achille Vianelli (1803–1894) *Scènes Populaires*, 36 etchings (n.p., n.d. no title page); a copy of this folio is housed in the Uni-

versity of Wyoming, Archives — American Heritage Center.
[16]Naples became a Spanish possession under Hapsburg rule from 1503 to 1704. In 1734 Naples became the capital of an independent kingdom of Sicily ruled by Prince Charles of Bour-

bon (later Charles III of Spain). The Teatro San Carlo and the great palace Caserta were built under his rule.
[17]Silver cites the postcard as a source for the *Parade* curtain in his 1984 essay in *Jean Cocteau and the French Spirit*. I had

come to the same conclusion independently and presented these findings in a lecture at the Institute for Contemporary Art in Boston on 19 November 1982 in conjunction with the exhibition *Art and the Dance*.

227 Achille Vianelli, *La Taverna*, 1831 from *Popular Scenes of Naples*, postcards bought by Picasso and inserted in his Italian notebook

228 and 229 Achille Vianelli, additional untitled postcards from *Popular Scenes of* *Naples*, bought by Picasso and inserted in his Italian notebook

provincial hotels . . . I'm like a drinker who needs wine. As long as it's wine, it doesn't matter which wine.' By inserting the postcard into his Roman notebook it is almost as if he were leaving future biographers or historians a clue to at least one of the curtain's sources.

The Museo di San Martino, where Picasso purchased the Vianelli reproductions as well as a number of other postcards relating to *Pulcinella* and the *commedia dell'arte* (see chapt. 3), is known for its displays of Neapolitan folk art. One of San Martino's most impressive and popular sights is the multi-figured créche group of the Nativity known as *presepe* [crib] installed in the nineteenth century, which was in place at the time of Picasso's visit and is still on view today (fig. 230).[18] Unlike traditional representations of the Nativity in Western art where the central characters of the drama – the Virgin and Child, Joseph, the three Magi and perhaps a shepherd or two – are either the only ones represented or are given prominence within the composition, in the San Martino *presepe* the presentation of the Magi is only one scene among many vignettes taking place on a rocky landscape. The viewer has to search for the Holy Family among the ordinary citizens going about their everyday tasks. While angels circle above we see scenes of bustling activity which recall the streets of Naples rather than ancient Bethlehem. Seedy types beg for money, men play guitars, women prepare food, ragged children run amok, and peddlers hawk their wares including strings of sausages and sides of beef that hang in open stalls. Slightly to the right of the Nativity, there is a group seated outdoors on wooden benches about to dine on a meal served upon a white tablecloth. The configuration of the group, table, and archway bring to mind the right-hand group of the *Parade* curtain. As in the curtain a member of the gathering (also on the left) serenades the others (here with a violin instead of a guitar). There is also a group of turbaned black men,

who like the Magi, seem no more than exotic visitors to a cosmopolitan city and who bring to mind the Blackamoor of the curtain (fig. 231).[19]

Besides visual similarities, the most compelling aspect of the *presepe* for our purposes is its union of the everyday and the sacred in a single context, a feature that is in line with the prosaic yet spiritual mood of the curtain and with Picasso's persistent urge to mediate between the secular and spiritual, the ordinary and the marvellous.[20] The *presepe* reflects the predominant attitude among Neapolitans to Church and religion characterized by a distinct lack of respect.

The people of Naples are notorious for the familiar way they treat God and their saints. It is common for the Madonna to be punished by shutting her up in her shrine as if she was in prison. If she does not fulfill prayers, terms of contempt and fury such as 'Madonnaccia fritta' are hurled at her and she is deprived of her accustomed offerings . . . The popular saints – Antonio, Nicola, Agata, or Rosalia – are also alternately extolled or reviled, adored or cursed, by the faithful, as if they belonged to the domestic circle . . . These familiarities are seen at their full height on the festival of San Gennaro.[21]

If the blood of San Gennaro, Naples' patron saint, is slow in liquefying in its vial, as it reportedly does twice a year, the saint is loudly exhorted by the local citizens to 'do your miracle, Yellow Face', and is called every abominable name that can be thought of.[22]

Picasso, who was by nature irreverent and disdainful of obeisance, must have found this national characteristic particularly winning. Moreover, he could not have been blind to the fact that something he was striving for in his own work – a general debunking of the exalted and a refusal to be impressed by anyone or anything – was for Neapolitans a firmly ingrained national attitude.

Mingling the commonplace with revered precedents in art and culture was another aspect of Picas-

[18]Letter to the author from director Theodoro Fittopaldi 18 Sept. 1985). *Presepi* are still made today on the street San Gregorio Armeno.
[19]Martin and MacDonald have

suggested the Blackamoor is a disguised portrait of Stravinsky who includes a Blackamoor as one of the three main character's in his fairground ballet, *Petrouchka*. Blackamoors also

occur in the paintings of Watteau and in popular prints (particularly from Spain which, like Naples, had strong links with Moorish culture).
[20]See Reff, 'Three Musicians',

p. 130ff.
[21]Augustus J.C. Hare, *The Cities of Southern Italy and Sicily* (London, George Allen Publishers, n.d.) p. 8.
[22]If the blood liquefies it means

that the saint will protect Naples from calamity. This frenetic ritual takes place in May and September.

230 and 231 Filippo Palizzi
and E. Cucciniello, *Presepe*,
nineteenth-century, Naples
(detail)

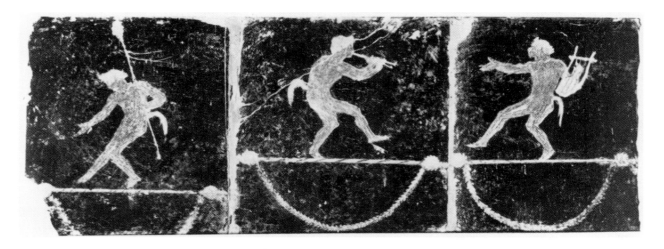

232 *Funambules à Rome*,
drawing of a Roman wall-
painting reproduced in Henri
Thétard's *Histoire du Cirque*

233 Postcard of Picasso and
Olga sent to Stravinsky from
Juan les Pins, 20 July 1920

so's urge to break the boundaries of what is considered high and low, sacred and profane. The embalmed cities of Pompeii and Herculaneum provided a classical foil to the lively popular culture of Naples. Picasso's visit to Rome and to these archaeological sites marked his first viewing of classical art *in situ*. There he could see on the walls of Roman and Pompeian villas the classical pedigree for the antics of Harlequin and Pulcinella (fig. 232), where acrobatic clowns enact movements long associated with the *commedia*. In Pompeii Picasso saw the drolleries and less serious side of antiquity and seemed to take a schoolboy's delight in viewing centuries-old graffiti and sexualy explicit frescoes (see Chpt. 4). These frescoes, though racy in subject matter, nonetheless often possess a quiet dignity. Other frescoes which he could have seen not only *in situ* but also at the National Museum in Naples are truly significant examples of classical achievement. The calm mood and muted colours of the curtain suggest that the frescoes of Pompeii and Herculaneum were also on Picasso's mind when he created it. Indeed, for the revival of *Parade* in 1921 Picasso refused to retouch the curtain's faded tempera colours because in its faded state it 'looked more like an antique fresco.'

The presence of classical ruins (the inverted column and Roman arch), the inclusion of references to mythology in the form of the Pegasus, the winged 'muse' or 'nike', and the laurel wreath worn by the monkey testify to Picasso's deliberate evocation of antique Mediterranean civilization within the curtain's imagery.[23]

On a personal level the Mediterranean had in the past, and would continue in the future, to hold a special place in Picasso's life and art. He seems to have been most at home in its relaxed and healthful environment of sea, beaches, and sunshine. It was where he could connect to nature and to classical myth. He once said, 'In Paris I never draw centaurs, fauns, or mythical creatures, they always seem to live in these [Mediterranean] parts.'[24]

A postcard Picasso sent to Stravinsky from the Riviera dated 20 July 1920 evokes the calm sense of well-being that is the initial feeling evoked by the overture curtain's Mediterranean setting (fig. 233). It shows a photograph of Picasso and Olga dining outside their Juan-les-Pins villa. With her hair unbound, wearing a casual dress and espadrilles, Olga appears in an uncharacteristically intimate light. The photograph conveys the same sense of relaxed and companionable sociability in an inviting Mediterreanean setting as the *Parade* curtain, down to the coffee pot, cups, wine bottle, and fruit resting upon a fresh white tablecloth.

[23]Nesta MacDonald cites the drop curtain from the San Carlo theatre in Naples, where the *Ballets Russes* performed on their 1917 trip to Naples as a source for the overture curtain. The San Carlo curtain painted in 1854 by Giuseppe Mancinelli depicts a scene on Mount Par- nassus of Apollo presenting to the muses civilization's great artists and writers including Homer, Petrarch, Giotto and Donatello. MacDonald, p. 239.
[24]Quoted in *Picasso's Diary* shown on Public Broadcasting Station, Oct. 1981.

Chapter 10

Inspiration for the «Parade« curtain in the poetry of Apollinaire and Verlaine and in the painting of Rousseau

Apollinaire once claimed that it was he who conveyed to Picasso a sense of the mystery that the saltimbanque represented. After that, throughout 1905, they both inspired and influenced each other in mining the poetic and artistic content inherent in the subject of the impoverished, travelling performer.[1] In 1917 the commission to design décor for a theatre piece on itinerant fairground players must have prompted Picasso to recall and recycle the themes, poetry, and friends that preoccupied him in 1905. Although the overture curtain is often described as lyrical and poetic, no one has seen poetry as a key factor in the curtain's iconography. Yet, in a manner similar to the recollection of his own 1905 circus works, Picasso was also thinking of poems by Apollinaire and Verlaine during the creation of the overture curtain.

The thematic relationship between Picasso's circus or saltimbanque paintings and certain poems by Apollinaire is frequently mentioned by scholars, but the gap between Picasso's 1905 paintings and the publication of Apollinaire's poems in 1909 remained unexplained until documents in the Musée Picasso revealed that the poems and the paintings did in fact originate simultaneously.[2]

Apollinaire sent Picasso two poems in 1905 entitled *Spectacle* and *Les Saltimbanques*. They were not published until 1909 when they were revised under the different titles of *Crepuscule* (Twilight) and *Saltimbanques*.[3] The first, handwritten on a blue postcard was mailed from Chatou and addressed to Monsieur/Monsieur Picasso, artiste-peintre, 13 rue Ravignan, dated, 'de mercredi, 1er novembre 1905', and signed *Guillaume Apollinaire*. The poem reads:

Spectacle

Ayant la forêt pour décor	With the forest for décor
Sur l'herbe où le jour s'exténue	Day droops in the grass
L'arlequine s'est mise nue,	Columbine disrobes and
Et dans l'étang mire son corps.	Admires her reflection in the pool.
Sur les tréteaux, l'arlequin blême	Wan harlequin mounts the boards
Salue d'abord les spectateurs:	Bows to his audience:
Des sorsiers venus de Bohême,	Wizards from Bohemia
Avec des fées, des enchanteurs.	Fairies and sorcerers.
Ayant décroché une étoile	Then he unhooks a star
Il la manie à bras tendu	Then twirls it in his palm
Tandis que des pieds, un pendu	While a hanged man with his feet
Bat trois coups, pour lever la toile.	Bangs three times to raise the curtain.

Two important themes of the poem are the act of seeing and the art of magical illusion.[4] This is also true for *Parade*; both in the ballet and the curtain the audience views scenes which in turn are about audiences watching a magical performance. In Apollinaire's poem: Spectators, including both the reader and the audience of sorcerers, watch . . . as *voyeur*[s] . . . the female Harlequin disrobe . . . Meanwhile, on a stage the pale Harlequin greets another audience, magicians of all trades, and dazzles them by catching [*sic*] a star to signal that the show is about to commence. The spectacle then, is at once the female Harlequin unaware she is seen, the strange audience composed of yet another group of actors, and the *parade* performers; Harlequin and his (literal) sidekick, a hanging figure who taps three times with his leg to raise the curtain to begin a performance as yet unseen.[5]

The odd assembly of poor yet sorcerous *commedia* players in Apollinaire's poem who watch a performance of fellow-actors brings to mind the *Parade* curtain group. This identification is confirmed by the watercolour sketch for the curtain (see fig. 191) where the figure in blue tights appears to 'décrocher une etoile [unhook a star]'. The

[1] Francis Steegmuller, *Apollinaire: Poet among the Painters*, New York, 1963, n. 10, p. 263, quoted from a letter Apollinaire wrote to the Italian poet, Giuseppe Raimondi in Feb. 1918 (published in *La Nazione*, Florence, June 8 1970) in which Apollinaire recalls his first frightened memories of a *parade*, and how he had communicated this feeling to Picasso.
[2] Reff had astutely ventured that some of Apollinaire's poems, especially *Crepuscule* and *Saltimbanques* might have been written earlier than their publication date. Reff, p. 42.
[3] Apollinaire rewrote *Spectacle* two more times, both versions were retitled *Crepuscule*. The poem was published in *Les Argonauts* (no. 9, Feb 1909), in *Le Parthenon* (no. 3, Dec. 1911), and in the collection *Alcools* (April 1913) where it was dedicated to Marie Laurencin.
[4] Observed by Marilyn McCully in 'Magic and illusion in the Saltimbanques of Picasso and Apollinaire', *Art History* (vol. 3, no. 4, Dec. 1980) p. 427ff.
[5] Ibid., pp. 427–8.

relaxed mood of the scene — where the performers seem to be dining and fraternizing after work — has the feeling of taking place towards the end of the day, at twilight. The stars and crescent moon on the blue ball as well as the star being unhooked by the acrobat/Harlequin are in keeping with the evocative, mystical tone of Apollinaire's poem. Finally the figure who bangs three times to raise the curtain summons the same impression of the actual *Parade* curtain, which will soon be raised for the ballet to begin. All of these coincidences, which do not precisely illustrate Apollinaire's poem but strongly evoke it, are in keeping with the way Picasso used other art and literature as inspiration. And, one might add, are also in keeping with the non-specific and elusive way Picasso's art, not to mention poetry itself, functions. It is likely that this poem, as well as the two cited below, were active components in Picasso's imagination as he created the *Parade* curtain.[6]

Apollinaire hand-wrote the second poem *Les Saltimbanques* to Picasso on a single sheet of paper the same day — 1 November 1905. It reads:

Les Saltimbanques

Dans la plaine aux calmes jardins,	Across the plain of calm gardens
Où s'eloignent les baladins,	Where the mountebanks withdraw
Devant l'huis des auberges grises	By doors of grey inns
Et les villages sans église	And villages without steeples
Les plus petits s'en vont devant	The smallest lead the way
Les autres suivent en rêvant.	The others follow in a dream.
Chaque arbre fruitier se résigne	Each fruit tree resigns itself
Quand, de très loin, ils lui font signe	When they hail it from afar
Ils ont des poids ronds ou carrés	Weights they carry round or square
Des tambours, des cerceaux dorés.	Drums and gold hoops.
L'ours et le singe, animaux sages,	Those wise beasts the bear and monkey
Quêtent des sous, sur leur passage.	Beg pennies along the road.
Devant l'un qui meurt en chemin	Before one who dies on the road
Et qui l'on oubliera demain,	And who will be forgotten tomorrow
La main d'un petit saltimbanque	The hand of the little saltimbanque
Suplée au mouchoir qui lui manque	Supplants the handkerchief that he lacks
Et la femme donne à téter	And the woman breast feeds
Son lait d'oubli comme un Léthé	With her milk of forgetfulness like a Lethe
Au dernier-né, près du nain triste	Her last born close to the sad dwarf
Et de l'arlequin trismégiste	And the harlequin trismegistus

Apollinaire eventually revised *Spectacle*, changing its title to *Crepuscule*, and altering the last stanza by cribbing from the original *Saltimbanques* he had sent Picasso. *Crepuscule*, as it was published in 1909, ended:

L'aveugle berce un bel enfant	The blind man rocks a fine baby
La biche passe avec ses faons	A doe goes by with her fawns
Le nain regarde d'un aire triste	The dwarf stares sadly
Grandir l'arlequin trismégiste	As harlequin grows
	And grows
	And grows

'Arlequin trismégiste', 'three times great', is a learned reference to Hermes Trismegistus, reputedly the founder of alchemy and the author of cabalistic books on magic and astrology. Here he signifies a learned magician/acrobat who grows before the onlookers' eyes, taking on figurative as well as literal stature. Trismegistus was sometimes

[6]Apollinaire's poetry had not lost its appeal to Picasso in the years following 1905. In the summer of 1918, during his honeymoon, Picasso painted neo-Classical figures accompanied by quotes from Apollinaire's poetry on the walls of Mme. Errazuriz's villa in Biarritz.

conflated with the god Hermes or Mercury. Harlequin is also thought to be interchangeable with Hermes/Mercury, hence Apollinaire's substitution of Harlequin for Hermes (Trismegistus).[7]

Hermes/Mercury, Trismegistus, and Harlequin all share the ability to transform themselves and objects. They turn common objects to gold or, like the poet, give an illusion of doing so. No doubt for Picasso, as well as for Apollinaire and Cocteau, this magical ability to change and transform – especially the mundane into the fabulous – is the artist's chief attribute and is what allows him to enter the domain of the demi-urge. The poet and the artist share the mystery of artistic creation – 'the magical transformation of subject, of what we see, into evocative form.'[8]

The ability to transform is tied not only to the creation of a work of art, but to illusionism and impersonation. Together these qualities are a recurrent theme throughout *Parade*. From the Conjurer who magically transforms objects and who misdirects attention (he points to his feet before he pulls an egg out of his mouth), to the Little American Girl who is impersonated by a woman and who performs superhuman feats, to the acrobats who convert hours of practice into seemingly effortless flight – all are about the thin line between trickery and artistry, between mundane preparation leading to wondrous execution. *Parade*, as Cocteau claimed, was concerned with transforming crude and popular entertainments into something sublime and profound, while retaining their spirit and content.[9]

Another literary source for Picasso's 1905 Saltimbanque pictures which may have been available in 1917 is Paul Verlaine's poetry.[10] A sketchbook Picasso took on his trip to Holland in the summer of 1905, now in the Musée Picasso, contains the poem

Cortège (the author is not indicated) written in Picasso's hand.[11] The poem first appeared in Verlaine's collection *Fêtes Galantes* in 1869, and is about three figures reminiscent of Italian comedians whose costumes and performances were associated with eighteenth-century French *Fêtes*: a monkey dressed in a brocade vest, a negro attendant in red, and a voluptuous woman performer. Needless to say, all are closely related to the *dramatis personae* of the *Parade* curtain.

Cortège

Un singe en veste de brocart	A monkey with a brocaded vest
Trotte et gambade devant elle	Trots and capers before her
Qui froisse un mouchoir de dentelle	She who crumples a lace kerchief
Dans sa main gantée avec art,	In her hand gloved with art,
Tandis qu'un négrillon, tout rouge	While a black boy, all red
Maintient à tour de bras les pans	Holds with all his strength the pleats
De sa lourde robe en suspens,	Of her heavy robes aloft
Attentif à tout pli qui bouge;	Attentive to every crease that moves;
Le singe ne perd pas des yeux	The monkey cannot take his eyes off
La gorge blanche de la dame	The white bosom of the woman
Opulent trésor que réclame	Opulent treasure claimed by
Le torse nu de l'un des dieux;	The nude torso of one of the gods;
Le négrillon parfois soulève	The boy sometimes raises
Plus haut qu'il ne faut, l'aigrefin	Higher than necessary, the rake
Son fardeau somptueux, afin	His sumptuous burden, so as
De voir ce dont la nuit il rêve;	To see that of which at night he dreams.
Elle va par les escaliers,	She goes by the stairs,
Et ne paraît pas davantage	And doesn't appear the more
Sensible à l'insolent suffrage	Aware of the insolent suffrage*
de ses animaux familiers.	of her familiar animals

* As in 'vote' – a pun on suffering.

[7] Hermes or Mercury is the messenger of the gods, and as such is known for his speed. He is also the god of cunning, invention, theft and occult science. Harlequin shares these characteristics with Mercury, particularly his nimbleness, inventiveness, cunning, elusiveness, and mutability (see chapter 8). Harlequin's attribute of the rabbit's scut was both an emblem of speed as well as a token of pusillanimity, and his slapstick seems also a vestige of the *caduceus* carried by Hermes/Mercury. Beaumont writes, 'The purpose of the wooden stick or sword is not known with certainty. It has been likened to the wand or *caduceus* of Mercury, with which the god made himself invisible and caused himself to be transported whither he willed.' p. 49.

[8] McCully, ibid., p. 432.

[9] Apollinaire's notion that the artist translates reality, 're-presenting, not reproducing, the object by collecting all its visible elements into one integrated schema' is relevant here. This was why to Apollinaire Cubism was thought of not as a cerebral investigation of perception, but as an aesthetic means to create magic. See Axsom, pp. 194–9.

[10] Mentioned in Reff, McCully ibid., Ronald Johnson, 'Picasso's Parisian Family and the Saltimbanques', *Arts Magazine*, (vol. 51, Jan. 1977)

[11] This is the same notebook in which several studies of Harlequin bowing and 'blowing a kiss' occur.

Although there are specific points of similarity such as the monkey who performs in front of the beautiful actress, as with Apollinaire's poetry, Picasso does not illustrate Verlaine's imagery but rather evokes the mood of the poem and its characters. In the poem both the monkey and the black man are obsessed with a woman who is indifferent to their ardour. It is easy to see why *Cortège* struck a chord within Picasso's psyche. The poem's emphasis upon the sexual power of woman and its implication of man as a prisoner of his own erotic desire are major themes in Picasso's *oeuvre*.[12] The poem's intimation of 'woman' as dominant and unattainable, finds a parallel in the *Parade* curtain where the voluptuous equestrian is literally raised above the crowd and is viewed with intensity by the foreground Harlequin.

The *Parade* equestrian functions not only as a flesh and blood woman, but as a muse or personification of inspiration (see chapter 11). In the light of the similarities between the *Parade* curtain and the three poems which entered Picasso's collection in 1905, it should be noted that the homage paid to the muse on the overture curtain is to poetic, not artistic, inspiration. The equestrian, who refers to the ballet *Les Sylphides* (where a dreaming poet is visited by muses or sylphides); the laurel wreath worn by the monkey which is the attribute of the poet; and the presence of Pegasus, who was said to have caused the fountain of perpetual poetic inspiration to spring from Mount Helicon, all allude not to the art of painting, but to poetry.

In view of the capital role Apollinaire's poetry seems to have exercised upon the *Parade* curtain and upon the ballet in general, and considering the curtain's naïve, child-like style, a painting by Henri Rousseau appears to be a heretofore unnoticed

source for the *Parade* curtain. *The Muse Inspiring the Poet* (1909, Kunstmuseum, Basel) (fig. 234), a double portrait of Marie Laurencin in the role of inspiring muse and Apollinaire as poet, provides a precedent for the artist/poet's real-life love doubling as allegorical personification (see chapter 11).[13] Rousseau painted the work as 'a visual token' of the friendship between himself and Apollinaire who had been a vociferous advocate of his painting. Apollinaire owned the double portrait until 1914 and Picasso undoubtedly was familiar with it. The flat colours, deliberate disproportions and distortions of scale seen in the *Parade* curtain have been compared to popular imagery, in particular *images d'Epinal* (see p. 225), but they are also the same qualities that characterize Rousseau's style, a style to which we know Picasso responded.[14] Above all, Picasso admired Rousseau's complete integration of the real with the imaginary. Starting with ordinary observed or borrowed elements which range from posters and advertisements to public sculpture, Rousseau manipulated his images to realize a private vision. Thus a painting of a child holding a *pantin* puppet (1903, Kunstmuseum, Winterthur) which is 'a commonplace and banal theme – the child may have been derived from an advertisement, the Punch from a playing card – takes on an element of mystery.'[15]

Throughout his life Picasso maintained particularly close relationships with poets and men of letters, including Santiago Rusiñol, Max Jacob, Apollinaire, André Salmon, Cocteau, André Breton, and Paul Eluard. The inscription at the bottom of the page of a 1901 ink drawing depicting a winged personification of 'Art' in the process of admitting Picasso's friend, Rusiñol (who was a writer and poet

[12]See for example Michael Leja, 'Le Vieux Marcheur and Les Deux Risques: Picasso, Prostitution, Venereal Disease, and Maternity, 1899–1907', *Art History*, vol. 8, no. 1, March 1985, p. 73ff. Leja explores Picasso's attraction and futile resistance to female sexuality.

See also Picasso's play *Desire Caught by the Tail* (Jan. 1941, published in 1944 in *Messages II;* (Paris: Risques, Travaux et

Modes)). 'Its characters are obsessed by cold, hunger, and love and their attempt to avoid the first two and satisfy the third inevitably end in disappointment.' Quoted from Jane Fluegel, 'Chronology' in *Pablo Picasso: A Retrospective* (New York, 1980) p. 351.

In later years Picasso depicted a monkey looking up a ballerina's dress, and lascivious monkey-like old men reaching for

nude beauties – compositions which also bring Verlaine's poem to mind (Zervos, vol. 27, fig. 262; vol. 31, fig. 181; vol. 33, fig. 495).

[13]The similarity in name provides the occasion for a *double entendre* – Apollinaire and Apollo, the god of poetry who was associated with the muses.

[14]For Rousseau's relation to popular Epinal prints see Henri Béhar 'Jarry, Rousseau, and

Popular Tradition' in *Henri Rousseau* (New York, 1985) p. 23. 'It is not surprising that many people who admired Rousseau also admired *images d'Epinal*. Alfred Jarry who was among the first to advocate Rousseau's work, was also co-founder of the magazine *L'Ymagier* devoted to original graphic works through which he intended to bring the treasures of folk art [especially

those of the Fabrique Pellerin d'Epinal] to the attention of rich art lovers and to inspire contemporary artists to turn to and adapt the old traditions of woodcut and lithography.' p. 23.

[15]*Henri Rousseau* by Hoog, Michel, Lachner, Caroline and Rubin, William (MOMA, c. 1984) pp. 154–5.

234 Henri Rousseau, *The Muse Inspiring the Poet: Apollinaire and Marie Laurencin*, oil on canvas, 1909 (see colour illustration on p. 28)

235 Pablo Picasso, drawing of Rusiñol, 1901, ink on paper

as well as an artist), into the association of artists reads 'Lo que el Rusiñol se presaba', [what Rusiñol is waiting for], (fig. 235). Rusiñol had been an *Associé* of the Société National des Beaux-Arts since 1892 and here Picasso seems to poke fun at the artist/poet's desire to be recognized by officialdom, mistaking that recognition as being a guarantee of admission into the pantheon of civilization's cultural heroes. The drawing makes clear that Picasso was quite familiar with the trope of homage handed down from antiquity to poets.[16] He again uses the standard elements of homage — laurel wreath and winged muse — in the *Parade* curtain, but alters and combines them in unconventional ways so that their allusion to classical

tradition is neither absolute nor immediately evident.[17]

At the time of the *Parade* commission Cocteau was the most recent poet in Picasso's life.[18] In 1917 they shared an interest in connecting modern life and specifically popular culture to antiquity, and in transforming the common and low-grade into something haunting and enduring — as both Apollinaire and Rousseau had done. But beyond that the theme which dominated both Cocteau and Picasso's thinking throughout their lives was that of the mystery of poetic/artistic creation and the poet/artist's relationship to his calling.[19] All of these associations and concerns are reflected in the iconography of the *Parade* curtain.

[16]For example, Picasso was undoubtedly familiar with Ingres' *Apotheosis of Homer*, 1827, Musée du Louvre, Paris.

[17]MacDonald suggests that Picasso may have also had in mind a tongue-in-cheek response to the very grand drop curtain in the San Carlo Theatre in Naples where the *Ballets Russes* performed during their 1917 visit. (See chapter 9, n. 23.)

[18]Costello has discussed the importance of Cocteau's theatrical productions for Picasso's treatment of the theme of reality versus illusion in the *Suite Vollard*, pp. 138–44.

[19]For Cocteau see *The Blood of the Poet* and *Orpheus*.

Chapter 11

The «Parade» overture curtain as a reflection of Picasso's life in 1917

The *Parade* overture curtain accommodates multiple interpretations ranging over artistic, literary, mystical, political, patriotic, and autobiographical references. The curtain not only reflects the everyday life of the travelling player as it existed in the first years of the twentieth century, it also functions as an allegory (rooted in the particulars of Picasso's own life) on love and friendship. It refers to Latin culture, to poetry, and even to politics, and it serves as a meditation on artistic inspiration and creation, particularly upon the transformation of sensuous or vulgar impulses into something of a higher order through the ennobling power of art.

Several critics have seen the curtain as an autobiographical drama performed in *commedia dell'arte* dress.[1] The foreground Harlequin is always identified as Picasso on the basis of physical features, his isolation from the other revellers, prominence within the group, and the well-known fact that Harlequin was Picasso's frequent *alter ego*. The second Harlequin who sits across the table is often seen as representing Cocteau. Some critics identify the rest of the players as other artists or characters from ballets associated with Diaghilev's enterprise, but differ as to specific identification.[2]

The overture curtain has been interpreted as 'a self-portrait of the artist presented in a series of complex metaphors . . . the artist confronting himself in symbolic terms (Harlequin and monkey).'[3] The scene being enacted is read as a somewhat tongue-in-cheek 'Apotheosis of the Artist', represented by the laurel crowned monkey, that also comments on artistic introspection (Harlequin) and inspiration (muse/equestrian).[4] The curtain thus 'captures the artist meditating upon his various identities and roles – in a confrontation of selves, where one *alter-ego* of the artist (Harlequin) regards another *alter ego* of the artist (monkey).'[5]

The winged female equestrian of the *Parade* curtain, besides fitting the description of actual fairground bareback riders and tightrope walkers (both wore short ballet tutus as standard costume during the nineteenth and early twentieth centuries (see fig. 212), also accommodates identification with the ballet, and in particular with the winged muses of one of Diaghilev's most popular productions, *Les Sylphides*. Danced to the music of Chopin, the ballet featured one male dancer in the role of a daydreaming poet who is haunted by visions of inspiration, or Sylphides. First produced by Diaghilev in 1909, *Les Sylphides* shared the programme with *Parade* on its opening night in Paris.[6]

The sylphides' costumes consisted of white tulle skirts and wings (fig. 236). A *Ballets Russes* publicity photograph of 1916 shows Olga Koklova, Picasso's future bride, as one of the Sylphides (see fig. 2). Olga was rehearsing this ballet, when Picasso first made her acquaintance in Rome. Picasso made a number of drawings after the photograph, indicating he identified Olga with the role.[7] Thus, like almost everything else in *Parade*, the equestrian functions on multiple levels. She is the generic fairground performer, the romantic ballerina, the classical muse, and the real-life love (and inspiration) of the artist.[8]

While this argument is a good starting-point – i.e. that the curtain is the artist's homage to and reflection upon his own *métier*, with the equestrian symbolizing inspiration – the *Parade* curtain is even more Cubist in content, accommodating not only multiple identities but multiple interpretations.

If this is a scene of apotheosis, Picasso is exalting a specific aspect of the artist's vocation, in the form of the artist's ability to transform the everyday and common, including his own base urges, into something transcendant. The artist's casting of him-

[1] Axsom, pp. 107–47. Marianne Martin, *Art Quarterly* p. 103. MacDonald, p. 239ff. Note the same dual content of allegory and autobiographical drama in *Family of Saltimbanques, Les Demoiselles d'Avignon, Bread and Fruitdish, Three Musicians*. See Rubin, p. 637.

[2] Axsom, pp. 115–18 relates the Neapolitan sailor to Picasso's recent Neapolitan visit, and the toreador to his Spanishness, pp. 115–18. MacDonald and Martin believe all the ballet's collaborators are represented in the curtain. They believe the foreground Harlequin is Massine, the Sailor represents Diaghilev (alluding to his fear of water), the toreador is Picasso, the Blackamoor is Stravinsky, the equestrian is Lydia Lopokova, the Majorcan woman is Olga, and the other woman seated on the far side of the table is Marie Chabelska. Needless to say, this analysis seems entirely too forced and specific. MacDonald, pp. 239–41. (MacDonald cites Martin's lecture, 'Picasso, *Parade*, and Futurism', given at the Courtauld Institute, London, 22 Nov. 1972).

[3] Axsom, pp. 136.

[4] Axsom, p. 130.

[5] Axsom goes on: 'An introspective emblem of the artist, the Harlequin, watched the monkey's metaphorical display of the creative act within the context of a mock classical, theatrical apotheosis.' p. 165.

[6] Axsom first made the connec-
tion (p. 120). Diaghilev's ballet was derived from the classic Taglioni ballet, *La Sylphide* which was first performed in Paris in 1832. Diaghilev's updated version did away with a narrative and characters with definite personalities.

[7] Axsom, p. 121.

[8] Rubin has shown that by 1908

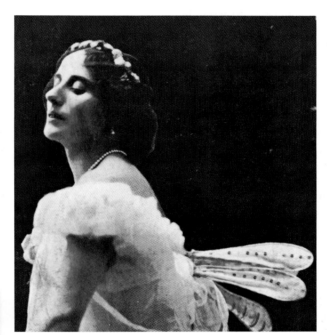

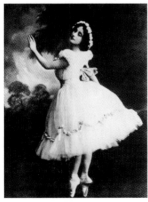

236 Anna Pavlova as a
Sylphide in *Chopiana*, c.1910

237 Anna Pavlova as Giselle,
1911

self as Harlequin is especially fitting, since the trick-ster was thought to possess the magic ability to transform the mundane into the miraculous. The monkey too, is an apt stand-in for Picasso, for besides his imitative facility and his role as prank-ster, magician and acrobat, he is traditionally thought of as a licentious or libidinous beast.[9] In the curtain the monkey is quite literally elevated by inspiration. The ladder, a traditional symbol for mediation between earthly and spiritual realms contributes to the interpretation that through love or inspiration the bestial and vulgar can be trans-mogrified. On a personal level this may be the way Picasso perceived love, and specifically Olga's effect on him. But it also applies to *Parade* and to the Cubist sensibility which informed the entire pro-duction; for like the debris Picasso transformed into Cubist collage, the ballet uses topical popular enter-tainments but converts them into something entirely new of an enduring nature. From the three *Parade* acts which were inspired by specific music-hall turns, silent film and circus performances to the humble materials at hand from which he con-structed the costumes, Picasso was motivated by a desire to alter and re-present the common and eve-ryday so that its marvellous qualities could be discerned.

While the other revellers are linked through hand and arm gestures, the Picasso Harlequin sits apart, staring at the ethereal winged figure. The place-ment constitutes a reference to the artist's essential isolation from ordinary society, a motif that runs through the whole of Picasso's work. If the curtain is a meditation upon the artist's calling and his devo-tion to his muse, then the worldly pleasures – wine, women and song – that he renounces in order to pursue that muse, are deliberately given their due in the curtain's iconography.

This reading of the curtain is further complicated by the multiple identity of the equestrian. If she is a real woman (Olga) as well as an abstraction (muse), does not she too pose a threat to the isolation needed by the artist in order to create? Not surpris-ingly the conflict between the demands of his vo-cation against those of his libido is a common subject in Picasso's work. He frequently expressed the irony of being both motivated to create and dis-tracted from that task by one and the same thing – a desirable woman.[10]

It is possible, however that Olga temporarily al-lowed for a reconciliation of the usual conflict since in the early days of their courtship she was the very model of modesty and virtue, qualities apparently Picasso was not used to finding in his female compa-nions. At the time he designed and executed the curtain for *Parade* Olga was indeed the embodi-ment of an inspiring muse who was both stimulat-ing and unattainable, the ideal combination for Picasso's creative imagination.

The self-absorbed and wistful Harlequin in the foreground sets a meditative tone for the curtain which is echoed by the other revellers who upon scrutiny appear oddly sad and introspective given the celebratory and idyllic nature of the scene. With the questionable exception of the Blackamoor, who bares his teeth more than smiles, none of the figures around the table seems merry, even though the Cocteau/Harlequin is in the process of raising his glass in a toast.

As is well-known, *Parade* marked a turning-point in Picasso's career, launching his reputation as an international art-world figure. Through Diaghilev's circle Picasso was introduced to high society and for a brief time lived as a prosperous *haut-bourgeois*. Yet throughout his life he would speak about his pre-war days of obscurity, poverty, and artistic com-panionship when he was the leader of the small in-sular *bande Picasso* as the best years of his life.[11] In

Picasso was using multiple iden-tities for a single figure. Rubin, p. 639.

[9] See H.W. Janson, *Apes and Ape Lore in the Middle Ages and in the Renaissance* (London, The Warburg Institute, 1952), pp. 287–333. Note these traits are similar to the attributes of

Harlequin who is also a tremen-dously libidinous figure.
[10] See Gert Schiff, eds. Thomas B. Hess and Linda Nochlin, 'Paint-ing as an Act of Love', in *Woman as Sex Object*, New York, *Artforum*, 1972, and also, Leo Steinberg 'A Working Equa-tion or – Picasso in the Home

Stretch', *Print Collector's News-letter*, vol. 197, pp. 102–5. This conflict is a subject addressed not only by Picasso, but by artists and writers throughout history. Hercules at the Cross-roads, Rinaldo and Armida are but two 'temptation moralities' where the hero must choose

between duty and pleasure. See also Cézanne, Zola's novel *Oeuvre* and many Symbolist works.

Schiff and Steinberg claim that in several etchings from *Suite 347* Picasso solved the problem by showing the artist painting and copulating at the

same time.
[11] Picasso said, 'At the Bateau Lavoir I was famous. Painters from all over the world would bring their work to me to see what I thought. I didn't have a sou but I was famous. I was a painter, not a freak.' *Picasso's Diary*.

1917 when the war and other circumstances had already distanced him from Braque, Apollinaire and Jacob and had put an end to familiar customs, he may have felt compelled to record the beginning of a new phase in his life (as he had done at other critical junctures) by creating a major painting that had hidden within it personal meaning.

Family of Saltimbanques (1905) (see fig. 208) and *Three Musicians* (1921, the Museum of Modern Art, New York) have been convincingly interpreted as two works which can be understood as referring to Picasso's private life.[12] The former are seen as a group portrait [of the artist, Apollinaire, Jacob, Salmon, and Fernande] although an imaginary one, in which Picasso and his closest friends, all of them associated in temperament, behaviour, and interests with both the gaiety and sadness of wandering acrobats and clowns, play the leading roles.[13]

The *Three Musicians*, where Pierrot and Harlequin appear, is interpreted as a memorial to Picasso's lost friends and bohemian youth, with the three musicians identified as Picasso, Max Jacob and Apollinaire.[14]

The Curtain for *Parade* seems to contain a similar message but this time it is a salute to Picasso's new-found loves and friendships as well as a departing bow to his old way of life before the war changed things. Perhaps the melancholic atmosphere derives from Picasso's understanding that this phase of his life would not be of the same order as the previous one. The years around 1900, termed by author Roger Shattuck, 'The Banquet Years', were characterized by exuberance, festivity and a desire to enjoy life to the full but without gaiety interfering with strict discipline or the seriousness of one's work. The spirit of the time fostered groups of close-knit friends who gathered frequently, encouraging, criticizing, and motivating one another. After the war it was not the same. Certainly Picasso realized Cocteau was no replacement for Apollinaire and that Olga too lacked the sense of fun and adventure concomitant with a willingness to live unconventionally that had characterized his other long-term liaisons.

If there is an allusion to the artist's past, it is possible that the curtain's winged equestrian who 'seems part of this world and yet also above it'[15] evokes the ballet *Giselle* as well as *Les Sylphides*, and by extension Picasso's departed mistress, Eva in addition to his new muse, Olga. *Giselle*, whose heroine also wears a white tutu and wings in her incarnation as a Wili (a ghost of a girl who dies at the peak of her youth and beauty) is particularly applicable to the 'small and perfect' Eva who died of tuberculosis while still a young woman and whose memory Picasso always cherished (see fig. 64).[16] *Giselle* had been in Diaghilev's repertoire since 1910 when it was performed by Karsavina and Nijinsky at the Paris Opéra. Pavlova too was identified with the role (fig. 237). A tangential identification of the equestrian with Eva, who by all accounts even in life was frail and delicate, is not implausible given the curtain's wistful tenor and other-worldly appearance of the left-hand group.

A final interpretation of the overture curtain centres on the political situation at the time of the *Parade* commission. The Great War and the cataclysmic effects it had on nearly everyone who lived through it, made national allegiance a constant preoccupation.

During the war nationalist feelings were strong

[12] Reff, and Reff, '*Three Musicians* . . .' p. 136.
Rubin has written: 'Picasso has long been considered one of the most diaristic of artists. 'I paint,' he is quoted as saying, 'the way some people write their autobiography.' But only with the publication of considerable material on Picasso's private life during the last two decades have we begun to realize how direct and specific the private references in his paintings really are.' Rubin, p. 636.
[13] Reff, pp. 42–3.
[14] Reff, '*Three Musicians* . . .' pp. 124–42. Rubin, while accepting Reff's identification of Apollinaire/Pierrot, Picasso/Harlequin, and Jacob/Monk, also believes Pierrot can be identified with Rousseau. He writes, 'Picasso's art abounds with images that conflate identities; it is therefore not in the least incompatible with Reff's reading of *Three Musicians* – in fact it is an extension of his interpretation – to find evidence of Rousseau's presence in the paintings as well as that of Apolliniare.' William Rubin, 'Henri Rousseau and Modernism,' in *Henri Rousseau* (New York, 1985) p. 54 and ff.
[15] Quote from George Balanchine *Balanchine's New Complete Stories of the Great Ballets* (New York, 1954) referring to Giselle, p. 179.
[16] According to Cabanne, Eva was born in 1885. p. 249. Balanchine writes of *Giselle*, '. . .it is the quintessential Romantic ballet and the one that embodies the mysterious and supernatural powers invoked by romantic poetry. He goes on, 'it made the story of *La Sylphide* look like merely the first step in the attainment of the romantic ideal. For the heroine of that ballet was purely a creature of the imagination, a figure in the hero's dream. We admired her beauty . . . but she was too illusory a character to make us feel deeply . . . Giselle however had a basis in real life, as a Wili she was real and unreal at the same time.' Balanchine (ibid.), p. 180.

everywhere and a wave of patriotism swept through the popular sector. Throughout the war in Parisian music-halls, circuses, and café-concerts, performers would sing nationalistic songs, lambast Germany or in some way make reference to the War. Clowns poked fun at the Germans – in particular their soldiers, women and food, the Folies Bergères chorus girls kicked up their heels in a revue entitled *En Avant* and torch singers mourned the loss of French youth perishing on the battlefield. Among the most popular performers was Damia whose *La Chasse* provoked tears from her audiences:

Hurlant prés des bois des corbeaux	Howling near the forests of vultures
Dont les arbres sont des flambeaux,	of which the trees are torches,
Les loups profanent des tombes,	the wolves desecrate the tombs,
Les loups de Prusse et de Lusace.	The wolves of Prussia and Lusace.
Mais une voix s'écrie: Assez!	But a voice cries: Enough!
Le grand veneur des temps passés,	The great huntsman of past times,
Les vivants et les trépasses	The living and the dead,
Se levent pour la Grande Chasse . . .[17]	Rise for the Great Chase . . .

Without cancelling the other references the *Parade* curtain also contains topical political allusions. Audiences are alerted to this by the tricolour scheme of red, white, and blue on the curtain's ladder and ball which immediately make a strong impression and sound a distinctly patriotic note.[18]

In the Spring of 1916 Picasso had participated in an exhibition organized by André Salmon at the Salon d'Antin, entitled l'Art Moderne en France which intended to show unity among the French and foreign artists in Paris, a reaffirmation of the value of art in the face of the horrors of war and a demonstration of the artists' loyalty to a France at war.[19] Picasso's brightly-coloured 1914 pointillist still-life entitled *Vive la France* (Collection Mr. and Mrs. Leigh B. Block, Chicago) as well as his cor-

respondence during the war indicate patriotic feeling toward his adopted country. He writes 'Vive la France' on several letters to Gertrude Stein, across one of his sketchbooks, and emblazons the French flag on a letter to André Salmon.[20]

It is likely Picasso's Italian journey made him aware that he shared with his adopted country a common Latinate heritage.[21] The motley group of Latin performers who gaze at the equestrian/Pegasus/monkey group and the ladder be-ribboned with the French tricolour are watching not only an apotheosis of the artist, but witnessing the triumph of France and by extension Latin culture during the war. In addition to accommodating a Sylphide (or a Wili), the equestrian can also be read as a Nike or Victory. And in addition to being symbolic of deification, the wreath is also a symbol of victory. A battalion of winged allegorical statues of Victory representing the triumph of France had begun to dot the Parisian landscape in the last century and were particularly revered throughout the Great War. In many instances these winged figures crown soldiers or statesmen with laurel wreaths or olive branches.[22]

A last precedent relating to the overture curtain in Picasso's own collection is Henri Rousseau's *Representatives of Foreign Powers arriving to Hail the Republic as a Sign of Peace* which Picasso acquired around 1910 (fig. 239). In it the personification of the Republic, wearing a red robe and the Phrygian cap of the Revolution, is shown with an olive branch poised over the heads of six Presidents of the Republic. Large urns containing more olive branches surround the podium and are inscribed with the words 'Paix, Travail, Liberté, Fraternité', an apt motto for Picasso at the time of the *Parade* commission. Rousseau's simplified, child-like style of unbroken contours, where abnormalities of scale and

[17]Quoted in Jacques Damase p. 8. See also Pierre MacOrlan's song about the days when women waited so anxiously to hear from their men at the front: 'J'ai dans la mémoire', un chanson qui gouge/ le nom des pat'- lins où t'as derrouillé/ Carency, Hablin, le Cabaret Rouge/ La rout'de Bapaum' où tu es resté

. . .' Quoted in Dormann, *Colette Amoureuse* (Paris, 1984) p. 191.
[18]See Linda Nochlin, 'Picasso's Colour: Schemes and Gambits', *Art in America* (vol. 68, Dec. 1980) pp. 105–23.
[19]Klüver and Martin, p. 104
[20]Gertrude Stein Archives, Beinecke Library, Yale University.

For 1914 sketchbook, see *Je suis le cahier*, no. 54. Letter to Salmon in the collection of Museé Picasso, Paris.
[21]Kenneth Silver has proposed that the Latinate tenor of the curtain and its classical allusions refer to a common sentiment during the First World War that France was the inheritor and

preserver of classical culture. When Italy joined the allies 'it ratified a war of Classicists and Latins against the barbarians [Germans] in a way that France herself could not do. . . . 'The word Latin had an *éclat* that only victory over the barbarians could have assured. More than a means of describing the

values for which the French and Italians had fought in the Great War, it now signified the perpetuation of a culture and the triumph of a way of life.' Silver, Chapt. III.
[22]Ibid., figs. 74, 75.

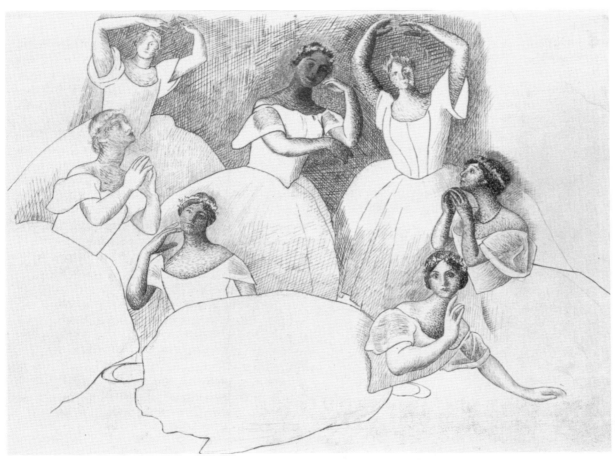

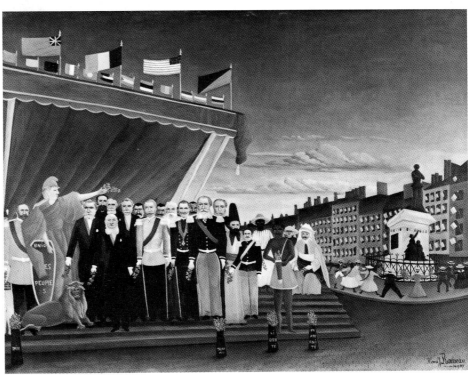

238 Pablo Picasso, *Seven Dancers*, 1919, ink drawing after a photograph (see fig. 2)

239 Henri Rousseau, *Representatives of Foreign Powers arriving to Hail the* *Republic as a sign of Peace*, 1906–7, oil on canvas (see colour illustration on p. 28)

facial alignment abound and where flat pattern and illusionistic modelling cohabit (note the three-dimensional awning against the flat flags and clothing), is a direct forebear of the style, and mix of styles, Picasso uses in the overture curtain. Picasso was probably making a deliberate reference to Rousseau – who was known for his patriotism and his devotion to his calling as an artist – in combining a naïve style with illusionistic elements in a composition that is both charming and hauntingly mysterious.

The Nike/Equestrian of the *Parade* curtain may be interpreted as having crowned the artist who has always held a position of honour in France. (See for example the monument to Ingres, in Montauban by Antoine Etex (1871).[23] As one critic wrote at the height of the war, 'France more than any other nation needs art.'[24] Through devotion to his *métier* the artist, represented in the curtain by the laurel-crowned monkey, not only achieves immortality but admirably serves his country. For Picasso who was probably sensitive to not participating in the war as a soldier, the curtain may have served as a personal vindication for his non-combatant status.[25] In it he asserts the artist's paramount contribution to French and Latin culture.

Along with the overture curtain's other meanings Picasso's message can be taken to be that Spain, Italy, and particularly France as promoters of a clas-sical heritage shall be victorious in the present struggle. With typical irony the culture to which he pays homage is not élitist but popular. The *commedia dell'arte* and its many popular descendants – the circus, travelling fair, cinema, cabaret and even the ballet are all products of Mediterranean civilization. In the end the *Parade* curtain is an homage to artistic creativity born in the streets and bred within Latin tradition – a tradition mutually shared and nurtured by France, Italy, and Spain.[26]

In performance, after the finale where the three *parade* acts collapse in exhaustion when their one last frenetic attempt to interest passers-by fails, the overture curtain was lowered again, returning the theatre audience to a state of poetic calm. For several minutes the audience was given another opportunity to ponder the scene. It is doubtful many took the curtain for anything other than a charming fairground tableau rendered in a naïve style. Like all his greatest works, however, Picasso's curtain is filled with elusive and indeterminate multiple meanings – some deeply rooted in his own psyche. This, the largest painting in Picasso's *oeuvre*, encompasses realism, traditional allegory, Symbolist ambiguity, and personal confession. Above all it induces reflection, a state which ultimately is bound up with the artist's quest for truth and self-knowledge.

[23]See L. Gabbilluad's poster for the 1889 Exposition Universelle de Paris (Musée d'Orsay, Paris) where an allegorical figure representing France holds a wreath above the head of a painter who wears a beret and holds a palette. Reproduced in Henri Béhar, 'Jarry, Rousseau, and Popular Tradition' in *Henri Rousseau* (New York, 1985) p. 38, fig. 1.
[24]The critic was probably André Salmon. Quoted in Klüver, p. 104.
[25]Also suggested by Silver.
[26]And to a large extent Russia. At the time of the overture cur-tain's execution, Russia was France's ally in the war. However, revolutionary activity had begun, and within a year the Russians would change sides, signing the Treaty of Brest-Litovsk with the Germans.
Echoing Winter's claim for the provenance of high brow entertainments such as opera and ballet as deriving from circus and fairground in Western Europe, René Fülöp-Miller writes in *The Russian Theatre*, that 'The Manager of the Proletkult started from the fact that in Russia the circus was older and nearer to the people than the theatre, which had been imported much later than in the West; Revolutionary art, therefore, aiming at something new, clung to the tradition of ancient popular buffoonery.'

Appendix

A description of «Parade» by Guillaume Apollinaire from his programme note to the 1917 production[1].

Definitions of *Parade* are bursting out everywhere, like the lilac branches of this delayed spring. . . .
It is a stage poem that the innovating composer Erik Satie has set to astonishingly expressive music, so clean-cut and so simple that it mirrors the marvellously lucid spirit of France itself.

The Cubist painter Picasso and that most daring of choreographers, Léonide Massine, have staged it, thus consummating for the first time this union of painting and dance – of plastic and mime – which heralds the advent of a more complete art.

Let no one cry paradox. The ancients, in whose life music held such a prominent place, were absolutely ignorant of harmony – whereas modern music is almost nothing but harmony.

This new union – for up until now stage sets and costumes on the one hand and choreography on the other were only superficially linked – has given rise in *Parade* to a kind of super-realism ['*sur-réalisme*']. This I see as the starting point of a succession of manifestations of the '*esprit nouveau*': now that it has had an opportunity to reveal itself, it will not fail to seduce the élite, and it hopes to change arts and manners from top to bottom, to the joy of all. For it is only natural to wish that arts and manners should attain at least the level of scientific and industrial progress.

Breaking with the tradition dear to those who not so long ago in Russia were curiously dubbed 'balletomanes,' Massine has taken good care not to fall into pantomime. He has produced a complete novelty, one so marvellously seductive, of a truth so lyrical, so human, so joyous, that it might well be capable of illuminating (if this were worthwhile) the frightful black sun of Dürer's *Melancolia* – this thing that Jean Cocteau calls a 'realistic ballet.' Picasso's Cubist sets and costumes bear witness to the realism of his art.

This realism, or this Cubism, whichever you prefer, is what has most deeply stirred the arts during the last ten years.

The sets and costumes of *Parade* clearly disclose his

[1] English translation from Francis Steegmuller, *Cocteau: A Biography* (Boston, 1970) pp.513–14 (Appendix VII).

concern to extract from an object all the aesthetic emotion it is capable of arousing. Frequent attempts have been made to reduce painting to its own rigorously pictorial elements. There is hardly anything but painting in most of the Dutch school, in Chardin and the Impressionists.

Picasso goes a good deal farther than any of them. Those who see him in *Parade* will experience a surprise that will soon turn into admiration. His main purpose is to render reality. However, the motif is no longer reproduced, but merely represented; or, more accurately, it is suggested by a combination of analysis and synthesis bearing upon all its visible elements — and, if possible, something more, namely an integral schematization that might be intended to reconcile contradictions, and sometimes deliberately renounces the rendering of the obvious outward appearance of the object. Massine has adapted himself in a surprising way to the Picassian discipline. He has identified himself with it, and art has been enriched by adorable inventions like the realistic steps of the horse in *Parade* whose forelegs are supplied by one dancer and the hind legs by another.

The fantastic constructions which stand for those gigantic, astonishing characters the Managers, far from hampering Massine's imagination, have enabled it, if one may say so, to function with greater freedom.

In short, *Parade* will upset the ideas of quite a number of spectators. They will be surprised, to be sure, but in the pleasantest way, and fascinated; and they will learn how graceful modern movement can be — something they had never suspected. A magnificent music-hall Chinaman will give free rein to the flights of their imagination, and the American girl, by turning the crank of an imaginary automobile, will express the magic of their everyday life, while the acrobat in blue and white tights celebrates its silent rites with exquisite and amazing agility.

Bibliographical abbreviations

Abbreviations of bibliographical references used in the footnotes

Axsom: Axsom, Richard H., *Parade: Cubism as Theatre* (New York: Outstanding dissertations in the fine arts, Garland Publishing, 1979)

Beaumont: Beaumont, Cyril W., *History of Harlequin* (New York: Benjamin Blom, 1926)

Carmean: Carmean, E.A., Jr, *Picasso, The Saltimbanques* (Washington D.C.: The National Gallery of Art, 1980)

Costello: Costello, Anita Coles, *Picasso's 'Vollard Suite'* (New York: Garland Publishing Co., 1979)

Damase: Damase, Jacques, *Les Folies du Music Hall: The History of the Music Hall in Paris from 1914 to the Present Day* (London: Anthony Blond, 1962)

Gilot: Gilot, Françoise and Carlton Lake, *Life with Picasso* (New York: McGraw Hill Book Co., 1964)

Klüver and Martin: Klüver, Billy and Martin, Julie, *Kiki's Paris: Artists and Lovers 1900–1930* (New York: Harry N. Abrams Inc., 1989)

Leach: Leach, Robert, *The Punch and Judy Show: History, Tradition and Meaning* (Athens, Georgia: University of Georgia Press, 1985)

MacDonald: MacDonald, Nesta, *Diaghilev Observed by Critics in England and the United States, 1911–1929* (New York: Dance Horizons, 1975)

Massine: Massine, Léonide, Phyllis Hartroll and Robert Rubens eds, *My Life in Ballet* (London: Macmillan, 1968)

Panofsky: Panofsky, Dora, 'Giles or Pierrot? Iconographic Notes on Watteau', *Gazette Des Beaux Arts*, (1952)

Penrose: Penrose, Roland, *Picasso; His Life and Work* (New York: Harper, 1958)

Poggi: Poggi, Christine, 'Frames of Reference; 'Table' and 'Tableau' in Picasso's Collages and Constructions', *The Art Journal*, vol. 47, no. 4 (Winter 1988)

Reff: Reff, Theodore, 'Harlequins, Saltimbanques, Clowns, and Fools' *Artforum*, vol. 10 (Oct. 1971)

Reff, *'The Three Musicians...'*: Reff, Theodore, 'Picasso's *Three Musicians*: Maskers, Artists, and Friends' Art in America, vol. 68, no. 10 (Dec. 1980)

Rubin: Rubin, William, 'From Narrative to 'Iconic' in 'Picasso: The Buried Allegory in *Bread and Fruitdish on a Table* and the Role of *Les Demoiselles d'Avignon*', *The Art Bulletin*, vol. LXV, no. 4, (Dec. 1983)

Silver: Silver, Kenneth E., *Esprit de Corps: The Art of the Parisian Avant-Garde and the First World War, 1914–1925* (Princeton: Princeton University Press, 1989)

Steegmuller: Steegmuller, Francis, *Cocteau: A Biography* (Boston, Little Brown and Co., 1970)

Winter: Winter, Marian Hannah, *The Theater of Marvels* (New York: Benjamin Blom Inc., 1962)

Bibliography

Amberg, George, *Art in Modern Ballet* (New York: Pantheon, 1946)

L'Ancienne Douane, *Les Ballets Russes de Serge de Diaghilev, 1909–1929* (Strasbourg: Dernières Nouvelles de Strasbourg, 1969)

Anthony, Gordon, *Massine* (Paris: Gallimard, 1939)

Apollinaire, Guillaume, trans. Nina Rootes, *Les onze mille verges* (New York: Taplinger Publishing Co., 1979)

Appignanesi, Lisa, *The Cabaret* (New York: Universe Books, 1976)

Axsom, Richard H., *Parade: Cubism as Theatre* (New York: Outstanding dissertations in the fine arts, Garland Publishing, 1979)

Auric, Georges, 'Une Oeuvre Nouvelle de Satie', *Littérature* no. 4 (April, 1919)

_____, 'Chronique sur *Parade*', *La Nouvelle revue française*, no. 7 (Feb. 1921): 224–7

Balanchine, George, *Balanchine's New Complete Stories of the Great Ballets* (Garden City, New York: Doubleday and Co., 1954)

Barr, Alfred H., *Picasso: Fifty Years of his Art* (New York: Museum of Modern Art, 1946)

Barry, Ann, 'Magic Casts Its Spell on Collectors', *The New York Times* (17 Aug. 1986): section D, 27

Beaumont, Cyril W., *Five Centuries of Ballet Design* (New York: The Studio Publications, 1936)

_____, *History of Harlequin* (New York: Benjamin Blom, 1926)

_____, *Serge Diaghilev* (London: 1933)

Béhar, Henri, 'Jarry, Rousseau, and Popular Tradition', in *Henri Rousseau* (New York: The Museum of Modern Art, 1985)

Bell, Clive, 'The New Ballet', *The New Republic*, no. 5 (July 30, 1919): 414–16

Benedikt, Michael, and Wellwarth, George E., eds, *Modern French Theatre: The Avant-Garde, Dada, and Surrealism – An Anthology of Plays* (New York: Dutton, 1964)

Berger, John, *The Success and Failure of Picasso* (Baltimore: Penguin Books, 1965)

Bernier, Georges, *Paris Cafès, Their Role in the Birth of Modern Art* (New York: Wildenstein, 1985)

Bloch, Georges, *Pablo Picasso: Catalogue of the printed graphic work*, 1904–1967, vol. I (Berne, 1968)

Bonfante, L., ed., in *Essays in Archaeology and the Humanities: In Memoriam Otto J. Brendel* (Mainz: 1976), 237–48

Boskin, Joseph, *Sambo: The Rise and Demise of an American Jester* (New York: Oxford University Press, 1987)

Bransten, Ellen. 'The Significance of the Clown in Paintings by Daumier, Picasso, and Rouault', *Pacific Art Review*, no. 3 (1944)

Brown, Frederick, *An Impersonation of Angels: A Biography of Jean Cocteau* (New York: The Viking Press, 1968)

Buckle, Richard, *In Search of Diaghilev* (London: Sidgwick and Jackson, 1955)

Cabanne, Pierre, trans. Harold J. Salemson, *Pablo Picasso, His Life and Times* (New York: William Morrow and Co. Inc., 1977)

Carandente, Giovanni, 'Il viaggio in Italia: 17 febbraio 1917' in *Picasso Opere del 1895 al 1971 dalla Collezione Marina Picasso*, exhib. cat. (Venezia: Centro di Cultura di Palazzo Grassi, 1981): 45–57

Carmean, E.A., Jr, *Picasso, The Saltimbanques* (Washington D.C.: The National Gallery of Art, 1980)

Carter, Huntly, *The New Spirit in the European Theatre, 1914–1924* (London: E. Benn, 1925)

Cassou, Jean, 'Le Rideau de *Parade* de Picasso au Musée de l'art moderne', *La Revue des arts*, no. 7 (Jan. 1957): 15–18

Cederschiold, Gunnar, *Efter Levande Modell* (Stockholm: Natur och Kultur, 1949)

Clark, T.J., *The Painting of Modern Life: Paris in the Art of Manet and his Followers* (New York: Alfred A. Knopf, 1985)

Cocteau, Jean, 'Avant *Parade*', *Excelsior* (18 May 1917): sec. 4, 4

_____, 'Parade Réaliste: In Which Four Modernist Artists Have a Hand', *Vanity Fair*, no. 5 (Sept. 1917): 17–19

_____, 'Pablo Picasso', in *My Contemporaries* (text of a talk delivered in Rome, 1968)

_____, *La Difficulté d'Etre* (Monaco: Editions du Rocher, 1947): 37

_____, *Oeuvres complètes de Jean Cocteau*, 10 vols (Lausanne: Marguerat, 1946–51)

_____, *Portraits Souvenir 1900–1914* (Paris: Editions Bernard Grasset, 1935)

_____, *Les Foyers des Artistes* (Paris: Plon, 1947)

_____, ed. André Fermigier, *Entre Picasso et Radiguet* (Paris: Hermann, 1967

Cooper, Douglas, *Picasso Theatre* (New York: Harry N. Abrams, 1967)

Cooper, Douglas, and Tinterow, Gary, The Essential Cubism, 1907-1920 (London, The Tate Gallery, 1983)

Costello, Anita Coles, *Picasso's 'Vollard Suite'* (New York: Garland Publising Co., 1979)

Cowling, Elizabeth, 'Proudly We Claim Him As One of Us': Breton, Picasso, and the Surrealist Movement', *Art History*, vol. 8, no. 1 (March, 1985): 82–104

Crow, Thomas, 'Modernism and Mass Culture in the Visual Arts', in Serge Guilbaut, ed., *Modernism and Modernity* (Nova Scotia: The Press of the Nova Scotia College of Art and Design, 1983)

Daix, Pierre and Boudaille, Georges, *Picasso, the Blue and Rose Periods, A Catalogue Raisonné of the Paintings 1900–1906* (Greenwich, Connecticut: New York Graphic Society, 1967)

_____, and Rosselet, Joan, *Le Cubisme de Picasso: catalogue raisonné de l'oeuvre peint 1907–1916* (Neuchatel: Ides et Calendes, 1979)

Damase, Jacques, *Les Folies du Music Hall: The History of the Music Hall in Paris from 1914 to the Present Day* (London: Anthony Blond, 1962)

Dexter, Will, *The Riddle of Chung Ling Soo, Chinese Conjurer* (New York: Arco Publishing Co., 1976)

Dormann, Geneviève, *Colette Amoureuse* (Paris: Editions Herscher, 1984)

Drew, David, ed. Howard Hartog, 'Modern French Music', in *European Music in the Twentieth Century* (New York: Praeger, 1957)

Duchartre, Pierre Louis, *The Italian Comedy* (New York: Dover, 1966)

Duncan, David Douglas, *Picasso's Picassos* (London: Macmillan and Co. Ltd, 1961)

Faure-Favier, Louis, *Souvenirs sur Apollinaire* (Paris: Grasset, 1975)

Fermigier, André, *Jean Cocteau entre Picasso et Radiguet* (Paris: Hermann, 1967)

Flint, R.W., (ed.) *Marinetti; Selected Writings* (London, 1971, 1972)

Franks, Arthur Henry, *Twentieth Century Ballet* (London: Burke, 1954)

Fréjaville, Gustave, *Au music-Hall* (Paris: Editions du Monde nouveau, 1923)

Fuerst, Walter Rene, and Hume, Samuel J., *Twentieth Century Stage Decoration*, 2 vols (New York: Dover, 1967)

Fülöp-Miller, René, trans. Paul England, *The Russian Theatre* (New York: Benjamin Blom, 1968)

Garafola, Lynn, *Diaghilev's Ballets Russes* (New York: Oxford University Press, 1989)

Garnier, Jacques, *Forains d'hier et d'aujourd'hui* (Orleans: Les Presses, 1968)

Gasman, Lydia, *Mystery, Magic and Love in Picasso, 1925–1938: Picasso and the Surrealist Poets* (New York: Columbia University, doctoral dissertation, 1981)

Gedo, Mary Matthews, *Picasso, art as autobiography* (Chicago: University of Chicago Press, 1980)

Geiser, Bernhard, *Picasso: peintre-graveur*. Berne: Bernhard Geiser, 1933

Gilot, Françoise and Carlton Lake, *Life with Picasso* New York: McGraw Hill Book Company, 1964)

Glimcher, Arnold and Marc., eds, *Je suis le cahier: The Sketchbooks of Picasso* (New York: The Pace Gallery, 1986)

Gold, Arthur and Robert Fizdale, *Misia* (New York: Knopf, 1980)

Gombrich, E.H., 'Imagery and Art in the Romantic Period', *Burlington Magazine* (June 1949)

Gontcharova, Nathalie; Larionov, Michel; Vorms, Pierre, *Les Ballets Russes: Serge de Diaghilev et la décoration théâtrale* (Dordogne: Belves, 1955)

Gopnik, Adam, 'High and Low: Caricature, Primitivism and the Cubist Portrait', *Art Journal*, vol. 43, no. 4 (Winter 1983): 371–6

Grasselli, Margaret Morgan and Rosenberg, Pierre, *Watteau 1684–1721* (Washington, National Gallery Exhib. Cat., 1984)

Great Performances: Dance in America (Video, first aired 21 Jan. 1976 Dance Collection, Lincoln Center)

Green, Martin and John Swan, *The Triumph of Pierrot, The Commedia dell'Arte and the Modern Imagination* (New York: Macmillan Publishing Co., 1986)

Grigoriev, S.L., *The Diaghileff Ballet, 1909–1929* (London: Constable, 1953)

Gris, Juan, trans. and Cooper, Douglas, ed. *Letters of Juan Gris (1913–1927)* (London: private printing, 1956)

Guicharnaud, Jacques, *Modern French Theatre from Giraudoux to Beckett* (New Haven: Yale University Press, 1961)

Guilleminault, Gilbert, *La France de la Madelon* (Paris: 1965)

Hadler, Mona, 'Jazz and the Visual Arts', *Arts* (June 1983): 91–101

Hammond, N.G.L. and H.H. Scullard, eds *The Oxford Classical Dictionary* (Oxford: Clarendon Press, 1970)

Hare, Augustus J.C., *The Cities of Southern Italy and Sicily* (London: George Allen Publishers, n.d.)

Haskell, Arnold, *Ballet Russe: The Age of Diaghilev* (London: Weidenfeld and Nicolson, 1968)

_____, in collaboration with Walter Nouvel, *Diaghileff: His Artistic and Private Life* (New York: Simon and Schuster, 1935)

Hermant, Abel, 'Les Ballets Russes'. *Excelsior* (29 May, 1917): 13

Hoog, Michel; Lancher, Caroline and Rubin, William. *Henri Rousseau* (Museum of Modern Art, *c.* 1984, distributed by New York Graphic Society Books, Little, Brown and Co., Boston): 154/5

Irrizary, Carmen, *Spain – the Land and its People* (Morristown, New Jersey: Silver Burdett Co., 1981)

Janson, H.W., *Apes and Ape Lore in the Middle Ages and in the Renaissance* (London: The Warburg Institute, 1952)

Johnson, Ronald, 'Picasso's Parisian Family and the 'Saltimbanques', *Arts Magazine*, vol. 51 (Jan. 1977)

Kaplan, Stuart, R., *The Encyclopedia of Tarot* (New York: U.S. Games System, Inc., 1978)

Karsavina, Tamara, *Theatre Street* (New York: E.P. Dutton and Co. Inc., 1931)

Kirby, E.T., 'The Shamanistic Origins of Popular Entertainment', in Richard Schechner and Mady Schuman eds, *Ritual, Play and Performance* (New York: The Seabury Press, 1976)

Kirstein, Lincoln, *The Book of the Dance: A Short History of Classic Theatrical Dancing* (New York: G.P. Putnam's Sons, 1935)

_____, *Movement and Metaphor: Four Centuries of Ballet* (New York: Praeger, 1970)

Klüver, Billy. 'A Day with Picasso', *Art in America*, no. 9, vol. 74, (Sept. 1986): 96–107, 161–3

_____, and Martin, Julie, *Kiki's Paris: Artists and Lovers, 1900–1930* (New York: Harry N. Abrams Inc., 1989)

Kochno, Borris, *Le Ballet* (Paris: Hachette, 1954)

_____, trans. Adrienne Foulke, *Diaghilev and the Ballets Russes* (New York: Harper and Row, 1970)

Kondoleon, Christine, *Realities and Representation: The Mosaics of the House of Dionysus at Paphos* (Ithaca, New York: Cornell University Press, 1988)

Kozloff, Max, *Cubism/Futurism* (New York: Charterhouse, 1973)

La Fontaine, Jean, 'The Monkey and the Leopard', in *A Hundred Fables of La Fontaine* (New York: Greenwich House, 1983)

La Meri (Russell Meriwether Hughs), *Spanish Dancing* (Pittsfield, Massachusetts: Eagle Printing and Binding Co., 1967)

Laporte, Geneviève, trans. Douglas Cooper, *Sunshine at Midnight* (New York: Macmillan Publishing Company, 1975)

Larionov, Mikhail, *Diaghilev et les Ballets Russes* (Paris: 1970)

Leach, Robert, *The Punch and Judy Show: History, Tradition and Meaning* (Athens, Georgia: University of Georgia Press, 1985)

Leighten, Patricia, *Re-ordering the Universe: Picasso and Anarchism 1897–1914* (Princeton, New Jersey: Princeton University, 1989)

_____, 'Editor's Statement – Revising Cubism', *Art Journal*, no. 4 (Winter, 1988): 269–75

Leja, Michael, *'Le Vieux Marcheur* and *Les Deux Risques*: Picasso, Prostitution, Venereal Disease and Maternity, 1899–1907', *Art History*, no. 1 (March 1985): 66–81

Lida, Clara E, *Anarquismo y revolucion en la España del XIX* (Madrid: Siglo veintiuno de España Editores, 1972)

Lieberman, William, S., *Pablo Picasso: Blue and Rose Periods* (New York: 1952)

_____, 'Picasso and the Ballet', *Dance Index*, no. 3 (November 1946): 230–40

Lifar, Serge, *Diaghilev: An Intimate Biography* (New York: G.P. Putnam's Sons, 1940)

_____, *A History of the Russian Ballet* (New York: Roy Publishers, 1957)

_____, *Serge de Diaghilev, Sa Vie, Son Oeuvre, Sa Légende* (Monaco: Editions du Rocher, 1954)

Lorca, Federico Garcia, 'Teoria y juego del duende', from *Obras Completas* (Buenos Aires: Editorial Losada, 1938)

MacDonald, Nesta, *Diaghilev Observed by Critics in England and the United States, 1911–1929* (New York: Dance Horisons, 1975)

McCully, Marilyn, ed., *A Picasso Anthology: Documents, Criticism, Reminiscences* (Princeton: Princeton University Press, 1982)

_____, *Els Quatre Gats: Art in Barcelona around 1900* (Princeton: Princeton University Press, 1978)

_____, 'Magic and Illusion in the Saltimbanques of Picasso and Apollinaire', *Art History*, vol. 3, no. 4 (Dec. 1980): 425–434

McElderry, Bruce R., Jr, 'A Game of Chess', in Jay Martin, ed., *A Collection of Critical Essays on 'The Waste Land'.* (New Jersey: Prentice Hall, 1968)

McQuillan, Melissa, *Painters and the Ballet 1917–1926: An Aspect of the Relationship between Art and Theatre* (New York: New York University doctoral dissertation, 1979)

Marinetti, Filippo T., ed. Giovanni Calendoli *Teatro* (Rome: V. Bianco, 1960)

Martin, Marianne, *Futurist Art and Theory 1905–1915* (Oxford: Clarendon Press, 1968)

_____, 'The Ballet *Parade*: A Dialogue between Cubism and Futurism', *Art Quarterly* (1978): 85–111

Massine, Léonide, Phyllis Hartroll and Robert Rubens, eds, *My Life in Ballet* (London: Macmillan, 1968)

Matos, M. Garcia, *Lirica Popular de la Alta Extremadura* (Madrid: 1944)

_____, 'Folklore en Falla', *Musica* (Madrid: I: 1953)

Meriden, Orson, 'The Ragtime Kings', *The Theatre*, xxiii (Jan. 1916)

Migel, Parmenia, *Designs for 'The Three-Cornered Hat'* (New York: Dover Publications, 1978)

Milhau, Denis, *Picasso et le théâtre* (Toulouse: Musée des Augustins, 1965)

Milhaud, Darius, trans. Donald Evans, *Notes Without Music: An Autobiography* (New York: Alfred A. Knopf, 1953)

Money, Keith, *Anna Pavlova: Her Life and Art* (New York: Alfred A. Knopf, 1982)

Nijinska, Irina and Jean Rawlinson, trans. and ed., *Bronislava Nijinska: Early Memories* (New York: Holt, Rinehart and Winston, 1981)

Nochlin, Linda, 'Picasso's Colour: Schemes and Gambits', *Art in America*, vol. 68 (Dec. 1980)

Noverre, Jean Georges *Lettres sur la danse et sur les ballets*, (rev. ed. St. Petersburg, 1803; Brooklyn, New York, Dance Horizons, 1968)

Olivier, Fernande, trans. J. Miller, *Picasso and his Friends* (New York: 1965)

Oursler, Fulton, 'Riddle in Red and Yellow: A Story about Chung Ling Soo', *Conjurer's Magazine* (March 1947)

Oxenhandler, Neal, *Scandal and Parade: The Theater of Jean Cocteau* (New Brunswick: Rutgers University Press, 1957)

Panofsky, Dora, 'Gilles or Pierrot? Iconographic Notes on Watteau', *Gazette des Beaux Arts* (1952): 325

Parmelin, Hélène, *Intimate Secrets of a Studio at Notre Dame de Vie* (New York: Abrams Inc., 1966)

Pearl White Scrapbook, Robinson Locke Collection, Theater Collection, New York Public Library, Lincoln Center

Penrose, Roland, *Picasso: His Life and Work* (New York: Harper, 1958)

Percival, John, *The World of Diaghilev* (London: 1971)

Picasso, Pablo, *Desire Caught by the Tail* (a play written Jan. 1941), pub. in *Messages II* (Paris: Risques, Travaux et Modes, 1944)

Poggi, Christine, 'Frames of Reference: "Table" and "Tableau" in Picasso's Collages and Constructions', *The Art Journal*, vol. 47, no. 4 (Winter 1988): 311–322

Pool, Phoebe 'Picasso's Neo-Classicism: Second period, 1917–1925', *Apollo* (Jan–June 1967): 198–207

Poulenc, Francis, *Moi et Mes Amis* (Paris and Geneva: Le Palatine, 1963)

Priestly, J.B., *Lost Empires: Being Richard Herncastle's Account of his life on the Variety Stage from November 1913 to August 1914* (New York: Vintage Books, 1965)

Propert, W.A., *The Russian Ballet in Western Europe, 1909–1920* (London: John Lane, 1921)

Public Broadcasting Station, *Picasso's Diary* (a television broadcast aired Oct. 1981)

Quinn, Edward, *Picasso, Photographs from 1951–1972* (Woodbury, New York: Barrons, 1980)

Radiguet, Raymond, *Parade*, *Le Gaulois* (25 Dec. 1920): 4

_____, *Le Bal du Comte d'Orgel* (New York: Grove Press, 1953)

Rafols, J.F., *Modernismo y modernistas* (Barcelona, 1949)

Reff, Theodore, 'Degas and the literature of his time' *French 19th Century Painting and Literature*, ed. Ulrich Finke (Manchester University Press, 1972): 200–2

_____, 'Harlequins, Saltimbanques, Clowns, and Fools', *Artforum*, vol. 10 (Oct. 1971): 30–43.

_____, 'Picasso's *Three Musicians*: Maskers, Artists, and Friends', *Art in America*, vol. 68, no. 10 (Dec. 1980): 124–42

_____, 'Picasso at the Crossroads. Sketchbook no. 59, 1916', in Arnold and Marc Glimcher, eds, *Je Suis le Cahier: The Sketchbooks of Picasso* (New York: The Pace Gallery, 1986)

_____, 'Picasso at the Circus', in Bonfante, L., ed., *Essays in Archaeology and the Humanities: In Memoriam Otto J. Brendel* (Mainz:1976): 237–48

Revell, Nellie, 'Acts and Artistes in Vaudeville', *The Theatre*, vol. XXV (April 1917): 224

Rhode Island School of Design, exhib. cat., *Caricature and its Role in Graphic Satire* (Providence: 1971) no. 78

Richardson, John. 'L'Amour Fou', *New York Review of Books* (19 Dec. 1985)

_____, 'Picasso's Secret Love', in Dorothy Kosinski, *Douglas Cooper and the Masters of Cubism* (Basel: Kunstmuseum, 1988) 183–196

Ries, Frank W.D., *The Dance Theater of Jean Cocteau* (Ann Arbor: UMI Research Press, 1986

Ringo, James, 'The Irreverent Inspirations of Erik Satie', notes on jacket of *La Belle Epoque*, Angel recording

Rischbeiter, Henning, and Storch, Wolfgang, *Art and the Stage in the 20th Century: Painters' and Sculptors' work for the Theatre* (Greenwich, Conecticut, New York Graphic Society, 1968)

Rothschild, Deborah Menaker, *'From Street to the Élite: Popular Sources in Picasso's Designs for Parade* (New York, Institute of Fine Arts, New York University, 1990)

Rosenblum, Robert, *Cubism and Twentieth-Century Art*, New York: Harry N. Abrams, 1966)

_____, and Janson, H.W., *Art of the Nineteenth Century* (New York: Abrams, 1984)

_____, Penrose and Golding, eds, 'Picasso and the Typography of Cubism', *Picasso in Retrospect* (New York: Praeger, 1973)

_____, *The Sculpture of Picasso* (New York: Pace Gallery, 1982)

Rubin, William, *Picasso in the Collection of the Museum of Modern Art* (New York: Museum of Modern Art, 1972)

_____, ed., *Pablo Picasso: A Retrospective* with chronology by Jane Fluegel (New York: Museum of Modern Art, 1980)

_____, 'Primitivism in Twentieth Century Art, Affinity of the Tribal and the Modern'. *Primitivism and Modern Art*, vol. 1, exhib. cat. (New York: The Museum of Modern Art, 1984)

_____, 'From Narrative to 'Iconic' in Picasso: The Buried Allegory in *Bread and Fruitdish on a Table* and the Role of *Les Demoiselles d'Avignon*', *The Art Bulletin*, vol. LXV, no. 4 (Dec. 1983): 615–49

_____, *Picasso and Braque, Pioneering Cubism* (New York: The Museum of Modern Art, 1989)

_____, *Henri Rousseau* (New York, The Museum of Modern Art, 1985)

Schapiro, Meyer. 'The Nature of Abstract Art', *The Marxist Quarterly*, vol. 1 (1937): 92

Schiff, Gert, 'Painting as an Act of Love', in Thomas B. Hess and Linda Nochlin, eds., *Woman as Sex Object* (New York: Artforum, 1972)

Shattuck, Roger, *The Banquet Years: The Origins of the Avant-Garde in France 1885 to World War I* (New York: Vintage Books, 1967)

Silver, Kenneth E., *Esprit de Corps: The Art of the Parisian Avant-Garde and the First World War, 1914–1925* (Princeton: Princeton University Press, 1989)

_____, *The Great War and French Art, Esprit de Corps*, 1914–25 (Yale University (Ph.D. dissertation) 1981)

_____, 'Jean Cocteau and the *Image d'Epinal:* An Essay on Realism and Naiveté', in *Jean Cocteau and the French Scene* (New York: Abbeville Press, 1984): 93ff

Sokolova, Lydia, *Dancing for Diaghilev* (London: Murray, 1960)

Sotheby's London, *Ballet Material and Manuscripts from the Serge Lifar Collection* (Auction cat., Diaghilev's music library, lot 157: 9 May, 1984)

Staller, Natasha, 'Méliès Fantastic Cinema and the origins of Cubism', *Art History*, vol. 12, no. 2, (June 1989): 202–32

Starobinsky, Jean, *Portrait de l'Artiste en Saltimbanque* (Geneva: 1980)

Steegmuller, Francis, *Apollinaire: Poet Among the Painters* (New York: Farrar and Strauss, 1963)

_____, *Cocteau: A Biography* (Boston: Little, Brown, and Co., 1970)

Gertrude Stein Archive, Beinecke Rare Book Library, Yale University

Steinberg, Leo, 'A Working Equation or – Picasso in the Home Stretch', *Print Collector's Newsletter*, vol. 197: 102–5

Stravinsky, Igor and Craft, Robert, *Memories and Commentaries* (Garden City, New York: Doubleday and Co. Inc., 1960)

_____, ed., and with commentaries by Robert Craft, *Selected Correspondence* (New York: Alfred Knopf, 1982)

_____, *Chroniques de ma vie*, vol. I. (Paris: 1935)

Thétard, Henry, *La Merveilleuse Histoire du Cirque* (Paris: Prisma, 1947): 258

Tinterow, Gary, exhib. cat. *Master Drawings by Picasso* (Cambridge: Fogg Art Museum, *Essential Cubism*, 1981)

Towsen, John H., *Clowns* (New York: Hawthorn Books Inc., 1976)

Volta, Ornella, *Erik Satie, e gli artisti del nostro tempo* (Rome: Galleria Nazionale d'Arte Moderna di Roma, 1981)

_____, *L'Ymagier d'Erik Satie* (Paris: Editions Francis van de Velde, 1979)

_____, *Erik Satie & la Tradition Populaire* (Paris: Musée des Arts et des Traditions populaires, 1988)

Winter, Marian Hannah, *The Theatre of Marvels* (New York: Benjamin Blom, Inc., 1962)

Zervos, Christian, *Pablo Picasso,* 27 vols (Paris: Cahiers d'art, 1932–73)

Publisher's acknowledgements

Publishers and authors of copyright material quoted in the text are detailed in foot-notes and Bibliography; they are all hereby thanked and acknowledged.

Grateful acknowledge-ment is made to the following institutions, bodies and individuals for kindly supplying illustration material and their permission for its repro-duction (numerals are figure numbers; illustrations refer-enced in bold type appear in colour between pages 13 and 28 as well as in mono-chrome):

New York
Culver Pictures, Inc., 99
Frederick R. Koch Foundation, 37, 43, 48, 54, 55—7
The Metropolitan Museum of Art, 184 (Bequest of Stephen C. Clark, 1960; 61.101.17)
Collection, The Museum of Modern Art, 104 (acquired through the Lillie P. Bliss Bequest), 181 (Abbott-Levy Collection: Partial Gift of Shirley C. Burden)
New York Public Library Picture Collection, 160, 237
Photo: Perl's Galleries, 235
The Billy Rose Theater Collection, The New York Public Library at Lincoln Center: Aster Lennox and Tilden Foundations, 49, 92; Robinson Locke Collection, 47, 50—1, 143

Paris
Bibliothèque de L'Arsenal, Collection Rondel, 46, 61, 206
Bibliothèque National, Source Photographique, 6, 195
Fonds Kochno, Bibliothèque de l'Opéra, 26—8, 31, 33, 35, 165
Musée Picasso: © photo R.M.N. — SPADEM, 11, 13—19, 29, 36, 39, 40, 53, 69, 72, **73**, 74, 79—87, **93—4**, 95, 96, 105, 106, 107—31, **132**, 133, 137—9, 146—55, **156**, **157**, 158 (Foto Saporetti, Milan), 159, 163—4, 166—9, **170**, 171—7, **185**, 186—90, **191**, 192—3,
194, 225, **239** (Donation Picasso, R.F. 1973.91)
Collection Marina Picasso (SPADEM), 23, 217
Fondation Erik Satie — Collection Boris Kochno, 3, 4, 58 (gift of David Vaughan), 59 (photo Herbert Migdoll), 60, 62, 63, 66, 78, 97, 98 (photo Sotheby's London), 103, 136, 180, 182; Collection Edouard Dermit, 25, 102, 178; Collection Etienne de Beaumont, 134
Collection SPADEM, 52, 211, 217, 218

Public sources in other locations
The Baltimore Museum of Art: The Cone Collection, formed by Dr Claribel Cone and Miss Etta Cone of Baltimore, MA, **209**
Musée Picasso, Barcelona, 205, 216, 222
Schloss Charlottenburg, Staatliche Schlösser und Museen, Berlin, 199
Columbus Museum of Art, Ohio: Gift of Ferdinand Howald, 7
The Harvard Theater Collection, 64, 142
The Trustees of the Victoria and Albert Museum, London, 68, 70, 71
National Gallery, London, 8
Pushkin Museum, Moscow: © R.M.N. — SPADEM, **234**
Museo San Martino, Naples, 230
National Gallery of Art, Washington, DC: Chester Dale Collection, **208**
Beineck Rare Book Library, Yale University, 22, 227—9

Private sources
The author, 24, 207, 231
Ken Brown, photographer, 224
Etienne, Georges and David Helft, **67**
Collection Billy Klüver (copyright 1970 Jean Cocteau/Edouard Dermit), 221
La Nouvelle Dag, Rome, 12 (reconstruction by Elio Marchegiani, 1967 for Obelisco Gallery)
Former Collection Jacqueline
Picasso, 238
Collection Paul Sacher Foundation, 233
Sotheby's London, **75**, 220

Photographed from published sources by John LeClaire, Williamstown, Massachusetts.
9, 10, 38, **76**, 100, 144—5, 161—2, **196—7**, 200, 203—4, 210, 212, 223, 2 (Douglas Cooper, *Picasso Theater*, Harry N. Abrams, New York, 1967), 20—1 (Robert Craft (ed.), *Dearest Bubushka*, New York, 1982), 30, 140—1, 179, 202, 219, 226 (Christian Zervos, *Pablo Picasso*, Cahiers d'Art, Paris, 27 vols, 1932—73), 32 (Jacques Garnier, *Forains d'hier et d'aujourd'hui*, Les Presses, Orléans, 1968), 42 (Robert Leach, *The Punch and Judy Show*, University of Georgia Press, Athens, GA, 1985), 45, 63, 76—7, (Will Dexter, *The Riddle of Chung Ling Soo*, Arco, New York, 1976), 65, 101, 215 (Henry Thétard, *La merveilleuse histoire du cirque*, Prisma, Paris, 1947), 88—90 (Raymond Lees, *The Films of Mary Pickford*, Barnden Castell Williams, London, 1970), 91 (Gustave Fréjaville, *Au Music-hall*, Editions du Monde Nouveau, Paris, 1923), 135 (Kenneth E. Silver, *Jean Cocteau and the French Scene*, Abbeville Press, New York, 1984), 198 (John H. Townsen, *Clowns*, Hawthorn Books, New York, 1976), 201 (A. Cirici Pelliers, *El-Arte Modernista Catalan*, Barcelona, 1951), 213—14 (Georges Bloch, *Pablo Picasso: Catalogue of the Printed Graphic Work*, Kornfeld & Klipstein, Berne, 1971), 232 (Pierre-Louis Duchartre, *The Italian Comedy*, Dover, New York, 1966), 236 (Keith Money, *Anna Pavlova*, Alfred A. Knopf, New York, 1982)

Index

Page numbers in italics refer to monochrome illustrations, those in bold to colour illustrations
'n' denotes a footnote

Acrobats, 33, 46, 49, 73, 75, 83, 85, 89–90, 97, 99, 101, 124, 132–3, 171, 186, 204, 207; *and see* Picasso, Pablo, Drawings: *Parade*
 female, **17**, 95, 124, *127–8, 130–1*
 male, **16**, *74*, 124, *126, 130*
Adam, Adolphe
 Giselle, 70, *98*, 263, *265*
Alber, 91, *94*
Alf, 99
Alhambra, London, 38, 41, 79
Alhambra, Paris, 79, *80*
allégresse, l', 32
Apollinaire, Guillaume, **28**, 32, 43–4, 46, 53, 87, 207, 225, 256, *257*, 263
 Alcools, 45
 Antitradition Futuriste, L', 51 n.16
 Onze mille verges, Les, 44–5
 Saltimbanques, Les, 253–5
 Spectacle (Crepuscule), 253–4
architectures vivantes, 167
Asquith, Mr., 95
Astruc, Gabriel, 43–4
Atget, Eugène
 travelling *forain*, Fête des Invalides, 204, *205*
avant-garde, 32, 35, 38, 45, 47, 75
Axsom, Richard, 171

baboon, theme of, as source for Picasso's curtain, 235, *236*
Baker, Josephine, 79
Bakst, Léon, 30, 35, 41, 43, 49
Balla, Giacomo, 49, *50*, 51, 61
ballet réaliste, 43, 70, 73 n.1
Ballets Russes, 30, *31*, 32, 35, 38–9, *40*, 43, 46–7, 49, 51, 61, 70, 79, 89, 97, 101, 133, 171, 227, 251 n.23, 258 n.17, 260
Baltimore Museum of Art, 229, 238
Bambara animal masks, 186
baraques, 73
Barbette, 79

Barnum and Bailey poster for the 'Greatest Show on Earth', 124, *131*
Baroque, 204, 207 n.49
Barr, Alfred, 212
batterie, 88
Baule
 masks, 186
 ritualistic two-man horse, 186, *188*
Beaumont, Comte Etienne de, 46
Bell Geddes, Norman
 Flying Colors, 171
Bell Marks, Mary, *80*
Benevol, 91
Benois, Alexandre, 30, 41, 227
Bérain, Jean
 Habit de musicien, 167, *170*
Berkeley, Busby, 171
Berlin, Irving
 'Mysterious Rag, The', 88, *92*
Bib and Bob, 79
Bibliothèque de l'Opéra, Paris, 43
 Kochno bequest, 61
Bierre, de, 91
Blackamoor, 214, 227, 248, 248 n.19, 262
Blasis, 59
Block, Mr. and Mrs., 264
Boccioni, Umberto, 165
boche, 47
Boeuf sur le Toit, Le, Paris, 88 n.8
Bongard, Germaine, 47
Braque, Georges, 35, 46, 263
Breton, André, 256
Bruant, Aristide, 87
bruits scéniques, 88
Buhrle collection, Zurich, 53
Burbridge, Edward
 reconstruction of *Parade* in performance (1973), *203*
Buttes-Chaumont, Paris, 59

Cabanne, Pierre, 53 n.24
café-concerts, 38–9, 85, *221*, 223, 264
Café de la Dome, Paris, 46
Café de la Ronde, Paris, 46, 240, *241*
cafés, influence of, on Picasso and *Parade*, 87, 223, 225, 227, *228*, 240, *241–2*, 243, *244*, 245
Callot, Jacques, 220
Canterelli, 91
Cantina Taglioni, Rome, 51

Casas, Ramon, 223
Chabelska, Marie, 33, 49, *74*, 95, *112*
Challamel
 Carlotta Grisi in act II of *Giselle, 98*
Chaplin, Charlie, 33, 95
Charivari, 38
Chat Noir, Le, Paris, 87
cheval dressé, 132
cheval jupon, 35, 132, 186, 189
chiaroscuro, 212
Chinese Conjurer, **67, 75**, 33, 46, 49, 73, 75–6, *77–8*, 79, 88–9, 89 n.15, 91, 91 n.22, *94*, 95, *96*, 97, 99, 101, *102–10*, 111, 124, 133, 165, 171, 186, 189, 204, 207, 255
Chinese Conjurer's costume, *see* Picasso, Pablo, Drawings: *Parade*
Chopin, Frédéric
 Sylphides, Les, 30, *31*, 256, 260, *261*, 263–4
'chromos', 90
circus acrobats, 124, *130–1*
circus, influence of, on Picasso and *Parade*, 35, 38, 41, 44, 53, 73, 90–1, 95, 97, 99, 101, 111, 124, 132, 165, 186, 189, 204, *206*, 214, 214 n.9, 223, 225, 227, 229, *230*, 231, 235, 238, 264, 266
Cirque d'hiver, 72
Cirque Franconi, *98*
Cirque Médrano, 35, 38, *40*, 41, 44, 85, 97, 186, 214, 225
Closerie de Lilas, Paris, 87
Cocteau, Jean, 30, *31*, 32–3, 35, 38–9, 41, 43, 46–7, 49, 51, 53, 61, *64*, 70, 73, 76, 79, 81, 83, 85, 87–8, 88 n.8, 90–1, 91 n.22, 95, 97, 111, 124, 132–3, 165, 167, 171, 189, 204, 207, 209 n.2, 225, 227, 229, 231, 240, 245, 255–6, 258, 260, 262–3
 • Drawings:
 female acrobat, 124, *131*
 Managers from *Parade*, 61, *67*
 Picasso and Olga Koklova, in Rome, 61, *64*
 Willy (Henri Gauthier-Vilars), Polaire, Colette and Toby Chien, 83, *84*
 • Notebooks:
 Italian notebook, 61,

62–3, *65*, 66, 73 n.1, 189, *190*
buildings, 189, *203*
Cocteau, Picasso and Olga Koklova, 61, *63*
Roman notebook, 61, *62*, 91, *93*, 97
• Manuscripts:
copyist's manuscripts of Erik Satie's score for *Parade*, 66, *69*, 76, *77*, *80*, 85, 88–9, 89 n.15, *92*
Photograph: on the terrace of the Café de la Ronde, 240, *241*
• Theatre pieces:
David, 43–4, 46
Dieu Bleu, Le, 43
Midsummer Night's Dream, A, 44–5
Train bleu, Le, *31*, 32
Colette
Claudine novellas, 83, *84*
Vagabonde, La, 83
collage, 35, 38, 87, 132–3, 165, 167, 212, 240, 262
commedia dell'arte, 45, 53, 53 n.24, 59, 66, 75–6, 99, 220, 220 n.14, 222, 225, 240, 243, 253, 255, 260, 266
• Characters:
Columbine, 87, 209, 214, 227, 243
Harlequin, 75, *77*, 87, 133, *134*, 167, 186, 189, *190*, 209, 212, 214, *219*, 220, *221*, 222, 223, *224*, 225, 227, *228*, 229, 229 n.46, n.49, 231, *232*, 235, *237*, 238, 240, 243, 245, 251, 253–4, 255, 255 n.11, 260, 262–3
Pierrot/Gilles, 87, 222, 227, 243, 263
Pulchinella, 53, *54–6*, *58*, 59, 75, 87, 235, *237*, 248, 251
saltimbanques, 222–3, 225, 227, 229, 235, 253–4, 263
Scarmouche, 225
Scarpino, 75
constructions, 38, 132, 165, 212, *213*
Cooper, Douglas, 212
costumes, 30, 35, 45, 53, *57*, 59, **67**, *74*, **75**, 90–1, **93**, **94**, 95, 95 n.28, 97, 101, *102–10*, 111, *112–21*, 124, *126–31*, 132–3, *134–5*, *137–63*, 165, 167, 171,

173–85, 186, 189, *203*, 204, 207, 212, 222, 229, *232*, 255, 260, *261*, 262, 266
côté 'allée' des attractions, 73
Courbet, Gustave, 223
Courrier Français, Le, 223
Cris de Paris, 167
Cubism, 30, 32–3, 35, 38, 45–7, 61, 71, 87, 90, 99, 133, 165, 189, 204, 207, 212, 214, 231, 240, 260, 262
Cucciniello, E.
Presepe, 248, *249*

Daix, Pierre, 227, 240
Damase, Jacques, 91
Damia, 38, 264
Dazie, Mlle., 87
Debussy, Claude
Après-midi d'un faune, L', 30
'Au clair de la lune', 87
décor, sets, 49, 101, 132, *161*, 167, **170**, 171, 189, *191–7*, *199–203*, 204, *205*, 207, 212, 227, 253
Degas, Edgar, 222
Depero, Fortunato, 51
study for Futurist puppets for *I piccoli selvaggi*, '*Balli plastici*', Rome, 165, *166*
Depeyre Lespinasse, Gaby, 46
Dermit, Edouard, 43
Deslys, Gaby, 88
Diaghilev, Serge, 30, *31*, 32, 35, 38–9, 43–7, 49, 51, 59, 61, 70, 88–9, 97, 101, 124, 132–3, 171, *172*, 214, 260, 262–3
dining themes, Neapolitan and Mediterranean influences on Picasso, 240, *241–2*, 243, *244*, 245, *246–7*, 248, *249–50*, 251
Ducos, Coralie, *98*
Dufy, Raoul, 47
Duncan, Isadora, 79

écuyères, 231
Eight Allissons, the, 124, *125*
Eluard, Paul, 256
Empire Theatre, 38, 76, 79
entrechats, 95, 220
Errazuriz, Mme. Eugenia 46, 254 n.6
Esparde, Georges d'
Demi-Cabots: Le Café-Concert, Le Cirque, Les Forains, *221*, 223

esprit nouveau, 32, 207
Etex, Antoine
monument to Ingres, Montauban, 266

Fang masks, 186
Femmes de Bonne Humeur, Les, 124
Férat, Sersi, 47
fête galante, 222, 255
Feuillet, Raoul-Auger, 59
films, influence of, on Picasso and *Parade*, 33, 61, 75, 81, *82*, 83, 91, 95, 111, *123*, 124, *125*, 167, *170*, 171, *172*, 262, 266
Fizdale, Robert, 70
flaques sonores, 88
Foire de Trône, 76
Folies Bergères, Paris
En Avant, 264
Foo, Ching Ling, 76
Footit clowns, 35, *36*, 186
forain, 66, 73, 75–6, 89, 111, 204, *205*, 214, *219*, 220, *221*, 222–3, 225
Foska, 61
Fratellini brothers, 35, *36*, 44, 186
'Frère Jacques', 87
Fréjaville, Gustave
Au Music-hall, 97, 124
Fresnaye, Roger de la, 35, 47
Futurism, 49, 51, 51 n.16, 61, 85, 165, 167

Galérie de la Boetie, Paris
Section d'Or exhibition (1912), 35
Garden of Punchinello, The, 87–8
Gauthier-Villars, Henri, 83, *84*
Geiser, Bernhard, 231, 235, 238
Gentleman's Magazine, 73
Gilot, Françoise, 227
Gleizes, Albert, 44–5
Landscape, 35, *37*
Gold, Arthur, 70
Goli helmet masks, 186
Goteborgs Konstmuseum, 235
Gouel, Eva, 46, 240, 263
Grand Robert, le, 91
Great Performances – Dance in America (1976), 90
Greco, El, 39
Greffulhe, Madame, 43
Gris, Juan, 71
Grisi, Carlotta, *98*

Gross, Valentine, 46, 49, 90, 132
guignol, 207

Hahn, Reynaldo, 43
Harlow, Jean, 111
Hart, William, *170*
haut-bourgeoisie, 43, 262
Herculaneum, wall paintings, influence of, on Picasso and *Parade*, 66, *67*, 251
Hermant, Abel, 33
Hills, H.
Harlequin and mountebank, reproduction of popular 17th century broadside, 'The Infallible Mountebank', *221*
Hippodrome, London, 79
horse, four-legged, 32–3, *34*, 35, *57*, 89, 97, 99, 132–3, *162*, *173–85*, 186, *187*, 189
Humbert, Marcelle, 46
Hyspa, Vincent, 39, 87

Ibels, H.G.
Parade, La, *221*, 223
Illustracion artistica, La, 223
images d'Epinal, 167, 212, 225, *226*, 227, 256
Imperial School, Moscow, 89
Ingres, Jean Auguste Dominique, 39, 266

Jacob, Max, 46, 87, 167, 225, *241*, 256, 263
jambe en bois, 39
Jarry, Alfred, 133
jazz music, 88, 88 n.8, *92*
jetés, 95
Joffrey performance of *Parade*, New York (1973), 90, *93*, 124
Juan-les-Pins, *250*, 251
jumping-jacks, 227, *228*
Junger-Vidal, Sebastian, *241*

Kahnweiler, Daniel Henry, 46
Karsavina, Tamara, 41, 95, 99, 263
Kirstein, Lincoln, 71
Kisling, Moise, *241*
Knesing, Theodore
Seiltanzer auf Nachtlichen, 231, *233*
Kochno, Boris, 46, 61
Kodak, 95
Koklova, Olga, *31*, 49, *50*, 61, *63–4*, *172*, 235, *250*, 251, 260, 262–3

Kunstmuseum, Basel, 256
Kunstmuseum, Winterthur, 256

LaFontaine, Jean de
'Monkey and the Leopard, The', 235
Lapin Agile, Paris, 87
Lapokowa, 33
Larionov, Michel, 49
Laurencin, Marie, **28**, 256, *257*
LeFauconnier, Henri, 35
Léger, Fernand, 35
Léris's *Dictionnaire portatif des Théâtres*, 73
Lhote, André, 35, 47, 61
Libion, M. 240
Lifar, Serge, 90
Little American Girl, 33, 46, 49, 59, 73, *74*, 75, 79, *80*, 81, 83, 87–9, 95, 95 n.28, 97, 99, 101, 111, 133, 167, 171, 207, 255; *and see* Picasso, Pablo, Drawings: *Parade*
London Coliseum, 38, *40*, 79, 171
Lopokova, Lydia, 97, 124
Louvre, Paris, 38, 222
Lyre et Palette, Paris, 35

make-up, **14**, 101, *108–9*
Managers, **23–4**, 30, 33, *34*, 49, 51, 53, *57*, 59, 61, 66, *67*, 70, 73, 75–6, 79, 85, 89–91, 97, **98**, 132–3, *135*, *137–8*, *140*, *143–6*, *156–8*, 165, 167, 171, *173–85*, 186, *187*, 189, 204, 207; *and see* Picasso, Pablo, Drawings: *Parade*
American, **23**, *161–3*, 165, 167, 171, 204
French, 133, *134*, *141*, *148–55*, *159*, 165, 167, 171, 204, 214
Musician, *139*, *142*, *147*, 165
Negro, 171
Manet, Edouard, 39, 222–3
Marcousis, Louis, 35
Marinetti, Filippo, 51, 53
In Praise of Variety Theater, 85
Marlet, Jean Henri
'Parade, A' (from *Les Tableaux de Paris*, c.1830), *219*
Marquet, Albert, 47
Maryinsky Theatre, 41, 132
Maskelyne, 91

Massine, Léonide, **75**, 30, 33, 38, 41, 43, 49, 53, 59, 61, 70, 81, 89–91, *94*, 95, 95 n.28, *96*, 99, *110*, 111, 124, 132–3, 165, 171, 186, 245
 Matelots, Les, 32
 Soleil de nuit, Le, 30
Méliès, Georges, 61
Metropolitan Opera, New York, 99
Metzinger, Jean, 35
Milka, 61
Minkus, Léon
 Don Quixote, 89
Minstrel in blackface, *187*
Mirliton, Paris, 87
mise en scène, 30, 46, 49, 212, 227
Mistinguett, 39
modernista group of Catalan artists, 223
Modigliani, Amedeo, 46
monkey, theme of, as source for Picasso's curtain, 214, 220, 231, 235, *236*, 238, 243, 255–6, 260, 262, 266
Montreuse, Gaby, 38
Morgan Library, New York, 43, 85
Motion Pictures
 article on William Hart (1916), *170*
Moulin Rouge, Paris
 Tais-toi, tu m'affoles revue, 88
Moving Picture world
 advertisement for The *Perils of Pauline* (1914), *82*
Musée Picasso, Paris, 53, 165, 214, 238, 253, 255
Museo di San Martino, Naples
 frescos, 251
 postcards, 51, 53, *54*, 245, *246–7*, 248
 Presepe, 248, *249*
Museo Picasso, Barcelona, 238
Museum of Modern Art, New York, 212, 231, 243, 263

National Gallery, Washington, DC, 229, 235
New York Public Library
 Billy Rose Theater, Robinson Locke Collection scrapbooks, 81
 Dance Collection, 43

Nijinsky, Vaslav, 30, 41, 43, 89, 263
Nouveau Cirque, 73
Noverre, Jean Georges, 220

Oiseau de feu, L', *see* Stravinsky, Igor, *Firebird, The*
Olivier, Fernande, 38, 225, 263
Opisso, Ricardo
 En Mitja Calta, 223, *224*
 Quatre Gats, Els, 240, *242*
Overture curtain, *20–1, 201*, 209, *210–11*, 212, 214, *215–18*, 220, 222–3, 225, 227, 229, 231, 235, 238, 240, 243, 245, 248, 251, 251 n.23, *253–6, 258, 260, 263–4*, 266

Palace Theatre, London, *78*
Palizzi, Filippo
 Presepe, 248, *249*
pantin, 227, 256
 Epinal, 227, *228*; *see also* images d'Epinal
papier collé, 35
papier mâché, 133, 186
Pâquerette, 46, *241*
parade, 33, 66, 73, 75, *77*, 91, 97, 133, 204, *206*, 214, *219*, 220, *221*, 222–3, 225, 231, 266
Paris Opéra, 263
paseo, 240
Passage, Comte de
 Cirque Forain, Le, 66, *69*
Pathé Studios, Paris
 Exploits of Elaine, 81
 Perils of Pauline, The, 81, *82*
Pavlova, Anna, 260, *261*, 263
Pegasus, source for Picasso's curtain, 231, 251, 256, 264
Pél i Ploma, 223
Pellerin, Fabrique
 images d'Epinal, 225, *226*
 pantin, 227, *228*
Penrose, Sir Roland, 212
Petito, Antonio, 59
Picasso, Claude and Paloma, 227
Picasso, Mme. Paul, 235
Picasso, Pablo, 30, 33, 35, 38–9, 41, 43–6, 49, 51, *52*, 53, 59, 61, *63–4*, 66, 70–1, 73, 75, 79, 81, 87, 90–1, 97, 99, 101, 132, 167, *210*, 222–3, 225, 227, 229, 231, *232*, 235, *236*, 238, 240, *241–2*, 248, *250*, 251,

253–6, 258, 260, 262–4, 266
• Drawings:
 Parade
 Acrobats
 female (pencil and watercolour), *17*, 124, *127*, 132
 female (pencil), 124, *128*, 132
 male, **16**, 124, *126*, 132
 Chinese conjurer's costume (watercolour), **13**, 101, *102*, 124
 Chinese Conjurer's costume (pen and ink), 101, *103*, 124
 Chinese Conjurer's costume (pencil studies), 101, *104–7*, 124
 Chinese Conjurer's make-up (pencil and ink), **14**, 101, *108–9*
 Chinese Conjurer's make-up (pencil and watercolour), 101, *109*
 décor, sets (pencil and gouache), *195, 204*
 décors, sets (pencil), **18**, 101, 161, 171, 189, *191–4, 196, 199–203*, 204, 207
 Little American Girl (pencil sketches from 1917 Italian notebook) 111, *113–21*, 124
 head of a Majorcan woman (pencil and watercolour), 209, *218*, 235, 238, 243
 Managers (pencil sketches from 1917 Italian notebook), *135–8, 140, 143–6, 156–8*, 165, 186
 Manager on horseback (pencil), *173–7, 180–1*, 186, 189
 Manager on horseback (pencil and ink), *2, 182, 184*, 186, 189
 Manager on horseback (pencil and gouache), *185*, 186
 Manager on horseback (pencil and watercolour), **24**, *179, 183*, 186, 189
 American Manager (pencil), *161*, 171
 American Manager (pencil and watercolour),

163, 165
 American Manager and head of a horse (pencil and gouache), **23**, *162*, 171, 186, 189
 French manager (pencil), *141, 148–52, 154, 159*, 165
 French manager (pencil and ink), *153*, 165
 Musician manager, *139, 142, 147*, 165
 overture curtain (pencil), *201*, 209, 212, 214, *216–17*, 243
 overture curtain (pencil and watercolour), **20–21**, 214, *215*, 243, 253
 see also costumes
• Other drawings:
 Acrobat's costume and study of a nude, 129
 Actor with cane and glove, 167, *168*
 Anna Pavlova as *Giselle*, 260
 baboon, 235, *236*
 Family of Saltimbanques with Monkey, 235
 fragment, *197*
 Harlequin's Family, 223, *224*
 Italian notebook (1917), 51, *52*, 61, 66, *68*, 83, *84*, *136*, 245, *246–7*, 248
 Majorcan woman, 235, *237*
 Man with Pipe seated at table, 167, *168*
 menu of Els Quatre Gats, Barcelona, 225, 227, *228*
 Père Romeu – 4 Gats, 240, *242*
 Picasso par lui même, 235, *236*
 Pompeii, 66, *67*, 251
 Practising the 'Jota', 243, 244
 Pulcinella (Pulchinella), 53, *55–6*, 248
 Pulchinella and two Harlequins, 235, *237*
 Rusiñol, 256, 257
 Seated man with a cane, 167, *169*
 Self-Portrait with Angel de Soto and Sebastian Junger-Vidal, 240, *241*
 Seven Dancers, 260, 265
 Still-life on a table

before an open window, 173, *186, 212*
 Suite Vollard, 244, *245*
 untitled, 186, 188, *231*, 233–4
 Woman standing, *167*, 169
• Paintings:
 Acrobat's Family with a Monkey, 235
 At the Lapin Agile, 227, 229
 Bread and Fruitdish on a Table, 207 n.51
 Carnaval au bistrot, 229, 243
 Circus Family, **27**, 229, *230*, 238
 Demoiselles d'Avignon, Les, 207 n.51, 212, 238
 Family of Saltimbanques, **26**, 229, *230*, 235, 243, 255, 263
 Guernica, 231
 Guitar Player, 165, *166*
 Harlequin (1915), 133, *134*, 167
 Harlequin (1971), 231, *232*
 Harlequin and Woman with a Necklace, 189, *190*
 Italienne, L', 53, *57–8*
 Painter and Model, 212, *213*
 Parade overture curtain, **20–21**, 209, *210–11*, 212, 214, 220, 222–3, 225, 227, 229, 231, 235, 238, 240, 243, 245, 248, 251, 251 n.23, *253–6, 258*, 260, *263–4*, 266
 Person on a ladder, 238
 Playing-card, Glass and Bottle on a Guéridon, 35, *37*
 Salchichona, La, 238
 Spanish Still-Life, 111
 Three Musicians, 88 n.8, 243, 263
 Vive la France, 264
 Wedding of Pierette, The, 240
• Other works:
 Harlequin *pantin*, cardboard, crayon and coloured pencil, 227, *228*
 Mercure, set décor, 133, *164*
 Table and guitar in front of a window,

construction, cut-out painted cardboard, paper and crayon, 212, *213*

Pickford, Mary, 81, 83, 95, 111, *122–3*

Pietro le Commandeur, 61, *65*

Pirandello, 97

placard, poster *à la porte d'un Théâtre de la Foire*, 222

Poggi, Christine, 165, 167

Pointillism, *195*, 204, *206, 218*, 238, 264

Poiret, Paul, 35, 46, *241*

Polaire, 83, *84*

Politics, influence of, on Picasso and *Parade*, 263–4, *265*, 266

Pompeii, frescos and wall paintings, influence of, on Picasso and *Parade*, 66, *67, 250*, 251

Pons y Massaveau, Juan *En Mitja Calta*, 223, *224*

postcards, Neapolitan, influence of, on Picasso and *Parade*, 51, 53, *54*, 245, *246–7*, 248

Poulenc, Francis, 32, 47 *Biches, Les*, 32

presepe, influence of, on Picasso and *Parade*, 248, *249*

Punch and Judy, 225, 256

puppets, influence of, on Picasso and *Parade*, 59, 165, *166*, 225, 227, *228*, 256

Pushkin Museum, Moscow, 235

Quatre Gats, Els, Barcelona, 223, 225, 227, *228*, 240, *242*

Rabier, Benjamin *Animaux de Gibbs (Série des Singes)*, 235, *236*

Radiguet, Raymond, 81

'Ragtime du Titanic', 89

Rameau, Jean Philippe, 59

Reff, Theodore, 222

Rembrandt van Ryn, 39

Richardson, John, travelling circus scene from *Harlequin Red-Riding Hood* (c.1830), *219*, 220

rideau de scène, 209

Rimsky-Korsakov, Nicholas, 41, 44

Scheherezade, 30

ronds de jambe, 95

Rose Amy, 38

Rosicrucians, 87

Roskoff, 61

Rousseau, Henri, 212 *Muse Inspiring the Poet, Apollinaire and Marie Laurencin, The*, **28**, 256, *257*

Representatives of Foreign Powers arriving to Hail the Republic as a Sign of Peace, **28**, 264, *265*, 266

Rubin, William, 229

Rusiñol, Santiago, 256, *257* *Alegria que passa, L'*, 223

Ryss, de, 91

Salmon, André, 46, 256, 263–4

Salon d'Antin, Paris L'Art Moderne en France, exhibition (1916), 35, 47, 264

San Carlo Opera House, Naples, 51

Satie, Erik, 30, 35, 38–9, 43–4, 46, 83, 87–8, 91, 95, 99, 132–3, 189, 209, 214 'Geneviève de Brabant', 87 *Five Grimaces for A Midsummer's Night Dream*, 44 'Morceaux en forme de Poire', 87 *Parade* score, 66, *69, 77, 80, 85*, 88–9, 89 n.15, *92* 'Pst, Pst, Pst, Je te veux', 87 'Tendrement', 39, 87

Satie Foundation, Paris, 43, 124

Schapiro, Meyer, 229

Schola Cantorum, 87

Senufo mask, 186, *188*

Sert, Misia, 43, 49, 133, 165

Seurat, Georges, 222–3 *Cirque, Le*, 204, *206* *Parade*, 204, *206*

Shakespeare, William *Midsummer Night's Dream, A*, 44

Shattuck, Roger *Banquet Years, The*, 263

Silver, Kenneth, 32

Snyder, Ted, and Company, New York, 88, *92*

Société National des Beaux-Arts, Paris, 258

Sokolova, Lydia, 95

Soo, Chung Ling (William Ellsworth Robinson), 76,

78, 79, *80*, 91, 95, *96, 110*

Soto, Angel de, *241*

Spencer, Mr., 39

'Steamboat Ragtime', 89, 95, 124

Steegmuller, Francis, 43, 45

Steens, de, 91

Stein, Gertrude, *57*, 66, 225, 264

Stradivarius, 90

Stravinsky, Igor, 41, 43–4, 51, *52, 57*, 245, 251 *Apollon Musagète*, 32 *Firebird, The*, 39, *50*, 51 *Fireworks, 50*, 51, 61 *Histoire du Soldat, 56*, 88 n.8 *Noces, Les*, 39 *Petrouchka*, 30, 39, 70, 227, 248 n.19 *Pulcinella*, 39, 53 *Ragtime*, 88 n.8 *Sacre du Printemps, Le*, 30, 39

Street vendor, Paris, Second Empire, *164*

Surrealism, 45

sur-réalisme, 43

Swerien, 33

Symbolism, 87, 266

Synthetic Cubism, 35

tableaux vivants, 75

Teatre Intim, Barcelona, 223

Teatro San Carlo, Naples, 53 n.18, *54*, 251 n.23, 258 n.17

tertulia, 240

Théâtre des Nouveautés, Paris, 66

Théâtre du Châtelet, Paris, 30, 33, 59, 79, 165, 209

théâtre forain, 41, 73, 75, 207

Theatre of Marvels, 73

Théâtre Salon Carmelli, Paris, 61

Théâtres de Magie, 75

Thomas, W. *Preacher at a fairground*, *77*

Tiepolo, Giambattista, 222

Titanic, 89, 95

Toulouse-Lautrec, Henri, 222

tribal sculpture, influence on Picasso and *Parade*, 186, *188*

trompe l'oeil, 212

'Tschin Maa and his Seven Holy Grave Watchers and Necromancers', 91

Ubu, Père, 133

Vanity Fair, 33, *80*

Varèse, Edgard, 45

Variété-Music Hall, 75

Vassilieff, Marie, *241*

Velazquez, Diego Rodriguez de Silva, 39

Verlaine, Paul *Cortège*, in *Fêtes Galantes*, 255–6

Vianelli, Achille *Taverna, La*, from *Popular Scenes of Naples*, 245, *246*, 248 untitled postcards, from *Popular Scenes of Naples*, 245, *247*, 248

Villa Medici, Rome, 49

Villon, Jacques, 35

War Benefit Fund, 30

Watteau, Antoine, 220 *Gilles*, 222 *Shepherds, The*, *221*, 222

White, Pearl, 81, *82*, 83, 95, 124, *125*

Williams Sportswear shop, Paris, 111

winged horse, source for Picasso's curtain, 231, *234*, 251, 263–4, 266

Winter, Marian Hannah, 66, 220

Wizard, The, 79

Woidzikowsky, 91

Zarate, Ortiz de, *241*

Zervos, Christian, 231, 235, 238, 240

Zverev, Nicholas, 97